Drawing from Life

Third Edition

CLINT BROWN

CHERYL McLEAN

THOMSON

™

WADSWORTH

Australia • Canada • Mexico • Singapore • Spain • United Kingdom • United States

THOMSON
✦
WADSWORTH

Publisher: Clark Baxter
Executive Editor: David Tatom
Art Editor: John R. Swanson
Assistant Editor: Amy McGaughey
Editorial Assistant: Rebecca Green
Technology Project Manager: Melinda Newfarmer
Marketing Manager: Mark Orr
Marketing Assistant: Kristi Bostock
Advertising Project Manager: Vicki Wan
Project Manager, Editorial Production: Trudy Brown
Print/Media Buyer: Barbara Britton
Permissions Editor: Joohee Lee
Production Service: Joan Keyes, Dovetail Publishing Services

Text Designer: Cheryl McLean
Photo Researcher: Cheryl McLean
Copy Editor: Michele Jones
Cover Designer: Preston Thomas
Cover Image: Richard Diebenkorn, American 1922–1993, *Seated Woman, Legs Crossed* detail, 1965. Opaque water-color and ballpoint pen on wove paper, 31.6 × 42.9 cm. Fine Arts Museums of San Francisco, Achenbach Foundation for Graphic Arts, Purchase, Beatrice Judd Ryan Bequest Fund, 1967.16.
Compositor: Lachina Publishing Services
Text and Cover Printer: Courier Corporation/Kendallville

Printed in the United States of America
3 4 5 6 7 07

For more information about our products, contact us at:
**Thomson Learning Academic Resource Center
1-800-423-0563**

For permission to use material from this text, contact us by:
Phone: 1-800-730-2214
Fax: 1-800-730-2215
Web: http://www.thomsonrights.com

Library of Congress Control Number: 2003101514

ISBN-13: 978-0-534-61353-2
ISBN-10: 0-534-61353-5

**Wadsworth/Thomson Learning
10 Davis Drive
Belmont, CA 94002-3098
USA**

Asia
Thomson Learning
5 Shenton Way #01-01
UIC Building
Singapore 068808

Australia/New Zealand
Thomson Learning
102 Dodds Street
Southbank, Victoria 3006
Australia

Canada
Nelson
1120 Birchmount Road
Toronto, Ontario M1K 5G4
Canada

Europe/Middle East/Africa
Thomson Learning
High Holborn House
50/51 Bedford Row
London WC1R 4LR
United Kingdom

Latin America
Thomson Learning
Seneca, 53
Colonia Polanco
11560 Mexico D.F.
Mexico

Spain/Portugal
Paraninfo
Calle/Magallanes, 25
28015 Madrid, Spain

Preface

It is our contention that no textbook can be a substitute for the actual studio experience. Accordingly, this book has been designed to augment the studio experience so that one comes to the drawing sessions with both prior knowledge and a greater appreciation for the history, vocabulary, and techniques of life drawing. It complements and reinforces the information that drawing instructors provide, and it carries a portable "museum" of figure drawing within its pages.

In this third edition, we have worked to clarify and enhance important concepts and provide an updated analysis of figure drawing in contemporary art. In addition, we have further enhanced the strong sense of historical context by quoting the artists themselves when possible to express the diversity of perceptions and expressions of the human figure in art. We aren't interested in promoting a single way of looking at the figure or drawing from life. We have presented a broad array of drawings, from both old masters and contemporary artists, designed to suggest the spectrum of possibilities in figurative drawing. We have made a determined effort to include drawings by women, artists of color, and non-Western artists so that the artistic visions as well as stylistic approaches might be as diverse as possible.

The textbook as a whole progresses in a way that parallels the creative process—tracing a series of evolutionary steps that begins with sketchy notations followed by analysis, clarification, embellishment, evaluation, and refinement. The first section establishes the basic vocabulary and defines the concepts necessary to begin drawing from the human form. Chapter 2 emphasizes a spontaneous and natural approach to figure drawing, with quick gestural beginning sketching and moving to schematic sketching. The more analytic study of proportions and perspective follows in Chapter 3. Chapters 4 and 5 are devoted to in-depth study of line and value—the primary tools through which drawings communicate.

The extensive anatomy section focuses on how the skeletal and muscular systems work together to determine the body's underlying structure and outward appearance. Chapter 6 presents the larger, more easily comprehensible forms of the torso; Chapter 7 covers the intricacies of limbs, hands, and feet; and Chapter 8 examines heads, portraits, and self-portraits.

Section three focuses on the significance of the figure in contemporary art and the continuum between compositional and expressive approaches to figure drawing. What's new is a discussion of the distinction between modernism and postmodernism as they pertain to the figure in art. The book concludes with guidelines for evaluating both one's own drawing and the work of others.

Although the book follows what we believe is a natural progression, it's still flexible and easily adapted to different approaches to teaching and learning figure drawing. Because each chapter is a self-contained unit, a course of study could rearrange the order of presentation to best suit individual needs or approaches. The instructor can determine how much emphasis and studio time to dedicate to each topic. For example, an entire semester could be devoted to anatomy, or this section could be assigned as independent study.

At the conclusion of each chapter, "In the Studio" sections suggest exercises to apply the concepts and develop the skills discussed in the chapter. These can be used as presented or tailored to meet specific goals. When possible, student illustrations are included.

In many ways, this book has been a collaborative process, and we want to express our

appreciation to a number of individuals who have contributed to this project. Joan Keyes for helping us stay on track through the process of turning a manuscript into a book; dynamite copy edtior Michele Jones for her precise, thorough, and knowledgeable editing; Jeff Lachina for his careful compositing; Trudy Brown for being so organized and flexible in handling innumberable art fees; Preston Thomas for an engaging cover design; Amy McGaughey for her encouragement and enthusiasm; and John Swanson for his tenacity in making this new edition a reality.

We are extremely grateful to the many museums, galleries, artists, and individuals who provided the illustrations reproduced in the text. We especially appreciate being granted access to study original master drawings in the British Museum and the Victoria and Albert Museum in London; the Royal Collection at Windsor Castle; the Ashmolean Museum and Christ Church College in Oxford; the Devonshire Collection at Chatsworth in Derbyshire; the Achenbach Foundation for Graphic Arts at the Fine Arts Museums of San Francisco; the Art Institute of Chicago; the Minneapolis Art Museum; and the Metropolitan Museum of Art in New York.

Thank you also to the reviewers of the book: Anita DeAngelo, East Tennessee State University; Kenol Lamour, Centenary College; Diane Oliver, City College of San Francisco; Kathleen Rivero-Lander, East Central University; Marjorie Williams-Smith, University of Arkansas at Little Rock.

—CB & CM

Contents

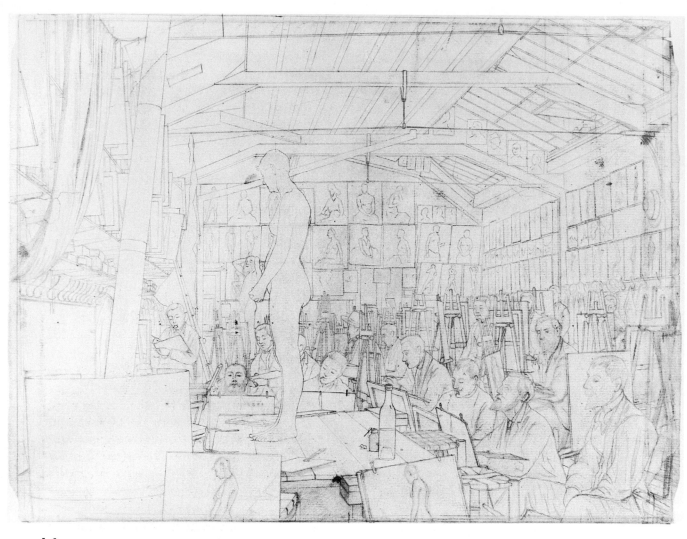

I.1

Jefferson D. Chalfant. *Study for the painting Bouguereau's Atelier at the Académie Julian, Paris*. 1891. Graphite on laid paper, 44.3 × 36 cm. Fine Arts Museums of San Francisco, Achenbach Foundation for Graphic Arts. Gift of Mr. and Mrs. John D. Rockefeller III, 1979.7.27.

The Fundamentals

It is a wonderful thing to draw a
human being, something that lives; it
is confoundedly difficult, but after all it
is splendid.

—*Vincent van Gogh*

For centuries, drawing from the human figure has given artists the concepts, tools, and vocabulary essential to all aspects of the visual arts. It is because drawing from life provides such an essential foundation for all other artistic expression that life drawing courses are at the core of virtually every art study program. Just as training with weights serves as a form of exercise for professional athletes who work to keep their muscles toned for the playing field, artists continue to draw from the figure as a discipline, honing their visual skills—no matter what the content or media of their creative pursuits.

"For me," says contemporary artist Wayne Thiebaud, "academic drawing presents a primary source of information, which is the reason it's been around so long and continues to be. It has to do mostly with the sense of giving yourself a vocabulary of visual information which can be adapted, extrapolated, extended, changed, modified. . . . Drawings like this . . . represent a means of telling you or showing you what you know and don't know, to see if you really can distinguish between what you are actually seeing as opposed to what you think you're seeing."[1]

Jefferson Chalfant's 1891 drawing of a Parisian atelier, or artists' studio session (Figure I.1), is typical of drawing classes still held in every art school, college, and university in the country today. The challenges to be faced in the life studio today are no different from those for artists who drew the human figure centuries ago. Unlike their counterparts from history, contemporary artists are not circumscribed by any academic dogma or religious canon. Today's artists enjoy unlimited possibilities for taking the knowledge and skills gained in drawing from life and using them to achieve their own creative visual expression.

Chapter One

Learning to See

As humans, we are united on a fundamental level with all other members of our species. When drawing a human being, we symbolically reach out and bring that person near. In the process, we instill a part of ourselves in the image we create. The drawing itself is never just a reflection of the subject: It is biographical and, for the artist, it therefore becomes autobiographical. It reveals as much about the artist's thoughts and perceptions as it does about the subject's physical appearance.

The image of the human figure has, across cultures and throughout history, served as a potent visual metaphor through which artists have expressed not only themselves but something of the world in which they lived. The human image in art is a mirror, one imbued with content beyond simple physical likeness. The human figure can reflect a culture and its values as well as the artist's individual perceptions. The drawing holds these reflections, like a memory, frozen in time.

Drawing from Life refers not only to the time-honored tradition of drawing from the life model (Figure 1.1) but also to the larger experiences of life, with all its shifting meanings and nuances. The conceptual representation of the figure changes from one generation to another, one culture to another.

It was the Greeks who first used the nude body as both the subject and the form of their art. Kenneth Clark, in his treatise *The Nude: A Study in Ideal Form,* describes the nude as "an art form invented by the Greeks in the fifth century, just as opera is an art form invented in seventeenth-century Italy . . . the nude is not the subject of art, but a form of art."[1] The nude as an art form stretches across the centuries, linking artists of this age with the great masters of the past. It provides a universal structure through which artists express their particular aesthetic, cultural, and personal views. As a symbol, the nude embodies much more than the mere physiology of the body.

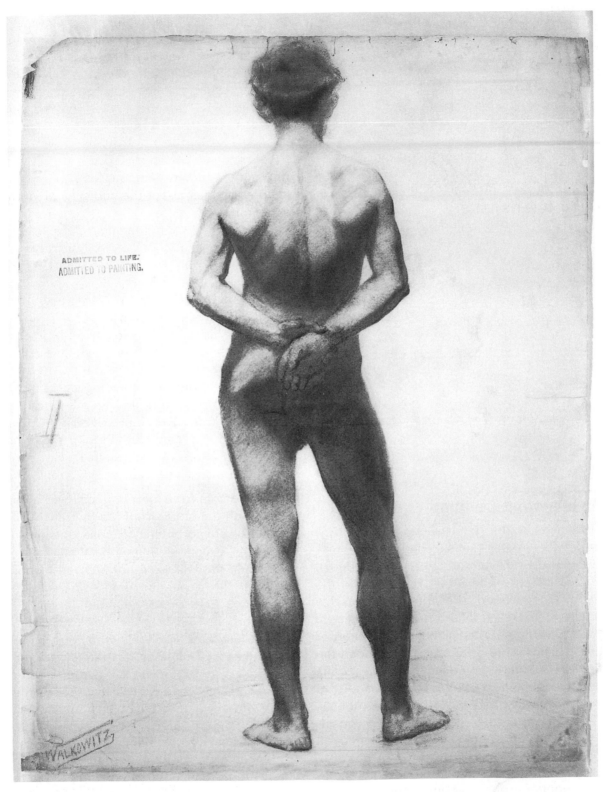

1.1
Abraham Walkowitz. *Life Study*. c. 1895–1905. Charcoal on paper, 60.01 × 41.91 cm. Whitney Museum of American Art, New York. Gift of the artist, by exchange. Geoffrey Clements Photography. (73.19)

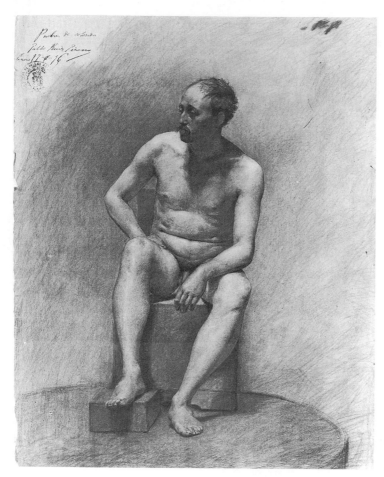

1.2
Pablo Picasso. *Academia del Natural*. 1896. Charcoal and conté. 60 × 47.4 cm. Museo Picasso, Barcelona. Gift of the artist. 1970. MBP 110.874. © 2003 Estate of Pablo Picasso/Artists Rights Society (ARS), New York.

An Important Tradition

The artists of the Renaissance, spurred by a desire for greater realism, began an intense study of the human body. A renewed interest in classical art, with its prevalent use of the nude, encouraged the more progressive artists to make studies from life models. In 1563, Cosimo de' Medici, a Florentine banker and patron of the arts, officially founded the first art academy in Europe, the Accademia del Disegno, which offered the opportunity to study anatomy and draw from life models. From then on, such study has been considered an essential part of artistic training for all visual artists.

Similar academies emerged in centers throughout Europe, and one of the most influential was the Académie Royale in Paris, founded by a decree from Louis XIV in 1648.

The Académie for a long time claimed a monopoly on the study from life in France, and models were forbidden to pose outside the Académie except in its members' studios.

Female models were not allowed to pose nude at the Académie until 1780, and the École des Beaux-Arts, founded in Paris in 1795, forbade female models until 1863. But it wasn't just female models who were barred from these prestigious academies; women students were excluded until near the end of the nineteenth century. The fact that women were virtually denied the opportunity to study the nude figure directly at a time when the nude was such a prevalent subject in Western European art explains to a great degree why there are so few nudes by women prior to the twentieth century. This was a particularly significant obstacle to women artists because one's ability to draw the human figure was

considered one's rite of passage. Students were required to prove their academic proficiency in life drawing before being admitted to the painting studio. Notice the stamp to the left of the figure, which reads "Admitted to life/Admitted to painting," on the examination drawing (Figure 1.1) done by American artist Abraham Walkowitz while studying in Paris.

Even Pablo Picasso followed this traditional path. His figure study (Figure 1.2), which he drew at age fifteen as a student in Barcelona, testifies to his focus and ability. This early training served as a foundation for the innovative and exploratory work of his later career. "There is no abstract art," Picasso once said. "You must always start with something."[2] He also felt that "there is nothing more interesting than people. One paints and one draws to learn to see people, to see oneself."[3] Picasso frequently worked from life models, and the human figure remained the most inspirational subject throughout his long career. Henri Matisse, Picasso's contemporary and another pillar of modern art, expressed a similar view. "What interests me most is neither a still life nor landscapes, but the human figure. It is through that I best succeed in expressing the nearly religious feeling that I have toward life."[4]

Although most artists view life drawing as an essential part of their formal education, for a long time it was highly suspect, considered by school administrators and the general public as an activity where nudity was sanctioned and morality questioned. Thomas Eakins was actually dismissed from his post at the Pennsylvania Academy of Fine Art in 1886 because his insistence that all students draw from the nude was thought to endanger the morals of the female students. It took decades and several hard-fought battles to get life drawing classes introduced into the curricula at many of the schools where it is now taken for granted. The outcome, however, has been greater diversity in the study and representation of the human form.

Drawing from the figure has been and continues to be at the center of the study of visual art. *The Life Class* (Figure 1.3) by American artist George Bellows depicts a drawing session in 1917. The bold and vigorous character of this early work is typical of Bellows, who originally trained as a baseball

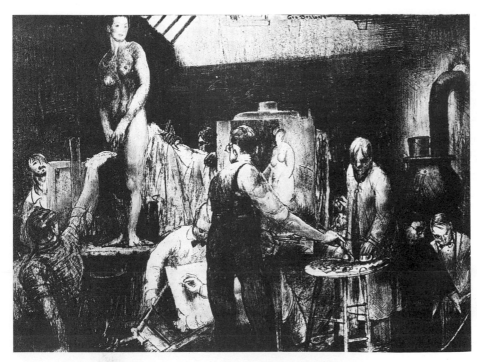

1.3
George Bellows.
The Life Class. 1917.
Lithograph, 13⅞ ×
19⅜". Metropolitan
Museum of Art, New
York. Purchase. Charles
Z. Offin Art Fund Gift.
(1978.670.1).

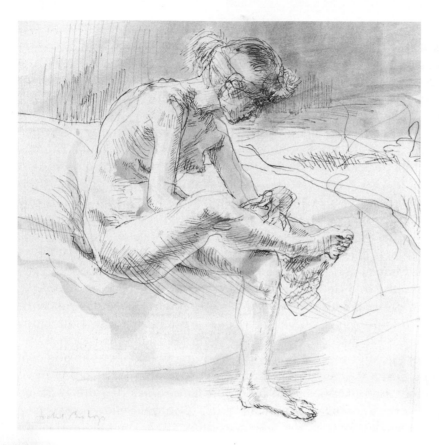

1.4
Isabel Bishop. *Seated Nude.*
c. 1945. Black ink and wash,
6$\frac{1}{2}$ × 7". Los Angeles County
Museum of Art. Gift of Miss
Bella Mabury. M.45.1.5.
Image © 2003 Museum
Associates/LACMA. Courtesy
DC Moore Gallery, New York.

player. "I found myself in my first art class under the direction of Robert Henri," Bellows recalled. "My life began at this point."[5] Henri, who was also a respected artist, has become legendary as an inspiring teacher. He often told his students, "There is nothing in all the world more beautiful or significant of the laws of the universe than the nude human body."[6]

Artist-teachers like Eakins and Henri not only emphasized the importance of figure study to modern artists but also opened the life class to both male and female students. Isabel Bishop represented a new generation of women artists who helped forge a bridge between artists of the past and contemporary women artists. "The nude, if you tackle it," Bishop stated, "is a very fascinating subject, especially for a woman."[7] Her nude studies (Figure 1.4) paid homage to the art of the past while incorporating a fresh sense of style and intent. She offered this advice about drawing from life: "The grand and heroic draftsmen, then, had

better be the models, though one's aim be far from heroic and grand. With their august help one learns to lay one's traps and spread one's nets, to snare the subject matter of one's own intuition and life experience, however special and small."[8]

The human figure, perhaps more than any other image, presents the artist with the greatest opportunity to explore all elements of visual arts with a single subject. Today, as in drawing classes of the past, aspiring artists in all disciplines continue to study the human figure as a vehicle through which to heighten their sensitivity, expand their visual perception, and refine their drafting skills. Contemporary artist Wayne Thiebaud said of the figure: "I think it is the most important study there is and the most challenging and the most difficult. . . . And when you see great academic drawings you realize what achievements they are. . . . It's the touchstone to poetry of form."[9] His drawing, *Nude with*

Folded Arms (Figure 1.5), is pure poetry in its simplicity of composition, presenting the intriguing and somewhat mystical figure seated in space. He uses the human form as a means of studying the interplay of light and shadow. The figure is such a compelling subject that the artist pays no attention to the background or even the chair on which the model was seated.

Jim Dine, another contemporary artist, also acknowledged his indebtedness to art history: "My real ancestors are artists of the past. I am comforted and excited and soothed and inspired by them."[10] Dine's own approach to figure drawing is far from traditional and very expressive. Dine said, "The figure is still the only thing I have faith in in terms of how much emotion it's charged with and how much subject matter is there."[11] Dine's drawing *The Red Scarf* (Color Plate VI) achieves this emotional potency. The dark, moody background into which the woman seems to be fading

1.5
Wayne Thiebaud. *Nude with Folded Arms*. 1975. Charcoal, 30 × 22". Courtesy of the Paul Thiebaud Gallery, San Francisco.

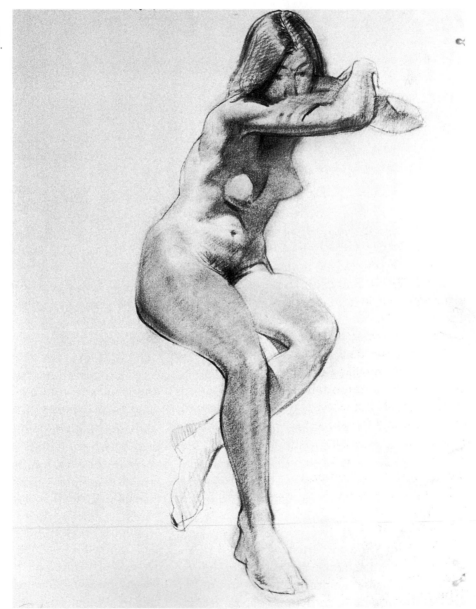

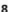

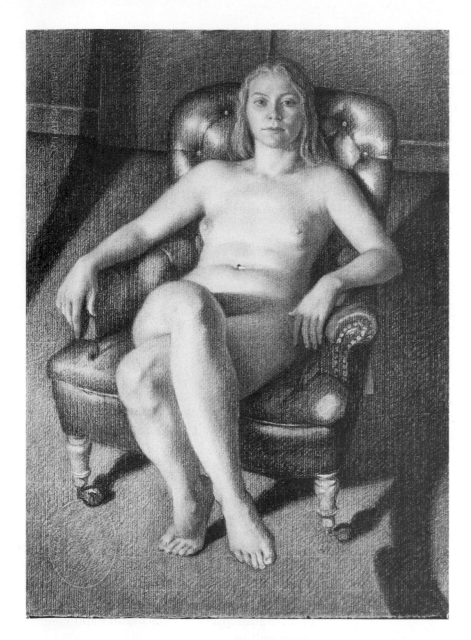

1.6
Katherine Doyle.
*Kathleen in the Green
Chair.* Charcoal, 26 × 19".
Courtesy of the artist
and Tatistcheff Gallery,
New York.

suggests isolation yet leaves the viewer with a lot of room to experience the drawing on many levels of meaning.

The human body remains the most powerful metaphor through which visual artists can document their own observations and ideals as well as the passion and pathos of the human experience. Two very different drawings by contemporary artists Katherine Doyle and Mauricio Lasansky begin to suggest the range of possibilities for the figure in art. For Doyle, the goal is to remain objective. Her in-

tent in Figure 1.6 is to be a meticulous observer of the subtle nuances of light, to realistically record what is before her eyes. Her presentation of the figure is studied and formal. We detect movement neither in the subject nor in the artist's hand. Her approach is methodical and her touch as soft as that of the light and shadows bathing the figure and the interior.

At the other end of the spectrum, Lasansky's more subjective approach makes us aware of his mark making and the energy he

invests in the drawing process. In *Nazi Drawing No. 21* (Figure 1.7), he responds to the horrors of World War II with a graphic indictment of the Nazis. The composition is dominated by a human hide that stretches across the space, the person's identity reduced to a tattooed number, the face twisted in anguish beneath a howling head of death. Like many other artists, Lasansky does not draw from a model but rather combines his extensive studio training with the powerful impact of human events on the artistic imagination.

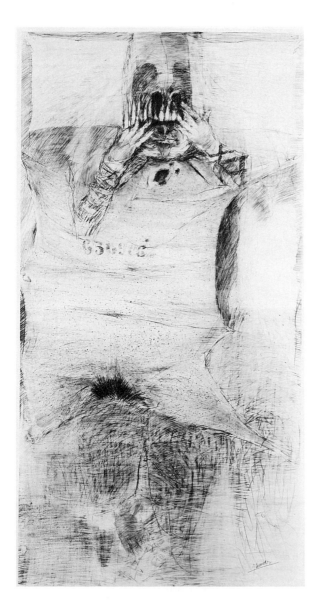

Whereas Doyle draws faithfully what she sees, Lasansky draws passionately what he feels. These drawings also represent the scope of what we mean by *drawing from life*. In the context of this book, it centers on drawing directly from the nude, which we feel is critical, but also includes drawing from the artist's broader experiences, from which, as Edgar Degas once said, "a transformation is effected during which the imagination collaborates with the memory."[12]

The Mind's Eye

One of the truisms of art is that you must first learn to see before you can learn to draw. What this statement implies has nothing to do with good eyesight. Rather, learning to see involves learning to think about what you see in ways that go beyond normal perception.

Michelangelo once said that you make art with your mind, not with your hands. The brain directs the hands' movement. It is also the brain that processes the information presented by the eyes—the brain that truly "sees." The brain has been the subject of a great deal of research that, in a nutshell, suggests that the two hemispheres of the brain hold dominion over very different processes and activities. It is the left hemisphere, researchers tell us, that is responsible for linear thought processes: analytical reasoning, sequential thinking, and language. The right hemisphere, on the other hand, is more intuitive and is responsible for understanding visual information and spatial relationships.

Drawing, we contend, belongs to both hemispheres. At its most basic, drawing is a *visual language*—a nonphonetic form of writing. Like all language, drawing is an information storage system. In fact, drawing was used to codify and store information for twenty-five thousand years before phonetic symbols came

1.7
Mauricio Lasansky. *Nazi Drawing No. 21.* 1966. Graphite and ink washes, 76 × 35". Collection of the Richard Levitt Foundation. Photograph courtesy of the artist.

to represent spoken language. In *A History of Writing*, Albertine Gaur argues that "the primary objective of all information storage is the preservation of knowledge. Knowledge can consist of thought, ideas, facts, concepts: it can be totally visual."[13]

Certainly a drawing presents information in a vastly different way from written words. "Reading" a drawing requires a different set of skills from reading written text. In our post–Industrial Revolution education system, we have perhaps developed our left brain skills—reading, writing, and arithmetic—to the detriment of our right brain skills—thinking and communicating visually. As artists, we need to expand our visual thinking skills. Drawing is a complex activity that engages the whole person, involving both analytic reasoning and intuitive response. In his book *Vision and the Art of Drawing*, psychology professor Howard Hoffman concludes, "Our eyes may look, but it is our brain, and ultimately our whole brain, that sees."[14]

Käthe Kollwitz's self-portrait (Figure 1.8) gives us a sense of how drawing involves the artist's total being—physically as well as psychologically. You can see the connections between the eye and the mind and the drawing hand. You can sense her concentration as well as the physical energy of her action. In order for Kollwitz to create this self-portrait, she had to employ analytical processes that are gen-

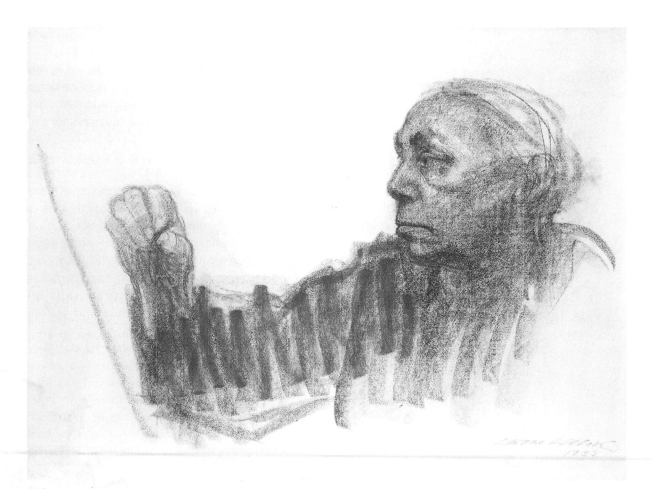

1.8
Käthe Kollwitz. *Self-Portrait Drawing*. 1933. Charcoal on brown laid paper, 477 × 635 mm (18³/₄ × 25"). © 2003 Artists Rights Society (ARS), New York/VG Bild-Kunst, Bonn. Image © 2003 Board of Trustees, National Gallery of Art, Washington. Rosenwald Collection. 1943.3.5217.

erally attributed to the left hemisphere of the brain—planning the setting to enable her to draw herself in profile. She also had to respond intuitively to spatial relationships, a process generally associated with the right side of the brain.

Ultimately, one's mental attitude has far more to do with artistic development than does the precise location of mental processes within the brain. When drawing from life, the artist must learn to see and think about the human body differently from the nonartist, to think in terms of the body's gesture, movement, mass, contours, volume, structure, proportions, and anatomy—all of which are codified and transcribed graphically onto the drawing surface. Viewing the figure with the necessary artistic vision and professional detachment to be able to draw the human form is an acquired skill, one that is achieved through focused observation and time spent drawing.

The Right Frame of Mind

One cannot learn to draw simply by having someone describe the process or explain how it is done. As is true of learning to play a musical instrument, learning to draw requires an investment of time spent in diligent practice. For a music student, an essential part of education is listening to the music of others. Likewise, drawing students benefit greatly by carefully observing the drawings of skillful artists. Because drawing is a visual language, a system of making marks to signify meaning, you need to study the way others have transcribed their ideas and codified information through mark making. As you look, try to see with the eyes of an artist, not those of a casual observer. Learn to look beneath the surface

and consider everything about how the drawing was made. How does the artist use line, apply value? How does the choice of paper or media affect the drawing? Where did the artist begin? How did the drawing progress from there? Ask yourself about the compositional and expressive elements of the drawing.

Through your study of drawings, your reading, your instructor's insights, and more especially through your diligent practice, you will begin to develop a sense of what constitutes quality in a drawing, you will hone your drawing skills, and you will expand your creative potential as a visual artist. As Edgar Degas once advised, "The secret is to follow the advice the masters give you in their work while doing something different from them."[15]

Getting in the right frame of mind also means being professional, being respectful of your models, and deciding you are going to make the most of each drawing session. Before each drawing opportunity, get in the proper mind-set and give every drawing your very best, whether the pose is for several hours or for half a minute. Recognize that not everyone begins with the same skill level, and keep in mind that one learns and improves with practice.

As you begin your study, remember that the nude is more than your subject matter. It is an art form with a long tradition yet with a potential that is perpetually renewed. Likewise, as you draw from the model, you define yourself as an artist, both through your actions and through the work you create. As Picasso once said, "What one does is what counts and not what one has intention of doing. The important thing is to do, and nothing else, be what it may."[16]

Chapter Two

A Sketch to Build On

Out of the artist's impetuous mood they are hastily thrown off . . . only to test the spirit of that which occurs to him, and for this reason we call them sketches.

—*Georgio Vasari*

The Drawing Process

Drawing is a genesis for creative expression in all of the visual arts. Through drawing, the artists' thoughts and ideas take form, their hunches and nebulous feelings are fashioned into something tangible and concrete. The sketch records a visual idea at its inception, before it is fully conceived or embellished. The Renaissance artist and writer Vasari wrote that sketches are "hastily thrown off," coming from "the artist's impetuous mood." This impetuousness is evident in a sheet of sketches by one of Vasari's contemporaries, Polidoro da Caravaggio, who fills the page with visual notations (Figure 2.1).

What is the difference between a drawing and a sketch? To sketch implies quickly expressing or capturing the essentials of an idea or subject without a great deal of refinement. Drawing, by definition, surely includes sketching, but sketching is limited to a particularly early stage of drawing when ideas are still indistinct, just beginning to take shape.

Today it is widely understood that even the intellectual creativity of a genius involves a process of exploring options, researching ideas, and accepting and rejecting possible solutions. An artist's sketch often serves as a stimulus for creative development. The concept for Picasso's monumental painting *Guernica* (Figure 2.2), for example, originated with a small, almost indiscernible sketch (Figure 2.3). Although many more drawings followed before his final composition was determined, this first sketch formed the impetus of that evolutionary thought process. As Picasso himself said, "The picture is not thought out and determined beforehand, rather while it is being made it follows the mobility of thought."[1]

Drawing is an evolutionary process that includes an initial exploratory stage, a confirming one, and eventually a refining stage. These stages and their sequence are rarely apparent in a highly finished work. When we admire such drawings, we often become

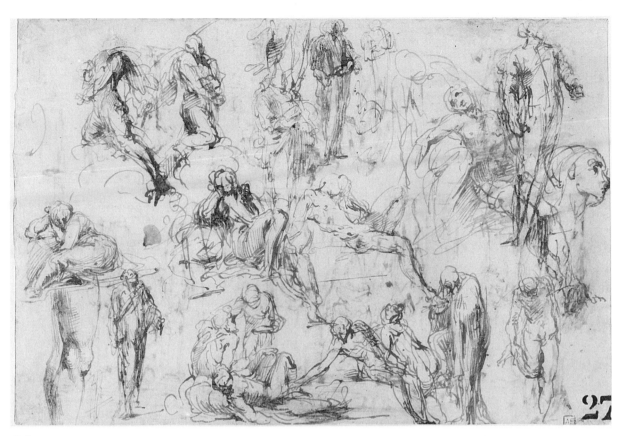

2.1
Polidoro da Caravaggio. *Studies for an Altarpiece with the Virgin Enthroned, Attended by Four Saints.*
Pen and brown ink wash, 20.2 × 29.8 cm. The Metropolitan Museum of Art, New York. Bequest of
Walter C. Baker, 1971 (1972.118.270r). All rights reserved.

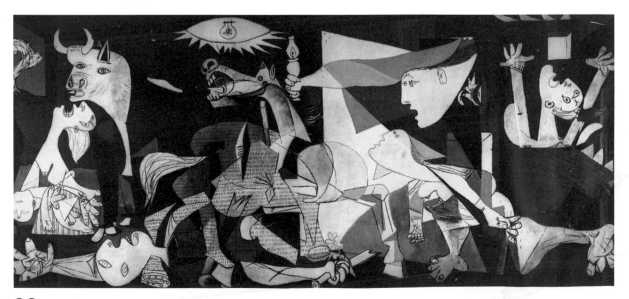

2.2
Pablo Picasso. *Guernica.* 1937. Oil on canvas, 3.5 × 7.8 m. Museo Nacional Centro de Arte Reina Sofia,
Madrid. © 2003 Estate of Pablo Picasso/Artists Rights Society (ARS), New York.

enchanted with details and surface treatment. In fact, we have developed a hierarchy of worth, which we often apply to drawings based on their degree of refinement. In some ways, this reflects a natural appreciation for the artist's time commitment to a particular drawing. Most artists value their laborious works more than their quick, rough sketches. Often exploratory sketches are made for the artist's eyes only, executed to test an idea, to probe the unknown, to make notations for future reference. Seldom are they intended for exhibition or distribution. Historians know that Michelangelo actually destroyed many of his rough sketches and working drawings, preferring that the world not know how arduously he searched and labored in the development of some of his ideas.

Learning from the Old Masters

In the same way that a sketch initiates ideas to be developed in other media, it also serves as a foundation for the evolution of the drawing. For someone involved in making draw-

ings, understanding this evolutionary process is essential.

In the drawings of the great masters, one can often find beneath the surface traces of an underlying sketch that originally served as the drawing's structural foundation. This is often evident where parts of the drawing were left unfinished or where, in the development of an idea, the artist abandoned one pose in favor of another. The remnants of these preliminary underdrawings, where the artist has had a change of mind, are known as **pentimenti**. These ghostly fragments of the drawing's sketchy beginning are especially common in older drawings, made before the advent of modern rubber erasers or with unerasable media such as **silverpoint**, a technique of drawing with a silver wire on paper coated with **gesso**.

Leonardo's drawing (Figure 2.4) provides an exceptional opportunity to study its evolutionary process, from the loosely derived sketch to the highly detailed rendering of the drapery. From top to bottom, we can see how he developed the drawing by adding layer

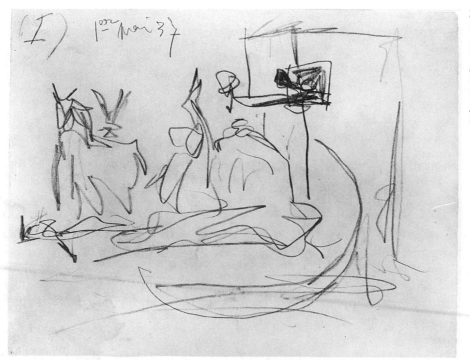

2.3
Pablo Picasso. *Sketch for Guernica.* Museo Nacional Centro de Arte Reina Sofia, Madrid, Spain. © 2003 Estate of Pablo Picasso/ Artists Rights Society (ARS), New York.

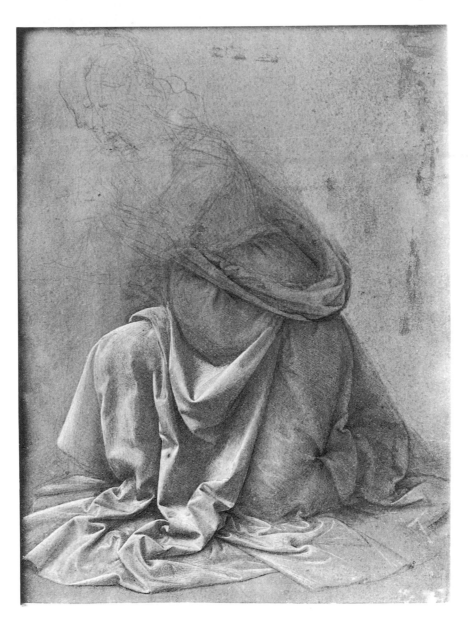

2.4
Leonardo da Vinci.
*Study of the Drapery of
a Woman.* Silverpoint,
charcoal, and white lead
over reddish-brown wash,
ground, 25.7 × 19 cm.
Gabinetto Nazionale delle
Stampe, Roma, Instituto
Nazionale per la Graphica,
Collezione Corsini.
Courtesy Ministero per
i Beni e le Attività
Culturali. Photograph
by Oscar Savio.

upon layer of refinement. The pentimenti faintly visible in the upper half of the drawing show how he began in silverpoint to sketch the head, changing his mind several times as he sought the appropriate gesture. In the middle of the drawing, we see some drapery that evolved from a quick sketch, with charcoal enhancing the faint silverpoint lines. At the bottom, Leonardo added white highlight, working it over and into the charcoal drawing. When we see the delineation of these three-dimensional folds, we no longer think about the drawing's sketchy beginning. For students of drawing, however, it is essential to understand the role of the preliminary sketch.

A sketch expresses a visual concept still in a state of flux between its inception and its clarification. The visual clues it presents are therefore sometimes ambiguous—the form is loosely implied, repeated lines and changing contours expressing the artist's search rather than a firmly conceived solution.

Another giant of the Renaissance was Raphael. As elegant and refined as Raphael's

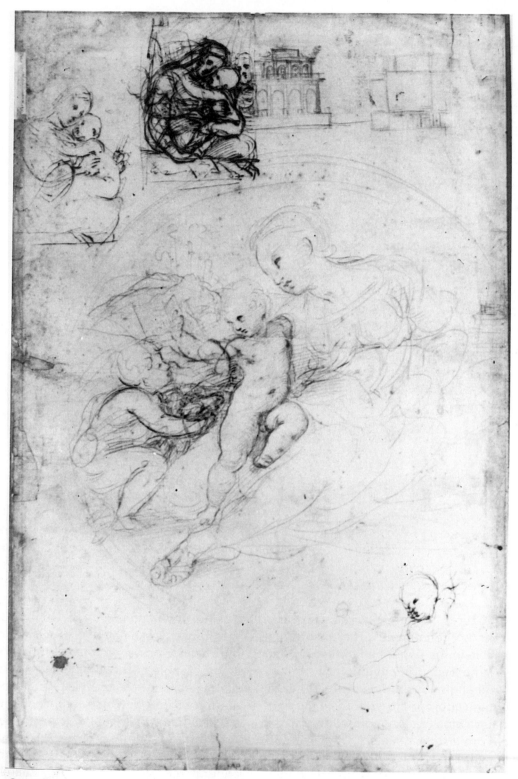

2.5
Raphael. *Study for the Alba Madonna.* Red chalk, partly worked over in pen. Quecq
d'Henripet. Lille, Musée des Beaux Arts. Réunion des Musées Nationaux/Art Resource,
New York.

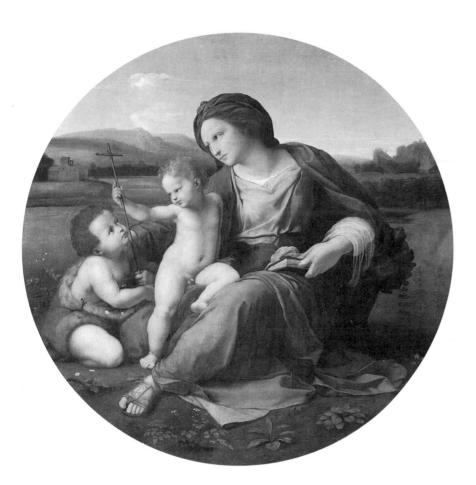

2.6
Raphael. *The Alba Madonna.* c. 1510. Oil on wood transferred to canvas, 94.5 cm diameter. Image © Board of Trustees, National Gallery of Art, Washington. Andrew W. Mellon Collection. 1937.1.24.

paintings are, his preliminary sketches, the seeds from which these masterpieces grew, are in many ways equally fascinating. Consider the *Study for the Alba Madonna* (Figure 2.5) and the finished painting (Figure 2.6). Just as the central composition in the sketch appears to evolve from a square (in the upper portion of the drawing) into a roundel, Raphael's figures also evolve from gestural interpretation, first drawn with a soft red chalk, into defined forms worked over with the distinct lines of pen and ink. Notice how the position of the Madonna's outer arm and hand is stated briefly with just a few strokes, whereas her head and the figure of the Christ child are further developed and fashioned with more detail.

Michelangelo's *Madonna and Child* (Color Plate I) is a remarkably captivating drawing despite its being forever unfinished. Like Leonardo's drawing, it tells us a great deal

about drawing as a creative, evolutionary process. Notice that Michelangelo first began with a loose sketch, lightly drawn. He drew the contours of the forms several times in an effort to define the right proportions and properly express the flow of the body's contour. If you look carefully, you can see the faint image of another position of the Madonna's head, looking down at the child. As the drawing progressed, Michelangelo confirmed the position of the head that glances to the side by adding darker lines. In the body of the child, we see where Michelangelo added red and white chalk to clarify and model the form. Ink, the least flexible medium used in this drawing, was added last to further sharpen the relief around the child's torso. In applying the ink and red and white chalk, Michelangelo covered the substructure of the initial sketch, but the vestiges of early marks remain in the rest of the drawing to document the

2.7
Eugène Delacroix. *Hamlet
Reading.* Pencil, 10 × 6".
Musée Bonnat, Bayonne,
France.

image-conjuring role of the underlying sketch in Michelangelo's creative process. The lightly drawn sketch provided both the suggestion and the foundation for Michelangelo's solidly conceived forms. During the drawing process, Michelangelo explored the pose and gesture of the body, clarifying and finally resolving the form and composition. They took shape as he drew. The sketch is both the consequence of thought and its impetus.

So often, aspiring artists are enamored with the details and technical facility displayed in a highly polished drawing, and for some very obvious reasons they are eager to draw with such skill. Yet because of this, they focus attention on details and begin their drawings by first attempting to render the surface appearance without having a grasp of the body's overall configuration or its gesture and proportion. Just as an automobile or house has a frame beneath its painted surface or façade, a highly developed drawing is built on an underlying foundation. If we could peel back the layers to look underneath the finished surface, we would find the beginning, the essence of the pose and configuration expressed in a gesture or schematic sketch.

Someone who appreciates a well-designed car or house does not need to know how to build one. Likewise, you don't need to know how to draw to be a connoisseur of drawings. But to make your own drawings, you, as an artist, have to know how to work from the ground up. The ground, in this case, is the drawing surface, and the sketch is a means of recording your initial impressions or laying the foundation for a more detailed and refined drawing that may follow.

The Sketch as Part of the Creative Process

The word *sketch* does not have the prestige associated with it that *drawing* has. It suggests an activity that is more intuitive, something one does freely and naturally as a sort of rough visual notation. It functions as a memory aid or as a means to work out a solution to a problem. Sketches are suggestive rather than conclusive. When you begin to draw the figure, it is beneficial not to be too precious about these first few marks or to make them too permanent or detailed. A sketch is preliminary, exploratory, dealing with generalities. Its marks are tenuous, open to further consideration, alteration, improvement. As Vasari stated, a sketch offers a way "to test the spirit" of an idea. Likewise, as Eugène Delacroix demonstrates in his drawing *Hamlet Reading* (Figure 2.7), "the original idea, the sketch, which is, so to speak, the egg or embryo of the idea, is usually far from being complete. . . . The thing that makes of this sketch the essential expression of the idea is not the suppression of details, but their complete subordination to the big lines which are, before all else, to create the impression."[2] It is only after Delacroix has captured the "essential expression" that he begins to involve himself with some additional refinement in the head and hands.

What all these examples share is that they visually document a process that parallels what researchers have discovered about creative activity in all fields. Essentially, the creative process begins with free association, observations, and information gathering, and only after an initial response and investigative probing does one start to select, clarify, and refine one's ideas. One doesn't draw just what is already known; drawing in general and sketching in particular offer a way to make discoveries, to learn what one didn't know. What makes all aspects of drawing so exciting and rewarding is that it is a process through which one acquires knowledge and understanding that are totally inaccessible through any other means.

The visual appearance of a sketch is as varied and unique as our handwriting and is a natural outgrowth of our personalities and thought processes. What follows is a discussion of a variety of ways artists have recorded

their ideas about the figure through efficiently executed sketches. Each has its own distinctive vocabulary, emphasis, and appearance.

The Figure's Gesture, the Artist's Hand

Kinesthesia is a term that refers to our ability to perceive and empathize with a body's position, presence, and movement. When doing a quickly executed gesture drawing, the artist has no time for lengthy analysis or for dwelling on details. Responding intuitively and through the kinesthetic act of drawing, the artist internalizes the pose and transcribes its movement and presence into lines. These lines not only follow along with the body's movement but capture and hold that movement in time. As Matisse once said, "Drawing is like making

an expressive gesture with the advantage of permanence."[3]

As is often the case with gesture drawing, the artist's eye looks at the subject rather than at the surface of the drawing. The hand moves blindly over the drawing surface, following the movement of the artist's eyes as they scan the pose, and in the process creates what is often referred to as a ***blind gesture sketch.***

Auguste Rodin often made blind gesture sketches of his models, encouraging them to move about the studio. Describing his process, he once said, "What is this drawing? Not once in describing the shape of that mass did I shift my eyes from the model. Why? Because I wanted to be sure that nothing evaded my grasp of it. . . . My objective is to test to what extent my hands already feel what my eyes

2.8
Auguste Rodin. *Lightly Draped Dancing Female Nude.* 1900. Graphite on tan paper, $12^{1}/_{8} \times 7^{3}/_{4}$". Reproduction © The Art Institute of Chicago, Alfred Stieglitz Collection. 1948.898.

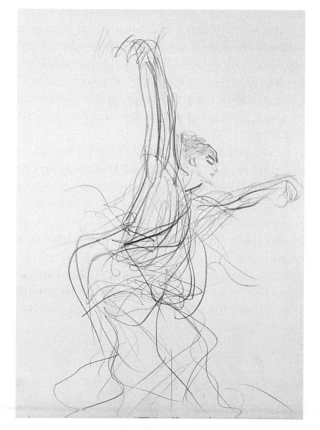

2.9
John Singer Sargent. *Sketch of a Spanish Dancer, El Jaleo Sketchbook.* 1879. Pencil on paper, $11^{1}/_{2} \times 9$". © Isabella Stewart Gardner Museum, Boston.

see."[4] With this statement, Rodin points out the kinesthetic and intuitive nature of his sketching method. Rodin's sketches are to a great extent an attempt to be guided by a subconscious knowing rather than an analytic thought process.

This same approach is evident in both Rodin's *Woman Dancing* (Figure 2.8) and John Singer Sargent's dancer (Figure 2.9). Both sketches serve as memory aids that the artists can refer to later to trigger the imagination and inspire further creativity.

Gesture sketches—*quick sketches* or *action drawings*, whatever the term—are concerned with expressing the dynamics of the body's life forces and capturing the gestural action implied in the body's visual presentation. These drawings respond to the body's kinetic energy and the dynamics of the pose, its physical force, whether the body is at rest or in motion.

The mobility of thought and hand collaborate to give gesture sketches their characteristic vitality. These sketches, often described as action drawings, are said to possess a lot of movement and energy. This is certainly conveyed in Sargent's sketch of a dancer (Figure 2.9), which was made on site and became the genesis for one of his major canvases. There is nothing static about the flamenco dancer, and the sketch serves as a facsimile of the dance, capturing its spirit of energy and movement. His line moves with the dancer's body rather than around its edge. Typical of gesture sketches, the drawing becomes a record of both the dynamics of the subject's action and the artist's lively mark making during the drawing process.

In large measure, gesture drawing is as tactile as it is visual. The artist traces the flow of form through the body's gesture—as the eye quickly scans the model's pose, the artist's hand moves over the surface of the drawing paper. This rhythmic, flowing movement of the hand gave much of Oriental art its calligraphic line quality. In Figure 2.10, we see that although the mark making that created

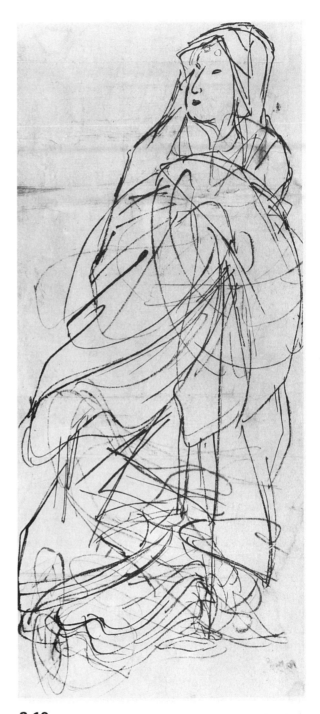

2.10
Ichiyusai Kuniyoshi. *Sketch for Kakemono-e of Tokiwa Gozen.* Ink on paper, 9⅞ × 22⅜".
Collection, Rijksmuseum voor Volkenkunde, Leiden, The Netherlands.

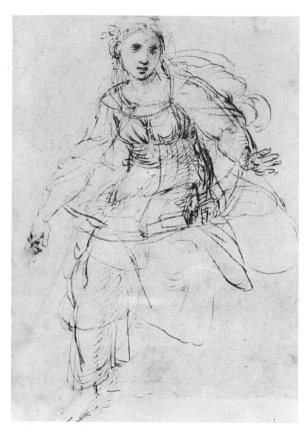

2.11
Raphael. *Allegorical Figure of Theology.* Pen and ink. Photograph © 2003, Ashmolean Museum, Oxford, England.

are not mistakes but very much a part of the natural drawing process, the image-conjuring process. A drawing can never be the subject it represents; it must always be something new that has to be invented and constructed as a graphic metaphor. *Metaphor* literally means "to carry over." The artist searches for the line, the movement, the form with which to capture, hold, and carry over the visual representation of an image.

When doing a gesture sketch, the artist attempts to see the body as a whole, seeing the **gestalt** rather than its isolated units. An initial overview is essential, enabling the artist to see the body's large relationships, thereby creating a stronger foundation and cohesiveness for the finished work. Gesture sketches respond quickly and intuitively to the impetus of a pose as a whole; they describe how the figure's energy and action move through the

this drawing was fleeting, the ink that documents the action gives it permanence. Kuniyoshi's gestural line sweeps over the page as a record of movement, tracing the body seemingly unchecked by any inhibiting desire to present a detailed representation, which would inevitably halt or diminish the spontaneous fluidity of line.

Similarly, in Raphael's sketch of a woman (Figure 2.11), line records the energetic choreography of Raphael's drawing action. The multiple layers of line seem to suggest not only the movement of the body but, once again, the artist's search for the most expressive sense of the form. Notice that the hand once held a book, and that the book itself has changed size. These changes, or pentimenti,

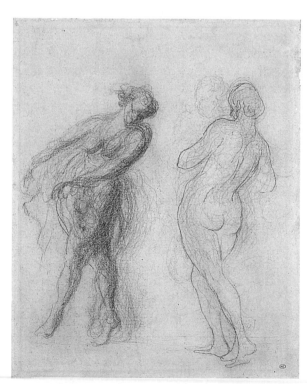

2.12
Honoré Daumier. *A Study of Female Dancers.* Black chalk and conté crayon, 338 × 274 mm. Paris, Musée du Louvre. Réunion des Musées Nationaux/Art Resource, New York.

interior of the form. Line is not relegated to the edge of the figure but often flows over and through the form.

Honoré Daumier was a master at exploiting the suggestive power of the sketch. He would let his hand move freely, conjuring the figure as he scribbled. His drawings evolved naturally from evocative impulses into more concrete and discernible forms, yet they always retained the sense of energy and movement found in his gestural sketches. In Figure 2.12, you can see this progressive development, taken in two different directions. To draw the right-hand figure, Daumier uses a strong singular line that overrides lighter ones and confirms and encloses the body's edges. Daumier recasts and intensifies the original lines of the left figure through repetition to build value that seems to fill out the body from within. A third figure, barely visible in the center of the drawing, suggests how Daumier began, using light marks to coax his figures into being. As the figures evolve, they become increasingly volumetric.

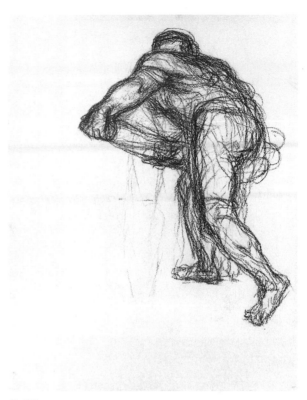

2.13
Pierre Puvis de Chavannes. *Study of a Man Carrying a Log.* Photograph © Fitzwilliam Museum, University of Cambridge (PD.86-1961).

Expressing Volume, Weight, and Mass

In addition to expressing the dynamic energy of the body's gesture, a sketch can begin to express a sense of the body as an object of substance. The human body exists in three dimensions. It has **volume**. Volume adds *depth* to *length* and *width*. The body is also a solid, with a density of matter much greater than its surrounding atmosphere. It has **weight**, due to the billions of molecules contained within its volume. **Mass** is the combination of volume and weight expressed in terms of energy.

To more fully comprehend a body's mass, imagine that you put your arms around a body and lift it. You have to exert a great deal of energy to counter the energy of the body's mass pressing down toward the ground.

Look again at the Daumier drawing, Figure 2.12. The build-up of lines on the left figure starts to suggest the body's mass as well as

its gesture. What Daumier's drawing begins to hint at, Pierre Puvis de Chavannes takes a step further in his *Study of a Man Carrying a Log* (Figure 2.13). Although the massing of lines is similar, the lines themselves are heavier, more forceful, containing the mass of the figure in motion. Notice how the heaviness of the lines suggests forward momentum. The weight of the figure is further augmented by the load he labors to carry, and together the weight and force of his movement drive the figure onward.

The body's volume, weight, and mass are all related to energy, but these elements can be expressed whether the figure is at rest or in motion. Although **line** can be used to suggest volume, weight, and mass, for many artists it is **value** that gives the figure a firmer sense of presence and solidity. For Degas's

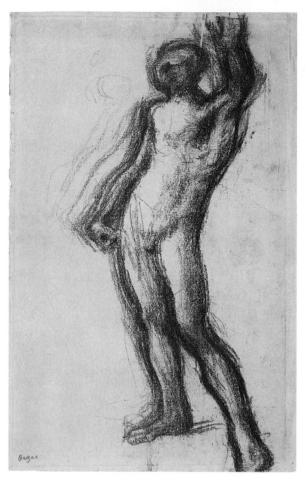

2.14
Edgar Degas. *Nude Man Standing with Left Hand Raised.* c. 1900. Charcoal, 17¹¹/₁₆ × 8¹/₂".
© Cleveland Museum of Art, Ohio, gift of Ralph M. Coe, twenty-fifth anniversary gift, 1941.3160.

molecular mass than its surroundings. Intellectually, we understand that the human body is a form that not only exists in space but also is a solid, dense, and opaque object, distinct from its invisible surrounding atmosphere. The broad areas of pigmentation help to communicate both the weight and energy of the body as it moves in space.

For many artists, the most efficient medium to use when sketching the figure's mass is liquid—either ink or watercolor washes applied with a brush. Thomas Eakins often encouraged his students to use this more painterly approach to sketching. "The brush is a more powerful and rapid tool than the point or the stump . . . the main thing that the brush secures is the instant grasp of the grand con-

quick but forceful sketch of a standing nude (Figure 2.14), line was not enough. Degas started the drawing with lightly drawn lines, but he rapidly built them into broad value areas. Through this process, Degas adjusted the contours and proportions of the figure, while more fully establishing the body's volume and mass. Degas achieves this effect in his sketch by simply laying his charcoal stick on its side as a more efficient tool for creating value.

In addition to implying shadows and rounding the form, the grainy opacity begins to suggest that the body contains a denser

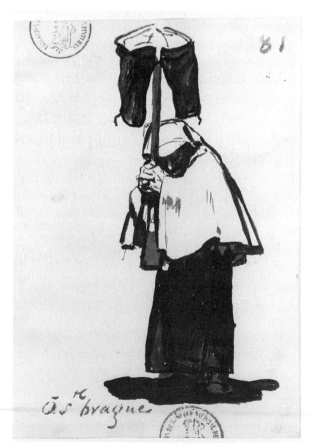

2.15
Francesco de Goya. *Holy Breeches (Sainted Culottes).* 8 × 5". Prado, Madrid, 308GW 1317.

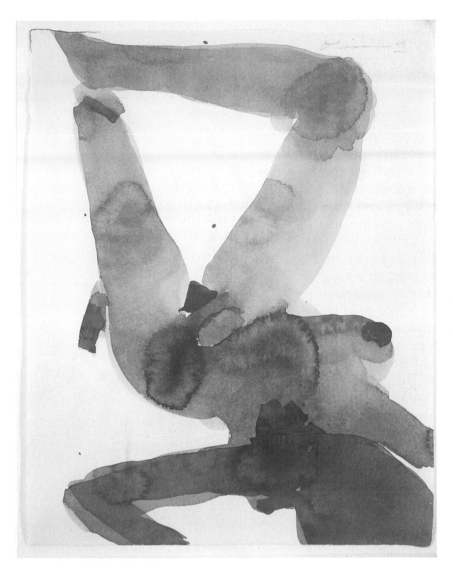

2.16
Nathan Oliveira, *Santa Fe Nude 8*. 1999. Watercolor, 12¹/₂ × 10³/₄". Courtesy John Berggruen Gallery, San Francisco.

struction of a figure."⁵ This grasp of the "grand construction" is immediately evident in an ink sketch by Francesco de Goya (Figure 2.15). Here, the very opaque black ink gives the figure both physical and psychological heaviness. Goya once scorned those "who always [talk] about line, never about masses. But where does one see lines in nature? I see only masses in light and masses in shadow, planes that come forward and planes into recession."⁶ Notice the efficient and forceful way Goya's darks suggest both shadow and recession under the monk's hood and cape.

Nathan Oliveira, a contemporary artist known for his large painterly oils, often sketched directly from the model, using watercolor or ink washes. As seen in Figure 2.16, Oliveira takes full advantage of the fluidity and semi-transparency of the media, allowing them to freely fill out the body's general shape, with no desire to linger or define details. The small sketch remains ambiguous. Its vacillation between body and paint, between subject and process, represents the hallmark of Oliveira's often very colorful and monumental paintings. Although the human figure is the paramount subject of this sketch—and central to most of Oliveira's paintings—the figure's substance is paint rather than flesh and blood.

As Oliveira explains, "The image of the human figure is the vehicle with which I can most positively relate. My concern for the figure is primarily a formal one, growing out of the problems of painting itself."[7]

The Schematic Sketch

Whereas gesture or action sketches are primarily an expression of the body's energy and movement and are often visually distinguishable by flamboyant gestures and fluid line, the *schematic sketch* plots or diagrams the configuration of the pose and the body's underlying geometric structure. The lines are generally straight and are transcribed with a crisp and abrupt staccato action that denotes a sequential chain of rapidly made calculations. As the eye notes the positions and relationships of one point on the body to another, the information is quickly and simply stated as structural line, as illustrated in a sketch by Matisse (Figure 2.17). Here the lines are primarily indicators of position, angles, and the outer perimeters of form. Starting as light, tentative indicators of shape, the lines become bolder as the sketch progresses. Although still executed rather quickly, the schematic sketch is often punctuated by stops for making visual comparisons and aligning points of reference, one to another.

Although drawings are viewed all at once, they are constructed in sequential stages. What a schematic sketch effectively does is help divide the complexity of drawing the figure into simple steps where different aspects of the drawing problem can be dealt with one at a time. Figures 2.18 and 2.19 illustrate two steps in this process. They allow the artist to index, or prioritize, the information, first plotting the body's two-dimensional configuration, then defining its interior structure and volumetric characteristics. The schematic process can in turn become the foundation for a more detailed, finished drawing where contour lines are refined and softened and value added to create a convincing rendering of light and volume.

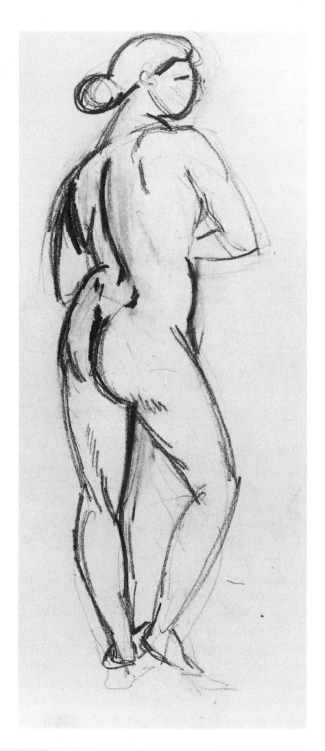

2.17
Henri Matisse. *Nude Study.* Graphite pencil. The Metropolitan Museum of Art. Gift of Mrs. Florence Blumenthal (10.76.3) © Succession H. Matisse, Paris/Artists Rights Society (ARS), New York.

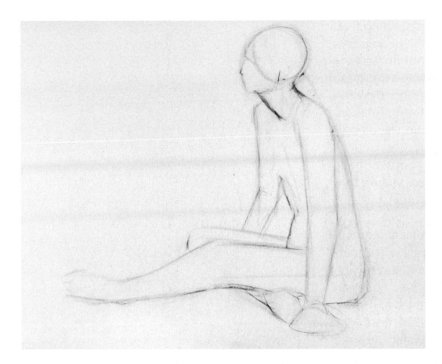

2.18
Plotting the body's
configuration.

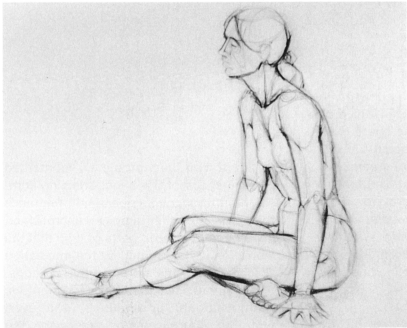

2.19
Expanded schematic
sketch.

When drawing, it is best to proceed from the general to the specific or, as Matisse put it, "Fit the parts together, one into the other, and build your figure as a carpenter builds a house."[8] When building a house, one first makes a plot plan and lays out the foundation. Then the floor joists, walls, and rafters are framed in. Only after this framework has been constructed and evaluated as true and square are the outer, visible surfaces applied and finished.

A schematic drawing often has the appearance of an architectural framework or scaffolding, with one line buttressing or tying into

another, as seen in Lin X. Jiang's drawing (Figure 2.20). Here, the drawing of the model's right leg suggests the early sketch of the two-dimensional configuration, whereas the torso shows how the artist has carried his drawing further into a study of volumetric relationships. As well as being informative, Jiang's line has a brisk and lively rhythmic quality. Notice, too, the remnants of some original plotting lines, which established visual connections from knee to knee, shoulder to knee, and so forth.

The schematic sketch provides a particularly useful approach to the study of proportions and how those proportions appear when the figure is viewed in perspective. The next chapter expands on the schematic approach to drawing the figure and discusses more fully its practical application in establishing a solid beginning for an accurate assessment of what the artist sees.

The Compositional Sketch: Figure-Frame Relationship

Equally important to an artist's ability to capture the model's pose is the way in which the drawing itself is composed. The figure is defined in part by the space in which it exists. Some artists call this the **figure-ground** *relationship*, referring to the figure's position within and against its background. Other artists prefer to think of this relationship as *positive-negative form*, or *yin-yang*. Whatever the term, there is a universal recognition that the subject of the drawing is defined not only by the space it occupies but also by its relationship to the surrounding space.

Therefore, you need to interpret the dynamics of the body's form with sensitivity to how the pose relates to the picture plane in which it is going to exist. As an actor on a stage remains conscious of the perimeters within which to perform, so the artist must be aware of the boundaries of the drawing surface.

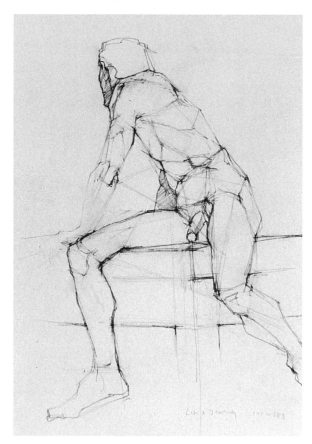

2.20
Lin X. Jiang. Untitled. Graphite, 24 × 18".
Courtesy of the artist.

A figure can be completely contained within the space of the page, affecting composition primarily by its position in reference to the borders. Or the frame can encroach on the body and even crop parts of it so that the composition is determined by the interaction of the body with the frame's physical edge. With any single pose, there exists a multitude of compositional possibilities, and even though the figure remains stationary, the artist can literally rearrange the surrounding space and change the way we perceive the subject. For example, depending on how the body is framed, it may appear to be distant or near. It may seem part of a larger environment or provide all of the composition's structural elements. The sketches that follow

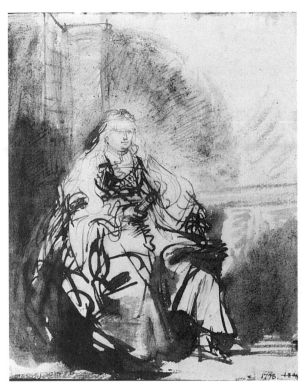

2.21
Rembrandt van Rijn. *Study for the Great Jewish Bride.* 1798. Pen and ink, 241 × 193 mm. National Museum of Sweden, Stockholm. Collection Statens Konstmuseer. NMH 1992/1863.

demonstrate how differently three artists compose their sketches of a similar subject.

The first is a compositional study by Rembrandt, *Study for the Great Jewish Bride* (Figure 2.21). Rembrandt first defines the essence of his subject's face and body with thin line. Then, using both pen and fingers, he disperses the ink to create value areas suggesting the play of light and shadow on the walls. The generous use of the full concentration of his ink suggests the lavishness of the bridal wardrobe. Compositionally, Rembrandt maintains a distance from his subject, allowing a radiance that seems to emanate from her to fill the room. Although Rembrandt's subject physically fills only a portion of the composition, we sense that the remaining space is not empty but filled with an aura that balances

the physical body and adds an essential ingredient to the composition as a whole.

In comparison, notice how Henri Matisse has constructed his drawing of a seated woman to fill the actual size and shape of his paper (Figure 2.22). This did not come about by accident; as Matisse stated, "If I take a sheet of paper of a given size, my drawing will have a necessary relationship to its format."[9] Here, Matisse first uses soft charcoal distributed as value to suggest the figure's configuration; then he works over this shadowy image with an application of line. You can still see the vestiges of several earlier expressions of Matisse's composition, which he rubbed out with his hand before arriving at his final composition.

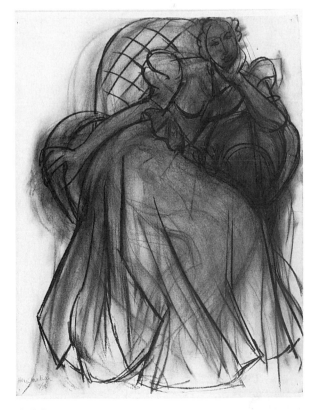

2.22
Henri Matisse. *A Seated Woman, Wearing Taffeta Dress.* 1938. Charcoal, 66.3 × 50.5 cm. © 2003 Succession H. Matisse, Paris/Artists Rights Society (ARS), New York. Image © copyright The British Museum.

2.23
Richard Diebenkorn. *Seated Woman*. 1966. Charcoal, 23¹/₂ × 19". Reproduced by permission of Mrs. Diebenkorn. Photo by Douglas M. Parker Studio.

Richard Diebenkorn uses these techniques in his sketch of a seated woman (Figure 2.23). Diebenkorn not only admired Matisse but agreed with him about the importance of the figure as a compositional element. Their drawings share a gestural and exploratory quality, and the pentimenti reveal how the drawings underwent changes during the drawing process. Compositionally, Matisse uses his line to direct our eye around and through the contained space of his paper. Diebenkorn, on the other hand, zooms in and crops off parts of the figure so that lines intersect with and are tied to the edge, effectively dividing the interior space of his drawing.

Both Matisse and Diebenkorn superimposed one drawing on top of another. In their search for the composition, they layered the images in a process of theme and variation. They seem to have followed Degas's advice: "Make a drawing, begin it again, trace it, begin it again, and trace it again."[10]

Sensitivity to gesture-frame relationships helps determine the composition, or internal relationships, of the forms in your drawing. Every pose contains compositional elements, such as the curve of the spine, the gesture of the limbs, the position or attitude of the head, the slant of the hips or shoulders. In a drawing, these elements do not exist in isolation.

They always exist in relationship to the picture plane. How the figure is framed plays as significant a role in determining the dynamics of your drawing as the model's body gesture. The gesture and mass of the body not only move through but also divide and activate the surrounding space.

Mary Cassatt uses a schematic approach when sketching commuters riding the Parisian omnibus (Figure 2.24). She uses both the figures on the bus and the bus interior to suggest shapes and divide her composition.

Cassatt, an American Impressionist painter living in Paris, was a good friend of Edgar Degas. Here, like Degas, she draws and then redraws her subject, using the sketch to gather information, make discoveries, and solve compositional problems as she draws. In this sketch, Cassatt is primarily concerned with the configuration of the figures, and her crisp line plots their arrangement along with the lines of the bus interior. The figures are somewhat flattened or compressed, similar to those found in Oriental prints, which Cassatt was

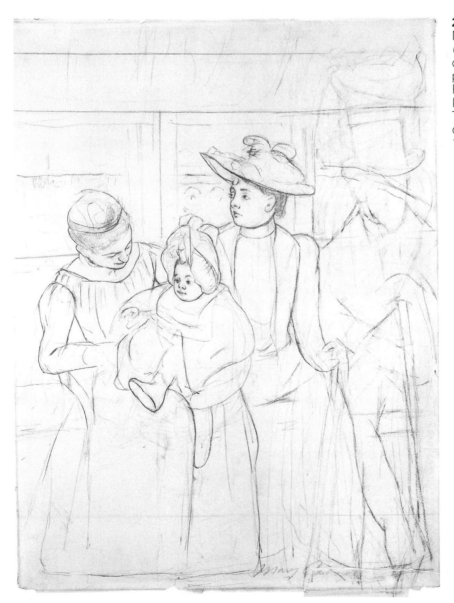

2.24
Mary Cassatt. *In the Omnibus.* c. 1891. Black chalk and graphite on wove paper, 37.9 × 27.1 cm. Rosenwald Collection. Image © 2003 Board of Trustees, National Gallery of Art, Washington. 1948.11.51.

known to admire. The lines of pentimenti may be a result of fidgeting subjects as well as the artist's experimenting with composition. In the end, her use of black chalk over her initial pencil drawing begins to affirm the position of the figures and focuses on what have become the key elements of her composition. The gentleman on the right, who remains the most underdeveloped in this drawing, was omitted from a print Cassatt later made from this sketch. She made it a habit to take a sketch pad with her on outings, when visiting friends or the museum or going to lunch or to the opera. Many of these rather small and unassuming sketches formed the bases for her paintings and prints depicting scenes from the lives of ordinary people.

Edward Hopper, too, often prepared a number of exploratory sketches before beginning a painting. At times, he focused on the effects of light; at others, he was concerned with exploring compositional variations. Notice in Figure 2.25 how he quickly manipulates the compositional elements using a gestural line technique. He also uses an outline to define his picture frame as a reference to the proportions of a painted canvas. In a follow-up study (Figure 2.26), he slows his sketching consider-

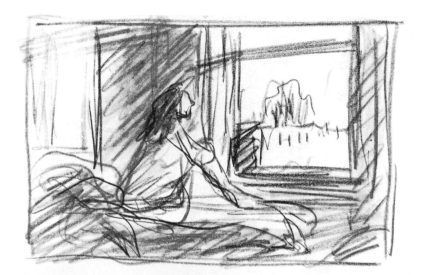

2.25
Edward Hopper. *Drawing for painting "Morning Sun."* 1952. Conté on paper, $5^1/_2 \times 8^1/_2$". Whitney Museum of American Art, New York. Josephine N. Hopper Bequest (70.243). Geoffrey Clements Photography.

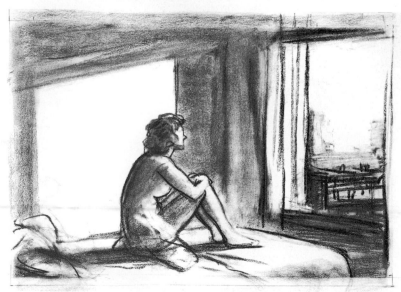

2.26
Edward Hopper. *Study for "Morning Sun."* 1952. Conté on paper, 12×19". Whitney Museum of American Art, New York. Josephine N. Hopper Bequest (70.244). Geoffrey Clements Photography.

ably, working more with value than with line. His concern is still with the larger structural elements of his composition, but his application of line and value is determined primarily by the light.

When doing a compositional sketch, the artist does not see the figure in isolation, as free-floating on the page, but rather as a form that is integrated into the total pictorial format. Conceptually, the artist is not drawing the figure per se, but a composition in which the figure is a component. Although composition is discussed in greater detail in Chapter Nine, it is never too early to start developing an awareness of its possibilities. The model may be the subject, but the composition puts the subject into a context. Realizing that it is a composition you are ultimately creating and not the figure is a fundamental breakthrough on the way to becoming an artist.

The Expressive Content of a Sketch

Every drawing, every sketch, has its own demeanor, emanating on some level an attitude; but for some artists, the expression of an emotional attitude is central to their purpose and is transmitted through all their works, even their rapid sketches. For these artists, expression is the essence of drawing. Quick sketches, in particular, allow artists to express ideas and visual impressions without taking time to analyze them—recording a fleeting impulse before it escapes and is lost. Each gesture, every attitude, visually transmits a message that fellow humans are capable of perceiving and empathizing with.

Although a sketch may be executed rapidly and economically, it can be both poetic and passionate. In Rembrandt's drawing (Figure 2.27) we see two women aiding a child just learning to walk. Rembrandt not only conveys the women's action but expresses an attitude of tender caring on the part of the two women. We can almost hear their words of encouragement. Within the economy of these few strokes, Rembrandt has captured a tender moment that is part of universal human experience.

Whereas Rembrandt worked from direct observation and used his sketch to express the emotions of the moment, Käthe Kollwitz's

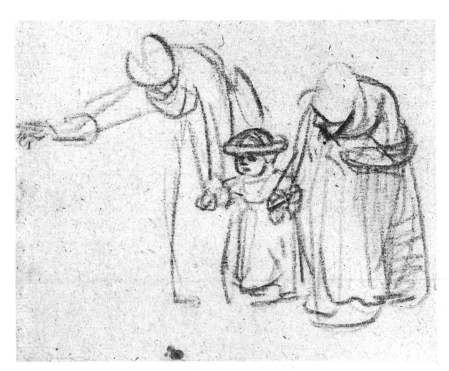

2.27
Rembrandt van Rijn. *Two Women Helping a Child to Walk*. Black chalk. © Copyright The British Museum.

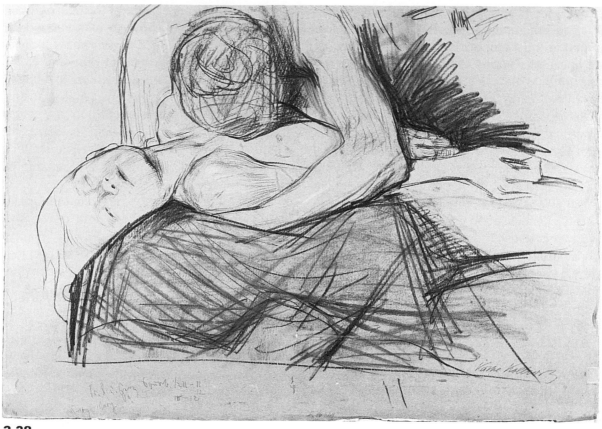

2.28
Käthe Kollwitz. *Mother and Dead Child.* 1903. Charcoal, black crayon, and yellow crayon on heavy brownish paper, 47.6 × 69.8 cm. Private collection, courtesy Galerie St. Etienne, New York. © 2003 Artists Rights Society (ARS), New York/VG Bild-Kunst, Bonn.

drawing (Figure 2.28) shows how effectively a sketch can express deeply felt emotions that are held in one's memory or imagination. Kollwitz witnessed a great deal of human suffering in her lifetime. In her diary she wrote: "I have never been able to carry out any work coolly. On the contrary, it is done so to speak with my own blood. Anyone who looks at my work must be able to sense that."[11] This sketch is one of several studies she made on the theme of a mother grieving for the death of her child. It is direct and forcefully executed. Notice how Kollwitz contrasts the still image of the child with the slashing, grief-laden lines of the mother. On a subconscious level, these visual lines emotionally activate the drawing and seem to equate with the mother's anguish. With this sketch, Kollwitz doesn't just show us what she saw, she implores us to feel what she felt.

Serious artists have used quick sketches and gesture or action drawings for a long time and for a variety of reasons. Sketches hold a wealth of information and can be full of life. Of course, artists like Rembrandt and Kollwitz had years of experience drawing and studying the human body, and this surely contributed to their ability to distill the complexity of the figure's gesture to its essential graphic elements.

Even for the masters, however, the initial drawing phases might involve many changes, as examples in this chapter illustrate. A complex and sophisticated work often starts with marks that are transitory approximations. A

sketch is a means of testing a hunch, gathering information, taking visual notes to be amplified and developed. The sketch provides a way to "float" an idea. It is the means by which an artist can muse and ponder, contemplate and make new discoveries. For all these reasons, many teachers feel the best place to begin drawing from life is with quick sketching exercises. It is therefore common to dedicate several sessions or even weeks of sessions at the beginning of a drawing course, and the first fifteen or thirty minutes of each session thereafter, to practicing quick sketches. This is the warm-up, the artist's calisthenics, when you limber your drawing hand, sharpen your eye, and open your mind to the myriad possibilities inherent in drawing the figure.

IN THE STUDIO

The most common philosophy and procedure in both academic life drawing courses and less formal, self-taught drawing groups is that the natural way to begin drawing from the model is with quickly executed, nonprecious sketches. A sketch, by definition, is unpretentious, exploratory—even disposable. Sketches deal with generalities rather than details, suggestions rather than affirmations. These exercises encourage you to respond to your natural drawing impulses and to let them provide the impetus and foundation for the more detailed study of life drawing that is to follow.

Dominant Action Sketches

Pose – 10 to 15 seconds each (for approximately 5 minutes)
Media – bold and thick conté, charcoal, or graphite on newsprint

In this exercise, the model changes from one pose quickly into the next. Place four to six poses on the same piece of paper. Each drawing may be 6" to 8" high. Allow sketches of different poses to overlap one another. The intent is to state quickly and efficiently what you feel is the essential element of the whole pose. To do this, use a bold line or lay a short piece of conté, charcoal, or graphite flat on the paper to make a broad value band through the core of the body. Do not attempt to draw the contour or edges of the body. Instead, try to see the movement through the center, or core, of the body. Get a feeling for the movement and gesture of the pose, then record, in seconds, its key compositional element. After filling a page with these rapidly changing body configurations, you can appreciate the comparison of these exercises with an aerobic warm-up. They offer an excellent interactive beginning to any drawing session.

Blind Gesture Sketches

Pose – 1 minute each (3 to 5 poses)
Media – conté, charcoal, or graphite on newsprint (one drawing per side of sheet)

This is a good exercise for developing eye-hand coordination and for learning to loosen up and be spontaneous. Its name derives from the fact that you draw without looking at the paper. Position yourself so you can see the model without seeing your drawing paper. Place your drawing tool on the paper, then, without looking at or lifting your hand, allow it to trace your eye movement as you scan the pose, drawing over and through the form. Work quickly and don't hesitate to redraw several times as a continuous expression of the movement of your eyes. Expect the results to be distorted and humorous. The goal is not realism but rather exploration of the connection between eye and hand movement.

Gestural Line Sketches (Action Drawings)

Pose – 1 minute each (for 10 to 15 poses)
Media – conté, charcoal, or graphite on newsprint (one drawing per side of sheet)

In this exercise, you are encouraged to draw large, placing only one pose on each side of the paper. The larger the paper, the better. The goal is again to "feel" the dominant gestural movement in the pose, but this time to transcribe it with a more fluid, continuous, repetitive action. As your eye scans and moves with the model's action, your drawing hand should move with a corresponding gesture, creating a line on your paper that follows the movement of your eye. This drawing is as much about your gesture and movement as it is about those of your model. Imagine that you are

drawing over and through the body's action. Do not attempt to outline the body. You want to feel the totality of the body's action and express it as directly as you can with the action of your line.

This exercise can be expanded in a number of ways by incorporating movement into the pose. Have the model take three related poses in succession, holding each for only about thirty seconds or a minute. Using line only, capture each pose as overlapping gesture, allowing your line to move and flow from one pose into the next.

Another alternative is to sketch the pose from memory. In this situation, the model holds a pose for about fifteen seconds. Do not draw while the model is posing. Rather, when the model stops, begin sketching the pose from memory. Developing your visual memory is as important when drawing as a verbal or phonetic memory is for reading. It also helps you develop the ability to focus in on the key visual relationships within each pose.

Sketching Volume with Circumscribing Line

Pose – 2 minutes
Media – conté, charcoal, or graphite on newsprint

The goal of this exercise is to build a sense of volume and mass through an accumulation of lines that appear to be circumscribing (wrapping around) the body's form. Begin by quickly suggesting the overall action and key components of the inner pose, as with the gestural line sketch. Then describe the full breadth and depth of the body with gestural lines that cross over and around the con-

tour of the body. Imagine that you are actually drawing on the model and that your line is wrapping physically around the body like string. See Figure 2.29 for an example.

Value Sketches: Gesture and Mass

Pose – 1 minute each (5 to 10 poses)
Media – conté, charcoal, or graphite on newsprint (may be done with ink or watercolor washes)

Use your drawing stick, approximately 1" long, held lengthwise against the paper to create a broad value area. The idea is to deposit your pigment in wide, grainy areas. Draw the figure without using line. At first, work lightly, trying to record the configuration of the entire pose. Think of the grainy texture of the drawing medium as representing the dense molecular structure of the body in an atmospheric space. As your eyes rescan the pose, make alterations as needed by expanding or darkening the form to express its gesture and mass. If you find yourself focusing on smaller aspects, rather than on the whole, try squinting at the model in order to slightly blur the edges and details.

Line and Value Gesture Sketches

Pose – 5 minutes each (3 to 4 poses)
Media – conté, charcoal, or graphite on newsprint (may also be done with ink or watercolor washes)

In this exercise, use both line and value as complementary elements. First, do several drawings, starting with value to suggest the mass and gesture of the overall pose. Then draw back into the

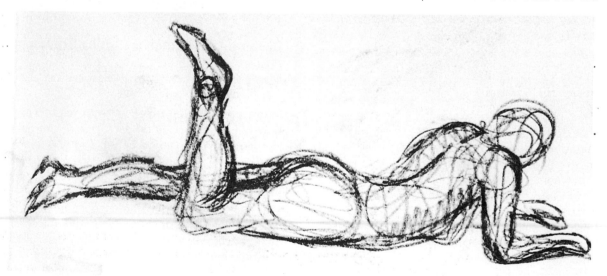

2.29
Cynthia Limber. Student drawing. Circumscribing line.

sketch with line. Avoid simply outlining your value drawing; let your line drawing be a new response to the model's gesture. After you have completed several drawings, reverse the steps, starting with line and following with a value drawing over the line drawing. Each element should complement and amplify the statement made by the other.

Schematic Configuration Sketches

Pose – 1 minute each (5 to 7 poses)
Media – charcoal or graphite pencil on newsprint

The goal of this exercise is to create a quick schematic diagram of the body's configuration. The three-dimensionality of the figure is flattened and traced as large, simple two-dimensional shapes. The goal is to lightly sketch what you see as the plot plan for the figure on your paper. The process and purpose are analogous to a surveyor's defining the footprint or foundation for a house on a building site. Begin by mapping the large primary shapes and lines, then add secondary ones. For expediency, lines representing outer contours can be simplified. Light lines can also be used to indicate horizontal, vertical, and diagonal alignments of one part of the body to another. Some artists indicate the position of landmarks on the body, such as joints, with a small circle. Detailed areas, such as the head, hands, and feet, are reduced to simple geometric notations. The primary goal is to indicate the size and location of what you observe. Forms are first defined in terms of their basic geometry, with the idea that they will be rounded off and details will be added later. Refer to Figure 2.18 for an example.

Volumetric Schematic Sketch

Pose – 5 to 10 minutes
Media – charcoal or graphite on newsprint

This exercise begins with a schematic configuration sketch, but the goal here is to literally expand the two-dimensional plot plan, to fill it out, to give volume and depth to the figure on the paper. This is accomplished by using your lines to suggest the body's three-dimensional structure. First, look for forms that overlap, surface planes that turn, ridges or recesses that appear. Cross-contour elliptical lines can suggest the cylindrical nature of the body's form. This sketching process is analogous to that of the stone carver, where the form is first "blocked out" or "rough cut." Refer to Figure 2.19 for an example.

Compositional Sketches: Figure-Frame Relationship

Pose – 5 minutes each (6 to 8 sketches of 1 pose)
Media – conté, charcoal, or graphite on newsprint

The purpose of this exercise is to help you see more clearly the interrelationships between the body's configuration and the picture plane of your paper. Draw six to eight small rectangles (approximately 5 × 7") on a piece of large drawing paper, varying the format between horizontal and vertical. Then, drawing from the model, create a new sketch within each small rectangular picture plane. Attempt to see the pose as a compositional component in relationship to the frame of your drawing paper and the space around the figure. Draw quickly, considering how the dynamics of the composition may change by placing the figure in a different part of the picture plane or by changing the size of the figure in relationship to the frame.

Extended Gesture Sketch

Pose – 5 to 15 minutes
Media – conté, charcoal, graphite, or ink pen and brush on newsprint

The extended gesture sketch begins with the same concerns you dealt with in the previous exercises. It requires that you respond quickly and intuitively to transcribe your feelings about the body's gesture and mass, and that you consider how the figure relates to the rectangular picture plane. In fact, as you begin your drawing, there should be little difference from how you would begin a one- or two-minute gesture or schematic sketch. What distinguishes an extended gesture drawing is not how it begins but, rather, how it develops. Over the extended period of time, your drawing should evolve into an expanded statement.

Independent Study

1 Take a sketchbook out to draw people as they go about their daily activity: working, playing ball, shopping, walking. Draw quickly, filling each page with many small drawings. Concentrate more on sketching their activity than on their personal appearance. **2** Drawing larger (one figure per page), attempt to record in your sketchbook the activity of people you have observed in seconds, before they move; then use your memory to see what details you can add about the individuals whose actions you have recorded.

Chapter Three

Proportions, Perception, and Perspective

A good figure cannot be made without industry and care. . . . And in devising such figures great attention should be paid to human proportions.
— *Albrecht Dürer*

Whereas gesture drawing and sketching emphasize intuition and a spontaneous response to the figure, much of drawing involves cognitive mental processes and a more systematic approach. We analyze, compare, describe, classify, synthesize, and evaluate, as well as respond to the figure with empathy. Because drawing is a cognitive process as well as an intuitive one, this chapter emphasizes a more deliberate and objective manner of drawing the human figure than that discussed in the previous chapter. The complexity of the human body requires that we also study it in more depth than a quick sketch permits. It stands to reason that the more we know about the human figure, the more effectively we can use the figure as a vehicle for our own artistic expression. Masters such as Leonardo, Michelangelo, and Albrecht Dürer made their drawings of the human figure a serious intellectual endeavor. Although they executed countless quick sketches, their approach to drawing at other times was contemplative and investigative, going far beyond the scope of simple sketching. For them, drawing was often a tool for gathering information and recording the details of their discoveries. Artists of the Renaissance were particularly interested in discovering a universal standard for human proportions along with a method by which they could accurately portray the figure as a three-dimensional object in space.

The Search for a Standard of Proportions

The study of the relationship of one part of the body to another is the study of human *proportions*. Leonardo da Vinci's famous drawing of a man within a circle and square, referred to as the *Canon of Proportion* or the *Vitruvian Man* (Figure 3.1), has become an archetypal symbol of the Renaissance blending of art and science. Leonardo spent years attempting to resolve a fundamental question: Are there divine or ideal proportions for the

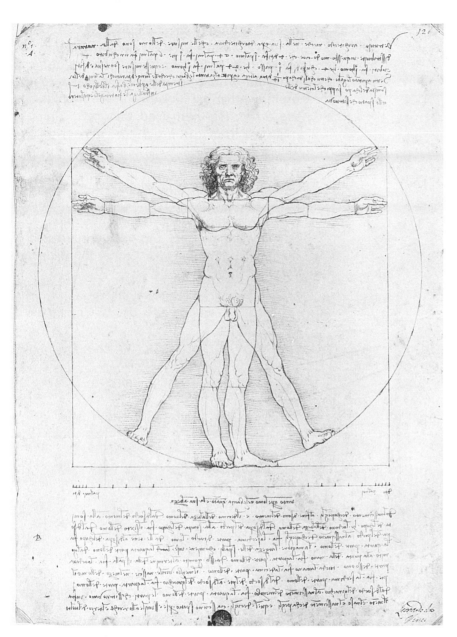

3.1
Leonardo da Vinci.
*The Vitruvian Man
(Uomo Vitruviano).*
Pen, metal point, and
brown ink, 13½ × 9⅝"
(34.3 × 24.5 cm). Galleria
dell' Accademia, Venice.
Courtesy Ministero per
Beni e le Attività Culturali.

human body that can be defined mathemat-
ically and that will harmonize with geome-
try? Although the concepts expressed in this
drawing actually originated with Vitruvius, a
Roman architect who believed that beauty in
nature is based on mathematical relationships,
Leonardo, who was a meticulous observer of
nature, modified Vitruvian theory to conform
to his own intense studies of the human form.

Leonardo's drawing suggests a variety of
proportional relationships; for example, a
man's reach is equal to his height, and his
height is approximately eight times the length
of his head. In one of his treatises on propor-
tion, Leonardo indicated that the width of the
man's shoulders is approximately one-fourth
of his height, and the distance from the ground
to the hip joint at the top of the femur (thigh
bone) is one-half the body's length, or four
heads high. This lower portion can be divided
in half at the knees. The upper half can be di-
vided into two equal parts at the nipples, and
the uppermost quarter can be halved again
under the chin.

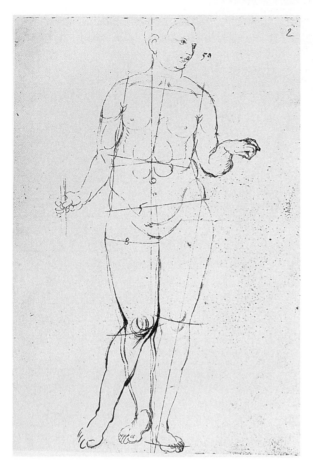

3.2
Albrecht Dürer. *Nude Woman with Staff*. 11³/₈ ×
7⁵/₈". Sächsishe Landesbibliothek, Dresden.

During the Renaissance, numerous other artists were attempting to work out codes and canons for determining human proportions. The most popular treatise was Dürer's, published in 1528. It was so widely read that the book went into fifteen editions and was used respectfully by many succeeding generations of artists throughout Europe.

Dürer made methodical studies of the proportions of all kinds of body types. Figure 3.2 shows his attempt to analyze, in terms of simple geometric relationships, the body's gesture and proportions. If you were to take a caliper or ruler and measure the size of the head and then use that as a unit of measure, you would discover that Dürer used a propor-

tional standard of seven-and-a-half heads high. Unlike Leonardo, who divided the body in half at the hip joint, Dürer used four head lengths to measure from the top of the head to the groin, with equal divisions at the nipples and the navel. He then used four head units to measure from the ground to the top of the pelvis, which overlaps the upper section by half a head length. This division of the body's proportions is quite logical when you consider that when viewed from the front, the torso appears to fit down into the formation of the hips.

Michelangelo, too, was keenly interested in human proportions. Like Leonardo, Michelan-

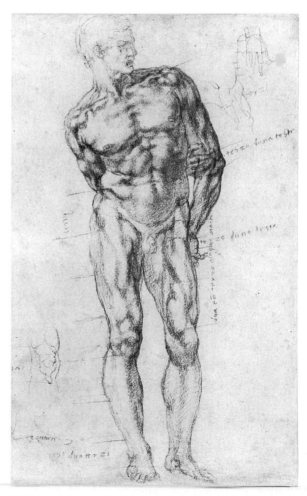

3.3
Michelangelo. *Male Nude, with proportions
indicated.* Red chalk, 11¹/₂ × 7¹/₈". The Royal
Collection. © 2003, Her Majesty Queen Elizabeth II.
(RL12765)

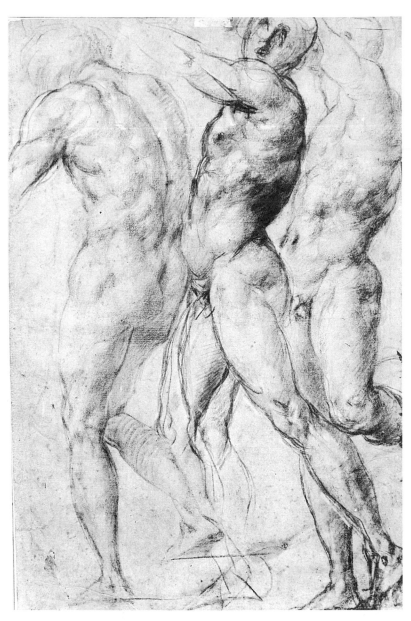

3.4
Jacopo Pontormo. *Study of Three Male Nudes*. Red chalk, 40 × 26.7 cm. Lille, Musée des Beaux Arts. Réunion des Musées Nationaux/ Art Resource, New York.

gelo made numerous anatomical studies. However, he modified what he observed in nature to express his Neoplatonic idealism. His figures took on epic proportions. For example, the body in Figure 3.3 approaches a height equal to nine head lengths. The body is elongated, with longer-than-average legs and a broader torso. In this drawing, it is the length of the face that has been used as a unit of measurement and scaled off alongside the body.

This expression of the body's fluidity and elongated proportions was further developed by the **Mannerists** who followed. Pontormo's study of three male nudes (Figure 3.4) clearly shows Michelangelo's influence. For example, notice how long the legs are in comparison with the upper body.

What society as a whole or the artist as an individual considers the ideal proportions or the perfect body type has continued to evolve. The society in which Rembrandt lived and painted seemed to prefer a smaller, more robust female body, as suggested by his portrayal of Cleopatra (Figure 3.5), considered by

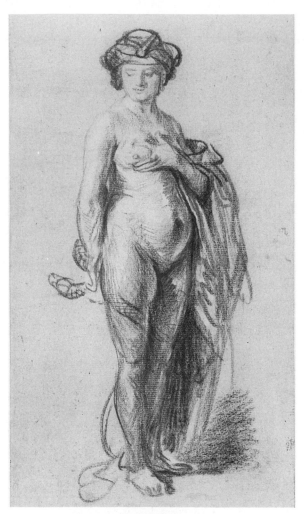

3.5
Rembrandt van Rijn. *Nude Woman with a Snake (as Cleopatra)*. c. 1637. Red chalk heightened with white chalk, 24.7 × 13.7 cm. The J. Paul Getty Museum, Los Angeles (81.GB.27).

legend to be an enchanting beauty. She stands a slight seven heads high. For Giacometti, who often greatly elongated his figures, the distortion and exaggeration of the body's normal proportions were an expressive device. His drawing (Figure 3.6) depicts a woman who stands twelve heads high—not intended to represent an accurate physical likeness but, rather, a reflection of the artist's aesthetic interpretation. Hopper's sketch of a standing nude (Figure 3.7) presents a woman who, like Dürer's proportional model, stands seven-and-a-half heads high. By comparison, con-

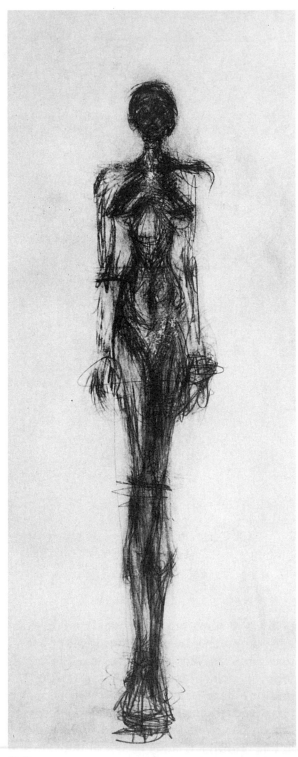

3.6
Alberto Giacometti. *Standing Woman*. Pencil, 35 1/8 × 19". Location unknown. © 2003 Artists Rights Society (ARS), New York/ADAGP, Paris.

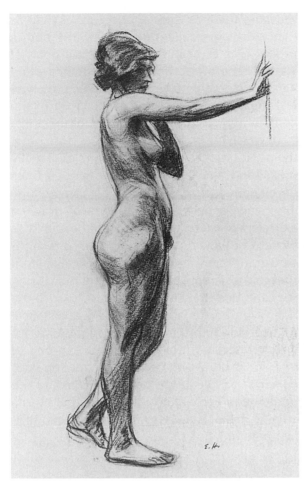

3.7
Edward Hopper. *Standing Nude.* c. 1920. Sanguine on paper, 18 × 12 1/8" (45.72 × 30.8 cm). Whitney Museum of American Art, New York. Josephine N. Hopper Bequest (70.375). Geoffrey Clements Photography.

temporary realist William Beckman presents an almost photographic likeness in Figure 3.8, where the figure, like Leonardo's Vitruvian man, stands eight heads high. Her physical characteristics also reflect contemporary society's ideal of an athletic body type.

The Eight-Heads-High Standard of Proportions

It is impossible to derive a proportional standard to which all body types would conform perfectly and that all artists would consider ideal. It is useful, however, to have a propor-

tional standard that can serve as a basis of comparison when drawing from a model and to use as a guide when drawing the figure from memory or imagination. Toward that end, we have applied the eight-heads-high standard Leonardo suggested to the adult male and female figures in Figure 3.9, which provides a comparison of the front, back, and side views of the body.

Although many other proportional standards have been suggested, those offered by Leonardo are simple, and they conform well to visually perceivable reference points on the body, such as the knee, hip, navel, nipples, and chin. Notice that the horizontal midway point of the chart is level with the hip

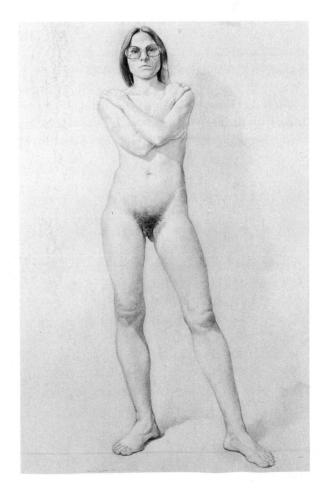

3.8
William Beckman. *Study for Diana IV.* 1980. Pencil, 29 × 23". Forum Gallery, New York. Photograph by eeva-inkeri.

rather than the waist, and the wrist is also level with the hip when the arm hangs at the side. You might find it interesting to use a yardstick and measure the proportions of your own body to see how they compare with Leonardo's *Vitruvian Man* (Figure 3.1) and those in Figure 3.9. Using your own head as the unit of measurement, try to determine how many heads high you stand and where you would locate your body's midpoints.

Understanding how to analyze and compare the body's proportions simplifies the complex problem of drawing the human figure. It also allows you, like Leonardo and Beckman, to record realistically what you observe or, like Michelangelo and Giacometti, to manipulate proportions as a vehicle for personal expression.

Sight-Measuring Proportions

When the artist wishes to draw with accuracy the correct proportions of a model, it is neither practical nor desirable to measure the body's proportions physically. The artist must measure them as they *appear*, rather than as they exist physically, determining the body's proportions as seen from the artist's point of view. These proportional relationships often vary considerably from what the actual physical measurements might be because of the configuration of the model's pose or the angle from which the pose is viewed. Therefore, what the artist must achieve is a means of visually measuring and comparing the various units of the body from a distance. This can be done intuitively, especially after years of drawing experience; mechanically, with the aid of a camera or viewing device; or from direct observation, with a simple technique called **sight measuring.** Artists have used sight measuring for centuries, enabling them to measure the body's proportions visually from a distance. All that is required is a thin, straight stick, for which you need look no further than one of your longer drawing pencils. By holding your pencil at arm's length between you and the model, you can sight with one eye along its edge to make useful visual comparisons, as illustrated in Figure 3.10.

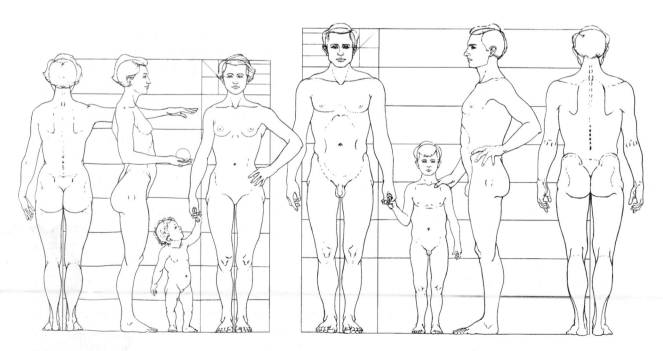

3.9
Diagram of the proportions of eight-heads-high adult male and female figures, with infant and child proportions.

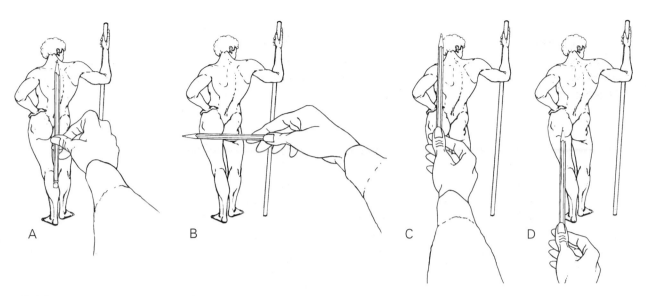

3.10
Diagram of sight measuring using level and plumb lines.

To determine the general relationship of the various body parts and how they align with one another, the artist in Figure 3.10A holds the pencil vertically as a plumb line, revealing how the body's organic mass is proportionally distributed along a vertical axis. If there is any curve or sway in the spine, it is easier to analyze its movement by comparing it to the straight line of the pencil's edge. In Figure 3.10B, the artist holds the pencil as a horizontal level to calculate the degree of slant in the shoulders, hips, knees, or feet.

To measure proportions and compare the size of one form with another, hold the pencil at arm's length between you and your subject. Align one end of your pencil with one edge of the form to measure. While holding this end of your pencil stationary, slide your thumb down the pencil until it is aligned with the other end of the form to be measured. For example, in Figure 3.10C, we see the artist measuring the distance from the top of the thigh bone, at the hip, to the top of the head. Now, with your thumb held in place, shift the pencil so that the end aligns with the edge of a new portion of the body and compare this with the previous measurement (as in Figure 3.10C and 3.10D). You can use this procedure to compare any proportion of the body with another.

Plotting the Body's Proportions

Creating a tentative schematic underdrawing of the body's proportions and configuration is a process referred to as *mapping* or *plotting*. It involves graphically transcribing the proportional relationships and alignments of the various parts of the body. Leonardo offered the following advice: "When you begin to draw, form in your mind a principal line, let us say, a perpendicular. Observe the relationship between the various parts of your subject to that line: whether they intersect it, are parallel to it, or oblique."[1]

These observations form the basis for a lightly drawn linear diagram, or *plot plan*. This process was introduced in the previous chapter with schematic sketching, but now our plotting of the body's proportions is more methodical, involving sight measuring and carefully checking the proportions of the body and the alignment of its parts as a prelude to a more descriptive follow-up drawing.

Essentially, mapping or plotting separates the complex problem of accurately determin-

ing the body's proportions and defining its contours and surface appearance into logical, sequential steps. The general configuration, scale, and proportional relationships are determined prior to considering the contours, so that the artist is free to concentrate on the precise path of the contour lines and any description of details, confident that the proportions have been accurately determined. The underlying structural notations and plotting lines become submerged as the drawing develops, buried beneath subsequent layers of drawing. For a step-by-step representation of plotting proportions, see Figure 3.27 in the "In the Studio" section of this chapter.

Learning to See: Beyond Preperception

True vision requires more than 20/20 eyesight and involves more than just seeing something well enough to tag it with its name. For the artist, seeing is *perceiving,* a word derived from the Latin *percipere,* which means "to grasp or comprehend."

Preperception

To know an object thoroughly, to fully perceive it, takes a greater effort than casual observation. It requires one to go beyond what the American psychologist and philosopher William James (1842–1910) referred to as **preperception**: the storing of visual concepts. In our everyday life, this stored visual knowledge facilitates our recognition of objects, but it can often prevent us from looking more than superficially at objects we have previously experienced, and, as a result, we make assumptions that are inaccurate. Psychologists have noted that three of the strongest preperceptions we have about the human figure involve its size, shape, and symmetry. For example, we know intellectually that both arms are the same size, that the body is structured symmetrically, with a right and left side of equal size and proportion. These preperceptions are limiting to the artist, creating obstacles when he or she is faced with drawing

a pose that presents the human body in ways that do not conform to what we have learned to expect.

Our preperceptions create a strong subconscious desire to modify what we actually see and to fashion in our drawings something that conforms to the stereotyped image in our minds. Our preperception tricks us into thinking that our prior knowledge is sufficient and that we therefore needn't look any closer. Artists who draw well have learned not to rely on preperceptions. They have trained themselves to be objective and accurate observers.

One means of overcoming the influences of preperception is understanding how to measure objectively the proportions we see. One method we have discussed is sight measuring. Another helpful tool is an understanding of the principles of **linear perspective**. Perspective helps the artist perceive how the physical proportions of the figure are visually altered by their spatial relationship to the viewer.

Dürer's Window

The Screen Draftsman (Figure 3.11) illustrates a very particular technique that Albrecht Dürer experimented with as a means of counteracting the subconscious influence of preperception and accurately transcribing the proportions of a reclining figure. Although this apparatus would be impractical for use in a drawing class, the fundamental concept provides some important insight into both the nature of visual perception and the basic principles of perspective. For example, the vertical shaft over which the artist appears to be sighting ensures a stationary **point of view**. The artist looks at the model through a window divided by a grid pattern that corresponds in scale and proportion to the grid on his paper. To transcribe accurately the proportions of his subject, the artist notes where and how the contours of the body visually intersect the grid lines in the window between the artist and the model, then duplicates these configurations of line on the gridded paper before him. In this way, Dürer's artist could

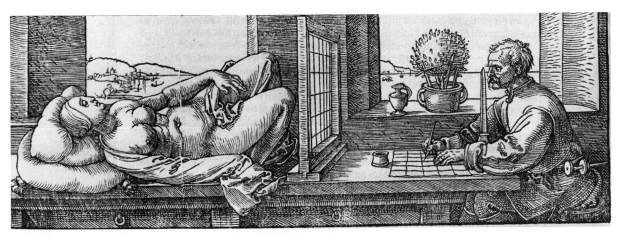

3.11
Albrecht Dürer. *The Screen Draftsman (Draftsman Doing Perspective Drawings of a Woman)*. 1523. Woodcut, 7.5 × 21.5 cm. The Metropolitan Museum of Art, New York. Gift of Felix M. Warburg, 1918 (18.58.3).

objectively measure the angles and proportions of the subject *as they were perceived*, avoiding the influence of preperceptions in terms of the body's shape and symmetry.

Dürer's print also illustrates that whenever you draw a three-dimensional object on a piece of paper, you represent on the flat **picture plane** of your paper what you view through an *imaginary* picture plane between you and your subject, as if seen through a window or the viewfinder of a camera. Rather than using a grid screen in front of you from which to take measurements, as in Figure 3.11, you can use sight measuring, the basic principles of which are essentially the same. When you extend your arm, as in sight measuring, you are, in effect, placing your pencil against an invisible window: the imaginary picture plane between you and your model.

Perspective and Its Influence on Proportions

Perspective and perception are interrelated. The word **perspective** comes from the Latin *perspectus*, which means "seen through or into." A modern dictionary defines *perspective* as a point of view, an evaluation or assessment, as seeing things in their proper relationship and proportions, and as a tech-

nique for representing three-dimensional objects and depth relationships on a two-dimensional surface. All these meanings apply to drawing, but the final definition has the most direct bearing on our study of the figure. Artists employ several kinds of perspective devices when drawing. For example, **overlapping**, when one form is placed on top of another, suggests that one object is in front of the other in space; **vertical positioning**, whereby some forms are placed lower and others higher on the drawing surface, usually suggests that the higher forms are farther away; **size differentiation** suggests that the smaller forms are farther away. **Atmospheric perspective** is based on the observation that as objects recede in space, light fades, colors dull, and details become obscured.

Linear perspective is based on the general observation that parallel lines, as they recede in space, appear to converge. Forms visually become smaller as their distance from the viewer increases. When a form is viewed in perspective, with part of the form near the viewer and part of it farther away, it is **foreshortened**, meaning that we no longer see the full dimension of the form, but a shortened, compressed view of it. Understanding linear perspective helps the artist realize intellectually the way forms are visually altered as they

recede and in turn draw figures that are more three-dimensional and visually convincing.

The Development of Linear Perspective

The basic principles of linear perspective can be found in Greek art and the works of the classical scholars Euclid, Ptolemy, and Vitruvius. However, it wasn't until the Renaissance that the concept started to come together into an applicable drawing system. At that time, linear perspective became a subject of passionate interest.

In fact, the power and magic of perspective were so great that it lured Northern Renaissance artist Albrecht Dürer across the Alps to Italy, where he hoped to learn more about it from Andrea Mantegna and other practitioners of the early Renaissance. Mantegna was one of the first artists to understand fully the principles and graphic potential of perspective. In his famous painting, *Dead Christ* (Figure 3.12), he uses perspective to create a convincingly realistic illusion and a powerful psychological effect. He puts the viewer at the feet of the dead Christ, using the dramatic foreshortening to force the viewer to confront

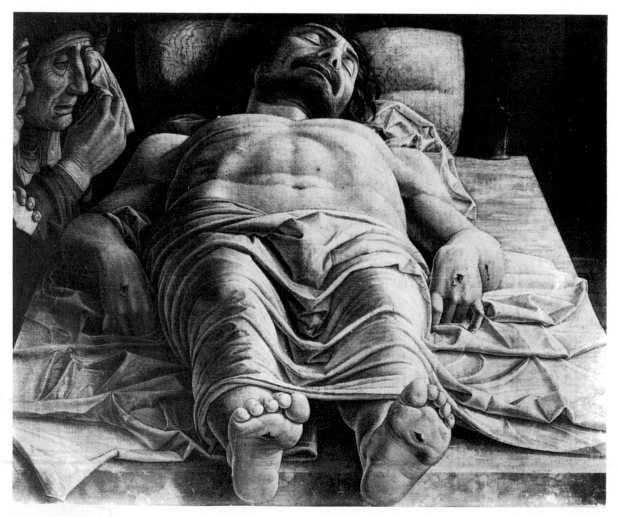

3.12
Andrea Mantegna. *Dead Christ.* 1466. Tempera on canvas. Pinacoteca di Brera, Milan.

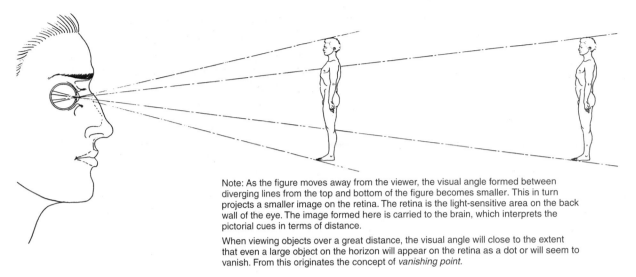

Note: As the figure moves away from the viewer, the visual angle formed between diverging lines from the top and bottom of the figure becomes smaller. This in turn projects a smaller image on the retina. The retina is the light-sensitive area on the back wall of the eye. The image formed here is carried to the brain, which interprets the pictorial cues in terms of distance.

When viewing objects over a great distance, the visual angle will close to the extent that even a large object on the horizon will appear on the retina as a dot or will seem to vanish. From this originates the concept of *vanishing point.*

3.13
Diagram of visual angle.

what Ernest Hemingway later referred to as "the bitter nail holes in Mantegna's *Christ.*"[2]

Perspective, more than any other discovery, changed the face of Western art. With perspective, Renaissance artists liberated the figure from the limitations of the static world of flat symbolism. In its stead, they gave us a three-dimensional world of drama and illusion, an illusion based on a rational system that made it possible to produce a convincing likeness of the human figure as a three-dimensional volume in its physical surroundings.

The Elements of Linear Perspective

Linear perspective can be further defined as any method of drawing by which three-dimensional volumes and spatial relationships are represented in terms of their geometric relationship to the viewer's eye. We are capable of vision because light waves reflected from perceivable objects are focused by the lens onto the retina at the back of the eye. The object forms the base of a triangle, and light waves reflected from the object form the two converging sides, with the apex at the eye's lens. The lens recreates the image of the object in direct proportion on the wall of the retina. This geometric relationship, diagrammed in Figure 3.13, illustrates a principle of sight known as Euclid's law and forms the basic element of linear perspective. It also explains why objects that are far away appear smaller than objects close to us. As the object moves away from the viewer, the visual angle formed by diverging light rays reflected from the object's extremities becomes smaller and, in turn, produces a smaller retinal image, even though the actual size of the object remains constant.

In George Tooker's *Study for "Subway"* (Figure 3.14), we see how the progressive reduction in scale of the figures produces an optical illusion of depth by imitating on paper what is visually experienced in reality. Some of the drawn figures produce progressively smaller retinal images and, as a result, imply distance and depth even though the images of all the figures exist on the same plane of the drawing surface. In addition to using perspective as a device for plotting the size of his figures, Tooker uses perspective to pull the viewer deeper and deeper into the endless maze of the city's underground. His drawings and paintings often deal with the anonymity and isolation of the city dweller. Here, his use of perspective, with its cool, impersonal regimentation, not only delineates the cage-like maze his figures occupy but also seems to express

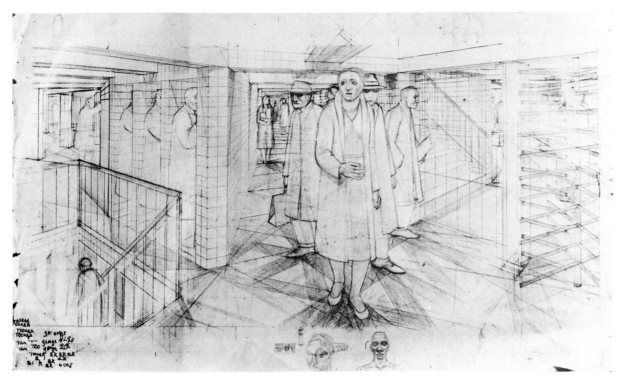

3.14
George Tooker. *Study for "Subway."* 1950. Pencil, 18 × 36". Courtesy of the Marisa Del Re Gallery, New York.

metaphorically the geometrically increasing pressures of modern urban life. Tooker creates an unending world from which there appears to be no exit.

Foreshortened Figures

Another factor that determines the visual angle and the size of the image on the retina is the **angle of recession**, or the degree to which a form recedes in space, as illustrated in Figure 3.15A. As the model reclines, the visual angle narrows, and the image it projects onto the retina shrinks—even though the size of the figure has not physically changed. The more the figure recedes in space away from the viewer, the more foreshortened the normal proportions appear. Figure 3.15B illustrates what the viewer actually perceives as the figure changes position from standing to full reclining.

Pavel Tchelitchew's self-portrait (Figure 3.16), done with feet propped up in front of a

mirror, shows the combined influence of distance and recession on the proportions of his body. Even though we can see only part of the body, he suggests his full length by greatly reducing the proportion of his head and hand in relationship to the size of his feet.

Changing Eye Level

A change in eye level can also visually alter proportions. **Eye level** refers to the actual position or level of the artist's eye. It is also the **point of view**, or **point of perception**. The normal eye level of a standing person would be approximately five feet above the ground. But it is possible to be looking down at an object from high above, as in "a bird's-eye view," or to look up at an object from below. Every change in position brings a related change in the perceived shape and proportions of the subject.

For example, Figure 3.17 shows two people drawing the same figure from two different

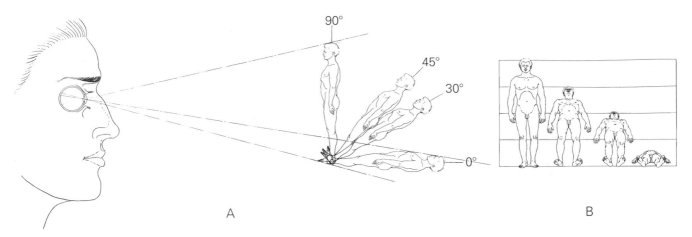

3.15
Diagram of angle of recession, side view (A) and front view (B).

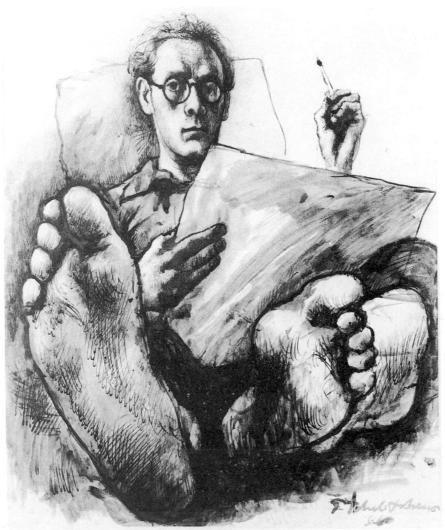

3.16
Pavel Tchelitchew. *Tchelitchew*. 1934. Pen and ink and sepia wash, 16 1/4 × 12 3/4". Reproduced by kind permission of the Trustees of the Edward F. W. James Foundation, West Dean, Chichester, England. (Inv. No. 210.)

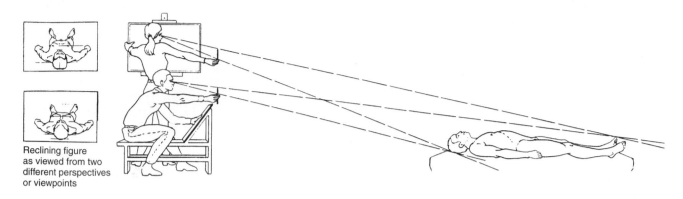

Reclining figure
as viewed from two
different perspectives
or viewpoints

3.17
Diagram of the eye level and angle of perception.

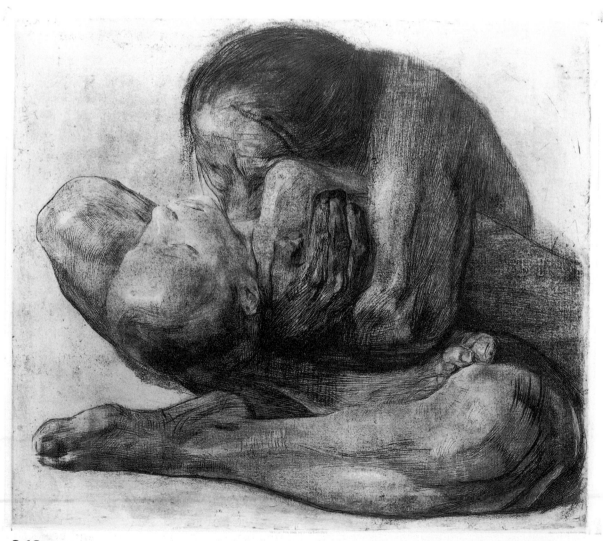

3.18
Käthe Kollwitz. *Mother with Dead Child*. 1903. Etching, 16³/₄ × 19¹/₈" (42.2 × 48.3 cm). Library of Congress. (Klipstein 72. 9th state.) © 2003 Artists Rights Society (ARS), New York/VG Bild-Kunst, Bonn.

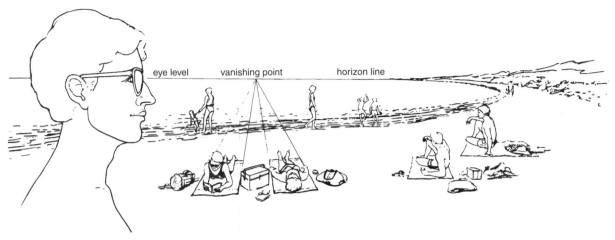

3.19
Diagram of horizon line, eye level, and vanishing point.

eye levels and indicates how that difference alters the visual proportions of the same reclining figure. To ascertain the foreshortened body's correct visual proportions, the artists each use sight measuring.

When sight measuring, you in effect measure the width of the visual angle projected by a form in front of you. It is as if you are taking the measurement from an invisible picture plane between you and the model.

Eye level not only indicates the position and view of the artist who created the drawing, it also manipulates the viewer by dictating a particular point of view. For example, in her print *Mother with Dead Child* (Figure 3.18), Kollwitz both describes her subject and controls the viewer's position in reference to the subject. By drawing her figure large and establishing a low eye level, Kollwitz brings you in close, down on your knees, to mourn this child's death along with its grief-stricken mother. Composition and perspective, in this case, are as much about defining one's perceptions as they are about arranging objects within the picture frame. Compare this work with an earlier sketch (Figure 2.28). Notice how she refined the composition, clarified the form, and lowered the point of view.

The artist's eye level is also what determines the height at which one sees the *hori-*
zon line. The horizon line is an imaginary line in the distance, where earth and sky meet. It remains at your eye level, moving up or down as your eye level changes. As foreshortened forms recede toward the horizon line, the visual angle narrows to the extent that the image on the retina is reduced to a point or appears to vanish altogether. *Vanishing point*, then, is an imaginary point on the horizon toward which parallel receding lines appear to converge and the proportions of receding forms progressively reduce in size. Figure 3.19 demonstrates these concepts, where the artist's eye level is the same as that of the figure in the foreground.

The complexity of the human figure—its ability to bend at different angles and assume a variety of configurations—means that within a single pose, parts of the body often recede or taper toward different vanishing points. This is referred to as *multiple-point perspective*.

In a line drawing by contemporary artist Eleanor Dickinson (Figure 3.20), two nudes recline in more or less parallel alignment, but as the bodies progress upward on a converging perspective path, limbs bend and project to several different vanishing points. Dickinson suggests the compressed proportions of the foreshortened figures as well as a progression

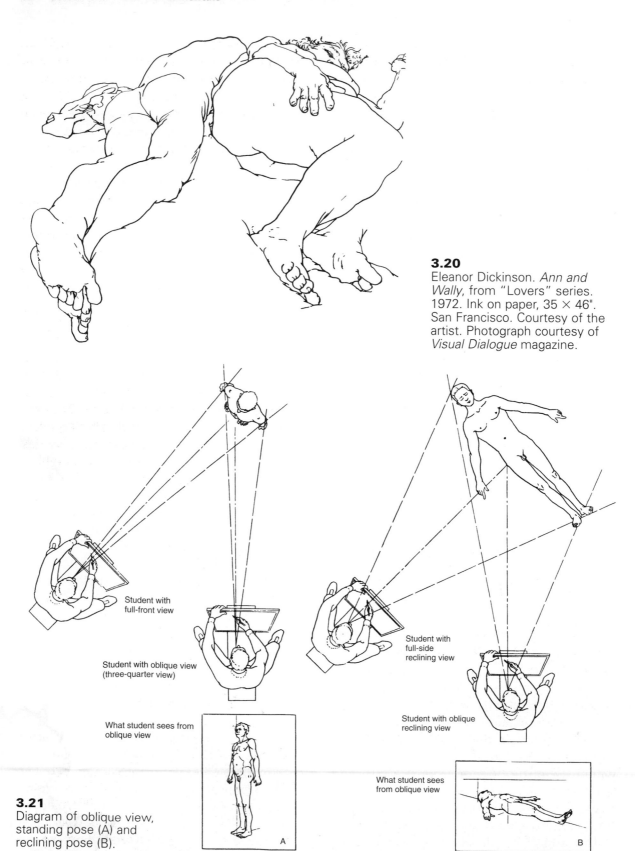

3.20
Eleanor Dickinson. *Ann and Wally*, from "Lovers" series. 1972. Ink on paper, 35 × 46". San Francisco. Courtesy of the artist. Photograph courtesy of *Visual Dialogue* magazine.

Student with full-front view

Student with oblique view (three-quarter view)

What student sees from oblique view

A

Student with full-side reclining view

Student with oblique reclining view

What student sees from oblique view

B

3.21
Diagram of oblique view, standing pose (A) and reclining pose (B).

back in space by using overlapping lines. It was not necessary for Dickinson to plot the perspective lines of each form; however, every line conforms with the underlying principles of perspective.

Drawing Oblique Views

Even when drawing a standing pose, we often see the body from a diagonal point of view, which affects its normal symmetry and proportions. As Figure 3.21A illustrates, the artist drawing the figure from a ***three-quarter view*** or ***oblique view*** does not see the body symmetrically as it would appear to someone with a frontal view. The right and left sides are no longer visually equal. In this situation, sight measuring from points along the body's normal symmetrical center (such as nose, breastplate, navel, or spine) to the outer edges enables the artist to establish accurately the visual proportions of the two sides of the body and the degree of turn or twist in the pose. Notice, too, how in the drawing done from the oblique view, the principles of perspective affect the positioning of the feet and shoulders and the relative length of the two arms.

When a reclining figure is drawn from an oblique view, the symmetry and proportions of the figure are even more dramatically altered. Figure 3.21B illustrates how the proportions of the upper body are significantly smaller than those of the lower body (divided at the hip joint). Sight measuring, using visual reference points on the body as a basis for objective visual comparisons, ensures a more accurate and therefore more believable representation of the figure in perspective.

Paul Cadmus's drawing of a reclining male nude (Figure 3.22) presented him with the combined challenge of foreshortened proportions and a diagonal, oblique view. All the normal proportional relationships that one has learned to expect when drawing a standing figure have been greatly altered. As the body moves back in space, we can see how it appears to be moving upward, affected by the artist's eye level, and how forms such as the torso have been compressed or reduced, while forms in the foreground—those closest to the artist—have increased in size. Once the artist is aware of the proportion-altering effect of perspective, drawing a pose such as this one can be engaging as well as challenging.

Consider how many different proportions of the two male figures in Figure 3.23 have been altered to conform to the principles of

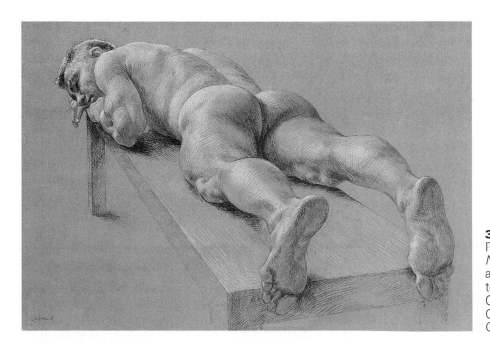

3.22
Paul Cadmus. *Male Nude TS7.* 1955. Pencil and egg tempera on toned paper, $9^3/_8 \times 14''$. Collection unknown. Courtesy DC Moore Gallery, New York City.

perspective. Because the arms and lower leg of the crouching figure and the visible arm of the reclining figure are placed on an axis parallel to the picture plane, they can be drawn proportionally full scale, but just about every other form projects at a divergent angle to the picture plane and, therefore, is foreshortened.

Every pose presents a unique drawing problem. A basic understanding of perspective provides a clearer picture of the physical and visual phenomena involved, enabling the artist to resolve those visual problems. To a great extent, the skill and craft of a representational artist involve the ability to present a graphic facsimile that transmits to the retina of the viewer the same visual relationship transmitted from the actual three-dimensional figure to the artist. What an understanding of linear perspective provides is a guidance system for the analysis and presentation of the structural characteristics of the body in an illusionary space.

Structural and Planar Analysis

The effects of linear perspective can be more easily observed in objects with clearly defined lines, such as a box or cube, where the parallel lines of the edges can clearly be viewed as receding toward a vanishing point. With the softer organic form of the human body, the lines of perspective are not so clearly delineated. However, two very useful techniques—*structural analysis* and *planar analysis*—can assist in simplifying the body's forms by reducing it to its underlying geometric components. As Paul Cézanne once suggested, "treat

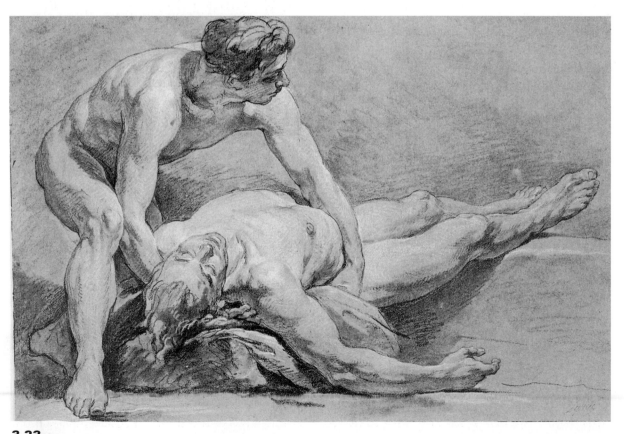

3.23
Nicolas-Bernard Lépicié. *Two Nude Male Figures*. Charcoal, stumped black chalk, heightened with white on gray-green paper, 33.5 × 50.8 cm. The Metropolitan Museum of Art, New York. Harry G. Sperling Fund, 1981. (1981.15.4)

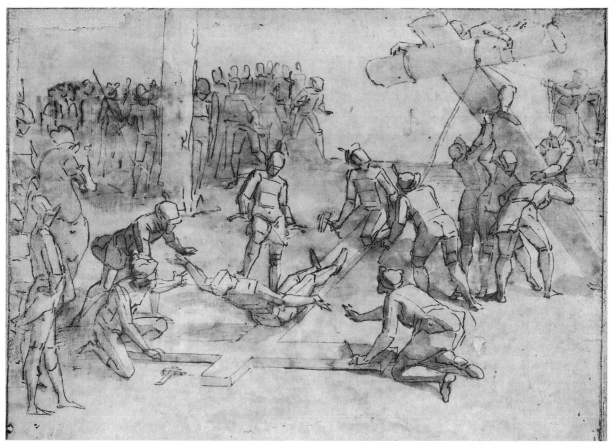

3.24
Luca Cambiaso. *The Crucifixion.* After 1570. Pen, brown ink, and wash, 21.4 × 29.5 cm. Whitworth Art Gallery, The University of Manchester.

nature by the cylinder, the sphere, the cone, everything in proper perspective."[3]

Long before Cézanne, sixteenth-century artist Luca Cambiaso had discovered that interpreting the body's form as simple geometric volumes and its surface as planes made it easier to grasp how the body conforms to the principles of perspective. His elaborate geometric constructs helped him work out the complexity of his figurative compositions. In *The Crucifixion* (Figure 3.24), we see how linear perspective guided the plotting of his figures and how interpreting the body as rectangular, boxlike units clarified their structure. Cambiaso reportedly used articulated wood models of the human figure for the pur-

pose of studying the effects of perspective and the play of light. Notice the similarity in the way Cambiaso plots both the shape of the cross and the forms of the bodies around the cross.

A sketch by Giovanni Paolo Lomazzo (Figure 3.25) shows how he used structural analysis to understand the proportions of a figure viewed from below. Notice how he constructs the arms and legs as geometric shapes and uses line to draw elliptical rings encircling the legs and torso to help visualize how one section overlaps another and to plot the foreshortening of the body. Of course, this sketch, like that of Cambiaso, was not intended to be a work of art. Instead, it served as a useful tool for visualizing, a technique that is still

practiced by many artists as a foundation for their more finished works.

Alberto Giacometti did a number of drawings that followed Cambiaso's lead and Cézanne's advice. In Figure 3.26, for example, Giacometti is concerned not just with the simplification of large forms into their basic geometric volumes but with the possibility of seeing and interpreting the body's spatial volumes in terms of multifaceted planes. This way of drawing the figure is often referred to as *planar analysis* and, like structural analysis, is a useful method for reconstructing the body's structural relationships on a two-dimensional drawing surface. Giacometti's line plots the angular breaks between the planes on what

he sees as the body's multifaceted surface. His division of the surface terrain may have been derived from observation of the light and shadow on the forms of the model, but it also describes how the body's structure might be simplified in terms of flat planes and fabricated as a three-dimensional volume.

In most drawings, the structural notations lie beneath the surface and, like the structural framing of a house, are not seen in the finished drawing. Drawings that emphasize the body's underlying geometry and structural relationships are extremely useful as a foundation, however, and can be both informative and aesthetically engaging in their own right.

3.25
Giovanni Paolo Lomazzo. *Foreshortened Draped Man Looking Up.* Pen and brown ink, 19 × 12". The Art Museum, Princeton University. Gift of Frank Jewett Mather Jr. X1947-136.

3.26
Alberto Giacometti. Detail of *Seated Nude from Behind (Nu assisse, dedos)*. 1922. Pencil, 48.5 × 31.5 cm. Alberto Giacometti Foundation, Kunsthaus Zürich. © 2003 Artists Rights Society (ARS), New York/ADAGP, Paris.

IN THE STUDIO

The drawing exercises that follow provide an opportunity to apply much of the information presented in this chapter. Although the exercises are considerably longer in duration and emphasize a more methodical and systematic approach than that employed in gesture sketching, you will see that sketching is still vital in establishing the foundation for a longer, more detailed drawing.

Warm-Up with Schematic Sketches

Pose – 5 minutes (3 to 6 poses)
Media – charcoal or graphite on newsprint

An ideal way to begin a drawing session on the study of proportion and perspective views of the figure is by warming up with some quick schematic sketches, as described in Chapter Two. These sketches should emphasize plotting the larger forms of the body and define the pose in terms of simple geometric relationships by noting proportions and alignments with quick, straight lines.

Plotting the Proportions of a Standing Figure

Pose – 20 minutes, model standing at ease
Media – charcoal or graphite on drawing paper

The purpose of this exercise is to study the proportions of a standing model, using sight measuring to make comparisons. Use the proportional relationship of an eight-heads-high figure as a standard while attempting to discover how the individual model's proportions may vary. Concentrate on the size relationships of larger body sections before drawing details. Plot the proportions of the model from the front, back, and side, spending approximately twenty minutes on each view. The purpose here is not to develop a highly finished drawing but to feel that you have accurately measured and plotted the proportions of your model as they are presented visually. Before you begin, you may want to review sight measuring and proportions.

Review of Sight Measuring and Proportions

Figure 3.27 suggests a step-by-step study of proportions that points out what to look for and what comparisons to make when drawing a standing figure. Draw the full figure, beginning with a lightly drawn straight vertical line to indicate its full height and where it is placed on the paper. This line relates to what Leonardo referred to as the "principal line," to which all proportions and alignments are compared. With short horizontal lines at both ends, indicate the top of the head and the bottom of the feet.

According to Leonardo's eight-heads standard, the midpoint should be at the hip (not waist), the knee midway between the hips and the floor, and the upper half divided by head lengths: from the top of the head to the underside of the chin, from chin to midchest, from midchest to navel, and from navel to hips, as in Figure 3.27A. Use sight measuring to determine how this canon of proportions

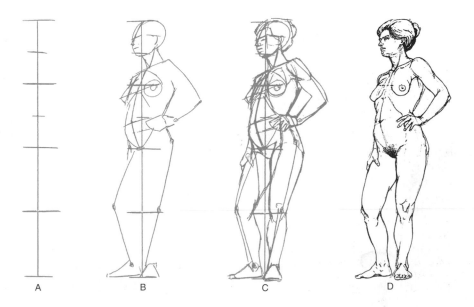

3.27
Diagram of plotting the figure's proportions.

A B C D

applies to your model and your viewing angle. You may discover that you need to make minor adjustments to the placement of horizontal lines drawn on the vertical to establish the body's true midpoint and the placement of knee, navel, and chest points.

Next, hold your pencil out horizontally, as if it were a level, to establish the positions of the feet and knees and the tilt of the hips and shoulders. Mark their position with line, then observe and plot the location and angle of the head and limbs. Use an oval to suggest the general shape of the head and straight lines running through the center of the limbs from joint to joint, as in Figure 3.27B.

To check the location of the joints and other points of reference, sight along the vertical or horizontal pencil, held at arm's length, to determine how these reference points align with others on the body. For example, the ankle bone might be directly below the ear, or an elbow at the same height as the navel. Plot the often subtle but essential gestural rhythms in the torso by comparing the curvature of the spine (or the line of division over the breastplate and abdomen on the front) with the straight edge of your pencil.

To plot the width and outer contours of the torso and limbs, simply compare the horizontal widths with the vertical proportions you have plotted. For example, the width of the shoulders can be compared with the length of the head or the distance from the floor to the knee. These proportions should be lightly inscribed with straight lines on your paper, as in Figure 3.27C.

This diagrammatic plotting of the major proportional relationships represents only a fraction of the time spent on a drawing. Before completing it, step back from your sketch to compare, from a distance, the proportions of the figure on paper with those of the model. This enables you to make comparisons because the visual scale of the drawing more closely matches the scale in which you view the model. Once you have captured the essential elements of the pose—gesture, balance, and proportions—you can add details (Figure 3.27D).

Drawing the Standing Figure

Pose – 60 minutes, model standing at ease
Media – charcoal or graphite pencil on drawing paper

The goal with this longer pose is to build on your experience and the information gained in studying proportions with the previous exercises. Begin by lightly drawing a schematic diagram of the model's

proportions. Note graphically any gesturing of the body, such as a tip to the shoulders or hips, or a sway or curvature to the spine.

Next, build on your preliminary sketch. If you have accurately mapped the body's proportions, you should be free to concentrate on drawing the contours of the body. Be sure to note the subtle relationships of facial features, hands, and feet. After using line to note the body's proportions and delineate the surface contours, add value to further shape and refine the image. With value, your drawing of the figure should not only become more detailed but also develop a greater sense of volume and weight. In the process, your initial schematic diagram will be covered with added layers of drawing media as the drawing progresses.

Planar Analysis of the Body in Perspective

Pose – 30 minutes, model seated or reclining
Media – graphite or charcoal on drawing paper

Begin by plotting the overall configuration of the model's pose, using sight-measuring techniques and straight lines to indicate the size of various limbs and relevant points of reference. Then attempt to interpret each unit of the body in geometric, blocklike terms, seeking out the underlying structure and its perspective alignment. If you understand how to draw a rectangular box in perspective, you should find that when you draw the figure in perspective, it helps to think of its shapes as geometric solids, such as cubes, rectangles, and cylinders. Divide the larger shapes into secondary and tertiary units that suggest the angle or recession of surface planes. Note that shadows and reflected light provide clues to the shift in surface structures. Refer to Giacometti's *Seated Nude* (Figure 3.26) to see how your drawing might progress in the description of surface planes and angles.

Drawing the Foreshortened Figure

Pose – 60 to 90 minutes, model reclining
Media – graphite or charcoal on drawing paper

Simply stated, the goal of this exercise is to complete a drawing of the figure in a reclining pose that accurately indicates the body's proportions as you see them before you. To accomplish this, you can divide the complexity of the task into a logical sequence of steps, fully utilizing sight-measuring techniques to ensure that your preperceptions about the body's proportions are not leading you to make inaccurate descriptions.

The first step is to plot the the body's proportions graphically. Keep your lines light, and after you have completed this stage, stand back from your drawing and critique it. Make changes as you deem necessary. Once satisfied with the preliminary drawing, turn your attention to the volumetric description of the body with contour lines. Draw elliptical cross-contouring lines over the trunk, head, and limbs, as in Figure 3.28. These help reveal how the volumes of the body are arranged in space and viewed in perspective. The final step is to focus on the details, using line to further refine the image.

Independent Study

1 Rather than using a model, use your imagination and what you have learned about human proportions to create drawings of both male and female standing figures using the eight-heads proportional standard. Use one sheet of paper for each drawing. Your figures can be viewed from any side. Don't just copy drawings from the book—it will be more fun and worthwhile to invent your own. **2** Invent or imagine your own pose for a figure that would be seen dramatically foreshortened—a person falling or jumping, for example, or seen from above or below. **3** Use a mirror with yourself as a model and do a foreshortened self-portrait. You might sit on the floor with your feet stretched toward the mirror or place the mirror so that you must look up into it. You can draw what you see in the mirror or try a double image that includes the part of your body you see between you and the mirror as well as the image in the mirror itself.

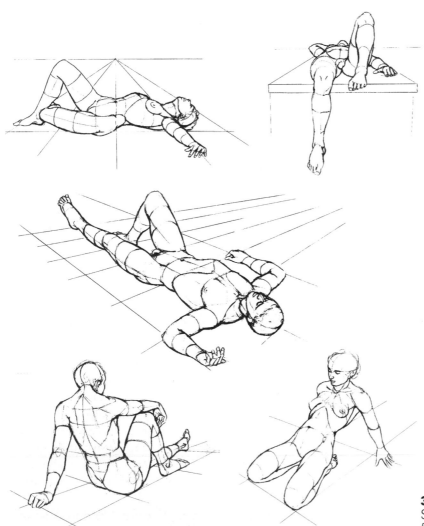

3.28
Schematic sketches of foreshortened figures.

Chapter Four

The Magic of Line

The line has in itself neither matter nor substance and may rather be called an imaginary idea, rather than a real object.

—*Leonardo da Vinci*

Of all the tools the visual artist uses, line is by far the most fundamental, probably the most valuable, and certainly the most magical. Much has been made of the invention of the wheel and other tools, but the first use of a line for symbolic representation was truly a quantum leap in the development of humankind. It is with mark making that humankind started thinking abstractly and symbolically. With mark making came the capacity for literacy, the development of language as an information storage system. The pictorial language of drawing is more than thirty thousand years old—twenty-five thousand years older than the earliest phonetic alphabet.

Physically, a line is nothing more than a two-dimensional mark on a surface. But when that mark stands for something or traces the configuration of an object, it traps within its confines the conceptual essence of that object, holding it through time. Used in this way, line fashions a sort of magic. It conjures the form and presence of that object, bringing it into being on the drawing surface and in the viewer's mind.

The Function of Line

We've all used line to draw since early childhood, but it would be as grave a mistake to assume we have nothing more to learn about its use as it would be for aspiring actors to assume they've mastered the art of speech simply because they began talking at the age of two. Line is such an important conduit of visual information and artistic expression that we must approach it with disciplined study in order to tap its full communicative power. Jean-Auguste-Dominique Ingres, France's leader of nineteenth-century neoclassicism, felt so strongly about the importance of line that when he first met young Edgar Degas, he advised, "Draw lines, young man, many lines, from memory and from nature—it is in this way you will become a good artist."[1]

Ingres's drawing (Figure 4.1) demonstrates the dual function of line: both utilitarian and

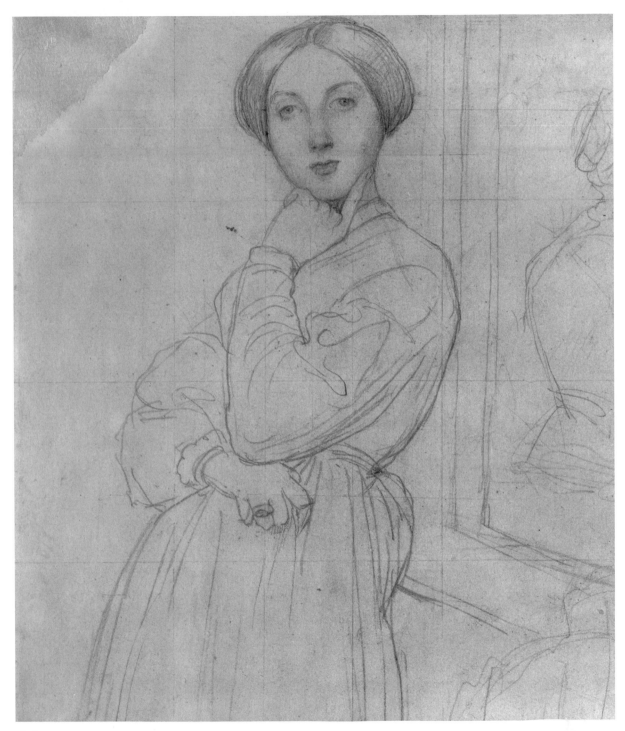

4.1
Jean-Auguste-Dominique Ingres. *Study for the Portrait of Madame Othenin d'Haussonville.* 1842–1845.
Graphite, squared, on white paper. 23.4 × 19.6 cm. Courtesy of the Fogg Art Museum, Harvard
University Art Museums, bequest of Meta and Paul J. Sachs. Photo by Rick Stafford © President and
Fellows of Harvard College. 1965.294.

aesthetic. Line's utilitarian function lies in its ability to describe and inform. When representing the human figure, line can outline its shape, plot its configuration, define its proportions, and suggest its volume and mass—all of which contribute to the creation of a communicable graphic symbol.

The aesthetic function of line comes from its rhythmic, choreographic qualities. A line serves as a frozen record of the kinetic energy by which it was created and, in turn, directs the movement of the viewer's eye through the drawing. Line can be imbued with an amazing range of qualities, from a soft and gentle touch to a frenetic flailing upon the drawing surface.

In Ingres's drawing, we can detect very faint lines used to create a grid for squaring the drawing for transfer and possible enlargement to another surface. These are lines of demarcation without depth or subject matter. They simply plot the location of forms on the two-dimensional drawing surface. The lines suggesting the figure are also utilitarian in the information they impart: the many details related to the individual characteristics of Ingres's model. We feel as if they are authentic conveyors of truth. Still, Ingres's lines have an aesthetic function, speaking with a particular voice that is a result of both Ingres's choice of medium (graphite pencil) and his light touch. Ingres felt that "one should make all traces of facility vanish."[2] He wanted to convey the presence and demeanor of his model without drawing attention to the line itself.

In contrast to the neoclassical refinement of Ingres's portrait, the drawing (Figure 4.2) by surrealist and expressionist Jean Dubuffet is as much about the media and the artist's unrestrained catharsis of expressive energy as it is about the figure of a woman. As Dubuffet explained, "I believe very much in the value of savagery; I mean: instinct, passion, mood, violence, madness."[3] Dubuffet feels little need or desire to restrict his line and make it conform to the body's actual physical appearance. Where Ingres's graphite

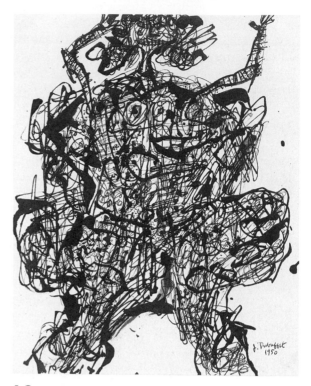

4.2
Jean Dubuffet. *Nude (Novembre) from "Corps de dames" series.* 1950. Pen, reed pen, and ink, $10^5/_8 \times 8^3/_8$". Image © The Museum of Modern Art, New York. The Joan & Lester Avnet Collection. Licensed by SCALA/Art Resource, New York. © 2003 Artists Rights Society (ARS), New York/ADAGP, Paris.

line whispers, Dubuffet's line, created with reed pen and India ink, rants and raves. Both Ingres and Dubuffet modulate line with purpose to meet vastly different needs and express very different aesthetic views.

Rico Lebrun once said, "True lines do not exist in nature. We invent them. They are poetic fiction."[4] Lines are fiction because of the illusion they invoke to pique our imaginations, poetic because of the expressive way they can trigger our emotions and delight our senses. As Leonardo suggested, lines are ideas that allude to nature, intellectually engaging the viewer in the illusion they create.

In *Seated Clown* (Figure 4.3) you can begin to see what he may have meant when describing line as "poetic fiction." Lebrun's lines

are inspired by reality, following the suggestions of edges, folds, and recesses to inform us about the physical presence of the figure. The expressive energy of these lines, however, comes from Lebrun's desire to give his line a poetic quality rather than simply provide only factual information. As he once said, "My aim is a continuous, sustained, uncontrived image, motivated by nothing but passion."[5] Whereas Lebrun's subjects provided the impetus for the drawing, it is Lebrun's impassioned use of line that enlivens his description and takes it beyond what is factual to the realm of the poetic.

In the discussion that follows, we take a balanced approach to line. Our goal is to understand how line is both descriptive and poetic, informative and impassioned. We will look at the often subtle differences in the ways lines are fashioned and how those differences affect both the information conveyed and the aesthetic quality of the drawing as a whole.

The Phrasing of Line

The overall quality of a line is determined by a number of factors. For example, each drawing tool or medium brings to a line its

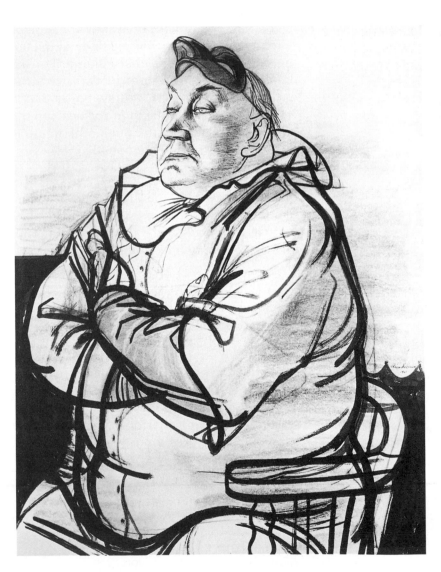

4.3
Rico Lebrun. *Seated Clown.* 1941. Ink and wash, red and black chalk, $39^1/_2 \times 29"$. Santa Barbara Museum of Art. Gift of Mr. and Mrs. Arthur B. Sachs. 1942.1.2. Courtesy of Koplin Del Rio Gallery, West Hollywood, California.

own distinctive features. Perhaps the most significant factors determining the character of line, however, are the artist's intent and how the artist conceptualizes the subject. In short, the information being conveyed through the notations of line will determine how the artist *phrases* the line.

According to the English art scholar Philip Rawson, a *line phrase* is a single line's uninterrupted movement from beginning to end.[6] Each phrase is a separate impulse, and the progression of such impulses eventually determines the character of the finished drawing.

Although the following classifications are broad, and individual drawings rarely represent pure examples of a single technique, we believe they serve to differentiate some of the basic ways line is phrased and will assist us in exploring the visual dynamics of line when drawing from life.

Outline

Outlining is the simplest way in which to circumscribe and symbolize an object. *Outline* is primarily a tool for demarcation, enclosing a shape by defining its boundary and thus separating it from its background. The line is usually consistent and continuous in its weight and application, giving the impression that it was made in one long, uninterrupted tracing—one unbroken line phrase. Of all the types of line used to describe the figure, outline is the most generic. When outlining, the artist focuses on the edge of the figure, and the reality of the flat, two-dimensional drawing surface dominates over the physical reality of the figure as a three-dimensional volume. For example, the human figure appears as a flat enclosure in Figure 4.4, a drawing by Benny Andrews. Except for the interior lines and the hint of perspective in the guitar, the figure is defined primarily as a silhouette.

Broken Outline

Matisse appreciated the transcendental effect of pure line. He spoke of learning to discipline the use of line. "What I dream of is an airy balance, of purity and serenity. . . . One must always search for the desire of the line, where it wishes to enter or where to die away."[7] In Figure 4.5, Matisse incorporates a *broken outline*, which portrays his refined phrasing of line. For Matisse, the primary reality of a drawing remains two-dimensional, his figures conceptual rather than tangible. Matisse regarded his ink line drawings as his purest translation of form. For Matisse, these thin, almost nonexistent lines were the most ephemeral and spiritual. His figures were meant to be held

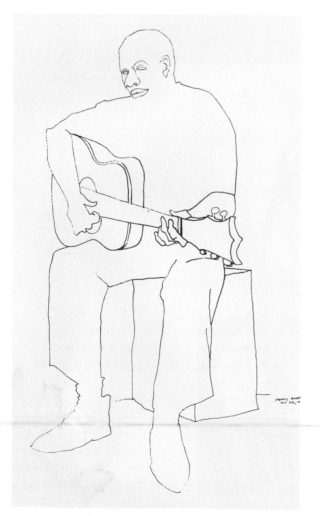

4.4
Benny Andrews. *Yeah, Yeah.* 1970. Ink on paper, 17³/₈ × 11¹/₂". Arkansas Arts Center Foundation Collection: The Museum Purchase Plan of the NEA and THE Barrett Hamilton.

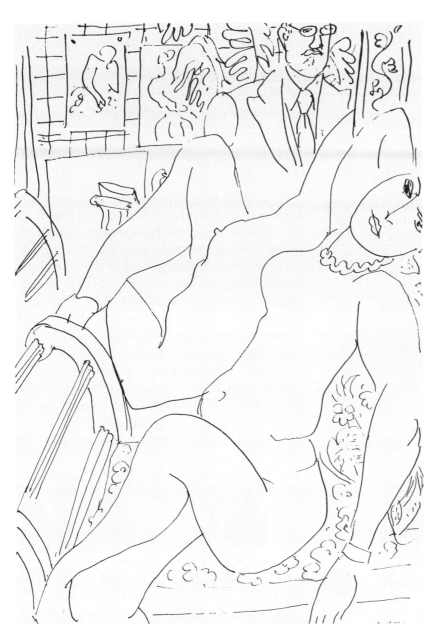

4.5
Henri Matisse. *Artist and Model Reflected in a Mirror.* 1937. Pen and ink on paper, 24^{13}/$_{16}$ × 16^{1}/$_{16}$". The Baltimore Museum of Art: The Cone Collection, formed by Dr. Claribel Cone and Miss Etta Cone of Baltimore, Maryland. BMA 1950.12.51. © 2003 Succession H. Matisse, Paris/Artists Rights Society (ARS), New York.

mentally, not physically. But these ink drawings, he pointed out, "are always preceded by studies made in a less rigorous medium than pure line, such as charcoal or stump drawings."[8] Knowing this helps us better understand how Matisse was able to give his ink lines this degree of economy in their distillation of form. Matisse's figures are flattened, seen in terms of their two-dimensional shape but not tightly enclosed. Space and volume have been compressed, yet Matisse's use of

open, loosely connecting lines gives his drawing the light, airy quality he sought.

The occasional line breaks allow the viewer to move freely from one part to another, carrying the line's momentum across open intervals. This connecting gap, the space between lines that the viewer links visually, permits the artist to express the body's gesture and form economically without completely enclosing shapes, therefore permitting greater movement between them. Implied line, the most

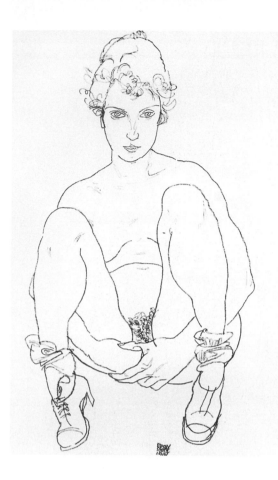

4.6
Egon Schiele. *Crouching Nude—Front View.*
1918. Black chalk, $18^3/_4 \times 12^1/_2$". Marlborough
Fine Art, London, England. Private collection.

illusory graphic presentation possible, is sensed rather than seen. The viewer is a willing participant who makes the connections from one line to the next.

Overlapping Line

Overlapping is a way of phrasing line that adds the illusion of depth. Whenever a line terminates at an intersection with another line, its momentum may continue, but the fact that it is no longer visible suggests that it is submerged. Dominant, uninterrupted lines suggest forms close to the viewer; subordinate lines that submerge or disappear behind others indicate recessive forms.

In Egon Schiele's drawing (Figure 4.6), such **overlapping lines** suggest overlapping body parts. The unbroken lines of the legs overlap those of the arms, clarifying their relative spatial positions. The thighs cover the lines of the

4.7
Katsushika Hokusai.
Wrestlers. Black ink
over red, $12^1/_2 \times$
$16^3/_8$". © Copyright
The British Museum.

breasts and abdomen, and the lines of the lower legs establish their position as farthest forward. Each overlapping line represents a different position in space and thus helps to suggest the body's three-dimensionality.

The Japanese master Katsushika Hokusai also uses overlapping along with a brisk, chisel-like line to present the tension and action of a wrestling match (Figure 4.7). Although these lines are phrased in short, abbreviated strokes (due in part to the limited ink-holding capacity of his brush), Hokusai takes full advantage of the suggestive power of overlapping lines, which cue us to the spatial position of the three figures and also the overlapping folds of fabric and muscles.

Modulated Line

Hokusai's *Wrestlers* also demonstrates the calligraphic effect of **modulated line,** or varying line weight, which is both functional and aesthetically pleasing. The word *calligraphy* is derived from the Greek *kalligraphia*, which means "beautiful writing." However, it was Asian artists who really understood its meaning and were most practiced in manipulating line through disciplined gestural movements of hand and sumi brush. Hokusai's lines lead our eyes through the two-dimensional arrangement that balances the thrust of the two wrestlers with the counter movement of the referee. Another element that contributes to the rhythm of this drawing is that the bold, black lines were preceded, as was customary, by an underdrawing in a diluted pale red ink. What was originally the prelude to this drawing now functions as a secondary refrain or faint echo to the lines in black.

Lines drawn without variation or overlapping tend to appear the same distance from the viewer. They also give everything the same degree of emphasis. By varying line weight, the artist can be both more descriptive and more expressive. Varying line is analogous to modulating one's voice. In addition to giving the line diversity and interest, the visual effect is to make forms fluctuate back and forth in space.

4.8
Rembrandt van Rijn. *Old Man Leaning on a Stick*. c. 1635. Pen and brown ink, $31^1/_2 \times 5^5/_{16}$" (13.4 × 8 cm). The Metropolitan Museum of Art, New York. Robert Lehman Collection (1975.1.796).

Rembrandt's pen-and-ink drawing *Old Man Leaning on a Stick* (Figure 4.8) provides another wonderful example of line modulation. Here, the rhythmic variation of line gives a vitality to Rembrandt's frail model even in his resting stance. Using a quill pen with a chisel tip, which can produce thick or thin lines depending on how it is held, Rembrandt begins with a fine point, then during the course of the drawing his strokes become bolder. He flattens or broadens his pen point, applies increased

pressure, and adds forceful lines for accent. By varying the thickness of his line, Rembrandt also varies the speed of our eye movement, which has a tendency to move quickly over thin lines and linger with the dark accents. As the hand phrases the line, it also directs the eye.

Multiple-Phrase Line

As with modulation, *multiple-phrase line* gains strength and life through repetition and rephrasing. In Figures 4.7 and 4.8, both Hokusai and Rembrandt restate some of their lines, Hokusai by changing from red to black and Rembrandt by rephrasing or overlapping his lines with another stroke of his pen.

Notice how Gustav Klimt has added strength and a sense of movement to his pencil drawing through the repetition of line in Figure 4.9. Repeating and restating the outer edge of the body allow the figure to expand and contract slightly, as in the stretching motion of the abdomen. Klimt's contour lines are more tactile than mere outline in that they seem to provide an extension of touch, charged with anxious energy. His multiple lines never really confirm the exact perimeters of the figure, causing the various edges to vacillate slightly around the edge of the form, implying movement. As Klimt phrases his line, his hand moves forward along the contour, then often retreats on itself before moving forward again. In this way, he also regulates the pace with which the viewer's eye encompasses his figures, at times fleeting quickly along the contour, at other times lingering or retracing.

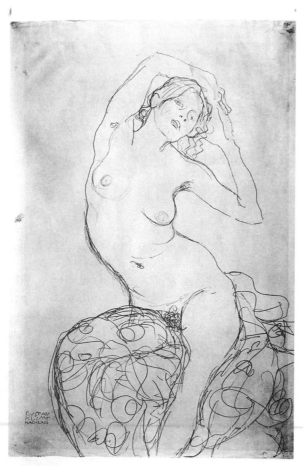

4.9
Gustav Klimt. *Seated Nude.* 1915. 56.9 × 37.3 cm. Graphische Sammlung der ETH, Zürich.

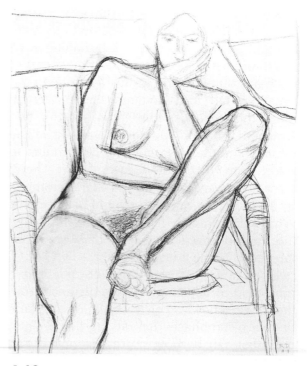

4.10
Richard Diebenkorn. *Seated Nude, Leg Raised.* Metropolitan Museum of Art, New York. Reproduced by permission of Mrs. Diebenkorn. Photograph by Douglas M. Parker Studio.

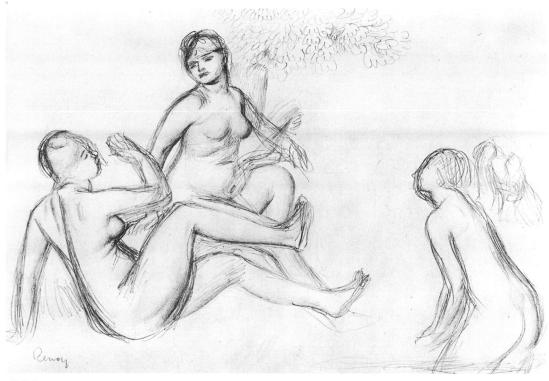

4.11
Auguste Renoir. *The Bathers.* Pencil, 9³/₈ × 13⁷/₈". Wadsworth Atheneum, Hartford. Purchased through the gift of James Junius Goodwin. 1937.213. © 2003 Artists Rights Society (ARS), New York/ADAGP, Paris.

Rephrasing a line is often a corrective maneuver, a way to change position and adjust proportions. Richard Diebenkorn has rephrased many of the lines in his drawing *Seated Nude, Leg Raised* (Figure 4.10). Some of these lines were redrawn to make proportional adjustments, as can be seen at the raised knee or right arm. Other lines have been added to reinforce and reaffirm. In the end, some of the lines remain light, made with a single line phrase. Others are woven from many strands like a strong rope or cable. Most of Diebenkorn's lines take their cues from the outer edge of the figure. These lines cross the picture plane, breaking up the surface area into smaller shapes. In this respect, Diebenkorn's phrasing of line is pictorial rather than sculptural, creating shapes that break up the surface and define the two-dimensional composition. The model and chair are compressed and flattened. The draw-

ing is conceived to emphasize the compositional elements of the pose in reference to the picture frame.

In *The Bathers* (Figure 4.11), Renoir expands the line into multiple repetitions. Notice how he reworks the lines that follow the outer edge of the bathers, increasing the width and spreading his line away from the edge by building repetitive strokes. This is a kind of *modeling,* whereby lines are repeated as parallel reverberations, beginning to traverse up and over the interior of the form. This seemingly insignificant extension of his line enables Renoir to suggest a fuller, more three-dimensional volume of the body. In this drawing, we see the close relationship between line and value. These visual elements are never presented in total isolation; they are separable only on a theoretical level. Line is distinguishable only because of the value contrast between it and the surface on which it is inscribed.

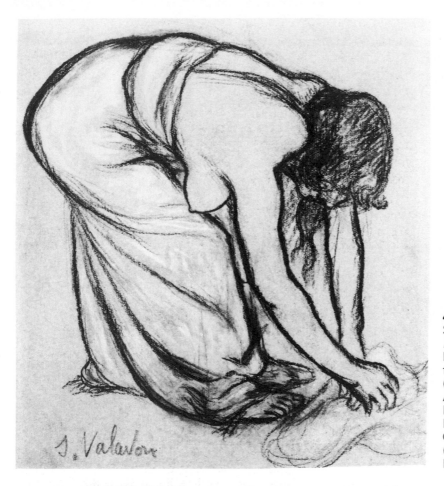

4.12
Suzanne Valadon. *Woman Bending Forward.* c. 1920. Black and colored chalk on tracing paper, 6³/₈ × 5⁵/₈" (16.3 × 14.3 cm). Cincinnati Art Museum. Gift of Dr. and Mrs. J. Louis Ransohoff. Photo © CAM, Forth. 1950.81. © 2003 Artists Rights Society (ARS), New York/ADAGP, Paris.

Conceptually, line often is an abbreviated representation of shadow at the edge of a form or in a recessed fold.

For example, in Suzanne Valadon's drawing *Woman Bending Forward* (Figure 4.12), we can see how her lines were reworked as if her chalk were a chisel point, visually cutting into the drawing surface. They begin to be expressive of the body's volume and mass by letting the elliptical curvature of the lines of fabric at the figure's waist cue us to the body's cylindrical volume. With a heavy hand, Valadon also amplifies her lines to function not only as an abbreviation of shadows but also as receding forms. Her lines are not intended to mark the outer edge of flat shapes but rather to suggest the turning back in space of the body's cylindrical form. The thick, dark lines conceptually begin to roll the edges away from the viewer and in turn suggest that the lighter areas are raised or closer.

Contour Lines

Although the surface on which we draw is indeed flat, the human body is not, and for many artists the challenge is to make line suggest the third dimension, to create a convincing illusion of volume and space. An artist can use line in a number of ways to suggest the physical vitality and dimensionality of the human figure. Collectively, these are referred to as *contour lines*.

For the nonartist, the word *contour* would be synonymous with *outline*; however, for most artists and artist-teachers, *contour* implies much more. The etymology of the word suggests the added dimension: originating from the Latin *contormare*, "to turn," and the Italian *contorno*, "to go around," the contour line directs the eye around the form. Outline, even when broken, repeated, or overlapping, for the most part notes the **configuration** of the body—its shape or position—without sculpt-

ing it in three dimensions. Such lines make little attempt to describe the internal terrain of the body's surface between the clearly established edges. Contour lines, in contrast, emphasize the body's three-dimensional volume, conceptually transcending the flat surface of the paper.

Alberto Giacometti uses free-flowing ***gestural contour line*** (Figure 4.13) as if it were wrapping around the head of his subject, in the artist's desire to capture "the life that is housed in the skull."[9] His line envelops the head as he draws front and back, simultaneously building its mass and the intensity of the image.

The phrasing of contour lines is essentially an effort to express the body's volume and mass rather than its edges and two-dimensional configuration. Pavel Tchelitchew's

Head VI (Figure 4.14) shows how ***schematic contour line*** can be regimented to circumscribe a volume. "I have the feeling that the whole visible world can be reduced to mathematical formulae or geometrical figures," Tchelitchew said. "In thus reducing the world of appearances to its basic numbers or geometrical forms we probe the very mysteries of Creation."[9] Notice how his elliptical lines cross over the contour of the head, like lines of longitude and latitude on a globe. They ride over facial features much as lines on a topographical map express elevations of the land.

In most drawings, the use of ***cross-contour line*** is abbreviated or fragmented in its suggestion of volume, rather than tracing it as completely as in Tchelitchew's study. In Fig-

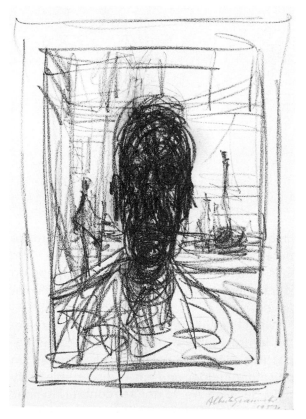

4.13
Alberto Giacometti. *Portrait of an Interior*. 1951. Litho crayon and pencil, 15³/₈ × 10⁷/₈". Gift of Mr. and Mrs. Eugene Victor Thaw (00680.65). © The Museum of Modern Art, New York/Licensed by SCALA/Art Resource, New York. © 2003 Artists Rights Society (ARS), New York/ADAGP, Paris.

4.14
Pavel Tchelitchew. *Head VI*. 1950. Colored pencil on black paper, 19⁷/₈ × 13³/₄". Image © The Museum of Modern Art, New York. Gift of Edgar Kaufmann Jr. Licensed by SCALA/Art Resource, New York.

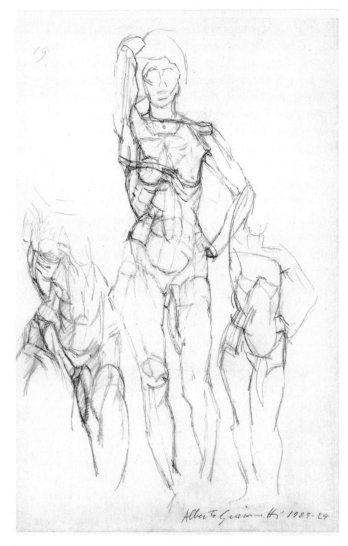

4.15
Alberto Giacometti. *Trois Femmes Nues.* 1923–1924. 44.5 × 28 cm. Alberto Giacometti Foundation, Kunsthaus Zürich. © 2003 Artists Rights Society (ARS), New York/ ADAGP, Paris. Photograph by Walter Dräyer.

ure 4.15, Alberto Giacometti describes the volumetric quality of the figure through planar analysis. Giacometti phrases his schematic contour lines as interconnecting straight lines that break the body into its underlying geometric structure, composed of multifaceted planes. The lines indicate where the surface planes turn, fold, and bend. As a result, even lines at the edge serve as abstract indications of where forms turn to angle back in space rather than as markers of where the edges of the form terminate.

Contour lines often function to convey information about the body's structure or surface terrain that is not immediately visible as line on the body. The artist uses line to de-scribe the body in schematic terms that relate more directly to our tactile awareness. The lines function more as a construct or mapping of the physical form than as a copy of what one sees.

When learning to draw, we are often reluctant to draw lines over the interior of the figure. For the most part, we use line as an indicator of edges and easily discernible body folds. Because we do not *see* contouring lines on the model, we're reluctant to draw them. But then, neither do we see black lines outlining the model's body—even though we frequently use such lines to define forms. Remember, a line is an "imaginary idea" or a "poetic fiction." Do not limit yourself by limit-

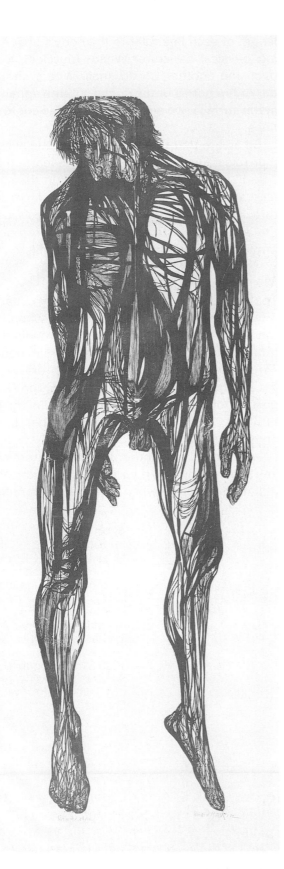

ing the use of line. Give yourself the freedom to use lines to express information about the interior of the form as well as its outer limits.

The cross-contouring lines exhibited in Leonard Baskin's life-size image, *Hanged Man* (Figure 4.16), express a very different sensibility from the precision of Tchelitchew (Figure 4.14) or the angularity of Giacometti (Figure 4.15). These are bold, crisp lines that cross over the body in varying thickness, filling it in and also filling it out dimensionally. The free-flowing nature of Baskin's line relates to gesture or action sketches, discussed in Chapter Two, except that these lines are no longer tentative. Despite a seeming randomness, there exist in this drawing anatomical references, suggesting arteries, veins, and muscles. But the main function of Baskin's lines is aesthetic, their "poetic fiction" promoting a sympathetic response to a gruesome subject. Although *Hanged Man* probably originated with a sketch, Baskin's line quality has become considerably altered by the carving action required to produce this large-format woodcut print. The subtractive gouging action of chisel strokes brings an abrupt hard edge to the otherwise flowing pattern of the line.

Anatomical Contour Lines

Many artists would argue that the body's anatomy is what determines its structure. For them, line should take its cue from the musculature beneath the skin, which in turn determines the surface topography. The anatomical approach to contour drawing often expresses the artist's knowledge of anatomy as well as a thorough observation of the body's surface modulation. Muscles interlock, overlap, and wrap around the trunk and limbs. The play of light and shadows provides hints of the presence of the body's underlying anatomical structure. *Anatomical contour line* phrasing

4.16
Leonard Baskin. *Hanged Man.* 1955. Woodcut, $67\frac{1}{2} \times 20$". Sheldon Memorial Art Gallery University of Nebraska-Lincoln. F. M. Hall Collection.

follows these cues to express these anatomical relationships.

Like cross-contouring, anatomical contour creates the illusion of three-dimensionality by allowing lines to move from the edge into the interior to suggest a spatial progression of anatomical forms, such as a muscle's crossing over another or turning inward to its point of attachment on the skeletal armature. For a closer study of how anatomical contour line might be used, consider Hyman Bloom's drawing of wrestlers (Figure 4.17). Bloom responds to the structural character of overlapping muscular forms to give his figures solidity. Notice how lines defining the outer edge of the body often turn inward, rolling with the cylindrical forms and evolving into a whole network of lightly drawn topographical contour lines, which define the bulging relief of flexed muscles. Bloom combines multiple phrasing to emphasize and modulate his line, which directs us forcefully through the entanglement of the wrestlers, engaging us as spectators in their conflict.

Raphael's study (Figure 4.18) further demonstrates how the body's anatomy can direct the artist's phrasing of line. The placement and length of each line refer to the body's underlying physical structure: Where muscles cross over one another, so do lines. Where shoulder or hip bones or the spinal column appears at the surface, we see its proximity as contour lines.

Be aware that Raphael did not actually see a physical line on the body, but he learned to "read" the slight rises or declines in the surface as clues to the anatomical understructure. Through these lines, Raphael describes the anatomical structure of his figures and implies the variations in surface relief.

Modeling Contour with Hatch Lines

The concept of modeling the figure usually refers to the tactile art of sculpture, whereby the artist shapes from clay or other media the three-dimensional volume of the human body. To model in two dimensions, when drawing, the artist creates the illusion of form, the suggestion of the third dimension. Drawing in this way is conceptually tactile rather than physically so.

In addition to contouring and anatomical line drawing, line can be an effective conceptual modeling tool when arranged in parallel,

4.17
Hyman Bloom. *Wrestlers.* 1930. Black crayon over graphite on darkened off-white wove paper, 32 × 48.3 cm. Courtesy of the Fogg Art Museum, Harvard University Art Museums, Louise E. Bettens Fund. 1933.39. Photographic Services © President and Fellows of Harvard College.

sequential strokes, referred to as *hatching*. Each stroke is a distinct linear phrase, crossing the body's interior. It is the accumulation of these traversing lines that enables the artist to define broad areas and thus differentiate planes from edges.

Raphael's drawing (Figure 4.18) uses hatching lines in addition to the longer, more fluid, and generally darker anatomical contour lines that denote the muscular rhythms of the body. Notice that these groupings of shorter lines ap-

pear to ride over the body's surface, suggesting planes or convex and concave undulation.

This way of phrasing line begins to blur the distinctions between line and value because when the individual hatch marks lose their individuality, they cease to be line in any conceptual sense. Hatching, like its counterpart *cross-hatching*, serves the primary purpose of creating broad value areas with a pointed drawing tool. Both techniques will be covered extensively in the following chapter.

4.18
Raphael. *Five Nude Men.*
Pen and ink, 10⁵/₈ × 7³/₄".
© Copyright The British Museum.

IN THE STUDIO

These exercises give you an opportunity to practice the art of making lines and a chance to focus your attention on the many ways line functions to communicate both factual and expressive information. With time and practice, you will develop your own signature line quality, but for now be open and experiment with a wide range of possibilities.

Outlining More Than the Outside Edge

Pose – 15 minutes
Media – dark pencil or ink on drawing paper

Many students of life drawing share a natural predilection for using line primarily as outline, as a device for indicating the outer edges or borders of the body only. The goal of this exercise is to encourage a more descriptive and informative use of line. Begin by drawing the general configurations of the body, then find smaller shapes within the larger ones by tracing shadows or indicating definite shifts in value where you can see ridges or furrows representing anatomical structure. Let the weight or thickness of the line suggest what you feel is the form's significance by making the more important lines darker.

Multiple-Phrase or Repeating Lines

Pose – 15 minutes
Media – soft charcoal or conté on drawing paper

The purpose of this exercise is to discover how repeating, or redrawing, the contour of the figure with several lines can accentuate that contour and give more force to your drawing. Begin with a light sketch of the model's gesture, capturing the configuration of the pose. Then, let the drawing evolve through a continuous process of rephrasing your line, adding to existing lines or using a new line adjacent to the previous one to suggest another interpretation of the contour. Do not erase your earlier lines, but allow them to remain and be followed by more emphatic statements of line along the same contour. See Figure 4.19 for an example.

Schematic Contour Lines

Pose – 30 minutes
Media – graphite or charcoal on drawing paper

In this exercise, the goal is to fully exploit the schematic and diagrammatic potential of line. The approach to the figure is essentially one of distilling it to its underlying geometric structure, using line to reconstruct a graphic diagram of the body's configuration that focuses on volumes and multifaceted surface planes. An analogy would be that you are to construct a scaffolding of lines that define the figure's mass, much the way the steel framework of a skyscraper defines the shape of the building before the exterior walls are hung over it. Another variation would be to interpret the body as consisting of cylindrical forms expressed with curvilinear cross-contour lines to suggest volume in a manner similar to the lines of latitude and longitude on a globe.

Anatomical Contour Lines

Pose – 30 minutes
Media – graphite or charcoal on drawing paper

The objective of this exercise is to make line as descriptive and informative of the body's volume as

4.19
Sandra Butler. Student drawing.
Multiple-phrase line.

4.20
Diagram of anatomical contour line.

possible through a description of its surface anatomy. Begin by lightly plotting the gesture and proportions of the body. As your drawing progresses, try to visualize the body's roundness, its fullness and curvature. As you observe and draw the outer edge of the body, find as many places as possible where the line of an anatomical form turns into the interior. Some of the most obvious lines will be folds or wrinkles where the limbs and torso bend. Try to discover the more subtle suggestions of overlapping forms that may only be implied by a slight furrow or ridge in the surface. Use line to suggest the overlapping of muscular forms.

Figure 4.20 illustrates typical features of contour lines that are phrased in accordance with the body's anatomical structure. One of the first things you will notice is how much depth and volume appear in the two outside drawings. The two outside drawings phrase the line as a sequential progression of overlapping lines. Essentially, the lines that express the edge turn in and begin crossing over the contour of the interior space of the limbs. In effect, every time the line begins to cross the contour, it contributes a bit of information about the body's anatomical structure. All three drawings have the same silhouette, but notice how the two outside drawings change our viewpoint and, therefore, the direction in which the legs appear to recede in space. This is determined by reversing the sequence of overlapping lines. In essence, it is a matter of expressing the nearer contours with lines that overlap those of farther contours.

Independent Study

1 Take a drawing done in class that may appear lifeless or underdeveloped. See if you can improve it by reworking the lines, creating greater line variations, making some darker and stronger, or using an eraser to break up or lighten others. Also, think about restating and using multiple-phrase line to express some contours. Don't be afraid to draw over the body's interior. Making these changes will teach you a great deal about how to vary line and, in the process, perhaps make that lifeless drawing come alive. **2** With a drawing you began in class as a quick sketch or simple line drawing, visualize the full volume of the body, then describe its shape with lines of longitude and latitude that would encompass the contours of the form as if on a globe. **3** Position yourself in front of a large mirror, stretching your arm or legs toward your mirror image. Using only sequential contour lines, draw yourself, starting with the tip of your pointed finger or toes and slowly working your way back. Observe how lines that suggest the outer edge frequently turn into the interior, crossing over forms that appear to emerge from behind preceding ones. Draw these cross-contouring lines as a suggestion of volume and depth.

Chapter Five

Value as Light and Form

The first goal of a painter [drawer] is to be able to make a simple flat surface appear like a relief... this is done by the correct use of light and shade. The one who can do this deserves the most praise.

— *Leonardo da Vinci*

Value refers to the tonal range of light and dark, from brightest white to darkest black—and all shades of gray in between. Some artists would argue that value is more truthful than line because it more closely depicts what the eye actually sees. Whereas line runs to circumscribe and contain forms, value lingers to fill and define them. Line is abstract and abbreviated; value is more comprehensive and complete. Value is more painterly, dealing with area rather than edges.

Although value can be descriptive and factual, like line it serves an aesthetic function as well as a utilitarian one. In his drawing *Man Waiting* (Figure 5.1), Sidney Goodman uses value not only as a tool to suggest the form of the figure but also as an expressive device to create a dramatic mood. Even though few details are revealed—his identity and reason for waiting remain ambiguous—with the body shrouded in shadow, this figure has a powerful, intriguing presence. Value implies the figure, sets the stage, and triggers the imagination.

Value can also be used to create a variety of richly decorated surfaces, to suggest texture, and to break up the surface of the drawing into clearly defined areas. In her large self-portrait, *Reclining with Pigs* (Figure 5.2), Selina Trieff uses value as much for its decorative quality as for its descriptive ability. Her body, the pigs, and the surrounding environment are flattened. Each value area becomes part of a larger composition where design and pattern are more important than light or volume. Her charcoal is orchestrated to give each area within the drawing a tonal quality and the aesthetic equivalent to what one would expect from color.

As demonstrated by both Goodman and Trieff, an artist's use of value can be dramatically expressive and visually opulent. But it is value's descriptive capacity that endows it with the power to create visual illusions. The way value simulates light and describes form will be the primary focus of our discussion in this chapter.

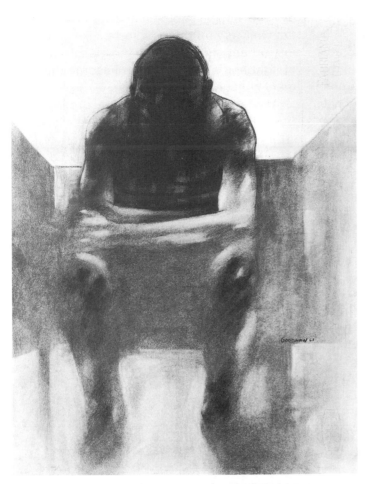

5.1
Sidney Goodman. *Man Waiting*.
1961. Charcoal, 25³/₄ × 19¹/₈". The
Museum of Modern Art, New York.
(143.1962) Gift of Mr. and Mrs.
Walter Bareiss. Image © The
Museum of Modern Art/Licensed
by SCALA/Art Resource, New York.

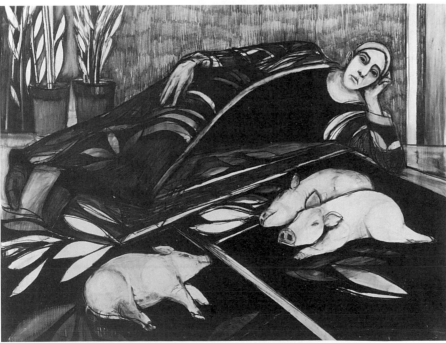

5.2
Selina Trieff. *Reclining
with Pigs*. 1984.
Charcoal on Arches
paper, 60 × 72". Private
collection. Photograph
courtesy of Graham
Modern, New York.
Reproduced by
permission of the artist.

Rendering Light and Modeling Form

Artists commonly refer to using value in drawing as a process of *rendering* or *modeling*. In the minds of many, these terms are synonymous. But there is a substantive distinction, and it is important to understand that rendering and modeling each represent a different way of conceptualizing and, thereby, manipulating value.

Rendering refers to the process of graphically depicting light. It is a process of recording, with value, the pattern of light and shadows as they fall across the subject. The artist who uses value to depict light functions like a camera, sensing and recording the presence or absence of reflected light. A camera has no awareness of form. It is sensitive only to light and is designed to record light's reflection from surfaces. The human eye is more sensitive, although not often as objective. Some artists strive for that level of objectivity as a practiced discipline. They maintain a physical

as well as psychological distance between themselves and their subjects. Like an optical instrument, they focus on the mosaic patterns of light and shadow, which become their primary concern when drawing.

At the time Georges Seurat drew *Seated Boy with Straw Hat* (Figure 5.3), he was being strongly influenced by the invention of photography and scientific theories related to the nature of light. In this drawing, Seurat renders light by applying varying gradations of value to show the degree to which light is reflected from the surface of the subject, leaving the white of the paper to show through and represent the most illuminated areas. Seurat is not concerned that much of his subject remains unknown; the facial features of the head and the anatomy of the body are obscured by his use of value as shadow. His drawing takes us only as far as the light takes the artist's vision.

In contrast, modeling is more tactile than visual. It conceptually shapes the form in three

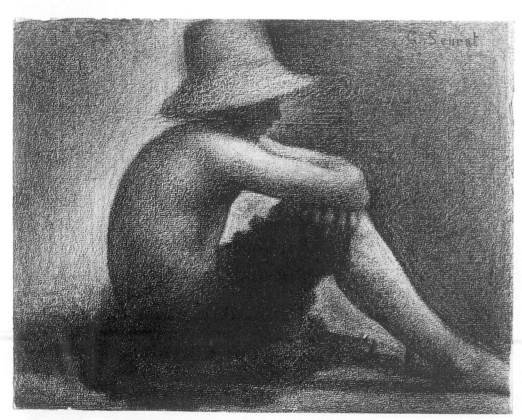

5.3
Georges Seurat. *Seated Boy with Straw Hat, Study for Bathers at Asnieres*. Black conté crayon, 9¹/₂ × 12¹/₂". Yale University Art Gallery. Everett W. Meeks, B.A. 1901, Fund.

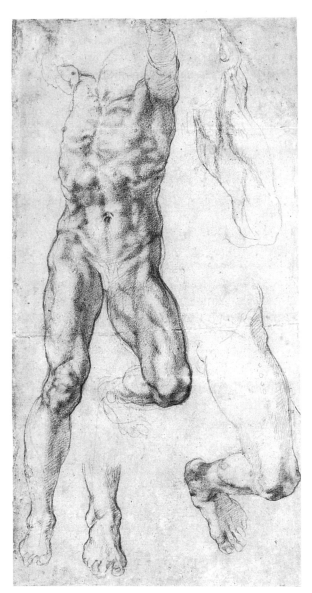

5.4
Michelangelo. *Crucifixion of Haman*. Black chalk,
15.9 × 8.1 cm. © Copyright The British Museum.

part, from the fact that most artists combine the two techniques in their drawings. Another reason for the ambiguity is that we assume value in a drawing exclusively represents a differentiation in the amount of light and shadow on the body. Unlike a photograph, which depends on a chemical process induced by reflected light, a drawing depends only on the artist's discretion to determine the degree of value. The presentation of value by some artists is essentially indifferent to the effects of light and instead is expressive of volume, implying tangible changes in the body's form and surface independent of what is revealed by a light source.

When modeling, we are directed by what we know on the basis of tactile experience. In the process of modeling, value substitutes for the tools a sculptor would use to physically mold the figure. Value is used to push a form back or to round out a volume in space or to define undulating surfaces. In contrast to Seurat, Michelangelo uses value to express his knowledge of the body's physical structure and anatomy rather than to describe the effects of light (Figure 5.4). His application of value is not directed by or dependent on a consistent source of light. Michelangelo sculpts and shapes the three-dimensional form of the body with his application of value. Value is a powerful shaping tool suggesting mass, not simply shadow or the absence of light. It is applied as a physical force that pushes form back in space and turns surfaces under. A skilled artist can use value to suggest mass as well as light. Optically we experience the modeling of the body's form as if it could be touched. Dark and light patterns over the body represent advancing and receding surfaces rather than light and shadows. Changes in value signify physical changes in the surface terrain and equate to tactile experience rather than to the illuminating quality of light.

Our knowledge of the body is derived from both tactile and visual sensations, interwoven and interrelated. Light reveals the form of the body, and the body's form modulates the light

dimensions, as if it were being sculpted. A common misconception is that depicting light and shadow is automatically and simultaneously modeling the form. As we see in Seurat's drawing, the absence of light—the rendering of shadow—can obscure form rather than model or shape it. The ambiguity between these two distinct conceptual tasks stems, in

patterns that fall on its surface. Granted, the artist who seeks to render the play of light on the form will unavoidably suggest the form itself, and the artist who models form with value creates a suggestion of the play of light. However, to fully understand and master the use of value, the artist must recognize that these are two very different approaches to drawing the figure. One focuses on light and the other on form or physical matter. Whereas Seurat allows the light to control the rendering of his subject, Michelangelo's drawing demonstrates that an artist can willfully manipulate tone to make value descriptive of what is known about the body's form and surface topography or to shape it according to his desire.

When drawing, the artist creates value areas in one of two basic ways: with *continuous tone* or with *hatching* and *cross-hatching*. The method depends on the artist's intent and the tools and media being used. Both methods are frequently blended in a single drawing.

Continuous Tone

The primary characteristic of continuous tone is the gradual transition in tonal gradation. The physical application of the drawing media is not obvious because the strokes are either so broad or so even that the directional force or vector of individual marks is nullified for the sake of achieving homogeneous value areas. Both wet and dry media can effectively create subtle value, usually with broad drawing tools such as a charcoal or conté laid on its side or a paintbrush or airbrush for applying watercolor wash or ink. However, areas of continuous tone can also be built up more slowly with a pencil point. In this case, the individual strokes are laid closely together or blended with a *stump* or finger to conceal the action or direction of the mark making.

Rendering Light with Continuous Tone

Continuous tone is particularly adept at mimicking the play of light and shadow because the artist can use it to create subtle and continuous gradations of tone as an optical response to the transmission of light. In his later career, Degas became interested in the transitory and atmospheric effect of light. He argued that "the tantalizing thing is not always to show the source of light, but the effects of light."[1]

Dancer Adjusting Her Dress (Figure 5.5) is an example of how Degas uses value to create the impression that the dancer stands between us and a bright source of light. The distribution of dark pigment on the paper suggests shadow and, therefore, implies light in areas without pigment. At the same time, it suggests that the body is an object of substance, standing out as a dense, physical mass through which the light does not pass, except near the outer edge of the gauzy skirt material and where the light spills over the body's contour. Degas applies value as continuous tone to imply the presence of light by drawing its opposite: shadow.

Continuous tone is also an effective technique for conveying the transmutability of light and thus integrating the figure into its environment. Unlike form, light has no physical boundary; it is dispassionate, illuminating the body and the background with the same silent indifference. Light has no shape. It is energy: elusive, ephemeral. It illuminates but cannot be touched or held. Form is matter: tangible, solid. We can wrap our arms around form and sense its mass and volume.

The way an artist applies value depends on whether the primary goal of the drawing is to render the visible effects of light or to model the form as if it could be touched. Degas focused on the effects of light, and although he gives us the impression of a figure in this drawing of the young dancer, he does not use value to model a concrete, physical form. We are left with an optical sensation, a visual impression. Degas did numerous studies of ballerinas, but he revealed his true interest when he said, "The dancer is only a pretext for drawing."[2]

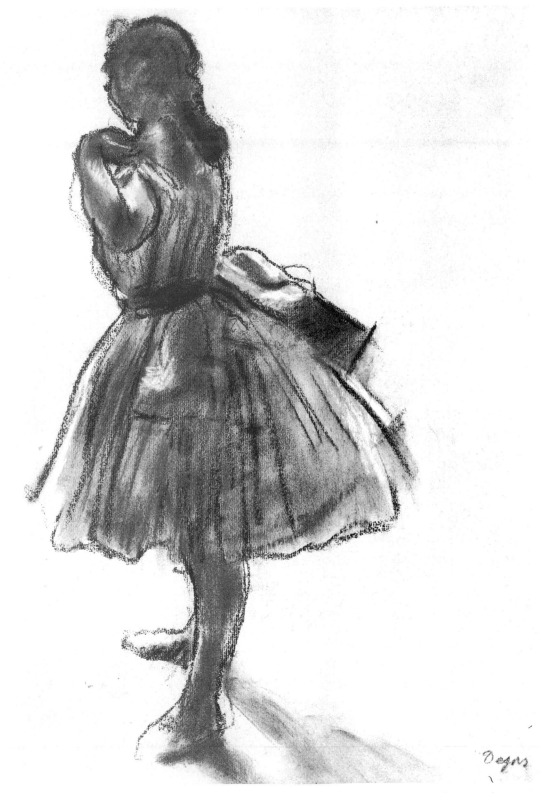

5.5
Edgar Degas. *Dancer Adjusting Her Dress*. Pastel on paper, 23$\frac{3}{8}$ × 12". Bequest of Winslow B. Ayer. Portland Art Museum, Portland, Oregon (35.42).

5.6
Norman Lundin. *Model Standing Before a Blackboard.* 1974. Charcoal, 24 × 36". Collection of Charles Judy, Seattle, Washington. Courtesy of the artist.

In Norman Lundin's *Model Standing Before a Blackboard* (Figure 5.6), light itself becomes the central structural element. As the light coming from an unseen window streams diagonally across the picture plane, it rakes across the wall and the figure's torso, revealing both the flat plane of the blackboard and the round contours of the body. By carefully recording the gradations in value, Lundin composes a convincing illusion of reality. The gestural lines on the blackboard are a foil to the stillness of the figure and the depiction of light and shadows. Part of the magic of this composition lies in the way it convinces us that it was created by the light rather than by Lundin's application of value. By applying value as continuous tone without a traceable record of the artist's drawing action, except for the marks on the

chalkboard, Lundin maintains a sense of stillness and quiet.

Chiaroscuro

The Italians combined two words—*chiaro*, for light, and *oscuro*, for dark—to create the term **chiaroscuro**, which is generally expressed in drawing as a blending of lights and darks. Chiaroscuro is a rendering technique that contrasts areas of bright illumination with those of deep shadow. Like its French equivalent, *clair-obscur*, it also means clear and obscured. As light reveals and clarifies objects, shadow masks and obscures them. Leonardo and Caravaggio were among the first to pioneer the study of light and give the rendering of light precedence over form, even if doing so meant losing the clarity of form in shadow.

5.7
Georges Seurat. *Standing Female Nude*. c. 1881–82. Black crayon, 63.2 × 48.2 cm. Witt Library, Courtauld Institute of Art, London.

Chiaroscuro refined the concept of ***sfumato,*** which means "like smoke" and refers to the gradual, almost imperceptible transformation of tones from light to dark. Leonardo advised other artists that light and shade should blend "without lines or borders, in the manner of smoke."[3] Both chiaroscuro and sfumato are attempts to eliminate the unnatural use of outlines as borders to enclose forms. Neither treats the body as a self-contained sculptural form. Instead, the body is integrated into a pictorial format where light and shadow move across figure and background alike.

Chiaroscuro often uses strongly contrasting areas of light and dark to produce highly dramatic effects. The figure often appears to emerge out of a deep, shadowy background into the light.

Georges Seurat created some of the most sophisticated studies of light that combine the atmospheric effects of chiaroscuro and sfumato, as seen in Figure 5.7. We sense that Seurat is as concerned with the environment surrounding the figure as with the figure itself. He generates the optical illusion that the body is emerging from its shadowy background into a dimly lit foreground. The atmosphere Seurat creates is not just behind the figure; it moves between his subject and the viewer to shroud much of the body. Light illuminates and reveals; shadow shrouds and obscures.

5.8
Fred Dalkey. *Diane Observing.*
1998. Sanguine on paper,
8⁵/₈ × 6". Courtesy of the artist
and Paul Thiebaud Gallery,
San Francisco.

California artist Fred Dalkey created *Diane Observing* (Figure 5.8) with a similar focus. As he describes it, "probably the most conscious part of my work is that attempt to confront the image or the object and the environment simultaneously."[4] He manipulates texture and value, enhancing dark tones and pulling light out of dark tones with an eraser. "There is a certain point where the whole work starts taking on what is ultimately very important to me: a feeling of air."[5]

The Music Teacher (Figure 5.9) represents the opposite end of the light scale. Both room and figure are flooded with light the way Seurat's figure was enveloped in shadow. In this drawing, the effect of sfumato is dominant; the bright light streams in like a mist from be-

hind and causes the edge of the figure to be softened and obscured, sometimes dissolving completely. An artist concerned with modeling a concrete form, rather than rendering light, would have maintained a line at the edge of the figure. Debra Bermingham is more concerned with capturing the impression of a transitory moment. This soft blending of tone can be achieved by applying powdered graphite or carbon dust with a soft sable brush or a cotton swab.

Joseph Piccillo's *Study F-8* (Figure 5.10) obscures parts of the body in its shadowy surroundings, and other parts seem out of focus, as if a camera lens were trained sharply on only a portion of the image. This drawing evinces a sense of mystery, not just because

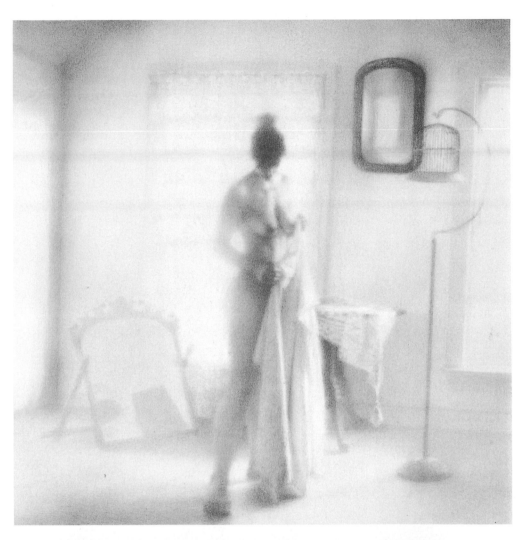

5.9
Debra
Bermingham.
*The Music
Teacher*.
1988. Graphite
on paper,
12$^{1}/_{2}$ × 13$^{1}/_{4}$".
Private
collection,
courtesy DC
Moore Gallery,
New York City.

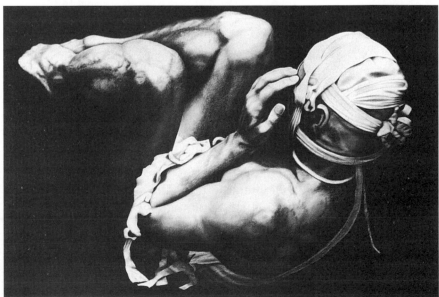

5.10
Joseph Piccillo. *Study F-8*.
1986. Charcoal on paper,
46 × 68". Arkansas Arts
Center Foundation
Collection, 1989.89.52.

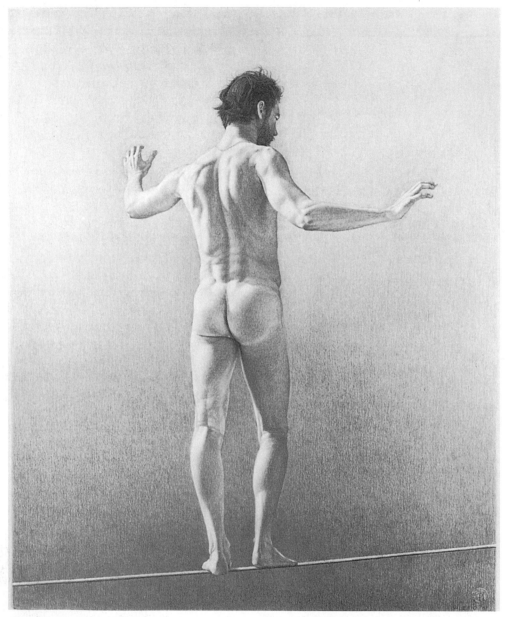

5.11
James Valerio. *Tightrope Walker.* 1981. Pencil on paper, 29 × 24". George Adams
Gallery, New York.

of its unusual content, but because in its contrast of light and dark, it both reveals and conceals, in the full meaning of chiaroscuro.

James Valerio's contemporary drawing *Tightrope Walker* (Figure 5.11) employs a subtle balancing of light and applied anatomy that equals his subject's acrobatics. In actuality, Valerio drew the model as he posed on a model stand, then added the tightrope to heighten the dramatic effect. The use of light and shadow also creates a sense of drama. The figure itself seems to float up from the dark space below, the atmosphere lightening as it rises. In this drawing, a graphite pencil is used to build up and blend a multitude of individual strokes into what is ultimately

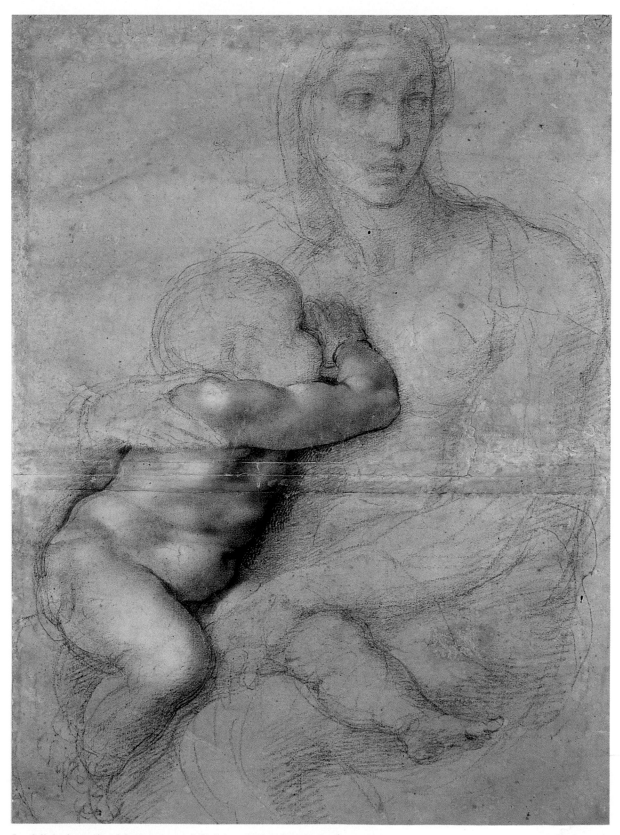

I Michelangelo. *Madonna and Child*. c. 1525. Black chalk, red chalk, white lead, and pen and ink, 54.1 × 39.6 cm. Forence, Casa Buonarroti. Inv. 71F. (Fototeca Casa Buonarroti)

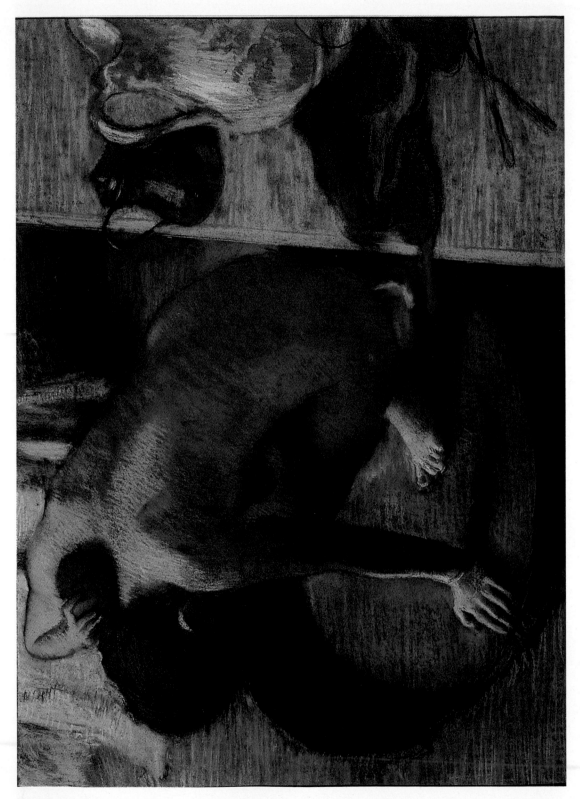

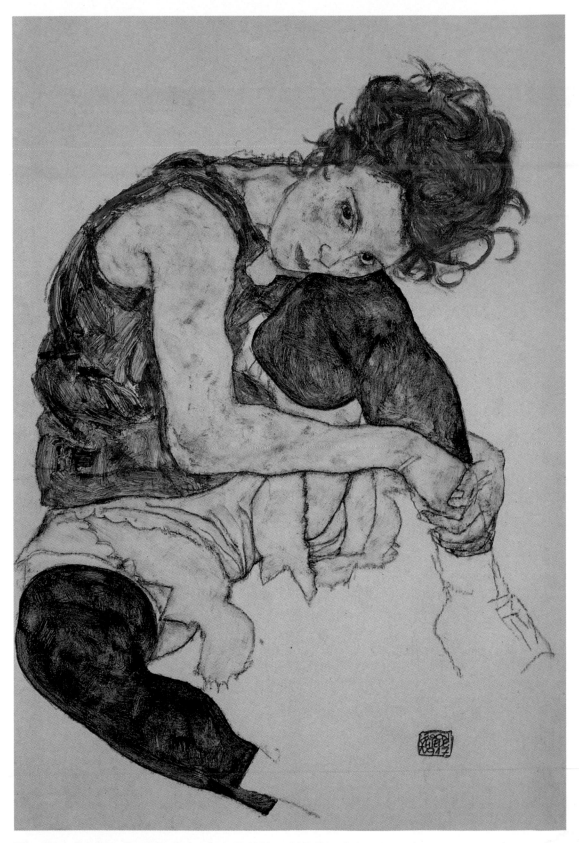

III Egon Schiele. *Portrait of the Artist's Wife.* 1917. Pencil, brush, and tempera on ochre paper, 46 × 30.5 cm. © 2003 National Gallery in Prague, Czech Republic. Inv. K 17862.

IV Elizabeth Layton. *Her Strength Is in Her Principles.* 1982. Colored pencil and crayon on paper, 30 × 72″. From the collection of Don Lambert, Topeka, Kansas.

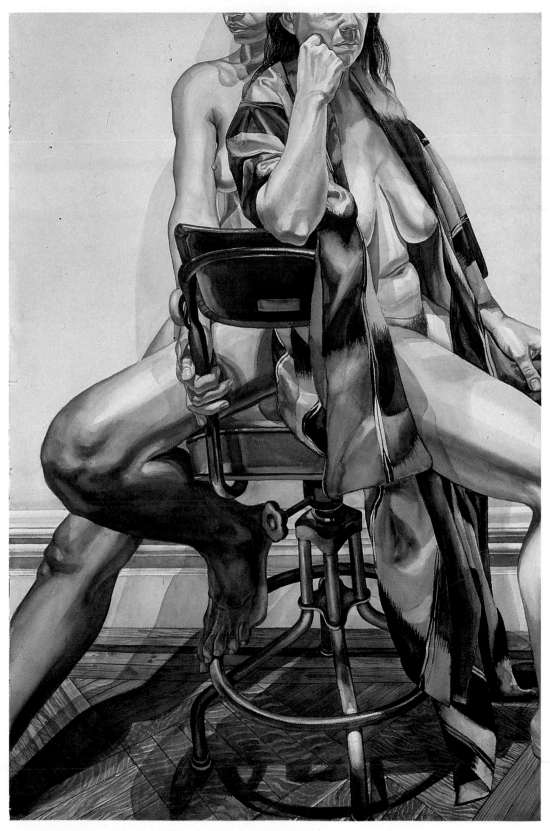

V Philip Pearlstein. *Two Models on Red Swivel Office Chair.* 1984. Watercolor, 60 × 40".
Private Collection. Courtesy of the artist and Robert Miller Gallery, New York.

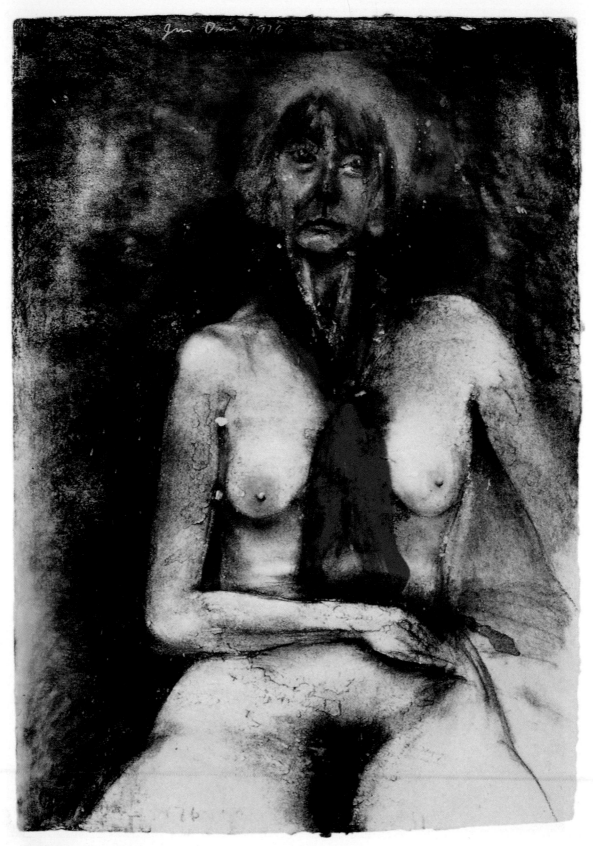

VI Jim Dine. *The Red Scarf*. 1978. Pastel, charcoal, and mixed media on paper, 21$\frac{1}{2}$ × 45$\frac{1}{2}$".
© 2003 Jim Dine/Artists Rights Society (ARS), New York.

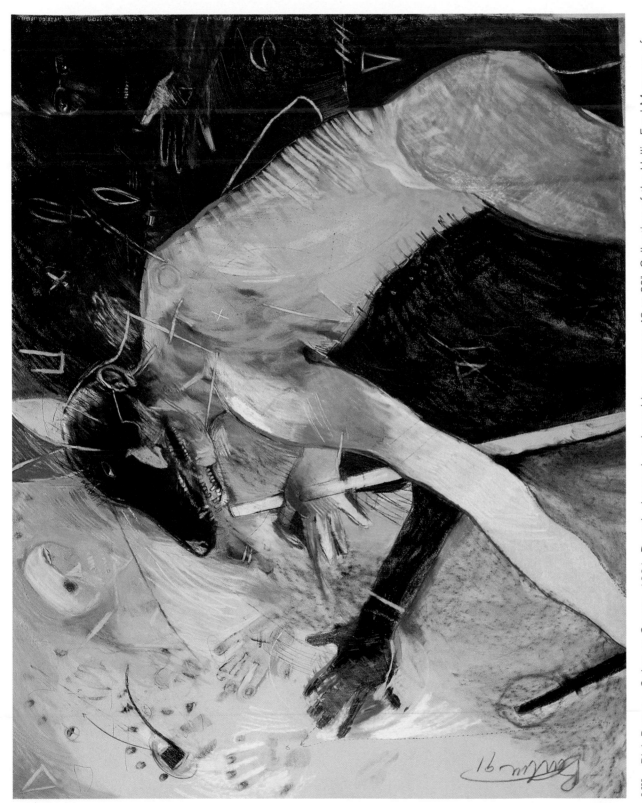

VII Rick Bartow. *Going as Coyote*. 1991. Pastel, charcoal, and graphite on paper, 48 × 60". Collection of the Hallie Ford Museum of Art, Willamette University, Salem, Oregon. Gift of the artist and Froelick Gallery, Portland, Oregon.

VIII Robert Arneson. *Blind Duck*. 1982. Acrylic and oil stick on paper, 53 × 42". Courtesy of the George Adams Gallery, New York.

perceived as tonal gradations. Valerio uses line to maintain an edge where needed, allowing neither the light nor the lack of light to dissolve the form. Value, in this case, both sculpts the body and illuminates it.

Modeling Form with Continuous Tone

An artist whose intent is to visually sculpt a three-dimensional figure on the two-dimensional plane of the drawing paper will use continuous tone to model form rather than illuminate it. For example, in his drawing of a reclining nude (Figure 5.12), the sculptor Aristide Maillol molds the body by extending the outline of the figure with value across the interior of the form, fading as it moves up and out. The darker edge of the outline now represents the deeper recesses, and the paler values read as the advanced area of a rounded form. Maillol uses the pointed end of the conté

stick for line work and then lays the same tool on its side to broaden the line and model the contour. In doing so, he takes full advantage of the textural tooth of the paper to control the grain of the value areas, allowing more paper to show for the emerging surfaces and less for the recessed forms.

Robert Beverly Hale, a renowned anatomy teacher at the Art Students League in New York and author of several books on drawing, said, "Beginners have more trouble with light and shade than with anything else in drawing. The reason is that the accomplished artist depends much more upon his mind than upon his eyes. He seldom draws exactly what he sees. He draws what he knows will promote the illusion of reality."[6] He added, "The rule: up plane light, down plane dark."[7] This rule could be expanded by adding: advancing forms light, receding forms dark.

5.12
Aristide Maillol. *Reclining Nude.* c. 1932. Red conté and traces of charcoal on white laid paper, 21¼ × 30¹¹/₁₆" (53.8 × 77.8 cm). Gift of Mr. & Mrs. William N. Eisendrath Jr., 1940.1044.
© The Art Institute of Chicago. © 2003 Artists Rights Society (ARS), New York/ADAGP, Paris.

5.13
Clint Brown. *Returning*. 2001.
Charcoal, 66 × 42". Courtesy
of the artist.

In Figure 5.13, the vine charcoal that first defines the edge of the figure is extended over parts of the body and into the background as areas of continuous tone for the purpose of modeling the form. These tonal areas turn forms under and push them back in space. Values are deepened with charcoal pencils and black conté. Hatch marks are often blended with the hand or a soft cotton rag into tonal areas. Although there is a suggestion of illumination from a high light source, the value is manipulated primarily to fabricate the illusion of volume and space. The artist manipulates the media not to render what he perceives but rather to give tangible form to what he conceives.

Hatch and Cross-Hatch

With these methods for creating value, the artist uses the pointed end of a drawing tool to build areas of tone through the distribution of adjacent linear strokes known as *hatch marks*. The lightness or darkness of the tonal area is determined by regulating the size or weight of the strokes as well as the intervals between them. The closer together the hatch strokes, the darker the value (assuming you are drawing with a dark medium on a light surface). It

5.14
Philip Pearlstein. *Model in Director's Chair.* 1978. Lithograph printed on light gray paper, 19³/₄ × 17". Collection of Bill and Kathy Rades. Courtesy Robert Miller Gallery, New York.

is possible to develop the entire value scale in a drawing by using only single-directional hatch marks, but one can also apply several layers of overlapping hatch marks, a technique known as cross-hatching.

Rendering Light with Hatch and Cross-Hatch

For some artists, the way light creates visually perceived shifts in value over the subject directs the phrasing of their hatch marks. Philip Pearlstein's lithograph (Figure 5.14) provides an example of how the hatching lines take their cue from light to build areas of varying opacity. Pearlstein created this image by drawing directly with litho pencils on a stone in preparation for printing. Value areas have been created entirely with thin diagonal hatch marks, all of which traverse with essentially the same vector. Where necessary, Pearlstein uses line to enclose and define the body's perimeter. He uses the same slanted hatch marks to describe the shaded portions of the body and the shadow cast on the wall.

Because all the marks are straight and follow the same diagonal slant, there is no specific meaning attached to their direction, such as the slope of a form (with the exception of directional lines in the model's hair and the wood grain in the chair). Value areas built up in this way are perceived as shadows, and it is through the reading of shadow areas that we extrapolate the form.

5.15
Wayne Thiebaud. *Nude in Chrome Chair*. 1976. Charcoal on paper, 30^1/$_8$ × 22^3/$_8$".
Courtesy of Paul Thiebaud Gallery. Photograph by M. Lee Fatheree.

Wayne Thiebaud also uses single-direction hatching patterns to create areas of shadow in Figure 5.15. Although the direction changes from one part of the body to another, from vertical to horizontal to diagonal, it seems to be more suggestive of the bending of limbs than an attempt to model the surface. In this drawing, the white of the paper is not just negative space but functions as solar energy surrounding the body in the same way that shadows enveloped Seurat's subjects. Value, distributed primarily with hatching, defines the cool, shadowy side of the figure. Notice how the aura of hot white light bleaches out parts of the figure on the forehead, chest, and thigh. Along the edges, Thiebaud relinquishes

the line that would contain the form. Notice, too, that the darkest values are not always on the far back or underside of the body but often in the middle, as we see on the leg and arm. This suggests that light is reflected off the ground, illuminating the figure from the underside, the way sunlight bounces off the pavement on a hot summer day. When the hatch strokes are straight and single directional, it is a strong indication that the artist's goal is to depict the light rather than to model the anatomy.

Modeling Form with Hatch and Cross-Hatch

For some artists, light is too fickle and deceptive to be the primary focus of their attention. They would argue that the form of the body is

consistent and doesn't alter with every change in the direction of light; therefore, value should be orchestrated to reveal the plasticity of the body, its structure and the nuances of its surface anatomy.

When modeling form is the artist's first concern, the direction of the hatch strokes takes on particular significance. In addition to establishing value areas, the hatching patterns provide special clues akin to elements of linear perspective. The degree of looseness or density in the hatch marks is not just read as lightness or darkness but becomes an indication of advancing or receding surfaces, of the slant or curvature of the surface. In this way, each hatch stroke conveys information about the slope and terrain of the body.

To visualize this phenomenon, imagine a net or wire screen with even-sized openings wrapped around a white cylinder. On the surface nearest you, the lines are straight and the openings appear at full size. But as the net curves around the cylinder, the lines also curve and the spacing appears to compress. At the outer edge, where the form rolls back and around to the other side, the open spaces disappear, the lines converging into a darker value. In like manner, the hatching pattern of inscribed lines can create value areas descriptive of volume that need not have a direct reference to the play of light or shadow. These are *contour modeling lines*, which, when taken collectively, are also conceptualized as value.

The hatching pattern used by the sixteenth-century Dutch draftsman Jacob de Gheyn II demonstrates their use as contour modeling lines (Figure 5.16). Notice how nearly every line, no matter how short, suggests the curvature of the form over which it lies. This is clearest on the arm of the center figure, where only single hatching is used to turn the form. On the torso of that figure we can also see

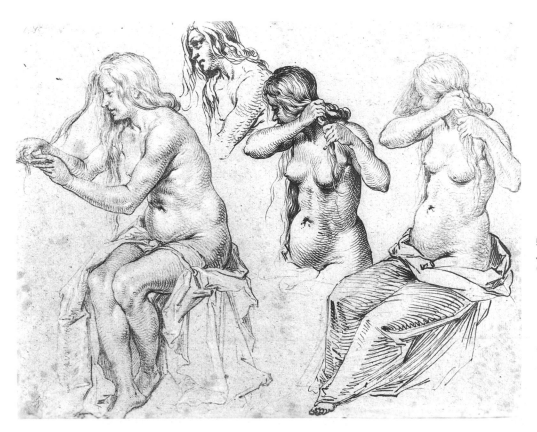

5.16
Jacob de Gheyn II.
Quatre Études de Femmes.
Pen and chalk, 10³/₈ × 13". Royal Museum of Fine Arts, Brussels, Belgium. Collection de Grez. Inv. 4060/1346.

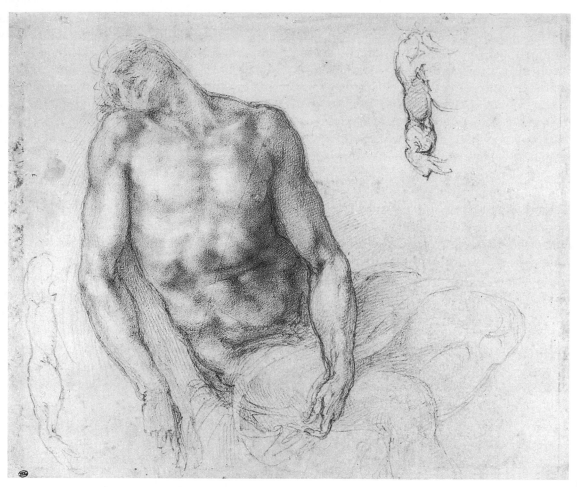

5.17
Michelangelo. *Study for a Pietà*. Musées Nationaux-Paris. © R.M.N. Inv. 716.

how the cross-hatching pattern becomes tighter toward the back of the torso. The primary role of these hatch marks is to sculpt the form of the body and represent a recession of the surface toward an edge, ideally implying the turning of the form around the other side. Any suggestion of the illuminating effects of light is secondary to the sculpting of the form. Value does not fall lightly over the surface as an indication of ephemeral shadows; instead, it builds with the accumulation of contour lines that collectively shape the body and define its spatial relationships. The hatch marks left behind record the shaping action of the artist's drawing tool, much like the marks left by the sculptor's chisel or filing rasp.

Michelangelo's *Study for a Pietà* (Figure 5.17) is a magnificently rich and deeply moving drawing as well as an informative documentary of the artist's step-by-step modeling of form with cross-hatching. It exemplifies what Kenneth Clark, in his treatise *The Nude*, referred to as "an expression of Florentine passion for the solidly comprehensible."[8] The legs show the initial sketching of the figure with very light lines. Notice that these lines are more searching notations of the contour and anatomical topography than they are unequivocal representation. Notice, also, the two smaller studies of the right arm. They were probably sketched after the larger study as alternative positions for this arm and

hand. However, because they have not been finished to the same degree on the central figure, we can rightly interpret them as Michelangelo's preliminary method of using anatomical contour line to define the body prior to developing his cross-hatching, which has been added to the more developed central figure.

Edme Bouchardon's drawing (Figure 5.18) further demonstrates how contour-following hatch strokes can convey a sense of the flowing, anatomical forms of the body. Notice that these interior traversing lines are relatively short and laid in with a light touch on surfaces that are advancing toward the viewer. The lines become heavier and closer together as the forms recede. Note also that each hatch stroke has a slight curve. The cumulative effect is to mold the body as if it were a free-standing sculpture. Bouchardon is also suggesting the play of light and shadow over the body and the background, which helps to integrate the figure with its surroundings. However, this is secondary to Bouchardon's desire to model the solidity of the body. Light is made to conform to the form.

Creating value with cross-hatching generally requires more time than working with continuous tone because of the small surface area covered with each movement of a pointed drawing tool. To fill in large areas requires patience because it often takes a multitude of strokes and several layered applications of media to mold the body fully, as seen on the torso of Michelangelo's figure.

Integrating Value Techniques

The artist whose focus is describing light is concerned with faithfully duplicating what the eyes can see, irrespective of whether the light and shadow patterns reveal or obscure the form. Light is both the artist's inspiration and the drawing's content. In contrast, the artist who is first concerned with modeling form interprets the body's physical characteristics—its volume and surface structure—and uses value as a plastic medium, formative and

malleable. Each bias has its particular aesthetic appeal. Each uses value symbolically, one to represent light, the other form. Using value to model form creates the illusion of a concrete solid and also encloses the object. Light is more open—it is everywhere, more pictorial or integrating, more dramatic or atmospheric. Most artists address both of these

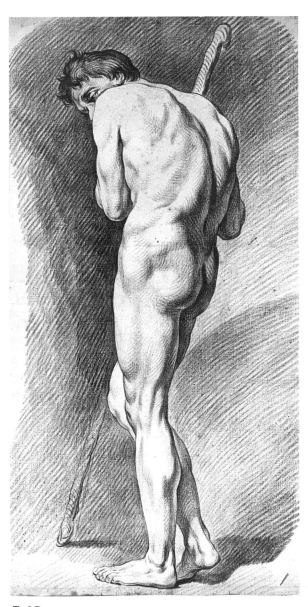

5.18
Edme Bouchardon. *Standing Male Nude with Staff.* Red crayon on white laid paper, $22^7/_8 \times 11^7/_8$". Santa Barbara Museum of Art, Museum Purchase, 1969.41.

concerns in applying value. They indicate cast shadows and the direction of a light source when they are modeling form. Others who render light patterns often use dark lines and add value beyond what is strictly visible to accentuate depth and lend clarity to the body's form.

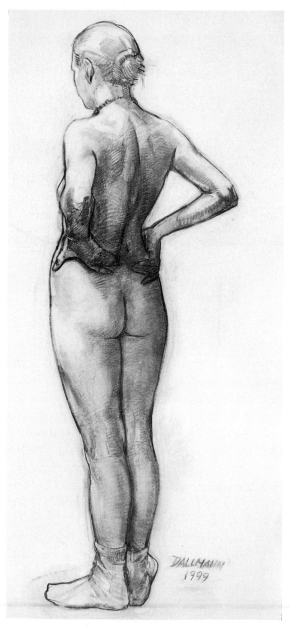

5.19
Daniel Dallmann. *Life Size Standing Nude*. 1999. Charcoal, 80 × 36". Courtesy More Gallery, Philadelphia.

Artists often combine tonal gradations with hatching strokes in the same drawing to take advantage of what both techniques bring to the drawing. Daniel Dallmann's *Life Size Standing Nude* (Figure 5.19) is an excellent example of varied media application and multiple concerns. Consider first the way line circumscribes and boldly shores up the outer edges of the model's stance. It encloses and flattens, defining the body's silhouette. Value adds volume, mass, and illumination. The charcoal is rubbed and blended to suggest the soft interplay of light and shadows. Hatch marks are smoothed into tones, then reintroduced to reassert the forming process of the artist's hand and to model more solidly the body's anatomical structure. Dallmann works with the body's two-dimensional outline while affirming its three-dimensionality. He pays attention to how light falls softly over the body, yet he also sculpts its mass with bold hatch marks. We are simultaneously struck by the powerful presence of the figure and the expressive power of the media.

Edward Schmidt is another contemporary artist who combines a variety of media, applications, and intent, as seen in Figure 5.20. What is most noticeable about his technique is the vigorous way he combines additive and subtractive methods of working the media. After defining the body's proportions and configuration with line, he builds its volume with hatch marks that he often smears and blends into tonal areas, taking his cues from the patterns of light. But these tonal areas are activated by the further addition of both dark charcoal cross-hatching and eraser marks that physically shape the body. In this way, Schmidt creates a network of interrelated light and dark cross-hatching patterns—subtractive marks dominating the high surfaces on which light is falling and darker charcoal marks working primarily to push forms back. Despite the stillness of the figure, the drawing is energized by the artist's animation and active involvement in the drawing process, the media, and mark making.

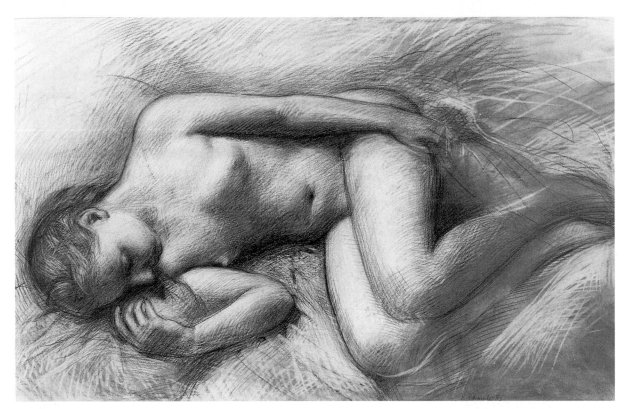

5.20
Edward Schmidt. *Figure 1*. 1992. Charcoal on paper, 26¹/₂ × 40". Courtesy of Hackett-Freedman Gallery, San Francisco.

Toned Paper and Color Media

Most drawings today are created by applying dark pigments on a white or off-white paper, with the surface of the paper functioning as the lightest value. Traditionally, however, artists have achieved wonderful results by drawing with both light and dark pigments on toned drawing surfaces, which themselves function as middle values. Today, you can buy paper of practically any color and value, but historically, artists often prepared the ground themselves, toning paper with a colored wash or dry pigment before beginning to draw.

Using toned paper in combination with multiple drawing tools of differing value and hue contributes greatly to the expressive possibilities when drawing from life. Choosing or preparing the ground is an aesthetic decision, made in consideration with the selection of drawing media. Michelangelo's *Madonna and Child* (Color Plate I) shows how effectively media and ground can work together. Even in the drawing's unfinished state, the toned surface clearly gives it a unifying aura and warmth. Even the most subtle use of color contributes to the overall feeling of the work. The toning or staining of the drawing surface prior to drawing is very similar to the Renaissance practice in oil painting of developing an underpainting of earth tones before the application of more vivid colors. In this drawing, Michelangelo began with black chalk, then followed with red chalk, finally adding white highlights to approximate warm, natural-looking skin tones. Although he uses only a few earth colors, Michelangelo demonstrates that it is possible to give the impression of a much wider palette.

Another artist who had a very strong preference for drawing on toned paper was the neoclassical court artisan of Napoleon, Pierre

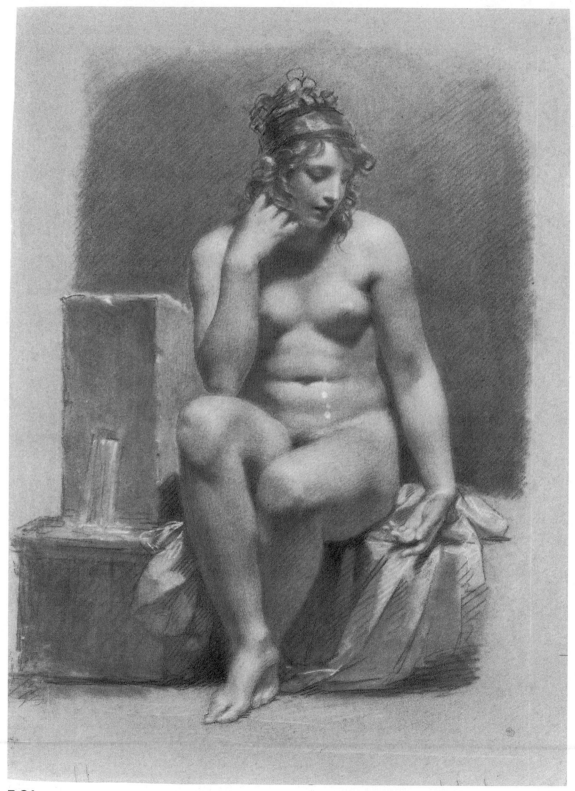

5.21
Pierre Paul Prud'hon. *La Source.* c. 1801. Black and white chalk on blue paper, 21¹³/₁₆ × 15⁵/₁₆".
© Sterling and Francine Clark Art Institute, Williamstown, Massachusetts. 1955.833.

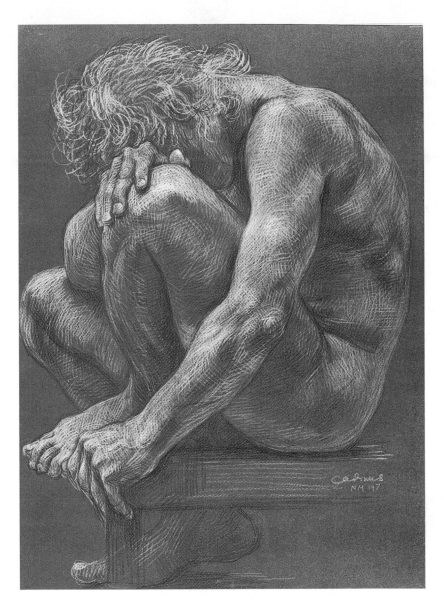

5.22
Paul Cadmus. *Male Nude NM 197*. 1986. Conté on green canson paper, 22⅞ × 16⅜". Private collection, courtesy DC Moore Gallery, New York City.

Paul Prud'hon. *La Source* (Figure 5.21) illustrates his technique of applying white and black hatching strokes on a light blue-gray paper. Using the middle value of the paper as his base, he renders areas of both highlight and shadow as two interlocking drawings. His hatching pattern consists of a tightly interwoven mixture of dark and light lines that delicately describe the play of light. The direction of Prud'hon's hatching is not without content, however. The marks align with the dominant direction of a form. As a form changes direction, so does the hatching pattern, thus indicating the direction of each body part while suggesting its illumination. The flannel-like gray surface of his paper functions as a middle ground between the dark recesses of space and the white advancement of forms.

In comparison to Prud'hon, modern artist Paul Cadmus uses white conté in a coarser, more erratic hatching pattern to define the figure on a dark greenish-gray paper (Figure 5.22). Because Cadmus uses a light medium on a darker ground, the result is a drawing with dramatic contrast that gains energy with the artist's raspy, unblended hatch marks.

Color is a special consideration in drawing because its presence begins to blur the distinction between drawing and painting. Although one might argue that this is an arbitrary distinction to begin with, traditionally the role of color in drawing has been limited. Certainly the absence of color does not diminish drawing as an expressive art form. Perhaps more important is recognizing that color adds to the expense and complexity of making drawings, two factors that can be restrictive to the beginning artist's progress. For these reasons, most drawing instructors reserve color media for advanced students. However, it is important to recognize that drawing has never been limited or defined solely as monochromatic. Artists have historically enjoyed using both dry and wet media of varying hues. The color plates in this book provide examples of several variations of media and technique.

Degas's procedure for his pastel drawing (Color Plate II) is similar to that used for his oil paintings. He typically began both pastel and oil compositions with a charcoal underdrawing and then added color. Often the drawings remained predominantly charcoal, but this drawing reveals his use of a wider range of color. Many artists who draw with color pastels add different colors as adjacent strokes rather than blend them. The colors are then mixed optically to blend when seen from a distance. Degas applies pigment in typical Impressionist style as broken strokes of color, yet an underlying tonality remains because the charcoal is allowed to show through as dark areas or line at the figure's edge.

Elizabeth Layton developed a national reputation for her artwork even though she did not begin making art until she was in her sixties. Her self-portrait, *Her Strength Is in Her Principles* (Color Plate IV), combines colored pencil with wax crayons. The color intensity may not be as vibrant as that of pastels or other color media, but Layton uses the thin-lined pencils to advantage in mapping the wrinkles of her skin and conveying the small printed messages of the buttons she wears. She also uses the linear characteristics of the pencil to create an aura of positive energy radiating from her body.

If dry color media blur the line between drawing and painting, the use of liquid color media can completely obscure it. Yet artists have used transparent watercolors as sketching tools for centuries. Egon Schiele loved to add color to his line drawings with *gouache*, an opaque mixture of watercolor pigment, which pushed his drawings in the direction of his oil paintings. In Color Plate III, the added color enhances the drawing to suggest flesh tones and hair color. It is applied freely, filling in shapes with little attention paid to the play of light and shadow. As Schiele once wrote, "The picture must give off its own light, bodies have light of their own."[9] There is no attempt to indicate a light source nor to cast shadows. The artist's preference for outline and flat color was influenced by Japanese prints as well as the Art Nouveau movement, popular between 1890 and World War I.

Philip Pearlstein's composition (Color Plate V) uses a full palette and demonstrates the degree of realism that can be achieved with transparent watercolor. Like Degas, Pearlstein carefully observes the pattern of light, and he uses the figure primarily as a compositional device. Transparent watercolor requires that the light ground show through to create light value areas, and multiple layers of wash define the more opaque regions. The interior composition is first defined with thin pencil lines that often indicate not only the edge of form but that of shadows and highlight areas as well. The lighter tints of watercolor pigment are usually layered in first, and the dark, opaque areas last. Because it is virtually impossible to lighten areas with transparent water-based pigment, it is a medium that requires considerable foresight and discipline.

Color, for Jim Dine, functions as an image-intensifying tool. His drawing (Color Plate VI) uses a limited amount of color pastel in combination with charcoal, but it has a dramatic

5.23
Clint Brown. 1976. *Pedestal Drawing Series: Venus on a Cake.* Xylene transfer, graphite, photocopy, and auto body primer paint, 40 × 26". Private collection. Courtesy of the artist.

effect, intensifying the image and adding an expressive dimension, a heightened reality. It remains primarily a charcoal drawing, and he incorporates aspects of traditional chiaroscuro, but he uses a brush and oil pigment to add emphasis.

Color has an expressive as well as a descriptive purpose. Dine has instilled the figure with a kind of resonant energy. The atmosphere of dark tones in the background brackets the body, encroaching on it with the force of something more physical than mere shadow, squeezing it together as well as forward. Dine aggressively works the drawing surface, let-

ting his energy and emotions become part of the drawing's content.

Mixed media is a term used to describe a work of art that incorporates a combination of media. It is not a particularly new phenomenon. Artists such as Leonardo da Vinci and Raphael would not hesitate to combine media or to work over the top of one medium with another. Over the centuries, artists have brought together all kinds of combinations of drawing materials to fulfill their expressive needs, which, for whatever reason, could not be met with a single drawing medium. In Figure 5.23, for example, a column of gray auto primer

paint forms the base of the composition. An ink solvent transfer of a fashion magazine photo is worked over with graphite at the top of the column, and at the foot, a photocopied image of Boticelli's *Venus* emerges from a cake rendered in graphite.

Contemporary artist Rick Bartow mixes not only various drawing media but also the imagery from multiple cultural influences. In Color Plate VII, *Going as Coyote*, the artist's face morphs into that of Coyote's as charcoal, graphite, and pastel interact in a cathartic ritual of image conjuring. Bartow described his way of working and image gathering: "I work standing up. That allows for good motion, so there's a gesture in the process. . . . I get my fingers in there to do what I need to do. Mostly what I do is draw and draw and draw. I begin, I listen, and I look and maybe a shadow happens. I don't know what it is. But it doesn't start in the studio. It starts with books and other images, people; it starts back in here someplace; it goes back to my family, to somebody else."[10]

Bartow's imagery is derived from his Native American roots, the natural environment, and contemporary cultural influences, but his work is just as much about color and the pure joy of mark making. He is open to what the media suggest and willing to be surprised by what emerges from his very physical manipulation of the media.

Robert Arneson's large mixed-media drawing builds the image of himself as a wild man from out of a multicolored, multimedia attack on the drawing surface (Color Plate VIII). Arneson's mark making is fundamentally that of gesture or action drawing, done on a large scale and in many overlapping layers. The texture and tapestry of his work involve the interweaving of images and words, perhaps in the hope that they will register on a subconscious level in the viewer's mind.

As Cézanne once declared, "Drawing and color are not separate. During the process of painting, one draws."[11] Likewise, drawing—particularly with color—is akin to painting. Just about any medium, alone or in combination with others, can be used to make a drawing. Like all the visual art disciplines, drawing is primarily concerned with expressing ideas. Perhaps if there is something that makes drawing distinctive, it is that it engages artists on a fundamental level, where they feel they can explore the spirit of their ideas freely with few inhibitions or limitations.

IN THE STUDIO

There are several ways to apply value and several concepts or visual images it can represent. These exercises give you a variety of experiences with applying value, which you may expand upon and repeat to practice rendering and modeling skills.

Using Value to Distinguish Figure and Ground

Pose – 2 minutes
Media – charcoal, conté, or ink wash on newsprint

Value is a way of distinguishing the figure from its surrounding space and of separating the figure from the background. This can be done by either presenting the figure as a dark on a light ground or the opposite, where the negative space around the figure has been defined with dark value. Use value to draw the figure as a dark silhouette on a light ground. Try to imply the physical presence of a solid, dense form without using lines of any kind. Squinting at the model while drawing makes it easier to see the general shape of the body rather than edges and small details.

Adding Value to Line Sketches

Pose – 5 to 6 minutes each (3 to 5 poses)
Media – charcoal, conté, or ink wash on newsprint

The goal here is to spend the first three to four minutes using line to create a gestural or schematic sketch of the model's pose. Then, have the model take a break, and without the model before you, add value as either continuous tone or broad hatch-

5.24
Bobbie Jo Epperson. Student drawing. Modeling volume with continuous tone.

ing strokes. Rely on what you know about the pose and simply and quickly add value to those forms that are recessed in space and to those areas that roll or slant back. Allow the advancing forms or upper portions of forms to remain light. Repeat with a series of poses.

Modeling Volume with Continuous Tone

Pose – 30 minutes
Media – conté, charcoal, graphite, or ink and brush on
 drawing paper

The objective of this exercise is to model form with a continuous-tone gradation of dry or wet pigment. Begin the drawing with line, then use the side of a solid medium or a broad brush to extend the line out over the form of the body. Model volume by using progressively darker values to roll a form back to the edge line or as a distinct value change to suggest a step back from one form to another, such as an arm overlapping another part of the body. If you choose a wet medium, begin with a di-

luted mixture, then gradually add layers of medium to define recessive forms. Any concession to cast shadows should be made only after the volume of the body and the spatial relationships of the form are fully established. Try to think of your application of value as a tool that can physically turn and push forms back and away from you. See Figures 5.12 and 5.24 for examples.

Rendering Light with Hatching

Pose – 2 to 3 hours; illuminated by a single light source
Media – pencil, graphite, charcoal, or ink on drawing paper

Lightly delineate the configuration of the pose, then add the shadow areas with single-direction hatch strokes. You will find that it takes considerably more time to disperse value over a broad area with hatching than it does with continuous tone. Start with the largest areas and with long, light hatch marks. Follow with shorter strokes in the same direction for smaller value areas, gradually building density. Single-direction hatching is adequate for rendering light areas; use denser patterns of hatch marks to achieve darker values. You do not have to make an effort to suggest the contour or slant of the surface by using curved hatch marks or changing their direction. Remember, you are rendering light and shadow patterns only. See Figure 5.14 for an example.

Modeling Volume with Cross-Hatching

Pose – 3 hours; illuminated to clearly reveal all aspects of
 the form
Media – pencil, graphite, or charcoal on drawing paper

When an artist is using hatching and cross-hatching to model the body's volume, the strokes actually represent the surface, not the shadow over it, and the lines follow the flow of the body's contours. Also, value builds in density to represent recesses, not shadow, although the recessive areas are most often shadow areas as well. Before attempting to draw the model, you might practice drawing a round ball on a sheet of newsprint. Try to imply the curvature of the ball as you apply your hatch marks, turning the ball back at its edges with a greater density of strokes. See Figures 5.16, 5.17, and 5.18.

Begin this drawing with line to lay the groundwork for your hatching pattern. Make as complete a cross-contour drawing as you can, allowing edge lines to turn in and over the form and using light lines to note the terrain of the surface. (Refer to the

contour line exercises in Chapter Four.) Then, apply hatch strokes over the internal forms of the body to establish spatial position, using value to step forms back or turn them under. Work from the general to the specific, indicating the character of the terrain over which values fall, hinting at the slant and slope of a surface, and suggesting, with curved lines, whether the surface is concave or convex.

Rendering Light with Continuous Tone

Pose – 2 to 3 hours; in front of a dark backdrop with single
 light source to create highlight and shadow
Media – conté or charcoal on drawing paper

The objective is to apply your media to create value areas of continuous tone. You will need to be a keen and objective observer of the distribution of light, seeing your subject as if you were a camera. Although some line might initially plot the body's

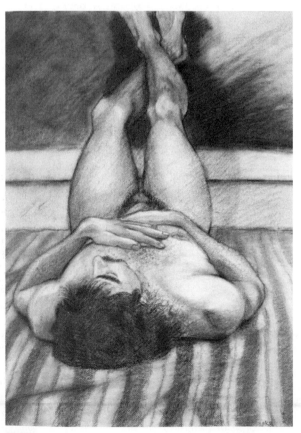

5.25
Susie Tuttle. Student drawing. Light and dark media on hand-toned paper.

configuration, the role of line should be obscured in the finished drawing. Use value to describe the distribution of light in the background and to integrate the figure with its surroundings. In this exercise, value—and the light and shadows it represents—becomes the central compositional element. By adding details and clarity to advancing forms and less clarity to those in the background, you can also begin to achieve a suggestion of atmospheric perspective. See Figures 5.7 and 5.8 for examples.

Using Hand-Toned Paper: Additive and Subtractive Methods

Pose – 2 to 3 hours
Media – graphite, charcoal, conté, and erasers on drawing
 paper toned with pigment

The subtractive method of rendering light patterns as they fall over and around the figure requires that you tone a piece of paper with your drawing medium—graphite, charcoal, or conté. To do this, simply cover your paper with a fine layer of pigment and rub it evenly into the surface with a soft drawing sham or paper tissue to establish a middle-value ground over the entire surface. Begin drawing by using an eraser to subtract pigment to represent bright areas, then use drawing tools to add pigment where darker values are required. Continue to both add and subtract pigment to reveal the body's form and the atmospheric effects of light. See Figures 5.13 and 5.25 for examples.

Drawing with Light and Dark Media on Manufactured Toned Paper

Pose – 2 to 3 hours
Media – black and white charcoal or conté, or graphite and
 white pencil on gray paper

This technique incorporates the paper as a middle value and requires that you draw with tools that are both lighter and darker in value than the paper. You can apply the pigment either as continuous tone using broad strokes, or as more linear hatch and cross-hatch marks. Use value to render the play of light patterns over the form. Essentially, this technique involves integrating two drawings: one that draws recessed forms or shadow areas and one that renders advancing forms or highlights. Use either light or dark pigment for sketching the under-drawing, but keep in mind that you may need to

5.26
Mary Rounds. Student drawing. Mixed media portrait.

work over a pigment with its opposite as you proceed. Refer to Figures 5.21 and 5.22 for examples.

Independent Study

1 Use either a commercially prepared toned paper or one you have prepared yourself as a ground for a portrait of yourself or a friend. **2** To better understand the way a camera sees light, either use a black-and-white photograph with strong value contrasts and attempt to match it as a drawing or, if you have access to a slide projector, mount a black-and-white negative in a slide mount so that you can project it onto a drawing paper and duplicate its value patterns. **3** To become more adept at modeling form with cross-hatching, practice using this technique to draw the larger units of the body, such as an arm or leg, sculpting the volume and curvature of the form with your hatch marks. You may want to refer to anatomy illustrations in the following chapters or make a copy from an old master's drawing. **4** Experiment with incorporating other media or materials into your drawing to add texture or meaning. See Figure 5.26 for an example. Here, a student took a portrait she had drawn of a neighbor and used the computer to superimpose her drawing over a photograph of a building in the community.

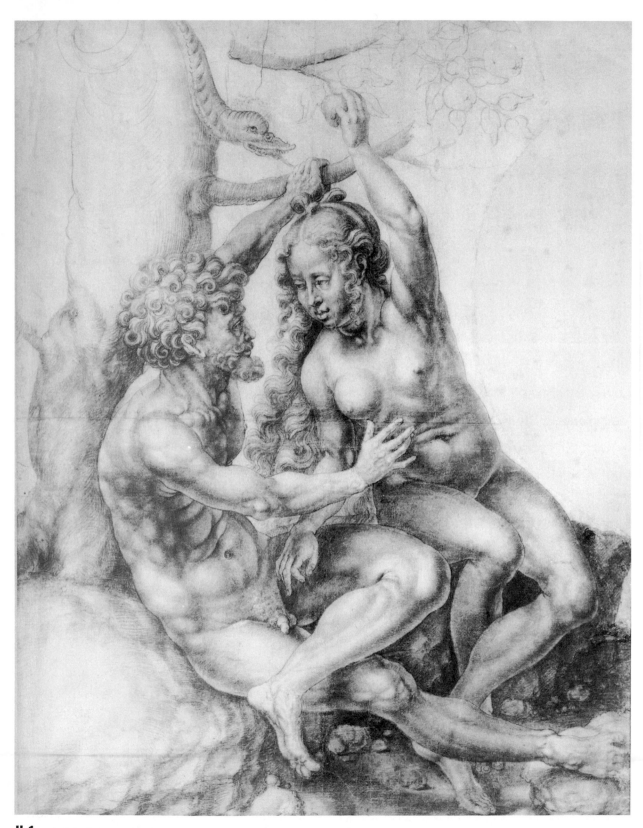

II.1
Jan Gossaert. *Adam and Eve.* c. 1525. Black chalk, 24⁷/₁₆ × 18¹/₁₆". Rhode Island School of Design, Museum of Art, Providence. Walter H. Kimball Fund. 48.425.

SECTION TWO

Anatomy

I have bought myself a very beautiful
book on anatomy. . . . It was in fact
very expensive, but it will be of use to
me all my life. . . . The key to many
things is in thorough knowledge of
the human body.

*—Vincent van Gogh, in a letter
to his brother, Theo*

What Anatomy Has to Offer

Drawing the figure well demands a thorough understanding of the body's structure, and anatomy is the primary determinant of that structure. Certainly you can discover a great deal about the figure's structure from observing the light the body reflects. However, many artists feel that a focused study of anatomy is the key to unlocking the mysteries of light on form, to anticipating form, even to inventing form. Knowing what lies beneath the surface gives meaning to the visual clues that light reveals. Our vision becomes sharper—we know what we're looking at and how to interpret the information that's right before our eyes. Anatomy is physical and steadfast, whereas light and shadow patterns are transient and fluctuating.

The highly respected artist-teacher Robert Henri advised his students: "Study muscles so that you know the nature of what you use. . . . Anatomy is a tool like good brushes."[1] This tool allows the artist to achieve greater realism, to define the essence of the form, to ab-

breviate and abstract the structure in ways that communicate meaningfully. Knowledge of anatomy liberates the imaginative artist in the way that learning to mix color expands the painter's palette. As Degas said, "The imagination collaborates with the memory."[2]

That collaboration frees the artist to use anatomy as an expressive element in drawing. For example, Michelangelo used his knowledge of anatomy not to describe what was real but rather to express what he felt was the ideal. Through his orchestration of anatomical elements, he created humans of immense beauty and power who symbolized the intellectual and spiritual as well as physical aspects of the human potential. Raphael found in the anatomy of the body not simply muscles and bones, but interconnecting forms and rhythmic lines. Through his use of anatomy, he conveyed a sense of grace, a glimpse of the divine.

There is more of down-to-earth realism in Northern Renaissance master Jan Gossaert's portrayal of Adam and Eve (Figure II.1). However, Gossaert's anatomy is intended to be

109

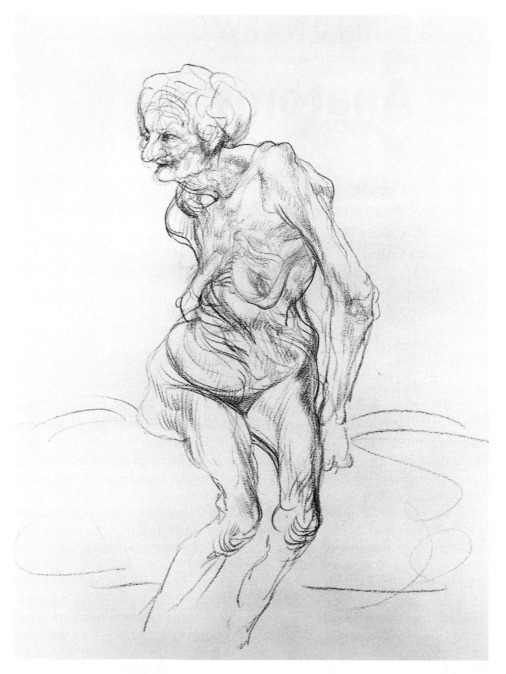

II.2
Hyman Bloom.
*Nude Old
Woman*. 1913.
Brown crayon,
$11^{15}/_{16} \times 8^{15}/_{16}$".
Collection of
the Grunwald
Center for the
Graphic Arts,
UCLA. Armand
Hammer Museum
of Art. Gift of the
Esther Robles
Gallery.

seductive as well as descriptive. It not only gives Adam and Eve their realistic physical appearance but also implies Gossaert's impression of the motivation that led to taking the forbidden fruit.

Perhaps more than anything else, what separates works of art from anatomical illustrations or charts is that the charts provide only raw information, whereas for the artist, anatomy is an aesthetic, expressive component. Hyman Bloom's drawing (Figure II.2) is a beautiful drawing of a figure that could be interpreted as unsightly, even grotesque. The twisting, turning, undulating contours depend on the anatomical references of the aged skin hanging from its framework of bones, but Bloom converts the woman's wrinkled folds into a rich concert of lines.

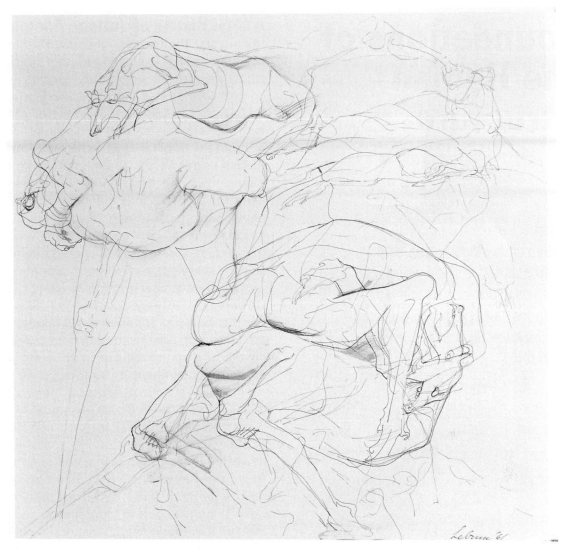

II.3
Rico Lebrun. *Three-Penny Novel—Beggars into Dogs.* 1961. Pen and ink, 37$\frac{1}{4}$ × 29$\frac{7}{8}$".
Worcester Art Museum, Worcester, Massachusetts. Gift of Daniel Catton Rich in memory of
Bertha James Rich. 1969.121. Courtesy Koplin Del Rio Gallery, West Hollywood, California.

Similarly, Rico Lebrun (Figure II.3) uses anatomy as the point of departure for a rich improvisation. Like Bloom's, Lebrun's anatomy is more energetic than realistic. His expressive, calligraphic lines impel us through his drawing. Anatomical elements provide the reference for Lebrun's line work, yet a great deal is left to our imaginations. Both Bloom and Lebrun give us more than information; they offer us an experience. Their figures are derived from, but not restrained by, their knowledge of anatomy.

As van Gogh said, "The key to many things is in thorough knowledge of the human body." Knowledge is liberating. Whether you desire greater realism or expression, acquired knowledge of the human form enables you to draw the figure with authority and invention—whether from life or from your imagination.

Chapter Six

Foundations of the Human Structure

Many, . . . in order to appear great
draftsmen, make their nudes
wooden and without grace, so that
it seems rather as if you were
looking at a sack of nuts than a
human form or at a bundle of
radishes rather than the muscles
of nudes.

—*Leonardo da Vinci*

A Brief History of Artistic Anatomy

Historically, the Greeks, who saw all things—even their gods—as having human characteristics, were the first to study *anatomy* in the context of art, as well as medicine. During the Dark Ages, however, the powerful church, with its emphasis on the spiritual world, brought the direct study of anatomy from the human body virtually to an end. The study of medicine in the early 1400s reaffirmed the need for accurate information about human physiology; and, although the church did not officially lift its ban on dissection until the mid-sixteenth century, the overwhelming desire for knowledge of anatomy continued to grow and gave new impetus to its study. The University of Florence authorized dissection for the purpose of anatomical study. Both artists and physicians attended, using the cadavers of disenfranchised members of society, such as criminals or traitors.

Historical accounts describe many of the master artists in their active study of anatomy. Signorelli is said to have had such a passionate interest in learning anatomy that he visited burial grounds looking for subjects. Anatomical studies such as *Écorché*, which means "without skin," by Michelangelo (Figure 6.1) lend support to biographical accounts that he, too, made anatomical drawings from cadavers. His investigations of anatomy, like those of most of his contemporaries, focused primarily on the bones and muscles that affect surface appearances.

Leonardo da Vinci was an exception. His study of anatomy went beyond that of his contemporaries. In 1505, he reportedly dissected two bodies at the hospital of Santa Maria Nuova in Florence. His scientific study of these figures produced extensive drawings and notes. His remarkable "x-ray" drawing of a female torso (Figure 6.2) reveals the depth of his study of the human body. At one point, he intended to publish a treatise on anatomy that would fully catalog the information that his drawings had recorded. As he wrote in

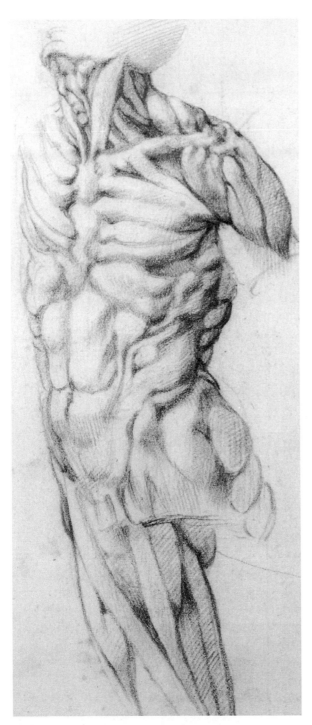

the margins of his notebook, "With what words, O writer, will you describe with like perfection the entire configuration which the drawing here does?"[1] and, "In the winter of 1510 I hope to complete all this anatomy."[2] He never finished the project, but fortunately for artists today, much of his work remains to enlighten us in our own explorations of anatomy.

Much of what Leonardo sought to achieve was to be realized by the anatomist Andreas Vesalius, who published anatomy volumes in 1538 and 1543. It was the most complete

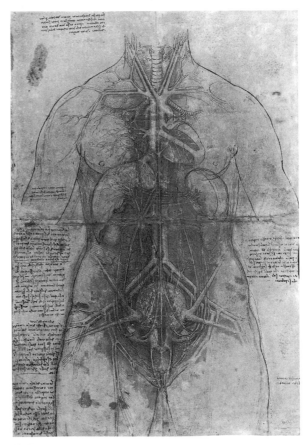

6.1
Michelangelo. *Écorché (detail)*. Red chalk, 28.1 × 10.8 cm. The Royal Collection. © 2003, Her Majesty Queen Elizabeth II. (RL0624)

6.2
Leonardo da Vinci. *Anatomical Study: Principal Organs of Female Torso*. Pen and ink wash over black chalk, 47 × 32.8 cm. The Royal Collection. © 2003, Her Majesty Queen Elizabeth II. (RL12281r)

study of the time and had wide distribution because of the new technology of the printing press. The superb wood engravings (see Figure 6.3) illustrate how Vesalius's artisans gave their subjects a natural appearance by presenting the figures upright and placing them within a landscape setting.

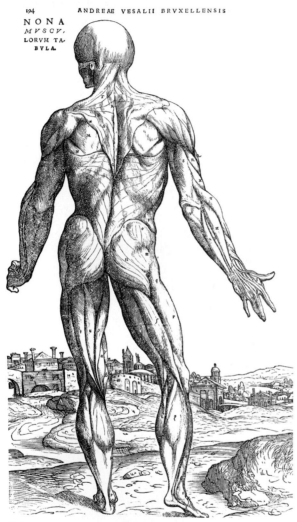

6.3
Andreas Vesalius. *Anatomical Chart of the Muscles.* Wood engraving by a student of Titian. Harvard Medical School, Boston. Francis A. Countway Medical Library.

6.4
Albinus. *Anatomical Illustration by Jan Wandelaar: First Order of Muscles, Front View.* Harvard Medical School, Boston. Francis A. Countway Medical Library.

The quality of Vesalius's work was not eclipsed until a professor of anatomy and surgery in The Netherlands, Bernhard Albinus (1667–1770), began a fresh examination of the human form and incorporated the latest refinements in copperplate engraving. These detailed plates (see Figure 6.4) were created for Albinus by the artisan Jan Wandelaar.

By the nineteenth century, the study of anatomy for medical purposes had increased enormously, and the demand for cadavers gave rise in some parts of Europe to the illicit business of the "resurrectionist," who would steal bodies from fresh graves. Art academies and many of the newer art schools also offered anatomy lectures, which encouraged the publication of texts designed particularly for the artist as an alternative or supplement to study from cadavers. One such text was the 1849 publication by Dr. Julian Fau, *The Anatomy of the Extended Forms of Man*, which provides many of the anatomical illustrations used in this section.

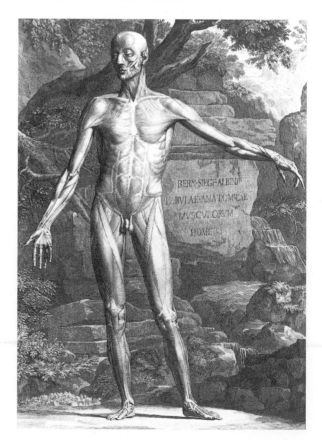

Learning from the Masters

Although it is beneficial for drawing students to make copies from the more scientific anatomical illustrations in order to learn the body's physiology, studying the works of master artists can reveal the expressive and aesthetic application of such knowledge. Whereas scientific illustrations attempt to give us an un-biased presentation of the facts, the artist is much more selective in interpreting and representing these facts.

In Figure 6.5 we can follow the evolutionary process of the drawing and see how Raphael uses cross-contour lines that conform to the body's anatomy. As his lines break away from the outer edge, they become notations for the body's anatomical structure

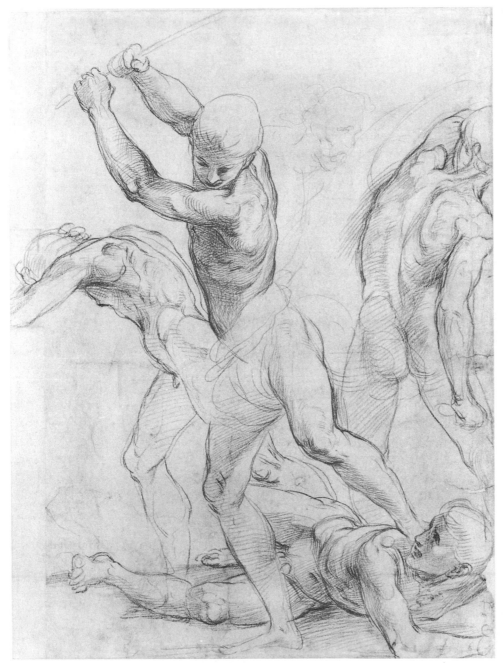

6.5
Raphael.
Combat of Nude Men. Red chalk over stylus, $14^{13}/_{16} \times 11^{1}/_{8}$" (37.9 × 28.1 cm). © 2003 Ashmolean Museum, Oxford, England.

and surface terrain. His initial line phrasing is often reaffirmed with darker lines to emphasize anatomical rhythms as well as the gestural movement of the figures. Notice how he integrates the forms of the limbs with the torso at the pelvis and shoulder girdles. This drawing probably was not done from models but was a compositional sketch conjured in the artist's mind. It suggests both a fluidity of thought and the solidity of the body, which were possible only because of the artist's knowledge of the human form as an integrated anatomical structure.

There is a great deal we can learn from the drawings of Michelangelo about how anatomy can be expressed without becoming overemphasized. When you look closely at drawings such as that in Figure 6.6, you see that Michelangelo uses both line and value to suggest what lies beneath the skin. Rather than diagramming every detail, he implies the presence of overlapping muscles with line

6.6
Michelangelo. *Study of a Male Nude Turning Leftward*. Black lead pencil and stylus, 16$\frac{1}{8}$ × 10$\frac{3}{8}$" (40.4 × 25.8 cm) Teyler Museum, Haarlem, The Netherlands. Inv. No. A19 recto.

6.7
Peter Paul Rubens.
Fisherman. Biblioteca
Ambrosiana, Italy.

and sculpts surface modulations with value. He does not render the muscles themselves, but rather he suggests the taut contour of skin as it stretches over a powerful understructure.

Rubens made numerous studies of the works of master artists who came before him—the Greek sculptors and Michelangelo in particular. He combined what he learned from others with his own direct study from the live model, the results of which, as in Figure 6.7, afford us an opportunity to see to what extent anatomy can be developed. Notice that Rubens has added veins and wrinkles to his muscular, earthy figure. "Living bodies have certain dimples, changing shape at every movement and owing to its flexibility of the skin, now contracted and now expanded," he once wrote.[3]

What we discover when studying the drawings of the old masters is not just how much they know about anatomy, but how much this understanding contributes to both the aesthetic appeal and the expressive power of their drawings. It gives their drawings authenticity and vitality.

Anatomy as a Whole

Anatomy and drawing texts, such as this one, usually divide the presentation of this material into two distinctly separate units, the first dealing with the skeleton and the second with the muscles. When the skeleton and muscles are studied separately, however, the reunification of bones and muscles is often difficult to visualize. For that reason, this text presents a more holistic approach, which emphasizes the interrelationship of bones, muscles, and fat within the different regions of the body.

You are also encouraged to use your own body as a readily available resource on which you can feel the bones and muscles described in the text and accompanying diagrams. When your fingers find and trace on your own arm the edge of the ulna and feel the shifting of the radius as you turn your palm from up to down, you will begin to make the connection between the physical anatomy and its graphic representation.

Before dealing with the specific regions of the body, it is worthwhile to discuss, in general, the ways the skeleton and the muscles influence the external form. Although integrated, each structural system performs a different function, and the influence each has on the various regions of the body, such as the torso or the limbs, is determined by those functions.

The *skeleton* forms the body's armature (Figures 6.8, 6.9, and 6.10). Without the skeleton to hold it up, the rest of the body would lie on the floor like a heap of discarded clothes. Although the skeleton of the human body may not be externally visible, as is a crustacean's, its influence on the external form of the body is profound. You have only to feel your own wrist, elbows, knees, head,

or ribs to confirm the presence and influence of the skeleton. In addition to providing support to the softer tissue, the skeleton is the primary determinant of the body's proportions and its articulation, or ability to move. The skeleton also influences the appearance of the muscles that surround and attach to the bones. Though varied in shape, the muscles follow the structure of the skeletal armature.

In some regions of the body, the skeleton houses and protects internal organs. The skull, for example, forms a protective helmet for the brain, eyes, and eardrums. The ribs form a cage that surrounds and protects the heart and lungs. The pelvic girdle cradles the intestines, bladder, and womb. In these three areas—skull, rib cage, and pelvis—the bones determine volume and are located near the surface. In the limbs, the bones are more likely to be buried by layers of muscle and tissue; yet even in the limbs, the shape and size of the bones play an important role in the outward appearance of the form. By learning the location and the shape of the bones, you begin to anticipate predictable structural relationships. Artists with this understanding are generally better able to determine proportions and structure as well as establish a greater sense of three-dimensional solidity in their drawings.

The *muscular system* gives the body movement. Unlike bones, muscles are elastic and can change in length as well as thickness as the body moves. The muscles are the major factor in determining the surface topography, and, in the case of the limbs, muscles also constitute the majority of the mass. Individual muscles vary greatly in shape and size and are attached to the skeleton with nonelastic tendons. The larger, bulkier muscles are generally located on the limbs, especially those linking the limbs to the torso. The muscles of the trunk tend to be broader and thinner. Figures 6.11 and 6.12 will serve as constant references to the musculature of the whole body throughout this section on anatomy.

Like bunches of rubber bands, the muscles both hold the skeletal armature of the body

together and power its movement. As a muscle contracts and shortens, it exerts force at the points of attachment. At the same time, opposite sets of muscles are relaxing and elongating. In this way, the alternating performance of the muscles controls the body's movement. The muscles that bend the skeleton are called *flexors*. For example, the *biceps* are flexors that bend the forearm up and toward the body, whereas their opposite, the

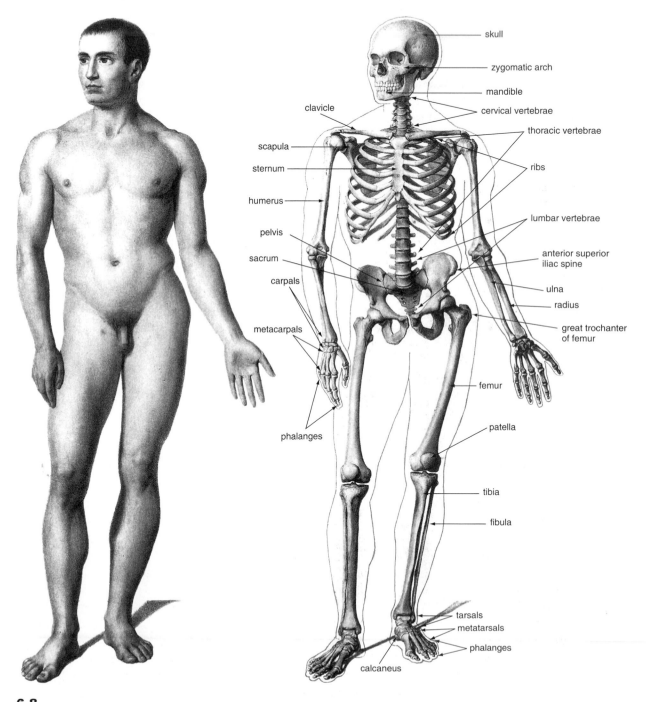

6.8
M. Leveillé/Dr. Fau. *Front View of Male Figure and Skeleton.* Harvard Medical School, Boston. Francis A. Countway Medical Library.

triceps, are **extensors**, which straighten the arm and extend it out and away from the body. There are also opposite sets of muscles that power rotation movements, such as the twisting of the trunk or the rotation of the forearm. Each muscle has a unique function for some aspect of the body's movement; however, most complex movements are possible only because the muscles work in concert, assisting each other in the performance of their tasks. Thus, we often find large muscular units grouped together as a mass.

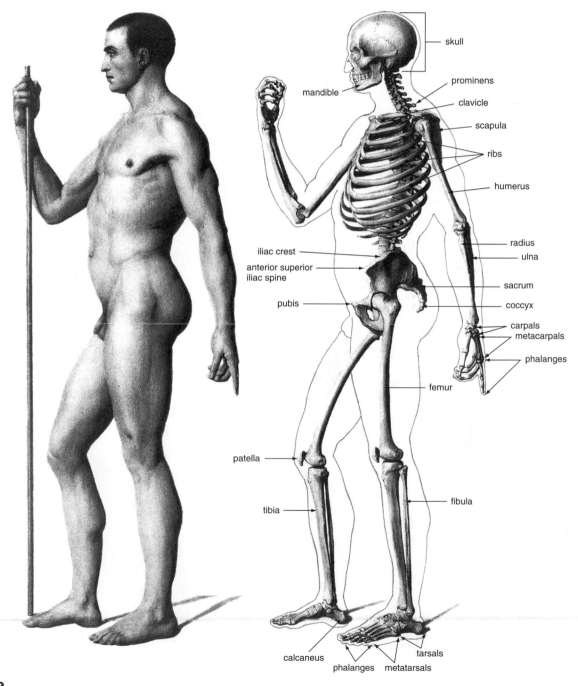

skull

prominens

mandible

clavicle

scapula

ribs

humerus

radius

ulna

iliac crest

sacrum

anterior superior iliac spine

coccyx

pubis

carpals

metacarpals

phalanges

femur

patella

fibula

tibia

calcaneus

tarsals

phalanges metatarsals

6.9
M. Leveillé/Dr. Fau. *Side View of Male Figure and Skeleton*. Harvard Medical School, Boston. Francis A. Countway Medical Library.

The storage of fat also contributes to the figure's form and appearance. As much as we may wish to reduce its influence on our own bodies, fat is a natural part of human anatomy and, therefore, cannot be ignored. The consequences of fat distribution on the outward appearance of the figure—how it obscures the skeletal and muscular structures underneath and sometimes alters the shape of the figure—must be taken into account in your study of anatomy and will be discussed whenever appropriate.

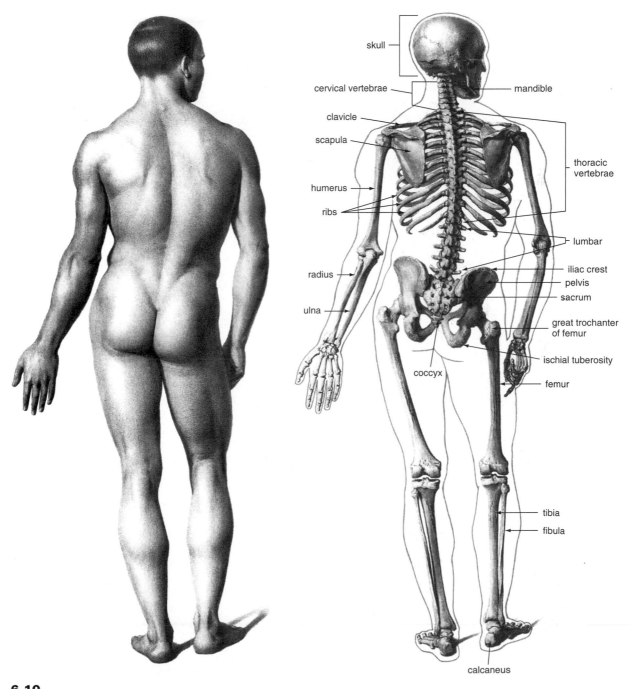

6.10
M. Leveillé/Dr. Fau. *Back View of Male Figure and Skeleton*. Harvard Medical School, Boston. Francis A. Countway Medical Library.

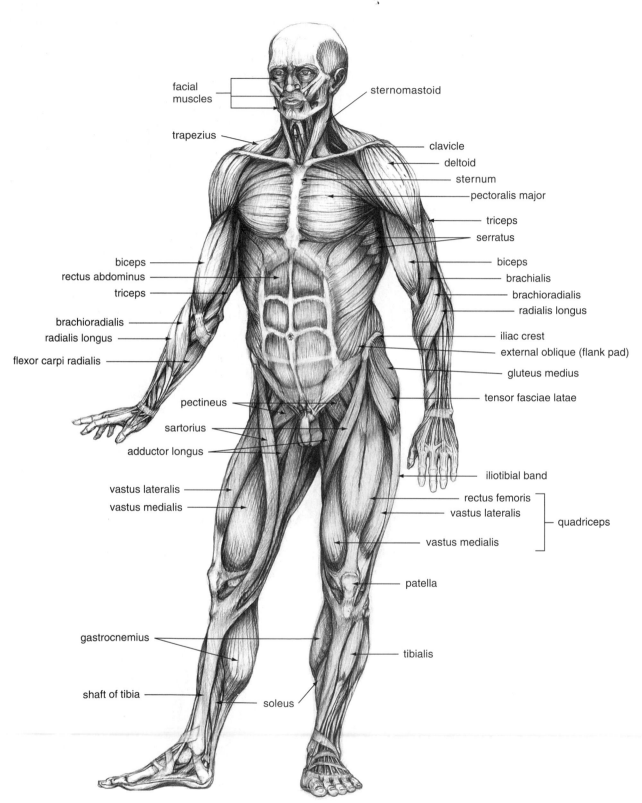

facial muscles

sternomastoid

trapezius

clavicle

deltoid

sternum

pectoralis major

triceps

serratus

biceps

rectus abdominus

triceps

brachioradialis

radialis longus

flexor carpi radialis

biceps

brachialis

brachioradialis

radialis longus

iliac crest

external oblique (flank pad)

gluteus medius

tensor fasciae latae

pectineus

sartorius

adductor longus

iliotibial band

rectus femoris

vastus lateralis

vastus medialis

vastus lateralis

vastus medialis

quadriceps

patella

gastrocnemius

tibialis

shaft of tibia

soleus

6.11
Clint Brown. *Musculature, Front View.*

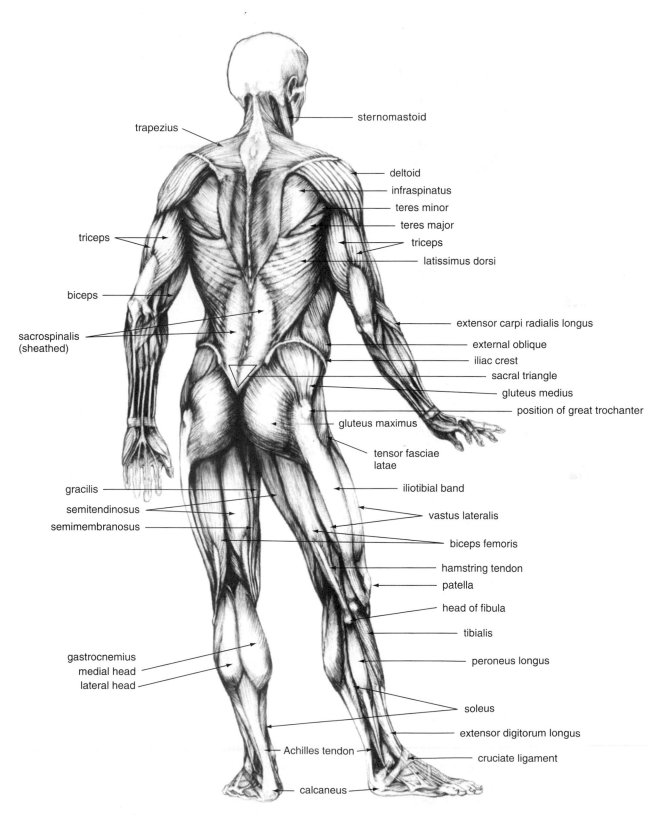

trapezius

sternomastoid

deltoid

infraspinatus

teres minor

teres major

triceps

triceps

latissimus dorsi

biceps

extensor carpi radialis longus

sacrospinalis
(sheathed)

external oblique

iliac crest

sacral triangle

gluteus medius

position of great trochanter

gluteus maximus

tensor fasciae
latae

gracilis

iliotibial band

semitendinosus

vastus lateralis

semimembranosus

biceps femoris

hamstring tendon

patella

head of fibula

tibialis

peroneus longus

gastrocnemius
medial head
lateral head

soleus

extensor digitorum longus

cruciate ligament

Achilles tendon

calcaneus

6.12
Clint Brown. *Musculature, Back View.*

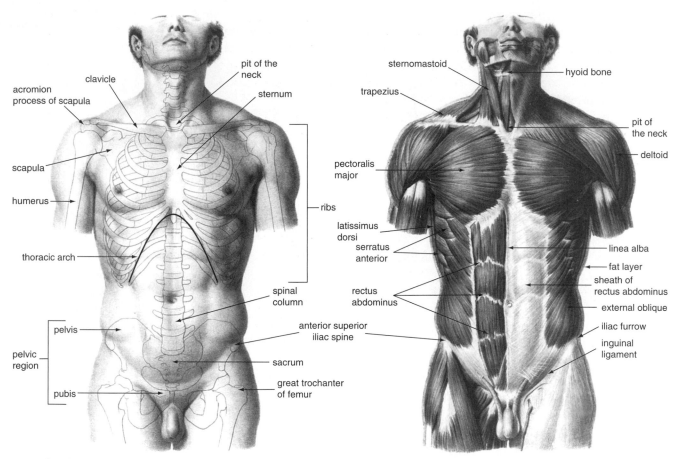

6.13
M. Leveillé/Dr. Fau. *Front View of Skeleton and Musculature of Torso.* Harvard Medical School, Boston. Francis A. Countway Medical Library.

Anatomy of the Torso

The torso, or trunk, of the body includes the neck, shoulders, chest, stomach, back, and pelvic region. Some of the muscles in the shoulder and pelvic areas belong jointly to the limbs in that they form the connection between the limbs and the torso. Therefore, there will be some overlapping between this chapter and the next.

The skeleton, rather than the muscles, determines the volume of the torso. Notice in Figure 6.13 the close proximity of the bones of the torso to the external surface of the body. The general form and proportions of the trunk are determined by four distinct skeletal units: the rib cage *(thorax)*, the hip girdle *(pelvis)*, the backbone *(spinal column)*, and the shoulder girdle.

Front View of the Torso

The rib cage, or thorax, is made up of twelve sets of curved bones that originate along the upper region of the spinal column. It forms an enclosure, houses the heart and lungs, and remains flexible enough for the lungs to breathe. The first ten sets of ribs are anchored in front to the breastplate *(sternum)* with sturdy bands of cartilage. The eleventh and twelfth pairs, called floating ribs, end freely. Notice in Figure 6.13 the downward slope of each rib as it curves from the spine toward the front of the chest, where the cartilaginous attachments make an abrupt turn upward to

the sternum. When seen from the anterior, or front view, this cartilage linking of the ribs to the sternum creates the *thoracic arch*, an inverted U form with its apex at the lower tip of the sternum (see Figure 6.13). This arch also forms a line of demarcation between the muscles of the chest and those of the abdomen. Due to the relative elasticity of the muscular abdomen in comparison to the bony ribs, the area just below the thoracic arch may appear as either a hollow, recessed pocket or a paunch, depending on the body's physique and posture.

The neck region consists of the uppermost portion of the spine and the muscles between the skull and the shoulder girdle. When viewed directly from the front, the contour of the neck is defined by a pair of neck muscles *(sternomastoids)* that originate at the base of the skull just behind the ear and extend diagonally to where their tendons attach at the joint of the clavicle and sternum. Here, they help to create the "pit of the neck" at the top of the sternum (see Figure 6.13). The visual effect of this muscle pair is to modify the cylindrical nature of the neck with their V-shaped orientation. The physical function of the sternomastoid is the tipping and rotating of the head. Between the sternomastoid in the top of the V just below the chin is the protruding form of the windpipe *(trachea)*. In front of the trachea, just under the chin, the small, slender *hyoid bone* accounts for the indentation in the neck just above the elevation called the "Adam's apple," which is, in fact, part of the cartilage of the voice box *(larynx)*. The Adam's apple is more prominent in the male than in the female and is most noticeable when the head tips back. Another muscle that makes a visual impact on the form of the neck when viewed from the front is the *trapezius*, called the cowl or hood muscle because of the way it lies on the shoulders. This muscle is physically located on the back side of the neck, but it is partly visible from the front. It attaches at the base of the skull in back and fans out to the shoulders, suggest-

ing a pyramid shape. One function of the trapezius is to tip the head back; another is to raise the shoulders, which results in a deep pocket between the trapezius and the clavicles. Raise your shoulders and you can feel the contracted trapezius muscle and visually note the pockets formed between it and your clavicles.

The shoulder girdle, which sits atop the rib cage like a yoke, is composed of the collar bones *(clavicles)* and the shoulder blades *(scapulae)*. The clavicles run from the top of the sternum to the top of the shoulders (Figure 6.13, left side). With your fingers, find the points of the clavicles that sit at the pit of your throat where they attach atop the sternum.

The *pelvic girdle* is actually a fusion of three bones. The largest portion consists of the two irregularly shaped pelvic bones, which unite to form a nonmovable joint in the front known as the pubic crest *(symphysis pubis)*, just above the genitals. The third bone of the pelvic girdle, a specially modified vertebra known as the *sacrum*, lies at the base of the spinal column. The sacrum and two pelvic bones form a cup surrounding the large *pelvic cavity*, which supports the internal organs and, in the female body, furnishes a cradle for the womb. Notice how the general shape of the pelvic girdle in Figure 6.13 is hinted at in the exterior appearance of the trunk and how the bones of the pelvis influence the pattern of the muscles in the figure shown at the right. The upper ridge on each side of the pelvis is known as the *iliac crest*, which you can feel on your side at the top of the pelvic bone. The line of this crest terminates in the front at a protuberance known as the *anterior superior iliac spine*. From the two anterior superior iliac spines, the *inguinal ligaments* stretch to the pubis, forming a noticeable U-shaped furrow just above the more sharply V-shaped furrow of the groin. The line of the inguinal ligaments forms a natural continuum on the front of the torso of the iliac crest, which creates an important line of demarcation over which no muscles cross. The

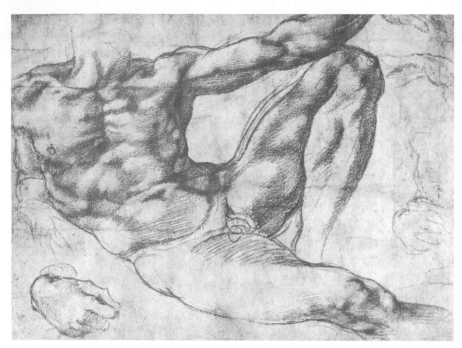

6.14
Michelangelo. *Adam (Study for the Sistine Ceiling Fresco).* c. 1511. Red chalk, $7^1/_2 \times 10^1/_4$". © Copyright The British Museum.

iliac crest and inguinal ligaments function as a border between the muscles of the upper trunk and those affiliated with the legs.

The *linea alba,* Latin for "white line," is another important demarcation line on the torso. This fibrous ligament runs from the lower tip of the sternum, down the center of the torso through the navel, to the pubis at the front of the pelvis. When viewed from the front, the linea alba, in combination with the sternum, creates a vertical central division for the muscles of the torso, forming a T-configuration with the clavicles at the top.

The fan-shaped chest muscle *(pectoralis major)* originates in a semicircular pattern of muscle strands attached to the sternum, ribs, and clavicle, then it twists and tucks under the shoulder muscle *(deltoid)* to attach on the arm bone *(humerus).* Where it attaches to the arm under the shoulder muscle, it forms the frontal half of the armpit *(axilla).* When contracted, this muscle pulls the arm forward and across the chest. The twist in the muscle before it attaches to the humerus allows for tremendous arm mobility. Extend your arm out to the side or above your head; then, as you pull it straight in front of your chest, note the movement of the pectoral muscle.

The stomach muscles *(rectus abdominus)* run as two vertical, parallel bands on either side of the central linea alba ligament. These two muscular bands stretch from their upper attachment beneath the pectorals on the rib cage to the pubis at the front of the pelvic girdle. Slightly narrower at the bottom than at the top, the lines of the muscles contribute to the V-shaped configurations that converge at the groin. Each abdominal muscle strap is divided horizontally into four segments.

The visibility of this segmentation depends to a great extent on the individual's physical condition and the amount of body fat present. As these muscles constrict, they bend the torso, pulling the rib cage closer to the legs.

The flank muscles *(external oblique)* span the gap between rib cage and pelvis on both sides of the rectus abdominus. Originating in eight progressive steps along the lower ribs, the external obliques terminate with a slight bulge just above the pelvis, attaching at the iliac crest. This bulge, called the *flank pad,* is prominent in Michelangelo's *Adam* (Figure 6.14). Along the bottom edge of a well-developed flank pad, an indentation known as the *iliac furrow* sometimes forms and conceals the raised ridge of the iliac crest. This

line is generally more visible on the male figure than on the female. Also, with obesity the iliac furrows become quite deep, evolving into clefts where the flank pads and stomach might overhang the iliac crest.

In *Adam* we see a dynamic expression of the anatomical elements we have been discussing. Even though this is a small sketch, it expresses the almost panoramic quality exhibited in Michelangelo's Sistine Chapel frescoes, for which this was a study. Beneath skin and muscle, we see evidence of a fully expanded rib cage pushing out the contour of the torso. The furrow indicating the position of the sternum appears as a deep shadow, and the linea alba continues over the abdominal area to the navel. Here, the rectus abdominus swells just above the line of the

inguinal ligament, which produces its characteristic U-shaped furrow. Adam's position of repose also causes some modification in the upper portion of his torso. Both shoulders have been raised by the action of the arms, showing clearly the cleft between the trapezius and the clavicle and giving the clavicle a diagonal rather than horizontal alignment.

Back View of the Torso

The spinal column dominates the back view of the torso, running all the way from the base of the skull to where the wedge-shaped sacrum, which means "sacred bone," unites with the pelvis. The spine is composed of many small interlocking bones *(vertebrae),* each specifically modified for its precise position in the four general regions of the spine (Figure 6.15):

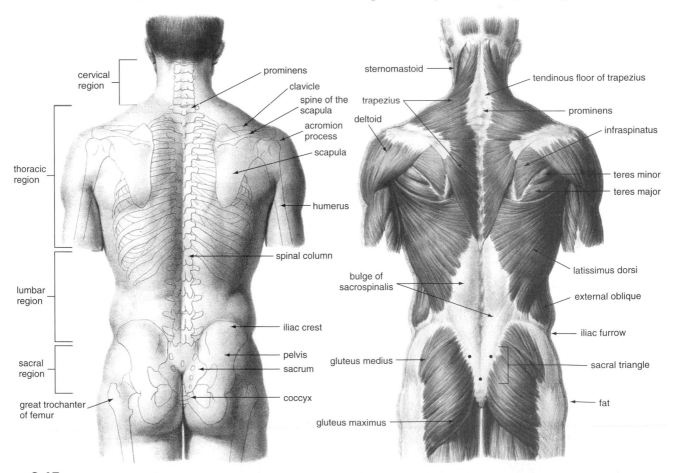

6.15
M. Leveillé/Dr. Fau. *Back View of Skeleton and Musculature of Torso.* Harvard Medical School, Boston. Francis A. Countway Medical Library.

the neck *(cervical),* the ribs *(thoracic),* the small of the back between the rib cage and pelvis *(lumbar),* and the pelvis *(sacral).*

No muscles cross over the spine, which is why the spinal column is a prominent visual element when viewing the body from behind. This line is strengthened visually as well as physically by the strong back muscles, *sacrospinalis,* which lie directly alongside the spine. These muscles, named because they stretch from the sacrum along the length of the spine, offer support to the back, working in opposition to the rectus abdominus muscles on the stomach. Although not visible in Figure 6.15 because they are covered by more superficial muscles, the thick sacrospinalis bands are significant in the lumbar region, where their bulk creates the furrow for the spine. This furrow, and the muscles that form it, are defined with

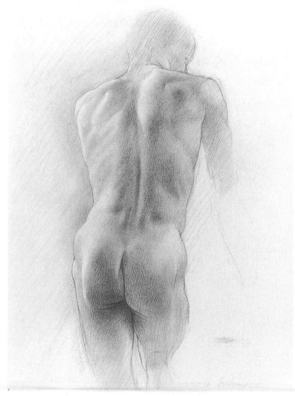

6.16
Martha Mayer Erlebacher. *Male Back. 1980.* Pencil on paper, 11^7/$_8$ × 8^7/$_8$". Arkansas Arts Center, Little Rock Foundation Collection: Donation Box Acquisition Fund, 1982. 82.31.1.

value in Martha Mayer Erlebacher's drawing (Figure 6.16). "Remember," she once told an interviewer, "the muscles of the body form patterns that are part of a continuity of patterns that exist throughout the body."[4]

At the base of the neck, the process, or protuberance, of the seventh vertebra *(prominens)* is generally visible as a slightly more pronounced bump on the spinal column; it signals a shift in the curvature of the spine and marks the top of the rib cage and the beginning of the thoracic region of the spine.

The rib cage is evident in the broad, bellowing contour of the back (Figure 6.15). Notice how the form of the back follows the general orientation of the rib cage and is affected by its proximity to the outer surface. Notice, too, the diagonal sweeping curve of the ribs from the spine toward the front of the body.

The shoulder blades *(scapulae)* make up the back half of the shoulder girdle (Figure 6.15, left side). These two flat, triangular-shaped bones ride freely over the rib cage. The inner margins, the edges of the scapulae facing the spine *(vertebral border),* can be detected under the flesh as the rims on either side of the spine. The raised ridge that runs along the top of the scapula, the *spine of the scapula,* is an important landmark because it forms a point of attachment for the muscles on the back of the shoulder girdle. The scapulae are most dramatically visible when the arms are pulled back, forcing the inner margins of the scapulae closer together.

The back of the neck is dominated by the upper portion of the large, diamond-shaped trapezius muscle, which attaches to the base of the skull and spreads the cylindrical mass of the neck outward toward the shoulders. The V formation of the frontal neck muscles is inverted on the back of the neck by the spreading action of the trapezius. A small, diamond-shaped opening at the base of the neck *(tendinous floor of the trapezius)* is in part responsible for the visibility of the projecting vertebrae in this area. The trapezius extends down the back as a flat wedge shape, but it is

too thin in this region to significantly affect the exterior form of the lower back.

The *latissimus dorsi* is the broadest muscle of the back. At its origin this muscle forms a thin, triangular layer of tendinous fiber over the lower back, veiling the sacrospinalis muscles that lie alongside the spine. The upper portion of the latissimus becomes increasingly fleshy until it forms a thickened lateral mass that makes up the back of the armpit.

The sacrum forms the base of the spine and is an important component of the pelvic girdle. Its upper portion lies just beneath the skin, visible as a flat, triangular shape *(sacral triangle)*. This bone is lodged between the two halves of the pelvis, with most of the lower portion covered by the fatty padding of the buttocks. The sacrum's wedge shape is designed to transmit the weight of the upper body from the spinal column downward through the pelvis to the thighs.

The iliac crest of the pelvis rises from both sides of the sacrum and can be traced as a furrow *(iliac furrow)* around the side to the front of the torso. This important muscle border forms the attachment of the external obliques above and the *gluteal muscles* below.

Below the iliac crest lie the thick gluteus muscles *(maximus, medius, and minimus)* of the buttocks. The three gluteus muscles originate along the lateral borders of the sacrum and the iliac crest (Figure 6.15, right) and attach to the thigh bone *(femur).* Although this group of muscles is thick and rounded on the back of the pelvis, it is the combination of muscles and fat that accounts for the total mass of the buttocks and hips and masks the irregular shape of the pelvis.

The width and contour of the hips are determined by the outward projection of the *great trochanter*, the large process on the outside upper end of the femur. This prominent process acts as a lever for the muscles controlling the hip joint, and you can feel it at your side beneath a covering of thin tendons about a hand's span below the iliac crest. Notice in Figure 6.15 (left side) that the great trochanter actually protrudes farther to the side than does the top crest of the pelvis.

Michelangelo's study for the Sistine Chapel (Figure 6.17) provides marvelous anatomical details to help us apply our knowledge of the anatomy of the back. Notice how he applies value to disclose the existence of the muscles beneath the surface without outlining each edge. The double twisting movement *(contrapposto position)* of the spine gives a dynamic, animated quality to his seated figure. Although the hips are in profile, the torso twists to reveal the full breadth of the upper back. At the same time, the neck turns the head back and into profile.

We are immediately aware of the full expanse of the rib cage, and as the arms swing in opposition to the hips, the torquing action is expressed most visibly in the oblique angle of the spinal column and the emphasized

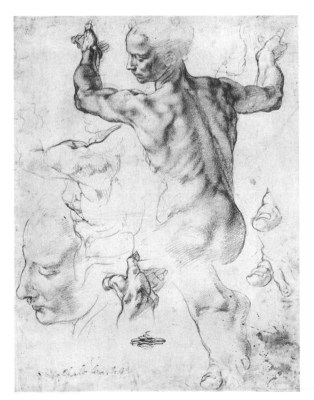

6.17
Michelangelo. *Studies for the Libyan Sibyl.* Red chalk on paper, 11³/₈ × 8³/₈". The Metropolitan Museum of Art, New York. Purchase, Joseph Pulitzer Bequest (24.197.2).

bulging of the adjacent back muscles (sacro-spinalis). The seventh vertebra (prominens) at the base of the neck appears as a highlight. There are also subtle suggestions of the iliac furrow and the external oblique, or flank pad. In spite of the neck's twisting action, we can follow the contour of the trapezius from the back of the skull out over the *acromion process* of the scapula on the top of the shoulder. The up and outward reach of the two arms pulls the scapulae forward and draws the viewer back in space. Michelangelo indicates the diagonal orientation of the near shoulder blade with shadow.

Side View of the Torso

The side view discussion will provide a means of unifying the front and back views of the torso. The side view (Figure 6.18) conveys more clearly the dimension and interrelationship of the anatomical components and reveals important aspects of the form not clearly discernible when viewing the body directly from the front or back. For example, the S curvature of the spinal column is now conspicuous, as is its influence on the orientation of the rib cage and pelvis. Notice how this movement is repeated in Thomas Cornell's life study (Figure 6.19). The spine curves down and out from the head, back in at the lumbar, and out again at the sacrum. The curvature of the buttocks draws the line back down into the legs.

The diagonal orientation of the neck is a direct result of this curvature of the spine (Figure 6.18). This directional movement is

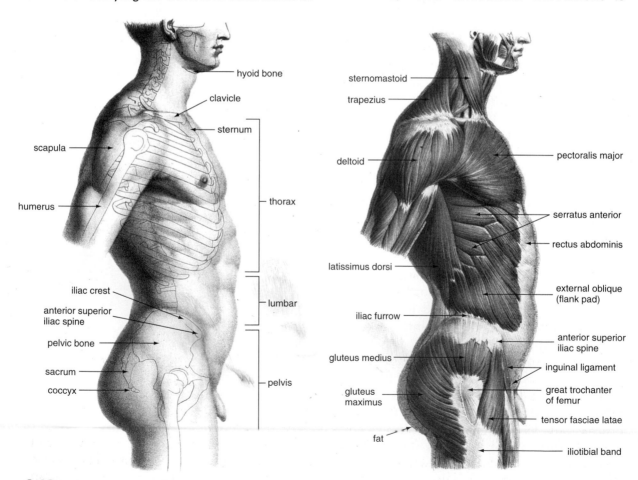

6.18
M. Leveillé/Dr. Fau. *Side View of Skeleton and Musculature of Torso.* Harvard Medical School, Boston. Francis A. Countway Medical Library.

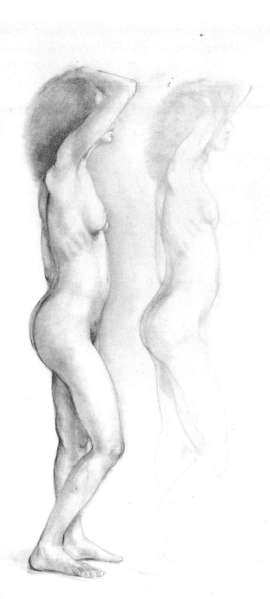

6.19
Thomas Cornell.
*Double Study of
Standing Nude.*
1984. Pastel on
paper, 30 × 22³/₈".
The Arkansas Arts
Center Foundation
Collection: The
Tabriz Fund, 1988.
88.14.1.

reinforced by the shape of the trapezius, from the skull to the spine of the scapula. The windpipe *(trachea)* at the front contour also follows the backward slant of the vertebrae. However, the muscular bands of the sterno-mastoid on the neck form an oblique counter movement from behind the ear forward and onto the front of the shoulder girdle at the pit of the neck.

Below the clavicle and along the profile of the sternum, you can see the chest muscle (pectoralis major) as it wraps over the upper form of the chest and tucks under the shoulder muscle (deltoid) at the armpit. Below the

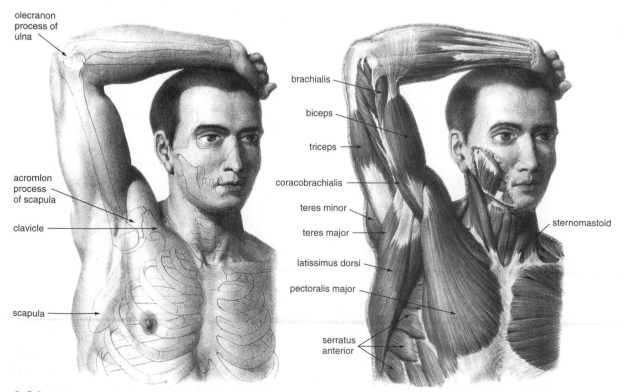

acromion
process

clavicle

spine of scapula

vertebral border
of scapula

deltoid

trapezius

supraspinatus
(under trapezius)

teres minor

infraspinatus

teres major

rhomboid

latissimus dorsi

6.20
M. Leveillé/Dr. Fau. *Back View of Skeleton and Musculature of Shoulder, Arm Raised.* Harvard Medical
School, Boston. Francis A. Countway Medical Library.

olecranon
process of
ulna

acromlon
process
of scapula

clavicle

scapula

brachialis

biceps

triceps

coracobrachialis

teres minor

teres major

latissimus dorsi

pectoralis major

sternomastoid

serratus
anterior

6.21
M. Leveillé/Dr. Fau. *Front View of Skeleton and Musculature of Shoulder, Arm Raised.* Harvard Medical
School, Boston. Francis A. Countway Medical Library.

bottom rib is the flank pad of the external oblique. A progressive sawtooth pattern of ridges easily mistaken for ribs is actually an indication of the *serratus anterior* muscles. The serrated pattern of these muscles can be seen in Figure 6.18, just under the armpit. Notice also how the profile of the abdominal wall in front tends to follow the movement of the spine, protruding toward the front, opposite the lumbar curve of the back.

Articulation of the Limbs and Trunk

The fact that the shoulder blade *(scapula)* rides freely over the rib cage and is held in place only by the elasticity of the muscles allows for a high degree of arm movement. Conversely, arm movement can greatly alter the orientation of the scapulae and the form of the surrounding muscles. Notice in Figure 6.20 (left side) that as the right arm is raised, the scapula pivots at the shoulder joint and the inner margin (vertebral border) tips out so that it is no longer parallel to the backbone. Also notice how a pocket forms above the shoulder around the acromion process (at the top of the scapula) from the flexing of the thick shoulder muscle (deltoid) as it draws the arm upward. At the underarm, the back muscle (latissimus dorsi) draws up along the outer contour of the torso, and the lower corner of the scapula swings out to the side, following the upper border of the latissimus dorsi.

When this action is viewed from the front (Figure 6.21), the chest muscle (pectoralis major) also pulls up and stretches out, revealing the underside of the arm and the armpit. The clavicle raises with the shoulder, changing its normal alignment from horizontal to diagonal. The best way to deal with modifications in appearance caused by arm movement is to consider the shoulder girdle, in particular the scapula, as an extension of the arm. As the arms move forward, reaching out in front of the body, the back is rounded off. When arms and shoulders are both drawn back, the vertebral borders of the scapulae become more visible and form a hollow between them.

The combined effects of these two actions are visible in a drawing by Raphael (Figure 6.22). Raphael firmly establishes both the rib cage and the pelvis as the foundation beneath the layers of muscle. The S-shaped curvature of the spine and the musculature of the back give the forward figure a particularly powerful and rhythmic gesture. The iliac crest, which is clearly indicated on both figures in Raphael's drawing as a shadowed furrow, provides the line of demarcation between the muscles controlling the upper and the lower halves of the body's movement.

Notice how the hip and the pelvis form a continuation of the leg. You can see a suggestion of the great trochanter as a protrusion on the hips, especially on the figure at the left. As the large gluteus muscles flex with the stride of the figure on the right, a hollow forms on the buttock just behind the hip, and the gluteal furrow is also sharply defined as the

6.22
Raphael. *Two Men for the Victory of Ostia.* 1515. Red chalk over stylus, 40.3 × 28.1 cm. Graphische Sammlung Albertina, Vienna, Austria.

leg draws back. The notation to the right of these figures was written by Albrecht Dürer. This drawing was part of an exchange between Raphael and Dürer.

Anatomical Differences Between Male and Female Figures

Martha Mayer Erlebacher's drawing (Figure 6.23) reveals her concern for anatomical accuracy. There is no doubt as to the model's gender, even though all of the more obvious clues as to the figure's gender have been omitted, even from the drawing's title. The primary indications that this is a female torso

are the proportional differences between the rib cage and hips and the way the pelvic region appears to extend to the base of the rib cage.

Although the basic skeletal and muscular structure of the male and female are the same, the bones and muscles of the female are typically smaller than those of the male. The torso represents the area of greatest differentiation between the sexes. The key factor is the relative proportion of the rib cage to the pelvis. This is clearly indicated in Dürer's *Adam and Eve* (Figure 6.24), where the male's rib cage is as wide as or wider than his pelvis, which gives the male torso its straighter appearance. The female's rib cage is smaller

6.23
Martha Mayer Erlebacher. *Standing Torso Back.* 1982. Pencil, 13$\frac{1}{2}$ × 11". Photograph courtesy of J. Rosenthal Fine Arts Ltd., Chicago.

6.24
Albrecht Dürer.
Adam and Eve.
1504. Engraving,
$9^7/_8 \times 7^7/_8$". The
Metropolitan
Museum of Art,
New York.
Fletcher Fund,
1919. 19.73.1.

in comparison to her hips. In the female figure, the shoulders, rather than the rib cage, most closely approximate the width of the pelvis.

Notice how the top of the pelvis is clearly marked by the indication of Adam's iliac furrow. On Eve, we don't see this indentation below the flank pad. Instead, the contour line of the pelvis continues over the flank, with little indication of the iliac crest, up to an indentation at the base of the rib cage.

Variations in the way males and females store and distribute body fat further dramatize sexual differences. In general, the muscular presentation in the male tends to be more pronounced, largely because the female body carries additional fat cells beneath the skin, which serve to obscure muscle definition.

Because a male's fat accumulation is primarily in the stomach, above the iliac crest and inguinal ligament, these lines become distinct furrows with added fat. The male

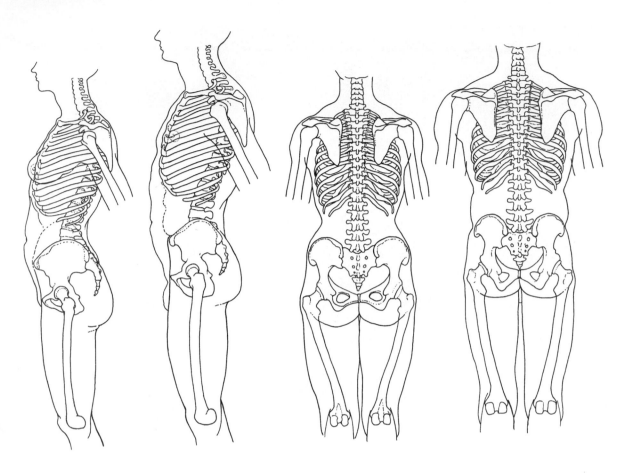

6.25
Diagram comparing female and male skeletal structure, side and back views.

breast is vestigial, consisting of a smallish nipple located just below the fourth rib over a thin disc of fat. Its overall shape is defined by the pectoral muscle. The nipples are separated by approximately one head length.

The form and size of the female breasts *(mammary glands)* vary greatly from one individual to another. Overlapping the pectoral muscles and occupying an area between the third and sixth ribs, the female breast is generally hemispherical in form. The size differs according to body type, age, and body fat, enlarging with pregnancy and lactation and becoming atrophic with extreme age. Changes in the body's position also modify the shape of the breasts.

The female body stores fat primarily in the lower region of the hips and thighs. A woman's waistband or belt is generally worn just below her rib cage, dividing the upper and lower portions of the torso in half. A man's belt and waist are lower, at the crest of the pelvis, dividing the male torso with two-thirds above and one-third below his waistline.

Figure 6.25 indicates that the male's pelvis is slightly elongated and funnel-shaped, whereas the female's is shallower with a proportionately larger internal cavity, created by the more dramatic inclination of the lumbar portion of the spine. The insertion of the sacrum, which is shorter but broader in the fe-

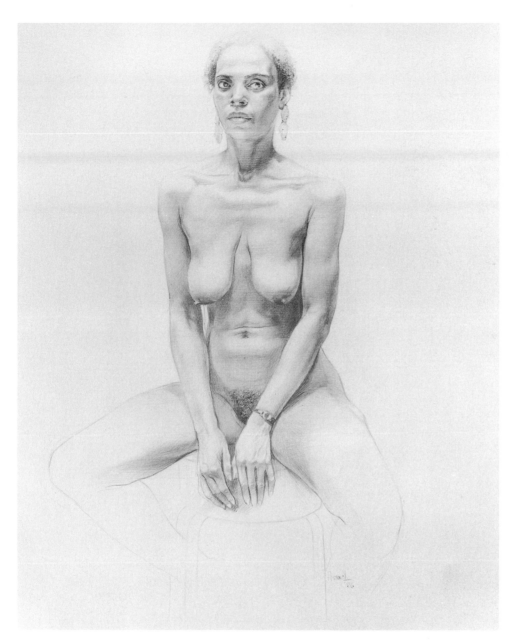

6.26
Steven Assael.
Female Nude.
1986. Ballpoint
pen, 13$\frac{1}{2}$ × 10$\frac{3}{4}$".
Tatistcheff Gallery,
New York.

male than in the male, is more to the posterior of the pelvis, which, in turn, brings the coccyx back farther. The outward projection of the sacrum affects the female external form in the appearance of a flatter, inclined plane over the sacral region. The anterior superior iliac spine gives an overall visual appearance that the pelvis tips forward with a greater diagonal orientation for the female than for the male. The larger pelvic cavity in females also spreads

the hip joints farther apart, which, in turn, affects the angle of a woman's thighs as they slant at a more oblique inward angle from hip to knee.

In Figures 6.26 and 6.27, Steven Assael skillfully renders the anatomy of female and male figures, neither of whom exhibits much fat accumulation. Notice that the breasts do not entirely obscure the pectorals underneath. The male's inguinal ligament and iliac

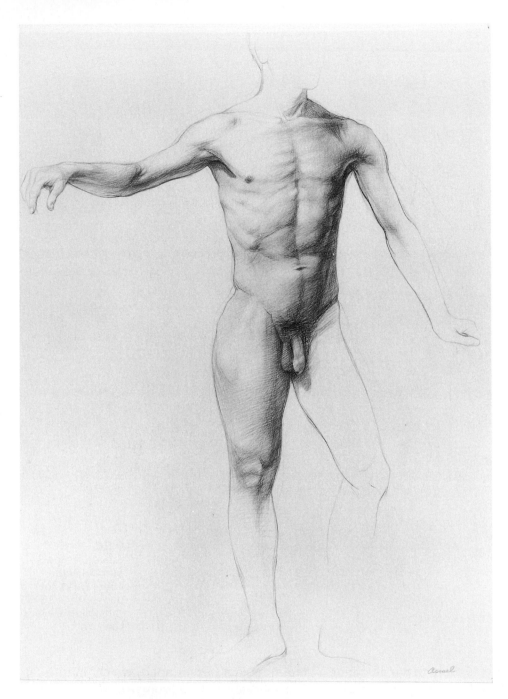

6.27
Steven Assael.
Untitled. 1982.
Ballpoint pen,
15 × 11".
Tatistcheff Gallery,
New York.

furrow are clearly defined. Assael's descriptive anatomy becomes an aesthetic device that orchestrates his subtle use of value.

The artist who understands the anatomical understructure of the human figure can use that knowledge as a touchstone for greater creativity and freedom of expression when drawing from life. In her evocative drawing *Female Mummy* (Figure 6.28), contemporary artist Peggy Macnamara invokes the skeletal structure that lies just beneath the surface of skin to add drama to the figure drawn in a position at once protective and vulnerable. The drawing's power comes from the sense of realism created by the clear presentation of the anatomy.

6.28
Peggy Macnamara. *Female Mummy.* 2001. Graphite, conté, and watercolor, 22 × 30". Courtesy of the artist and Aron Packer Gallery, Chicago.

IN THE STUDIO

Acquiring an understanding of anatomy takes time. It is a cumulative process achieved in a variety of ways. Written descriptions often point out important anatomical features. Use your own body to locate and sense anatomical features physically. The disciplined practice of drawing helps you not only to gather information but also to discover what you already know and what you still have to learn. The studio and independent study exercises suggested in this section will help direct your investigation into the study of anatomy. These are tasks you will want to return to and continue to practice.

Anatomy and Surface Comparisons

Pose – 90 minutes; standing or sitting
Media – graphite pencil, colored pencil, or conté pencil on drawing paper

Draw the configuration of the model's pose using light contour line. If a skeleton is available, place it near the model in approximately the same pose. After completing the line drawing, draw a small circle at the points where bones can be detected just beneath the skin, as in the kneecaps, shoulders, or hips. Then, using the skeleton and visual diagrams,

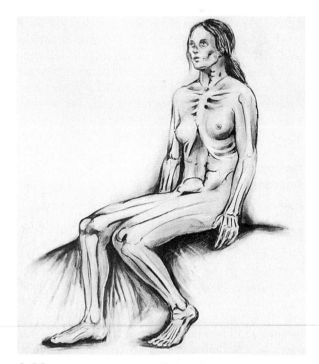

6.29
Mark Stockton. Student drawing. Skeleton surface comparison.

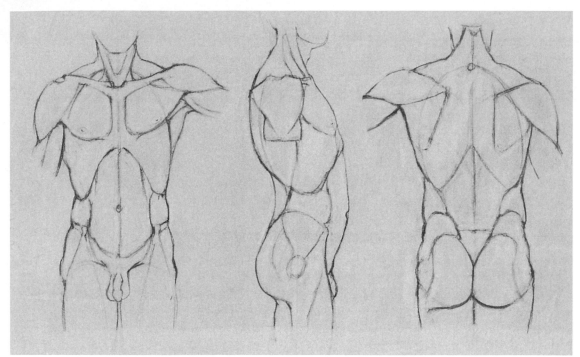

6.30
Schematic anatomy sketch of the torso.

draw the position and form of the anatomical struc-
ture as you visualize it beneath the surface, as if
you had x-ray vision (Figure 6.29). Notice in particu-
lar those areas in the torso where the skeleton
forms the primary structural component; this will
also help you locate the major muscular structures.
You may want to use a different color for drawing
the skeleton and muscles. If time permits, repeat
this exercise from different views.

Analysis of the Torso's Anatomical Structure

Pose – 30 minutes each; standing or sitting, three views
 (front, back, side)
Media – graphite or charcoal on drawing paper

Although you might sketch in the limbs, your pri-
mary focus in this exercise will be on the anatomi-
cal structure of the torso. After defining the initial
configuration, analyze the anatomical forms in de-
tail. Refer to the anatomical illustrations in the text
to help you identify the reason for the forms that
you see. This will also provide you with additional
information to give the figure a structural integrity
that derives from its underlying anatomy. Avoid get-
ting too detailed; there is no need to draw every

muscle strand. Instead, find the larger anatomical
factors that give the body its bulk and mass. Figure
6.30 provides an example of planar analysis of the
torso's anatomical structure.

Integrating the Skeleton and Muscles

Pose – 90 minutes, model standing or sitting on a stool
Media – gray-toned paper, colored pencils (recommended
 colors: light blue, reddish brown, black, and white)

To finish this drawing in the suggested time, focus
your attention only on the torso of your model.
Begin your drawing by lightly sketching in the con-
tours with either your white or black pencil. Use
your blue pencil to draw in the underlying skeletal
structure—rib cage, pelvis, spine, and shoulder gir-
dle. Then, using your reddish-brown pencil, add the
muscle structure—as it appears covered with
skin—over the skeletal armature. In the end, you
may wish to use both white and black to further
model the form. See Figure 6.31 for an example.

Another alternative is to draw with graphite,
using overlapping layers of transparent vellum. The
first drawing on the bottom sheet of paper defines
the torso's skeleton. The muscle structure is drawn
on the overlapping transparent vellum sheet.

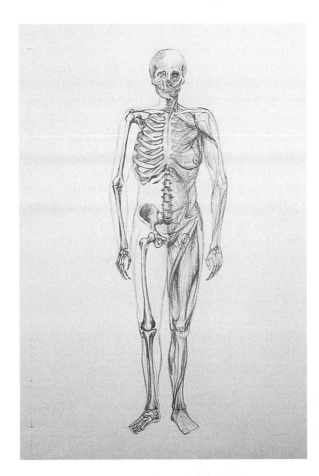

Independent Study

1 Using the anatomy illustrations in this text for reference, study the interrelationship of the skeleton and the muscles of the torso by doing a layered drawing with bones and muscles in different pencil colors or on overlapping pieces of tracing paper. First draw the skeleton, then draw the muscles of the torso from memory, in front, back, and side views. Check the accuracy of your memory, and make any necessary corrections. Repeat the exercise until you can accurately define the musculature of the torso from memory. **2** Draw the upper section of the torso from front and back, showing how the shoulder girdle is affected by raising the arm. Show one arm raised and the other lowered. Use the text illustrations (Figures 6.20 and 6.21) as references. **3** Make a study of the proportional differences between male and female figures as seen from the front, side, and back. See Figure 6.32.

6.31
Karen Hsu. Student drawing. Integrating the skeleton and muscles.

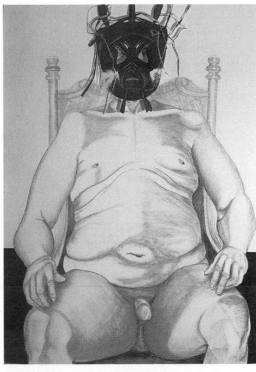
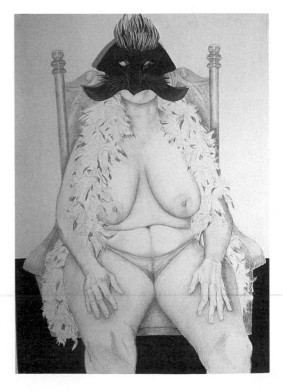

6.32
Mary Rounds. Student drawing. Study of male and female torsos.

Chapter Seven

Anatomy of the Limbs

Study muscles so that you know the nature of what you see. . . . Anatomy is a tool like good brushes.

—*Robert Henri*

Some of the bones and muscles affecting the articulation of the limbs with the torso, introduced in the previous chapter, provide a means of understanding how the anatomy of the different regions of the body are integrated. The muscles that overlap both limbs and torso, tying them together visually and physically, allow tremendous flexibility of movement while maintaining the position of the skeleton at the joints underneath.

This chapter will first present the anatomy of the legs and arms and then conclude with the hands and feet, which share structural similarity but are more complex and challenging to draw.

The Leg

Leonardo da Vinci's drawing (Figure 7.1) provides an excellent example of how one may direct one's study through creation of a personal anatomical notebook. Here Leonardo compares the skeletal structure of a human with that of a horse and studies the musculature of a man's legs.

The length and supportive capability of the leg are determined by the three longest bones of the body: the thigh bone *(femur),* shin bone *(tibia),* and calf bone *(fibula),* which can all be seen in the x-ray views of Figures 7.2, 7.4, 7.5, and 7.6. The great trochanter of the femur, visible as the bulge at the hip, serves as an important landmark on the body, approximately halfway between the heel and the top of the skull of a standing figure. Although the femur itself comes to the surface only at the hip and as protrusions at the knee, its slight bow from hip to knee is echoed in the general form of the thigh. At the knee, the kneecap *(patella)* forms another important landmark in terms of the body's proportions. You can trace the patella's triangular shape with your fingers, and when your knee is relaxed, you can feel how loosely the ligaments attach it, holding it afloat above the knee joint. On either side of the patella, you can feel the knobby ends of the femur *(epicondyles).* Just below, the top of the tibia protrudes slightly. From the patella, follow

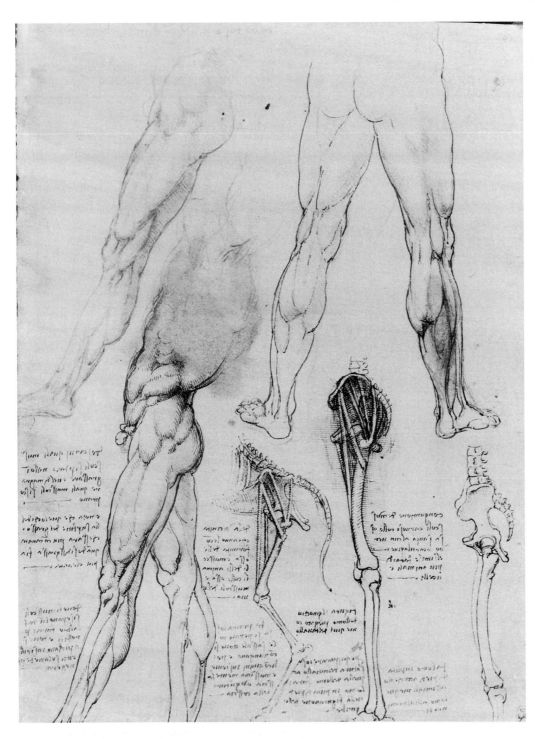

7.1
Leonardo da
Vinci.
*Comparison of
Legs of Man
and Horse.*
Black chalk,
gone over with
pen and ink on
white paper,
26.5 × 18.6 cm.
The Royal
Collection
© 2003, Her
Majesty Queen
Elizabeth II.
(RL12625r)

the forward edge and flat surface of the tibia down to the inner ankle. This outer surface of the tibia (shin) is not padded by muscle, which makes this bone easy to locate as a long, flat shape running the length of the lower leg. The fibula, which runs parallel to the tibia, is smaller and buried under the muscles of the calf, except for a slight bump at the outside of the knee and at the outer ankle.

Front View of the Leg

When viewed from the front (Figure 7.2), the leg reveals several bony landmarks worth noting: the interior ankle, the front surface of

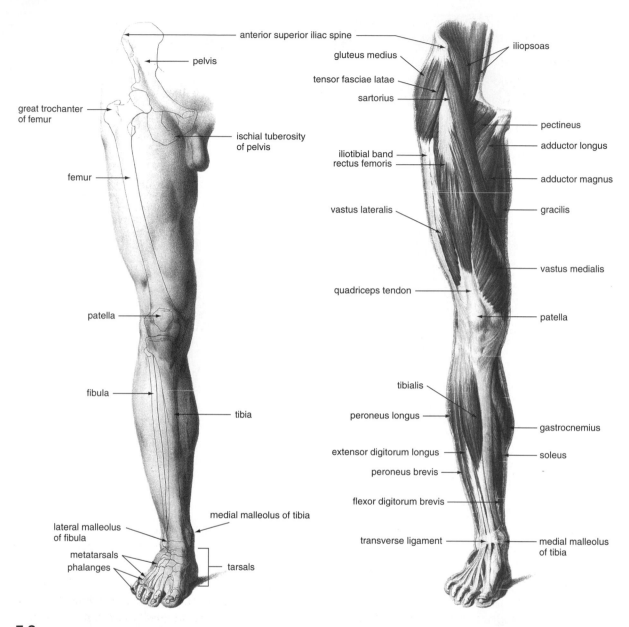

7.2
M. Leveillé/Dr. Fau. *Diagram of Skeletal and Muscular Structure of the Leg, Front View.* Harvard Medical School, Francis A. Countway Medical Library, Boston.

the tibia, the patella, and the frontal point of the iliac spine on the pelvis, called the anterior superior iliac spine. This protrusion is a point of origin for the large muscles known as the *quadriceps*, which make up the bulk of the thigh. The *rectus femoris* is the most visible, occupying a central position running from the pelvis to the patella. It is flanked by the *vastus lateralis* on the outside and the *vastus medialis* on the inside, which extends lower, creating the fleshy pad you can feel on the inside of your knee when your leg is extended and tensed. The fourth quadricep, the *vastus intermedius*, is covered entirely by the rectus femoris. The quadriceps, joined by a common band of tissue called the *quadriceps tendon*,

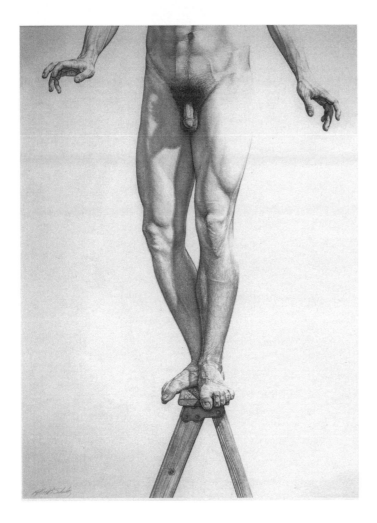

7.3
Robert Schultz. *Ascending.* 1999.
Graphite on paper, 17¹/₂ × 12".
Courtesy of Koplin Del Rio Gallery,
West Hollywood, California.

attach to the patella and continue below it in the fibers of the *patellar ligament*. You can grasp the quadriceps tendon above the patella when the leg is straight and tensed. As you bend the knee you can feel the patellar ligament. Several *adductor muscles (iliopsoas, adductor longus, gracilis,* and *pectineus)* fill the inside upper thigh, crossing from the pelvis to attach at the femur (Figures 7.2 and 7.5). These muscles are collectively significant because of their overall bulk.

Commonly called the "tailor's muscle," the *sartorius* is the longest muscle of the body. Narrow and flat, it originates at the anterior superior iliac spine and moves diagonally from the upper outside of the pelvis down to the inside of the thigh, attaching to the shaft of the tibia below the knee. The sartorius func-

tions to flex and rotate the thigh. As this strap of muscle crosses over the thigh from outside to inside, it gives a diagonal orientation to the front of the thigh from hip to knee. At the top of the leg, the tensing muscle *(tensor fasciae latae)* also starts at the iliac crest, then joins the *iliotibial band*, which stretches to the knee on the outside of the leg. The sartorius and tensor are referred to as the "reins of the knee" because they keep the knee joint in alignment. The muscles on the inside of the sartorius indicate the groin, or *adductor muscles*.

In Robert Schultz's intriguing drawing of a nude man precariously perched at the top of a ladder (Figure 7.3), the bunching tension of the flexing quadriceps is prominent. The inverted V form on the front of the thigh consists of the sartorius on the inside and the

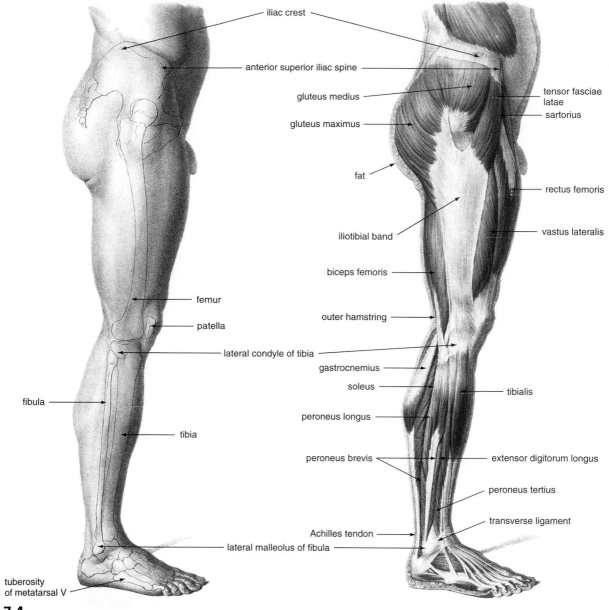

iliac crest

anterior superior iliac spine

gluteus medius

gluteus maximus

fat

iliotibial band

biceps femoris

outer hamstring

lateral condyle of tibia

gastrocnemius

soleus

peroneus longus

peroneus brevis

Achilles tendon

lateral malleolus of fibula

tensor fasciae latae

sartorius

rectus femoris

vastus lateralis

tibialis

extensor digitorum longus

peroneus tertius

transverse ligament

femur

patella

fibula

tibia

tuberosity of metatarsal V

7.4
M. Leveillé/Dr. Fau. *Diagram of Skeletal and Muscular Structure of the Leg, Outside View.* Harvard Medical School, Francis A. Countway Medical Library, Boston.

tensor fasciae latae on the outside. The large muscular form emerging between the two represents the bulk of the quadriceps: the rectus femoris in the center, the vastus lateralis on the outside, and vastus medialis emerging as a large form above the knee.

Inside and Outside Views of the Leg
The leg's outer profile (Figure 7.4) shows that the muscles that originate along the iliac crest and overlay the pelvis are in effect gathered together by the iliotibial band. This strong, flat ligament joins the *gluteus* muscles with the tensor fasciae latae, which originates at the anterior superior iliac spine and stretches the full length of the femur to attach itself to the tibia below the knee joint. In the upper leg, the frontal contour has greater curvature than the back due to the mass of the quadriceps. The reverse is true with the lower leg,

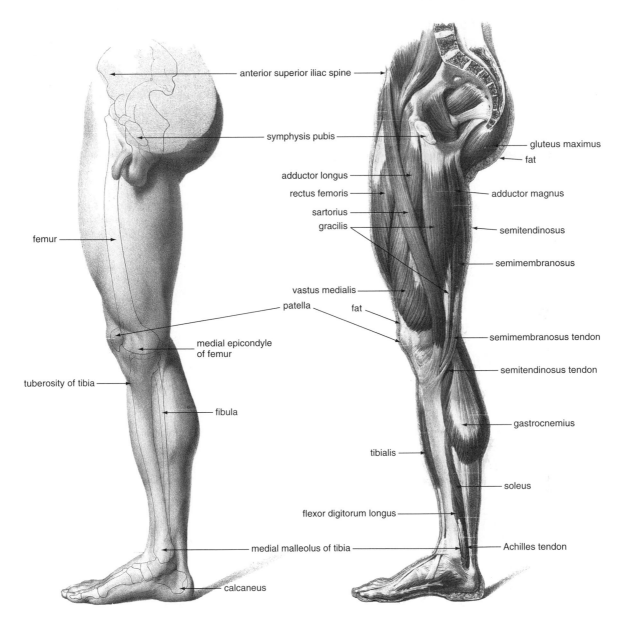

7.5
M. Leveillé/Dr. Fau. *Diagram of Skeletal and Muscular Structure of the Leg, Inside View.* Harvard Medical School, Francis A. Countway Medical Library, Boston.

where the more bulky calf muscle *(gastrocnemius)* creates a convex contour until it attaches, via the *Achilles tendon*, at the ankle. The frontal contour of the lower leg follows the tibia. The leg as a whole tapers continuously from pelvis to ankle. Near the ankle, the leg consists almost entirely of bones and ligaments.

Notice in the inner profile view (Figure 7.5) how the sartorius follows a curved path from the upper thigh to the back portion of the knee, attaching with several other muscles of the inner thigh via thick tendons at the tibia. This linear flow is amplified by the thigh muscles that move from back to front around the knee joint to the tibia. In the x-ray drawing illustrating the position of the bones in reference to the exterior, we can see how their position and shape combine with the muscles and tendons

to create the forms of the knee. The muscles of the calf originate on the femur, and their function is to flex the foot.

Back View of the Leg

When viewing the leg from behind (Figure 7.6), it is possible to see the full dimensions of the *gluteus maximus*, from its origin on the sacrum and iliac crest to the femur, where the

usual layer of fat (indicated on Figures 7.4 and 7.5) that forms the *gluteal furrow* has been omitted to reveal the muscles underneath. The visibility of this fold of skin depends on the amount of fat as well as whether the thigh is extended or flexed. Notice that the large *hamstring* muscles (the *semimembranosus*, *semitendinosus*, and *biceps femoris*) all emerge from under the gluteus maximus at

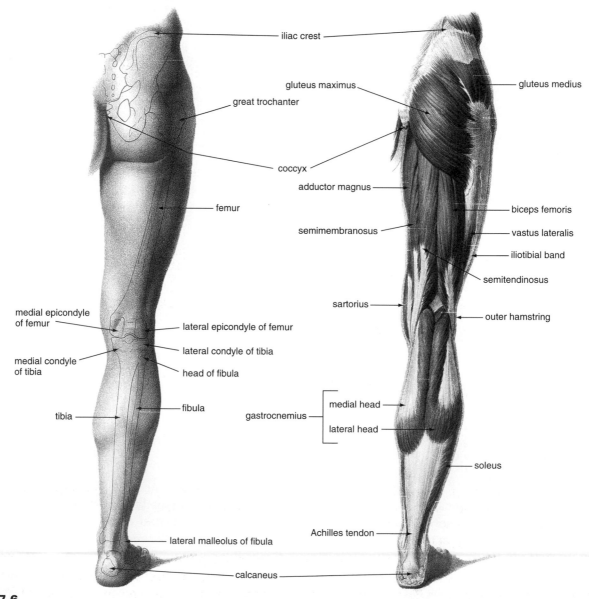

7.6
M. Leveillé/Dr. Fau. *Diagram of Skeletal and Muscular Structure of the Leg, Back View.* Harvard Medical School, Francis A. Countway Medical Library, Boston.

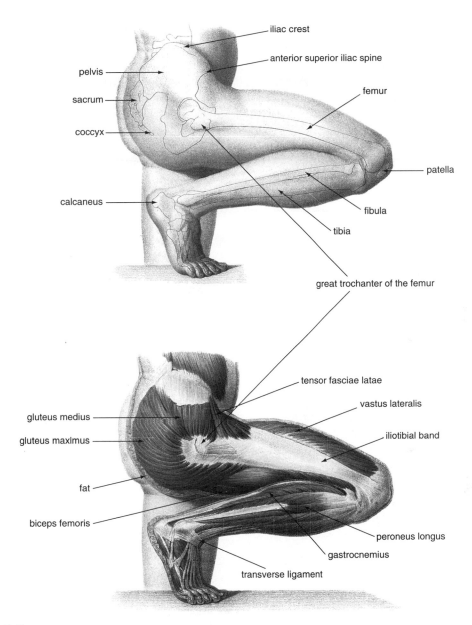

iliac crest

anterior superior iliac spine

pelvis

femur

sacrum

coccyx

patella

calcaneus

fibula

tibia

great trochanter of the femur

tensor fasciae latae

vastus lateralis

gluteus medius

gluteus maximus

iliotibial band

fat

biceps femoris

peroneus longus

gastrocnemius

transverse ligament

7.7
M. Leveillé/Dr. Fau. *Diagram of Bent Leg, Outside View.* Harvard Medical School,
Francis A. Countway Medical Library, Boston.

their origins on the pelvis and move along-
side the femur to part and attach to the tibia
and fibula on either side below the knee. The
calf muscles (gastrocnemius) emerge from
their origin at the lower end of the femur be-
hind the knee, out of the gap formed by the
tendons of the parting hamstring muscles of
the thigh. Although the gastrocnemius has
three heads, two are dominant (*medial* and

lateral) and apparent as bulges that give the
lower back leg most of its definition.

The Bent Leg

Four main points of articulation control the
movement and alter the shape of the lower
limbs: the hip, knee, ankle, and ball of the
foot. Figures 7.7 and 7.8 illustrate how the
form and musculature of the leg are arranged

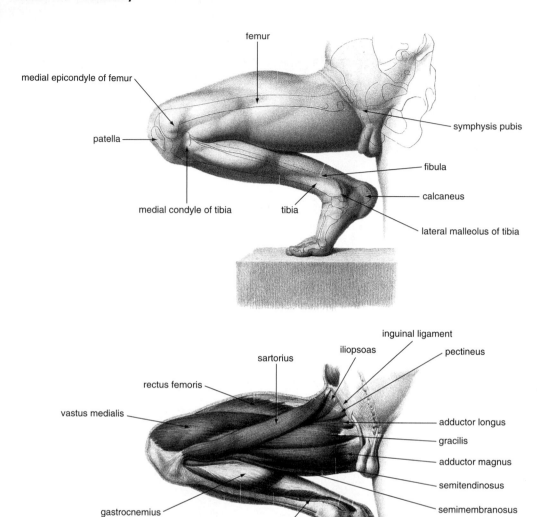

7.8
M. Leveillé/Dr. Fau. *Diagram of Bent Leg, Inside View.* Harvard Medical School, Francis A. Countway Medical Library, Boston.

when the leg is bent, with all four joints flexed. In the outside view (Figure 7.7), note how the subtle bow of the femur is accentuated by the muscles on the outside upper edge and how the bones of the leg relate to one another in length. The great trochanter of the femur rests almost directly above the ankle. The gluteal furrow on the underside of

the buttock is stretched out and no longer visible. Note also that at the knee, the bones of the lower leg pivot around to the back of the bulbous knob of the femur, and the patella shifts to protect the end of the femur and fibula.

The inner profile (Figure 7.8) reveals how the sartorius pulls diagonally across the main

7.9
Peter Paul Rubens. *Three Figures in the Miracles of St. Francis Xavier.* Black chalk, 8³/₁₆ × 11¹¹/₁₆". V&A Images, Victoria and Albert Museum, London.

flow of the thigh mass to attach at the tibia. You can see the large swelling of the quadriceps (vastus medialis) over the interior side of the knee. Near the trunk, along the inguinal ligament, a hollow pocket forms in the region of the adductor muscles, where the usually indistinguishable muscles and ligaments become more pronounced under the sartorius. In this position the calf muscle contracts, projecting noticeably over the shaft of the tibia from the knee to the inside ankle.

The leg study in Rubens's drawing (Figure 7.9), showing a similar position of the leg from the outside view, emphasizes the peroneus longus, which wraps from the side of the lower leg to attach at the base of the fibula. You can also see the slight bulge of the soleus be-

tween the peroneus longus and the gastrocnemius. At the knee, the bony understructure lies visibly just beneath the skin. The kneeling leg, viewed from the back, shows the cylindrical shape of the calf muscles.

Traditional and contemporary artists who use the figure often follow rough compositional sketches with more detailed anatomical studies from life models. Rubens's study (Figure 7.9) is an example of this kind of intermediate drawing. It provides information about how the underlying anatomy affects the shape and surface of a leg in several positions, but it also reflects the degree to which such old master drawings went beyond simply diagramming the anatomy. The primary concern is to make the figure convincing and lifelike without overstating details.

7.10
Leonardo da Vinci. *Muscles of the Right Arm, Shoulder, and Chest.* Pen and ink over black chalk. The Royal Collection © 2003, Her Majesty Queen Elizabeth II. (RL 19008v)

The Arm

Leonardo advised us to "study anatomy as a science. Be methodical and do not quit one part until it is perfectly engraved on your memory."[1] His arm studies (Figure 7.10) show the meticulous detail with which he documented his own explorations. He knew that a thorough understanding of the structure of the arm and hand enables the artist to fully capture their power and expressiveness.

The Skeletal Structure of the Arm

When considered as a skeletal unit separate from the trunk, the arm begins where the bone of the upper arm (humerus) fits into the shoulder socket (Figure 7.11). Together with the humerus, the two bones of the forearm, the *ulna* and the *radius*, provide the armature and determine the proportion of the arm from shoulder to wrist. The hand, with all its anatomical complexity and gestural diversity, will be dealt with in more detail later in this chapter.

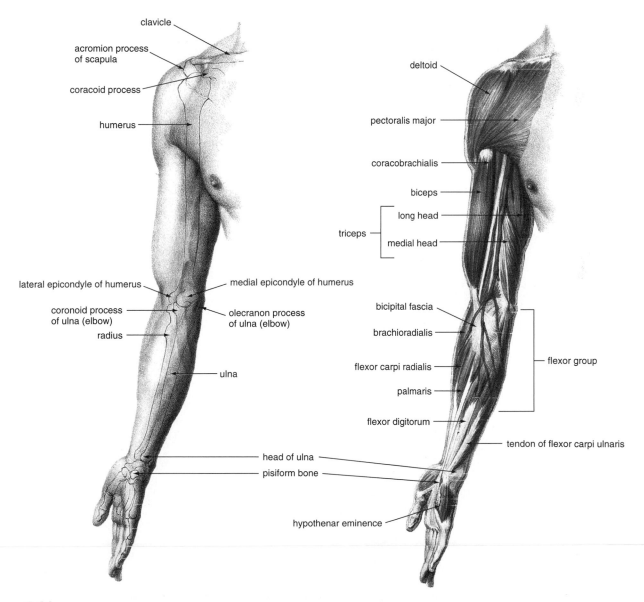

clavicle
acromion process of scapula
coracoid process
humerus
lateral epicondyle of humerus
medial epicondyle of humerus
coronoid process of ulna (elbow)
olecranon process of ulna (elbow)
radius
ulna
head of ulna
pisiform bone

deltoid
pectoralis major
coracobrachialis
biceps
long head
medial head
triceps
bicipital fascia
brachioradialis
flexor carpi radialis
palmaris
flexor digitorum
flexor group
tendon of flexor carpi ulnaris
hypothenar eminence

7.11
M. Leveillé/Dr. Fau. *Diagram of Skeletal and Muscular Structure of the Inner Arm.* Harvard Medical School, Francis A. Countway Medical Library, Boston.

The outer arm (Figure 7.12) reveals several key points of reference for the skeleton of the arm: the outside edge of the shoulder *(acromion process)* just above the joint; the point of the elbow, the *olecranon process of the ulna*; and the far ends of the ulna and radius at the wrist. The humerus is quite straight and does not influence the external form of the upper arm in an overt way except at the elbow, where it widens considerably to create the socket for the olecranon process of the ulna. The ulna inserts between two bony protrusions at the end of the humerus to form a hinge-type joint, with the olecranon process being the actual tip of the elbow at the back of the arm. From this tip, you can easily follow the edge of the ulna with your fingers down to your wrist. This edge, known as the *ulnar*

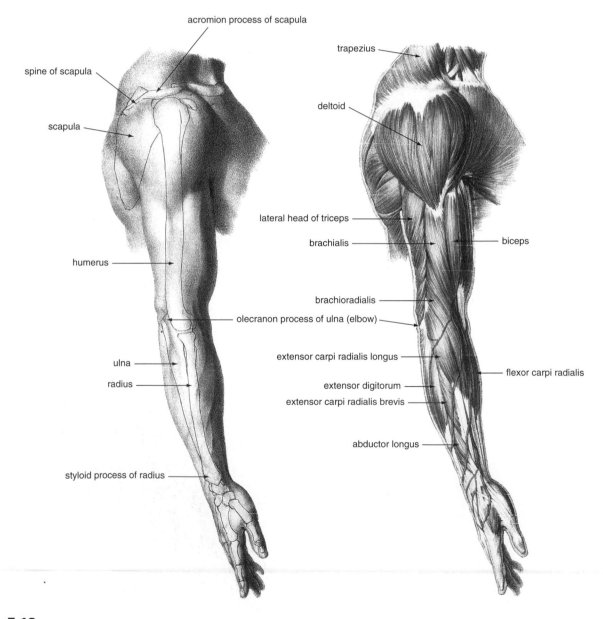

acromion process of scapula

spine of scapula

scapula

humerus

ulna

radius

styloid process of radius

trapezius

deltoid

lateral head of triceps

brachialis

biceps

brachioradialis

olecranon process of ulna (elbow)

extensor carpi radialis longus

flexor carpi radialis

extensor digitorum

extensor carpi radialis brevis

abductor longus

7.12
M. Leveillé/Dr. Fau. *Diagram of Skeletal and Muscular Structure of the Outer Arm.* Harvard Medical School, Francis A. Countway Medical Library, Boston.

crest, forms a direct line from the tip of the elbow to the head of the ulna, which you can feel as a bony protuberance on the little finger side of the wrist.

The elbow end of the ulna is locked into position, but the radius is free to turn and twist across the ulna, enabling the hand to turn over from a palm-up position, with the ulna and radius in parallel alignment, to a palm-down position, with the two bones of the forearm crossing. Rotate your hand from palm up to palm down, watching the action of the bones of your forearm, most visible just above the wrist. When the thumb is turned to the inside and down, the overall form of the forearm is modified and reflects twisting or crossing action.

The Muscular Structure of the Arm

The large shoulder muscle (deltoid) covers the shoulder socket, joining the shoulder to the arm and controlling the arm's vertical movement (Figures 7.12 and 7.13). Named for its resemblance to the Greek letter *delta*, the

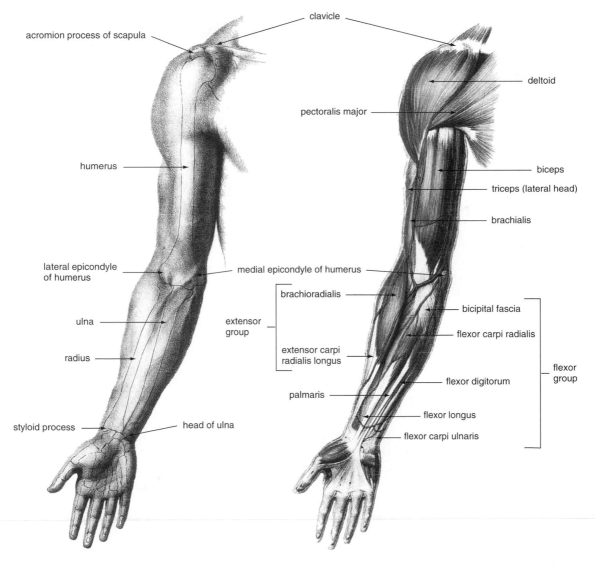

7.13
M. Leveillé/Dr. Fau. *Diagram of the Arm, Front View.* Harvard Medical School, Francis A. Countway Medical Library, Boston.

deltoid's shape can best be seen in Figure 7.12. The deltoid covers the insertion of the chest muscle, or pectoral, where it attaches to the humerus, and the origin of the large muscles of the upper arm (biceps and triceps).

Perhaps no single muscle in the human body is more familiar than the biceps (Figure 7.13). This great flexor is a symbol of power, and it will bend the arm of practically any youth hearing the command, "make a muscle." The biceps is assisted in its function by the *brachialis*, to a great extent covered by the biceps. Both muscles cross over the front side of the elbow joint as wide tendon bands to attach to the ulna and radius in between the flexor and extensor muscle groups of the forearm. Flex your own biceps and feel this tendon pulling up on your forearm.

On the back of the upper arm (Figure 7.14) is the triceps, an extensor that straightens the arm, as when doing push-ups. As the name implies, this muscle originates with three heads

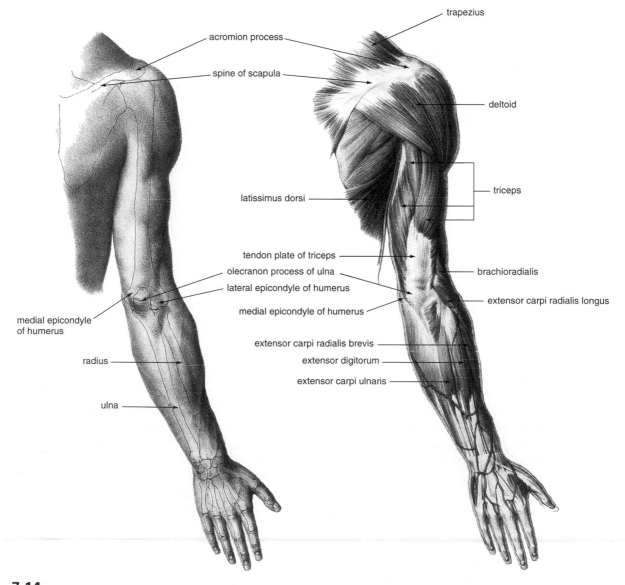

7.14
M. Leveillé/Dr. Fau. *Diagram of the Arm, Back View.* Harvard Medical School, Francis A. Countway Medical Library, Boston.

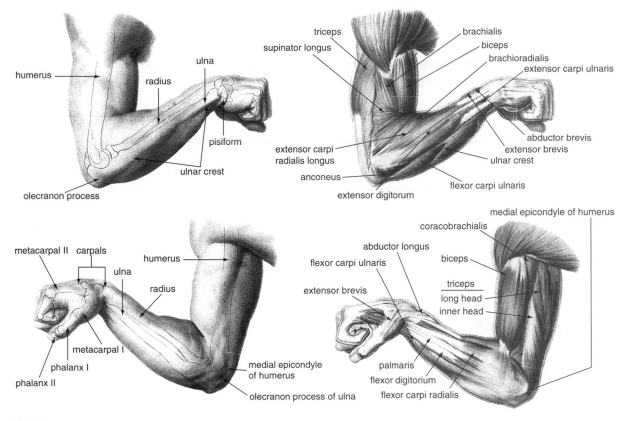

7.15
M. Leveillé/Dr. Fau. *Diagram of Arms Flexed.* Harvard Medical School, Francis A. Countway Medical Library, Boston.

that emerge from under the deltoid midway down the back of the upper arm. The three heads are integrated into broad tendon fibers that cover the lower back side of the humerus to the elbow joint.

The fact that the muscles of the forearm are much thicker near the elbow and then become stringy tendons at the wrist gives the forearm its characteristic tapered appearance. The wrist is primarily an area of tendons, skin, and bones, whereas the upper forearm is fleshy. The two main muscular masses on the forearm are divided by the ulnar crest on the underside of the arm and by the tendon of the biceps on the forearm. The first of these two muscle groups, those on the inside or underside nearest the body, are called the *flexor group*. They bend the hand toward the palm and rotate the wrist palm-side down (primarily, *flexor carpi radialis* and *flexor carpi ul-*

naris). They originate on the humerus at the inside of the elbow. From there, they extend to the palm side of the hand. These muscles are relatively short and bulky and create a considerable knot when flexing the hand, as Figure 7.15 shows.

The second muscular mass, the *extensor group* (*brachioradialis* and *extensor carpi radialis longus*, primarily), on the top of the forearm, extend the hand and rotate the wrist to a palm-up position. Notice in Figure 7.15 (top) that the extensor group of muscles originates a short distance up the shaft of the humerus, and as it moves down over the elbow joint, it wraps over the radius of the forearm, moving down to the back of the hand.

Throughout this section on anatomy, it is useful to examine drawings of old masters: see how the shifts in value and line define the muscular forms presented in the anatomy

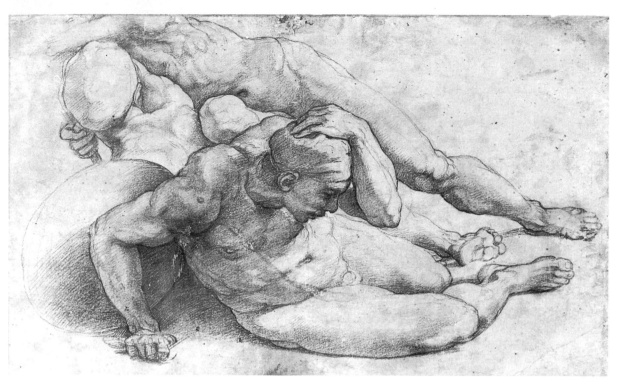

7.16
Raphael. *Three Guards*. Black chalk, 23.4 × 36.5 cm. The Devonshire Collection, Chatsworth. Reproduced by permission of the Duke of Devonshire and the Chatsworth Settlement Trustees.

charts; compare the charts with the drawings to identify the anatomy suggested beneath the surface.

For example, take a look at Raphael's drawing (Figure 7.16), which makes many references to anatomy: the use of line to define the sartorius as it wraps under the knee on the forward figure; the shift in value that delineates where the deltoid attaches to the humerus between the biceps and the triceps; the ridge of the ulna revealed with line in the arm that cradles the figure's head. Notice how the overlay and interplay of muscles are reflected in the rhythmic fluidity of Raphael's lines. Some of the lines are darkened for emphasis; others are left light as cross-contouring lines that make reference to anatomical forms. Lines often move in from the outer edge both to suggest the interlocking of the muscles and to create a sense of the spatial progression of overlapping muscles. Value shifts suggest many subtle surface

variations without losing the sculpted reality and unity of the whole.

The Hands

Hands are as individualistic as faces and in many ways reflect an individual's character as they express a momentary gesture. Compare the lifestyle suggested by the genteel hands so delicately playing an instrument in Figure 7.17 with the gnarly, big-knuckled hands of van Gogh's sketch (Figure 7.18) of a figure for his famous painting *The Potato Eaters*. Without seeing anything more, we understand a great deal about the individuals to whom these hands belong. Yet even though they speak of different worlds, these hands share a common anatomy.

Hands are particularly challenging to draw. They are complex, made up of many small bones and numerous joints, which allow freedom of movement and permit them to assume an ever-changing variety of postures. It

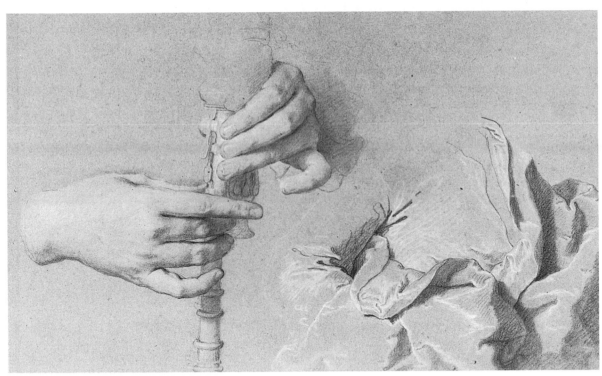

7.17
Hyacinthe Rigaud. *Sheet of Studies of Hands Playing Bagpipes and Drapery*. 1735. Black and white chalk on blue laid paper, 29.8 × 45.1 cm. Fine Arts Museums of San Francisco. Achenbach Foundation for Graphic Arts. Gift of Mr. and Mrs. Sidney M. Ehrman, 1953.34.

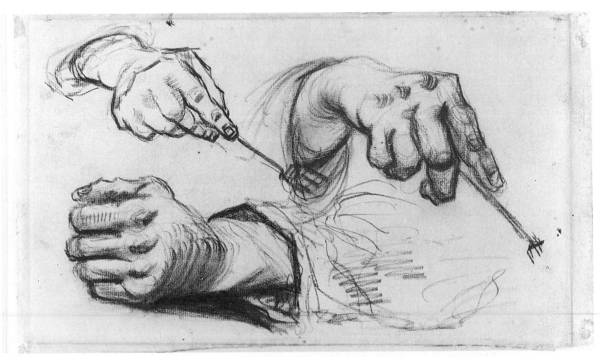

7.18
Vincent van Gogh. *Study of Three Hands*. 1885. Black crayon, 8 × 13". Vincent van Gogh Museum Foundation, Amsterdam, The Netherlands. Inv. No. F1161R.

may seem impossible to generalize about their form and proportion in such a way that would be consistently relevant and applicable from one drawing to the next. However, the structure of the hands remains constant, and when you understand it, drawing these mutable appendages can become a very expressive part of the overall presentation.

The Skeletal Structure of the Hand

The hand is composed of three regions—wrist, palm, and fingers—defined by the skeleton (Figure 7.19). The smallest portion is the wrist, the joint that connects the forearm to the hand, which consists of a cluster of eight small bones *(carpals)* that enable the hand to bend frontward, backward, and side to side. The middle section, the palm, is made up of the largest bones of the hand, the five

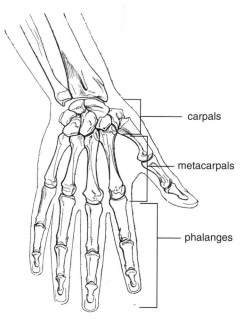

7.19
Bones of the hand.

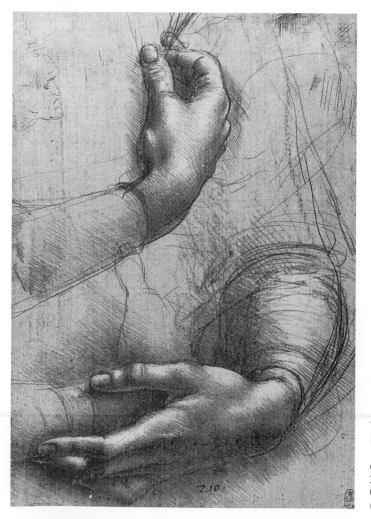

7.20
Leonardo da Vinci. *Study of a Woman's Hands (probably Ginerva de' Benci).* c. 1474. Silverpoint heightened with white, 21.5 × 15 cm. The Royal Collection © 2003, Her Majesty Queen Elizabeth II. (RL 12558)

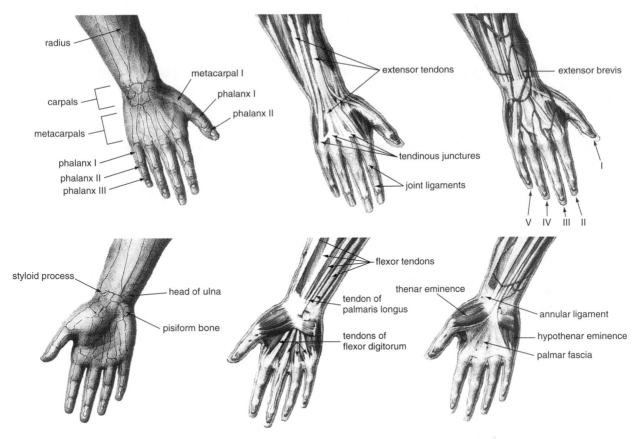

7.21
M. Leveillé/Dr. Fau. *Diagram of Hands, Top and Palm Views.* Harvard Medical School, Francis A. Countway Medical Library, Boston.

metacarpals. The four metacarpals connected to the fingers are linked horizontally by tendinous junctures, which inhibit their movement. The fifth metacarpal, the thumb, has no such restriction and can move independently. The third region comprises the five moving digits: the fingers, with three *phalanges* each, and the thumb, with two phalanges.

Bone structure determines the shape of the fingers with the bulging of the knuckle joints. On your own hands, feel down from the fingertip of your index finger to where it widens at the first knuckle joint. The middle phalange tapers to the center, then flares again to form the knuckles of the middle joint. The phalange joining to the palm of the hand is thicker but has bony knobs at either end to accommodate the joints. On the back of the hand, you can trace the lines of the bones to the wrist.

Although many exceptions exist to disprove such generalities, the female hand is comparatively smaller in proportion and generally narrower and more tapered than the male's. In Leonardo's study of hands (Figure 7.20), notice the pentimento image of the upper hand, where the knuckles were once drawn larger and are now partly covered by hatch lines. Leonardo reveals the solidity of the hand's skeletal understructure that lies beneath the soft exterior.

The Muscular Structure of the Hand

The muscles that control most of the movement of the hand do not reside in the hand itself but originate with the upper forearm, and only the tendons of these muscles pass into the hand at the wrist (Figure 7.21). This arrangement gives the hand a great deal of strength

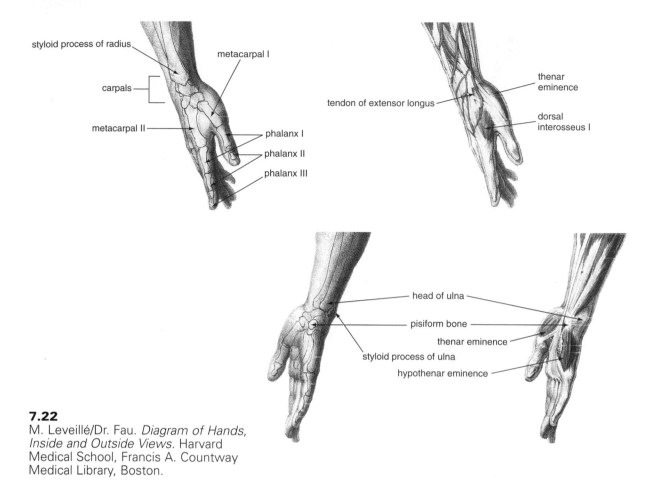

7.22
M. Leveillé/Dr. Fau. *Diagram of Hands, Inside and Outside Views.* Harvard Medical School, Francis A. Countway Medical Library, Boston.

without adding excess weight at the arm's extremities. Only on the palm are there muscles that assist in moving the fingers and thumb. Figure 7.22 shows two groupings that make a noteworthy contribution to the form of the hand: The "heel" of the hand *(hypothenar eminence)* helps flex the little finger. The muscles that move the thumb in opposition to the fingers constitute the larger "ball of the thumb" *(thenar eminence).* In many ways, the thumb and the ball of the thumb form an independent unit that works in opposition to the rest of the hand and is divided like the two units of a mitten. The palm muscles and a thicker skin pad on the palm mask the skeletal structure lying underneath. On the back of the hand (Figure 7.21), bones, veins, and tendons lie just beneath the skin and, therefore, play a more significant role in determining form and visual appearance. The most visible features

on the back of the hand, however, are the tendons that run from the forearm, under the *annular ligament* at the wrist, and over each of the metacarpal bones to the fingers. Flex and bend your fingers and watch the play of tendons on the back of your hand.

Notice in Figures 7.22 and 7.23, where the hand is seen from the side, how close to the top outer surface the bones are and how much thicker the padding is on the palm side. Also, notice how the knuckles in the clenched fist protrude, and how the flexor groups of the hypothenar eminence and the thenar eminence swell out the underside of the palm.

The visual impact of anatomical components is clear in a classic drawing by Hans Hoffman, after Dürer (Figure 7.24). The pair of hands on the left are often reproduced as praying hands and have become a well-known religious icon through years of mass production.

7.23
M. Leveillé/Dr. Fau. *Diagram of Hands, Flexed, Outside and Inside Views.* Harvard Medical School, Francis A. Countway Medical Library, Boston.

ulna

pisiform

ulnar crest

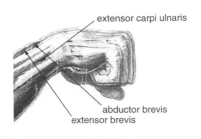

extensor carpi ulnaris

abductor brevis

extensor brevis

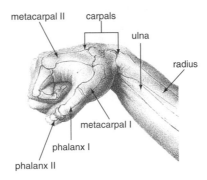

metacarpal II

carpals

ulna

radius

metacarpal I

phalanx I

phalanx II

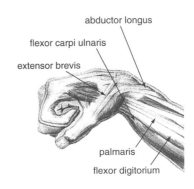

abductor longus

flexor carpi ulnaris

extensor brevis

palmaris

flexor digitorium

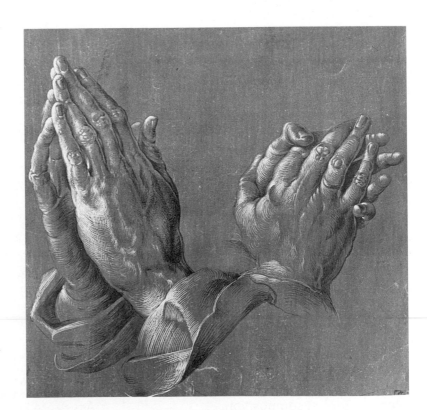

7.24
Hans Hoffman, after Dürer. *Study of Hands.* Pen with wash, 23.8 × 25.1 cm. Budapest Museum of Fine Arts, Hungary. Inv. No. 142.

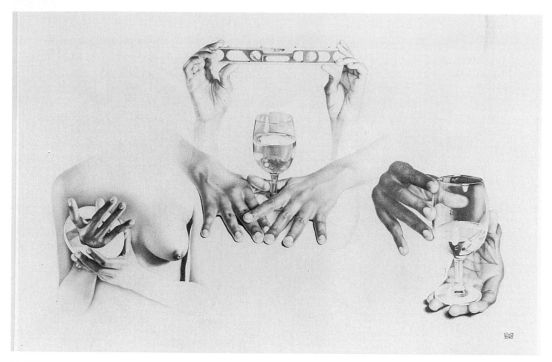

7.25
George Staempfli. *Althea's Hands.* 1982. Pencil, 14¹/₂ × 21". Courtesy of the artist.

Notice the suggestion of finger bones, the bumps of the knuckles, and a hint of the tendons that run over the metacarpals and the fingers.

In *Althea's Hands* (Figure 7.25), George Staempfli uses value as the primary tool for describing the anatomical form of the hand. To achieve a photographic likeness, Staempfli focuses his attention on the play of light, which he meticulously renders. The four sets of hands are sensitively arranged to allow the viewer to study them from a variety of perspectives and to compare the influence of the skeleton on the back side as well as the fleshier underside with its palm lines.

Like Staempfli's, the drawing by Canadian artist Ernest Lindner (Figure 7.26) is a form of portraiture. The interlocking arrangement of hands and feet conveys the posture and attitude of the figure as a whole as well as a pleasing formal composition.

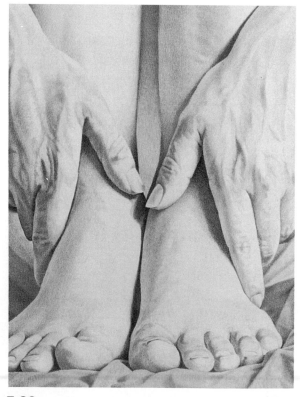

7.26
Ernest Lindner. *Resting.* 1975. Pencil, 29 × 21¹/₂". Collection of the Norman MacKenzie Art Gallery, Saskatchewan, Canada. Purchased with the assistance of the Canada Council Special Assistance Fund. © CARCC.

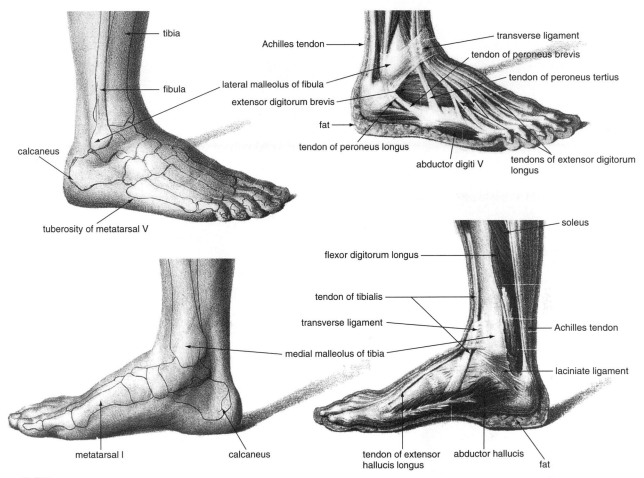

tibia

Achilles tendon

transverse ligament

tendon of peroneus brevis

fibula

lateral malleolus of fibula

tendon of peroneus tertius

extensor digitorum brevis

fat

calcaneus

tendon of peroneus longus

tendons of extensor digitorum longus

abductor digiti V

tuberosity of metatarsal V

soleus

flexor digitorum longus

tendon of tibialis

transverse ligament

Achilles tendon

medial malleolus of tibia

laciniate ligament

metatarsal I

calcaneus

tendon of extensor hallucis longus

abductor hallucis

fat

7.27
M. Leveillé/Dr. Fau. *Diagram of Foot, Outside and Inside Views*. Harvard Medical School, Francis A. Countway Medical Library, Boston.

The Feet

Drawing feet can be a challenge, though they are not as animated as hands, simply because the toes are shorter than the fingers and the diversity of movement is therefore limited.

The Skeletal Structure of the Feet

The foot, like the hand, consists of three parts, again defined by the skeleton (Figure 7.27). The tarsal bones make up the section equivalent to the wrist. This section of the foot articulates with the leg and bears the weight of the whole body. The seven *tarsal* bones are all bigger than those of the wrist, and the heel bone *(calcaneus)* is the largest of the group. The part of the foot that forms its midsection,

lying between the tarsals and the toes, is defined by the five *metatarsal* bones. These bones curve slightly and are arranged to form an arch between the tip of the heel and the toes. The toes have three phalanges each, except for the big toe, which, like the thumb, has only two. As with the hand, the bones of the female foot tend to be smaller and the whole form proportionately narrower than the foot of the male. When you see the foot in profile, you can envision how the weight of the body is carried down the bones of the lower leg to the ankle. Here, the weight is transferred to the heel and ball through the arch formed by the clustering of the tarsals and metatarsals. Notice how the metatarsals and phalanges are near the surface on top of the foot. A

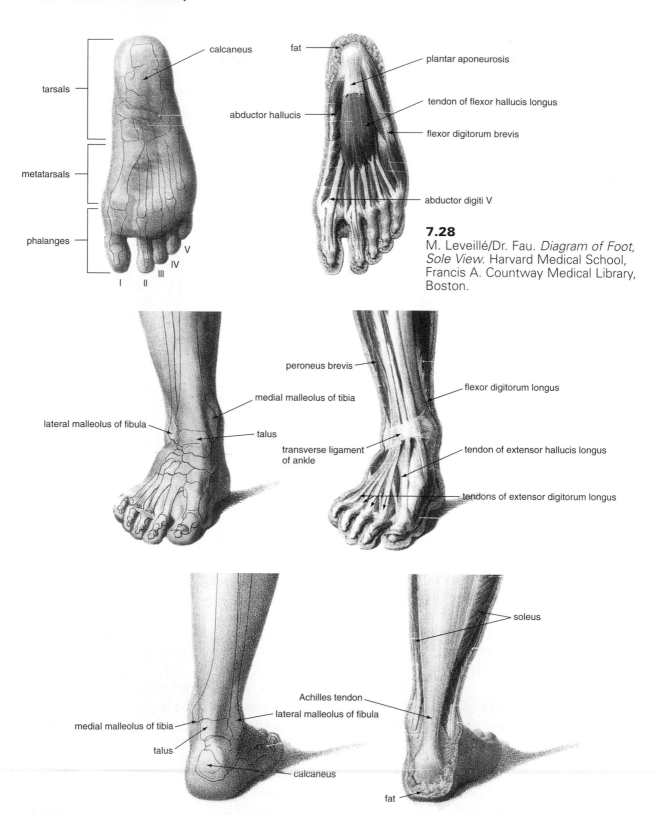

tarsals

calcaneus

fat

plantar aponeurosis

tendon of flexor hallucis longus

abductor hallucis

flexor digitorum brevis

metatarsals

abductor digiti V

phalanges

V

IV

III

I II

7.28
M. Leveillé/Dr. Fau. *Diagram of Foot, Sole View.* Harvard Medical School, Francis A. Countway Medical Library, Boston.

peroneus brevis

flexor digitorum longus

medial malleolus of tibia

lateral malleolus of fibula

talus

transverse ligament of ankle

tendon of extensor hallucis longus

tendons of extensor digitorum longus

soleus

Achilles tendon

medial malleolus of tibia

lateral malleolus of fibula

talus

calcaneus

fat

7.29
M. Leveillé/Dr. Fau. *Diagram of Foot, Front and Back Views.* Harvard Medical School, Francis A. Countway Medical Library, Boston.

slight bulge on the outer edge of the foot represents the tuberosity of the fifth metatarsal.

The Muscular Structure of the Feet

The bottom of the foot, as with the palm of the hand, contains more muscle and a considerable amount of padding. However, like the hand, most of the muscles that maneuver this appendage are not located on the foot itself but reside in the calf region of the lower leg and are attached to the foot with long tendons that pass over the ankle joint. On the top of the foot, these tendons fan out to each of the toes (Figure 7.28), creating a visual effect when you flex and extend your toes. When we stand, the heel and Achilles tendon form a right angle with the floor, and the instep rises on a diagonal incline to where it is flanked by

the ankles. Notice that the outside edge remains in contact with the floor from heel to toe, reflecting the proximity of the outside metatarsals to the floor. On the inside (Figure 7.27), where the bones are raised, the line from the ball of the big toe to that of the heel lifts slightly, revealing the arch of the foot.

In the back, the Achilles tendon attaches to the heel (Figures 7.29 and 7.30) and has a noticeable effect in defining form at the back of the foot, where it draws the ball of the heel into a teardrop shape. The ankle bones (the end of the tibia inside and the fibula outside, slightly lower) are also prominent where they flare out just above the foot. The ankles and tendons are tightly wrapped by the *transverse ligament*, which defines the diagonal slant from inside the ankle to the outside of

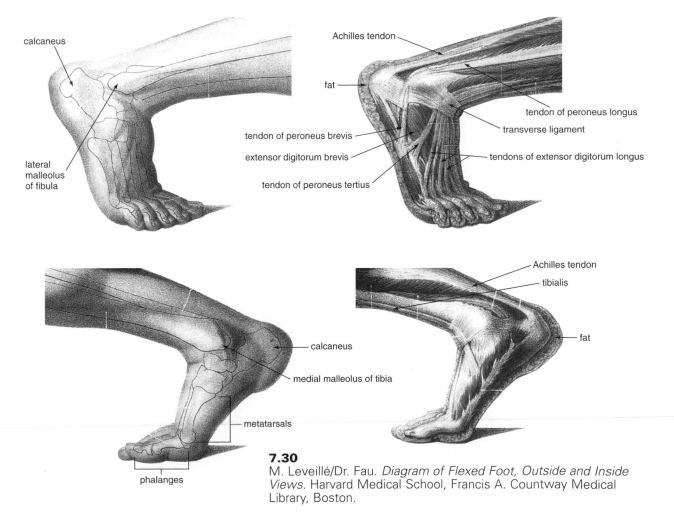

7.30
M. Leveillé/Dr. Fau. *Diagram of Flexed Foot, Outside and Inside Views.* Harvard Medical School, Francis A. Countway Medical Library, Boston.

the foot. The sole is dominated by substantial fat deposits at the heel and ball of the foot. Each toe pad also has a deposit of fatty tissue. This essential padding cushions the weight-bearing bones of the feet. For example, when running or squatting, all of the body's weight may be transferred to the forward portion of the foot. The articulation of this action can be seen in Figure 7.30.

The inset sketch of the profile and underside of the foot in the Rubens drawing shown earlier (Figure 7.9) displays some of the ways the basic proportions of the foot may become modified as it bends to extend and flex. Notice how the additional padding at the ball of the foot extends over much of the length of the underside of the toes, so that only the ends of the toes are visible, whereas they appear much longer in the profile view.

As with any aspect of drawing the figure, you have to draw the hands and feet often in order to draw them well. Rather than avoiding the challenges they present, face them. Make it a point to investigate their proportions and to analyze their structure. Use your own body as a resource, feeling your hands and feet to discover the bones, the muscular padding, and the tendons. Notice where and how they bend and how their movement brings about changes in their structure and appearance. An understanding of their basic anatomy will help alleviate the mystery and complexity of what you see. Most important of all, make a study of hands and feet through your drawings.

Drawings are not just for showing what you already know; they provide a means of gathering new information. When we see masters like Leonardo, Rubens, or van Gogh making studies of hands and feet, we must assume that we too need to give them some extra attention.

IN THE STUDIO

As with the previous chapter, the exercises here are designed to further your investigation of anatomy. Hands and feet are particularly challenging, even for accomplished artists. There is only one way to master the skill of drawing these complex appendages: through concentrated, repeated study and practice.

Schematic Analysis of Limbs, Hands, and Feet

Pose – 10 to 15 minutes for each study, several on a page
Media – graphite, charcoal, or conté on drawing paper

The purpose here is to use an analytic approach and a schematic-style drawing to define the structure of the arms, legs, hands, and feet. In general, this requires simplifying forms and describing them in terms of their basic geometric shapes. Begin by plotting the overall shapes, analyzing the angle and proportions of their configuration. Within the configuration, use your line to designate the placement of joints and any breaks in the surface planes. Refer to the illustrations in the text, but do not attempt to draw every detail. Instead, look for larger structural

relationships, as shown in Figure 7.31. The limbs of your model will often be bent or foreshortened and will not conform exactly to any illustration. Defining

7.31
Structural analysis of legs.

the anatomical structure in these situations will make you work harder, but the discoveries you make will be lasting.

Integrating Bones and Musculature of Limbs

Pose – 45 minutes
Media – colored pencils (recommended colors: light blue, reddish brown, black, and white) on gray-toned paper

After lightly defining the contour and configuration of the limbs with white or black pencil, use your light blue pencil to indicate what you believe would be the shape and position of the skeletal units, as if seen with x-ray vision. Use the visual cues where the skeleton's knobby protrusions lie just beneath the skin—at the hip, knee, and ankle. Then use your reddish-brown pencil to draw the flesh-covered muscular mass over your drawing of the bones. Your white and black pencils can be used to further model and add clarity to your drawing. See Figure 7.32.

An alternative approach is to do a layered drawing with graphite pencils. The underdrawing, done on regular drawing paper, defines the skeletal structure of the limbs. The overdrawing, on transparent vellum or tracing paper, reveals how the muscles are integrated with the skeleton.

Line and Value Studies of Hands and Feet

Pose – 30 minutes; using either a model or your own hands and feet
Media – graphite or charcoal pencil on drawing paper

Begin with a gestural sketch, drawing the configurations of the hands and feet. Allow lines to overlap to suggest spatial position, and lighten cross-contour lines to suggest interior bumps and furrows. Then, use value to define the structure of the forms, indicating variations in the surface and modeling the forms as they recede in space. You will find that if you draw each hand and foot close to its full scale, you will have a much greater feeling for its sculptural qualities.

Integrating the Bones and Muscles of the Whole Body

Pose – 3 hours
Media – colored pencils (light blue, reddish brown, black, and white) on gray-toned paper

The purpose of this exercise is to bring it all together by drawing the structural relationships of the bones and muscles of the body. Begin by lightly

7.32
Marc Bybee. Student drawing. Integrating bones and musculature of legs and torso.

drawing the configuration of the pose. Use a light blue pencil to draw in the body's skeletal armature. Then, using a reddish-brown pencil, define the body's musculature. Refer to the anatomical illustrations in the text for both of these steps. Black and white pencils can be used to add detail and clarity as well as to model the volume of the forms.

Independent Study

1 Using the anatomy illustrations in this text as models, draw the bones and muscles of the leg and arm from various views until you believe you have committed them to memory. Then, draw the skeleton and muscles of the leg and arm, relying only on your memory. Check your drawing for accuracy and make any necessary corrections. **2** Use both your text and yourself to make a thorough study of the anatomy of the hands and feet. **3** Complete anatomical studies of those areas of the body you find most challenging to draw, such as hands, elbows, or feet. Use yourself as a model and also draw from anatomy plates and old master drawings. **4** Putting it all together: Using the anatomical illustrations in the text, plot the anatomical structure of the interior body. First draw a standing male figure, then a female. Then, to test your understanding of anatomy, attempt to draw the figures from memory.

Chapter Eight

Heads and Portraits

If nature had a fixed model for the proportion of the face, everyone would look alike and it would be impossible to tell them apart; but she has varied the pattern in such a way that although there is an all but invisible standard as to size, one clearly distinguishes one face from another.

—*Leonardo da Vinci*

Portraits are often said to have captured not only the subject's likeness but the essence of the individual's personality. The very word *portrait* comes from the Latin *portrahere*, which means "to draw forth and reveal." In China, face reading is known as *siang mien* and has been practiced for centuries. In nineteenth-century Europe, reading facial features was developed into a pseudoscience called physiognomy. So much of an individual's personality is reflected through the face that drawing the face is often referred to as a character study.

Leonardo da Vinci was very interested in discovering a universal proportional standard for the head and face as well as for the human body, but he was equally fascinated by all of nature's subtle—and not so subtle—variations from what might be considered the norm. Figure 8.1 shows but one of many sketchbook pages Leonardo devoted to character studies. With these figures, Leonardo exaggerates physical differences to create caricatures in much the same way political cartoonists lampoon today's public figures.

In contrast, Michelangelo completed a number of elegantly drawn heads that were not studies for sculpture or paintings but were conceived as finished works in themselves (Figure 8.2). The fictitious subjects of these "presentation drawings," so called because they were presented as gifts, were the heads of ennobled humans, endowed with virtue, strength, and beauty. The characters Michelangelo portrayed came from his imagination and represented the personification of his ideals. In this regard, they are more portraits of the artist's lofty aspirations for humankind than of any living individual. The proportions and features of the heads he drew were, like many of his Neoplatonic beliefs, derived from classical antiquity.

Unlike the immortal figures of Michelangelo, Paula Modersohn-Becker's profile view of a peasant woman (Figure 8.3) comes directly from nature, presenting an honest depiction of down-to-earth reality. This profile has little resemblance to those classical features of

8.1
Leonardo da Vinci. *Eight Grotesque Heads*. Pen and ink, heightened with red chalk, 21.7 × 15.4 cm. The Royal Collection © 2003, Her Majesty Queen Elizabeth II. (RL 12491)

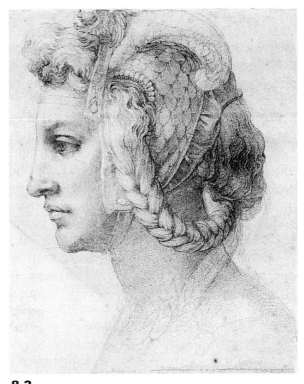

8.2
Michelangelo. *Ideal Head of a Woman*. Black chalk, 28.7 × 23.5 cm. © Copyright The British Museum, London.

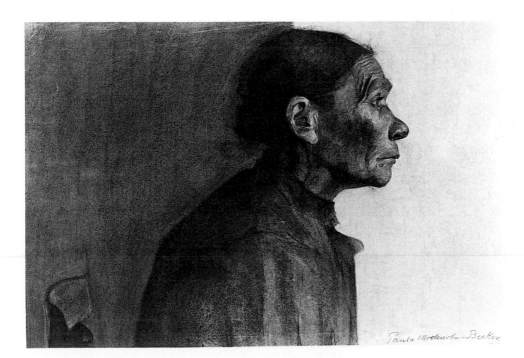

8.3
Paula Modersohn-Becker. *Portrait of a Peasant Woman*. 1898–1899. Charcoal on paper, 43.3 × 63.9 cm. Restricted gift of the Donnelley Family, 1978.26. Reproduction © The Art Institute of Chicago. Photo by eeva-inkeri.

antiquity, yet it captures a radiance and strength in the peasant woman's face. Placing the head in profile allows it to move across the divided background, out of the darkness and into the light. Unlike Michelangelo, Modersohn-Becker uses nothing more to adorn her subject than the light reflected from her weathered skin.

With this chapter's discussion of heads and portraits, our intent is not to offer a specific technique or method with which to draw the head but to present some universal information to establish a basic understanding of the structure of the head—its proportions and anatomy—and to present a cross-section of approaches to head studies and portraits.

The Proportions of the Head

As Leonardo pointed out, it would be very difficult to distinguish one individual from another if it were not for subtle variations in the proportions of our heads and facial features. Yet, as human beings, we all share some common structural features.

Leonardo suggested a universal standard that may serve as a proportional guide when drawing the head. In describing the proportions of the face, Leonardo located the eyes at a midpoint between the chin and the top of the head. "And from the chin to the nostrils is a third part of the face. And the same from the nostrils to the eyebrows, and from the eyebrows to the start of the hair."[1]

Figure 8.4 provides a simple schematic of the primary points of reference and proportional divisions of the head from both profile and front views. The general proportional relationships presented here conform to those prescribed by Leonardo and suggest how the head and face might be divided into easily remembered and comparable units. First, consider the overall shape or configuration of the head as an oval or an egg with the smaller, more tapered end in the position of the chin. Only after the appropriate location, size, and proportion of the head's contours are established will it be fruitful to draw the particular features of the face. A common mistake is to place the eyes too high, elongating the face

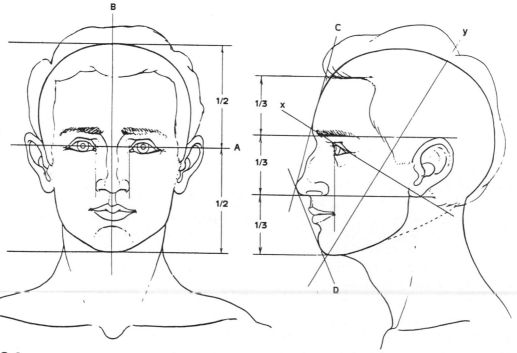

8.4
Diagram of the proportions of the head, front and profile views.

8.5
Leonardo da Vinci. *The Skull Sectioned*. 1489. The Royal Collection © 2003, Her Majesty Queen Elizabeth II. (RL 19057)

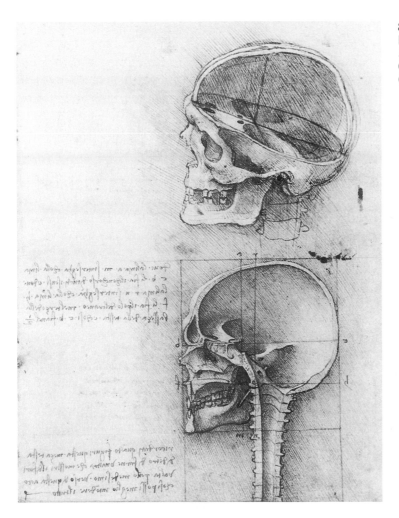

and making the upper portion of the head too small. Beginning artists typically exaggerate the size of the facial features and the area they encompass in comparison to the rest of the head. The intersecting lines *x* and *y* in Figure 8.4 divide the head into quarters, illustrating that, in profile, the features of the face make up only about one-fourth of the circumference of the head.

Profile Angle

This angle is created by a straight line drawn adjacent to the forehead and nose (Line C, Figure 8.4) that intersects with another straight line (Line D) drawn adjacent to the chin and the tip of the nose. Observing this angle correctly is critical to obtaining a likeness with a profile view. Look again at Michelangelo's and Modersohn-Becker's drawings in Figures 8.2

and 8.3. Try visualizing the outer egglike shape of these two heads, noticing the relatively small area the face occupies; then, compare the proportions of the three sections of the face and the profile angle of one face with those of the other.

The Anatomy of the Head

Although the size and shape of individual features vary, the dominant factor in bestowing that universally human form to all heads is the configuration of the skull.

The Skull

In Leonardo's cutaway study of the skull (Figure 8.5), the inner chamber of the cranium and the small orbs of the face are visible. If you drew a line on the profile view of the skull

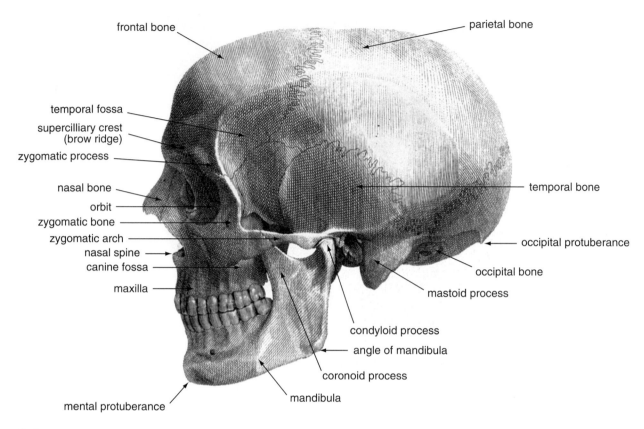

frontal bone

parietal bone

temporal fossa

supercilliary crest
(brow ridge)

zygomatic process

nasal bone

orbit

zygomatic bone

zygomatic arch

nasal spine

canine fossa

maxilla

temporal bone

occipital protuberance

occipital bone

mastoid process

condyloid process

angle of mandibula

coronoid process

mandibula

mental protuberance

8.6
Albinus. *Skull, Profile View.* Harvard Medical School, Francis A. Countway Medical Library, Boston.

(Figure 8.6), from the protuberance of the eye-brow *(superciliary crest)* over to the ear canal and back to the base of the skull, it could serve as a line of demarcation between the cranium and the facial region. Notice the volume of the cranium and its size in comparison to the region of the face. The skull consists of twenty-two platelike bones locked into an immovable unit, with the one exception being the lower jawbone *(mandible).* The oval shape of the skull can be divided into two parts, the larger housing the brain in a chamber known as the *cranial box,* or *cranium,* and the other, the *skeleton of the face,* consisting of several smaller chambers that contain sensory organs: the eyes, nose, and mouth.

Although the face is fleshier and, therefore, much more elastic than the cranial portion of the head, its external form and features still depend, for the most part, on its bony under-structure. For example, the size and shape of the *orbits,* the hollow eye sockets, will vary with individuals and be reflected in the exter-nal appearance around the eye. The soft, fleshy eyeball is set deep in the skull's orbital socket, protected by the bony orbital rim of the superciliary crest. The cheekbones *(zygo-matic bones),* which help to form the lower rim of the orbits, determine the width of the upper face and sculpt its relief. Trace the con-tours of the orbitals and cheekbones in your own face. Use your fingers to feel their struc-

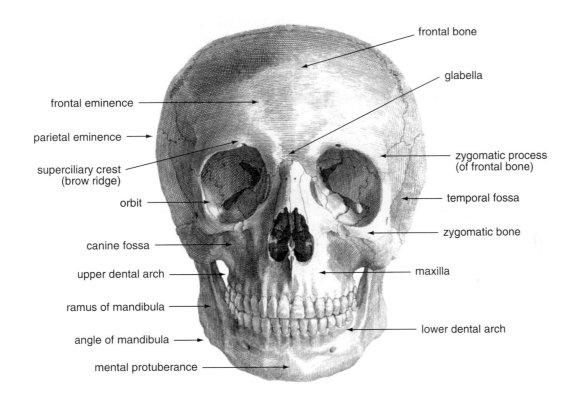

frontal bone

glabella

frontal eminence

parietal eminence

superciliary crest
(brow ridge)

orbit

canine fossa

upper dental arch

ramus of mandibula

angle of mandibula

mental protuberance

zygomatic process
(of frontal bone)

temporal fossa

zygomatic bone

maxilla

lower dental arch

8.7
Albinus. *Skull, Front View*. Harvard Medical School, Francis A. Countway Medical Library, Boston.

ture and to confirm the role of these bones in molding the external form of your head.

The prominence of the zygomatic bones, just under the eyes, is determined by the projection of the *zygomatic arch*, which extends the cheekbone like a buttress back to the ear, between the jaw and temple, where it forms a socket for the lower jaw, as in Figure 8.6.

The jawbone (mandible) is equally important in determining the characteristics of the face. Analyze the angle of the mandible below the zygomatic arch and the degree to which the chin *(mental protuberance)* projects in Figure 8.6. Note the mandible's width compared with that of the rest of the head, as seen in Figure 8.7. These lines distinguish

what might be described as an individual's square jaw, weak chin, or round face.

Although the nose has bone only at its base, and much of its form is determined by an armature of cartilage, the size and angle of bones at its base greatly affect the molded form of the whole nose.

The Muscles of the Head

The musculature of the head is almost exclusively associated with the face, and the function of these muscles primarily involves the opening and closing of the eyes or mouth. However, these are also the muscles of our facial expressiveness. Figure 8.8 maps the muscles of the face and enables us to see how

these relate both to the skull's framework and to the external appearance of the head and face. It is only in the face that muscles and fat fill in the skeletal framework and significantly modify the skull's contour. For example, when looking at the head in profile, we see that the hollows above and below the zygomatic arch are filled with two muscles that raise the jaw when closing the mouth. Above, on the temple, lies the temporal muscle *(temporalis)*. Below, the jaw muscle *(masseter)* enables us to chew our food but also knots when we clench our teeth.

Encircling the eye and mouth are disc-shaped *orbicular* muscles, which close these openings. The *orbicularis oculi* covers the front

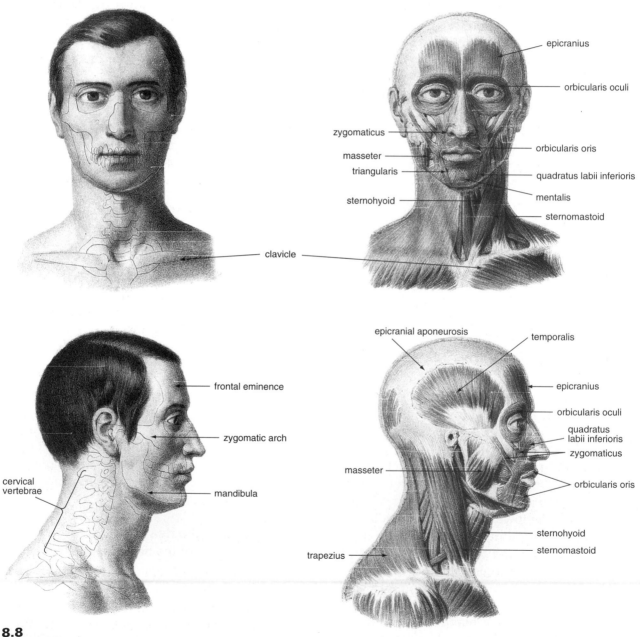

epicranius

orbicularis oculi

zygomaticus

masseter

triangularis

sternohyoid

orbicularis oris

quadratus labii inferioris

mentalis

sternomastoid

clavicle

frontal eminence

zygomatic arch

cervical vertebrae

mandibula

epicranial aponeurosis

temporalis

epicranius

orbicularis oculi

quadratus labii inferioris

zygomaticus

masseter

orbicularis oris

sternohyoid

sternomastoid

trapezius

8.8
M. Leveillé/Dr. Fau. *Diagrams of the Musculature and Skeletal Structure of the Head and Neck, Front and Side Views.* Harvard Medical School, Francis A. Countway Medical Library, Boston.

of the eye, attaching to the skull around the orbital cavity and forming the upper and lower eyelids. When you are drawing the eye, it is useful to remember that the exterior shape of the eye is determined by the spherical form of the eyeball protruding partially from its bony orbital pocket. The *orbicularis oris* covers the teeth and forms the lips. Several bunches of small muscles radiate from the orbicularis oris and attach it indirectly to the bones of the face. The *zygomaticus* muscles, which are attached to the cheekbone, draw the corner of the mouth upward when we smile. This, in turn, bunches up the fatty tissue of the cheek. Likewise, muscles radiating from the mouth to the mandible *(triangularis, quadratus labii inferioris*, and *mentalis)* pull the corner of the mouth down when we are displeased. Similar action occurs around the eyes to change their shape and elevate,

lower, or slant the eyebrows. These muscles *(epicranius)* also produce a wrinkled nose and furrowed brow. The thin epicranius muscles stretch over the cranium and draw the scalp backward and forward and raise the eyebrows.

The *muscles of expression* can be grouped into four different areas of influence: mouth, nose, eyes, and brow. We express emotions through the subtle and often subconscious use of these muscles. At times, the distinction between one emotion and another is a matter of degree, as between disapproval and anger. At other times, a slight shift or introduction of another muscle group, such as shifting the angle of an eyebrow, will distinguish horror from terror. One of the best ways to study the many nuances of facial expression is to use a mirror and yourself as a theatrical model—an exercise artists have engaged in for centuries.

Variations in Orientation of the Head

Often the head presents itself to us at angles that deviate from either the profile or frontal views, as seen in the study sheet of nine positions of the head by Jacob de Gheyn II (Figure 8.9). In such situations, drawing the head becomes a more formidable challenge. De Gheyn's study of his model's head from various positions reveals his understanding of how and where to position facial features when the head is tipped or seen from an angle. For the beginning artist to acquire this skill, it is important to keep in mind that although the angle from which we view the head may change, its basic form is spherical; the lines of division referred to earlier in our discussion of the proportions of the head and face can still serve as lines of orientation.

The key to correctly plotting the location of facial features when drawing the head from an unusual angle is to conceptualize the head as a three-dimensional egg-shaped form with the lines of division, like those on a globe, encompassing the head. These crossing lines of longitude and latitude will help you locate facial features and determine the proportion of various units of the face as the head rotates.

8.9
Jacob de Gheyn II. *Study of Nine Heads*. 1604. Black chalk, 36.2 × 26 cm. Kupferstichkabinett. Photo by Jörg P. Anders. © 2003 Bildarchiv Preussischer Kulturbesitz, Berlin. Inv. KdZ 2456.

Figure 8.10 diagrams the head in a variety of positions as it rotates from a frontal view to those progressively more oblique. Notice how the line that divides the head vertically down the middle shifts as the position of the head changes. It is good practice when drawing the head from an oblique angle to inscribe these compass lines lightly to help define the orientation of various features before trying to draw them in detail. Although experienced artists may not find it necessary to physically draw in these lines of longitude or latitude, they are always conceptually aware of their existence and how the detailed features of the head need to conform to them.

Age and Gender Differences

No matter how methodically one attempts to render facial features such as eyes and lips and noses, the characteristics of a person's age and gender will be lost if an artist ignores

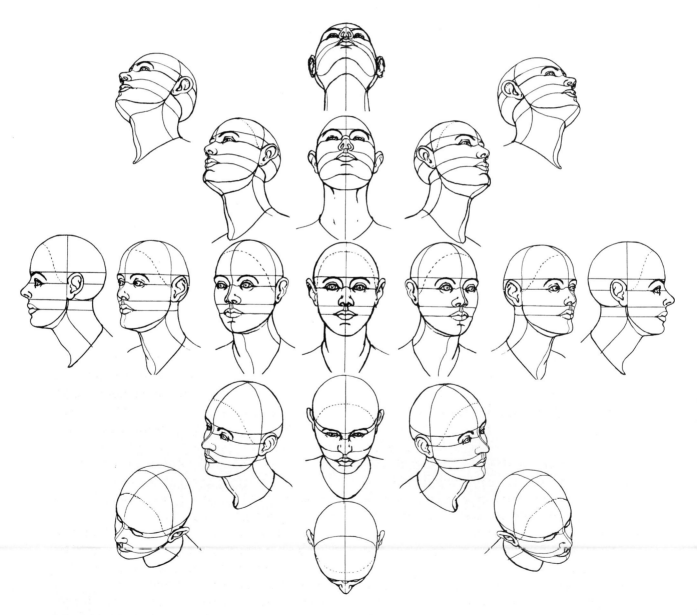

8.10
Diagram of heads in perspective.

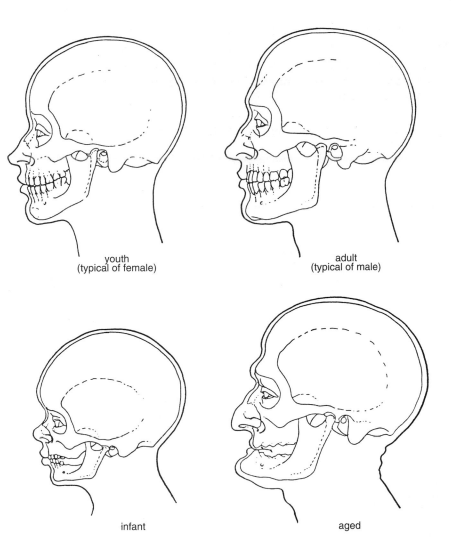

8.11
Diagram of skulls at various stages of aging.

youth
(typical of female)

adult
(typical of male)

infant

aged

the underlying structure of the skull. This will, of course, vary from one individual to the next, but Figure 8.11 suggests some typical changes to anticipate in reference to age and gender differences.

The skull of the child is not only smaller, but the section containing the brain is disproportionately larger than the face. Babies are born without teeth, and their first set of "milk teeth" are small. A child's jaw is not fully developed. The frontal curvature of the forehead is more pronounced on the child's skull, whereas in the adult, the brows become more developed, flattening the forehead. This is particularly true of the male and not as prominent in the female, where the forehead tends to retain more roundness. The size and mass of the female head, as with the rest of the body, may be somewhat smaller. Her jaw line is also more likely to be rounded, not as large and angular as the male's. In addition, nasal bones and cartilage in the female skull may remain smaller compared to the male's. As we age, our noses and ears increase in size. In old age, teeth often wear down or are lost, and atrophy of the lower jaw may reduce its mass, causing the chin to become smaller and more forward in its projection. Lips and cheeks, no longer as effectively supported by teeth, become wrinkled, and the cheeks and jawbones become more prominent.

Käthe Kollwitz depicts the characteristic proportions of a child's head with its small facial area and the rounded, protruding forehead in

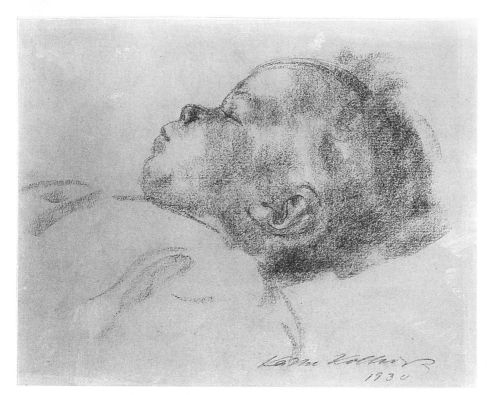

8.12
Käthe Kollwitz.
*Sleeping Child, Facing
Left.* 1930. Black
chalk on paper.
Private collection,
courtesy Galerie St.
Etienne, New York.
© 2003 Artists Rights
Society (ARS), New
York/VG Bild-Kunst,
Bonn.

8.13
Julie Schneider. *The Very Young Medusa.* 1997.
Graphite, 29 × 23". Private collection. Reproduced
by courtesy of the artist.

her drawing of a sleeping child (Figure 8.12).
Julie Schneider's drawing *The Very Young
Medusa* (Figure 8.13) reveals the reducing
prominence of the forehead and the rounded
facial features associated with youth. Andrew
Wyeth's portrait *Beckie King* (Figure 8.14) il-
lustrates many of the characteristics typically
found in the aged. With an eye for detail,
Wyeth maps out the wrinkled terrain of the
skin, larger nose and ears, and prominent
chin. The tissue of the face hangs across the
bony underframe of the skull. In her visage, it
is also possible to see traces of facial mus-
cles, which are seldom discernible in youth.

Portrait Variations

There is nothing to prevent artists from in-
venting their own fictional characters, fabri-
cating everything about them, much as an
author would for a character in a novel. Chil-
dren have a delightful time creating imagi-
nary people as they draw. Many adult artists
the world over have found that the people

8.14
Andrew Wyeth. *Beckie King*. 1946. Pencil on paper, 30 × 36". Dallas Museum of Art, Dallas, Texas. Gift of Everett L. DeGolyer. © Andrew Wyeth. Gift of Everett L. DeGolyer. Photo © Dallas Museum of Art. (1949.7).

they've invented on paper are often more intriguing than those they meet in real life. Others find truth more interesting than fiction and would rather base their drawings on life experience, preferring the challenge of capturing a real person's visage as they draw. But having a model to draw from does not have to limit one's creative imagination. In fact, portraits tell us not only about the subjects but about the artists who draw them. What artists see as important enough to record, how they describe these aspects of the individual, the kinds of marks that they make—all are personal and distinct. These are the characteristics that carry over from one drawing to the next, the elements that enable us to distinguish one artist's work from another's without looking at the artist's signature. In the end, it is the artist's vision and presentation of the subject that are ultimately more interesting than whether or not the portrait was a realistic likeness.

Although artists have been doing portraits and self-portraits for centuries, the fact that they still use drawing media to create them—even after the invention of photography—suggests that the element of artistic interpretation and hand-manipulated media may be more desirable than the objective eye and mechanical processes of the camera.

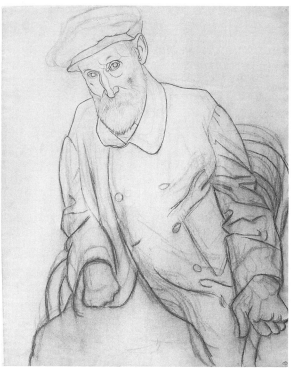

8.15
Pablo Picasso. *Portrait of Renoir* (after a photograph). 1919. Graphite on paper, 61 × 43.9 cm. © 2003 Estate of Pablo Picasso/Artists Rights Society (ARS), New York. Photo by J. G. Berizzi. © Réunion des Musées Nationaux/Art Resource, New York. Musée Picasso, Paris.

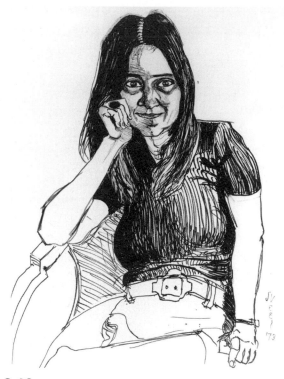

8.16
Alice Neel. *Adrienne Rich*. 1973. Ink heightened with Chinese white, 30 × 22". Courtesy Robert Miller Gallery, New York.

Picasso's *Portrait of Auguste Renoir* (Figure 8.15) does more than simply capture the aged face and crippled hands of one of the Impressionist movement's greatest painters; he also transfers his own artistic energy, through his strong use of line, to Renoir. Picasso sees Renoir eye to eye, injecting his own intensity and scrutiny into Renoir's eyes. A photograph of Renoir near the end of his life shows a pitifully crippled man confined to an invalid's chair. Picasso's portrait reveals the inner strength of the man who once told his doctor, "If I have to choose between walking and painting, I would much rather paint."[2]

Alice Neel loved to draw and paint her fellow New Yorkers—friends, neighbors, fellow

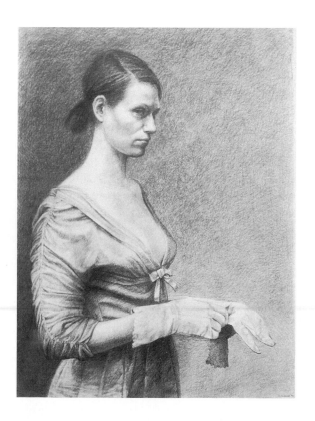

8.17
Michele Fenniak. *Woman with Gloves*. 1998. Charcoal, 22$\frac{1}{2}$ × 20". © Michele Fenniak. Courtesy of Forum Gallery, New York.

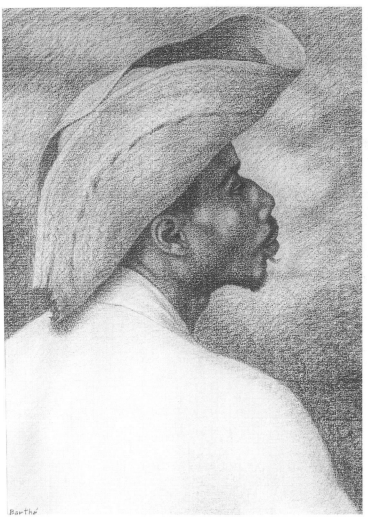

8.18
Richmond Barthé. *Portrait of a Man.* c. 1938. Charcoal on paper, 17½ × 12½". Arkansas Arts Center Foundation Collection: The Sam Strauss Memorial Fund. 1993.024.

artists—whoever would sit for her. Her portrait of poet Adrienne Rich (Figure 8.16) shows Neel's style of portraying her subjects with a raw intensity and directness that were anything but flattering. As she admitted, "I don't want to do what will please a subject. The person themselves dictated to a certain extent the way they are done."[3] She also noted that "when I talk to the person, they unconsciously assume their most characteristic pose."[4] However, Neel's portraits begin to suggest more than her subjects' surface appearance or pose. She had an uncanny way of getting beneath the skin. "Like Chekhov, I am a collector of souls," she explained. "I think if I hadn't been an artist, I could have been a psychiatrist."[5]

In a more realistic style but one full of mystery and intrigue, Michele Fenniak gives us the portrait *Woman with Gloves* (Figure 8.17). The drawing is one of subtle complexity and tension. The style of dress suggests a time and place where appearance and pretension to gentility were important. Yet the sideward glance and revealing neckline send conflicting messages—is that a wayward glance, an invitation, a condemnation? The elegance of dress contrasts with the severity of the facial expression and hairstyle. In the end, Fenniak's portrait suggests that there is a great deal more to this woman than meets the eye.

Portrait of a Man (Figure 8.18), by Richmond Barthé, also speaks of the complexity of the human condition. The presentation of his subject from a three-quarter profile, viewed from above and behind, is unusual and suggests that the man's thoughts are beyond us. The

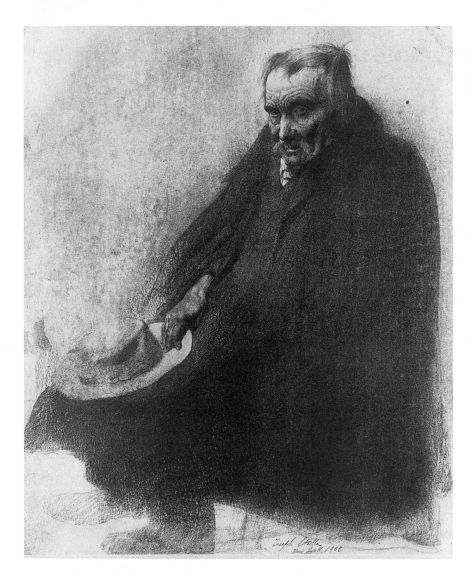

8.19
Joseph Stella. *Portrait of Old Man.* 1908. Graphite and colored pencil, $11^3/_4 \times 9^1/_4$". University of Nebraska–Lincoln. Howard S. Wilson Memorial Collection, Sheldon Memorial Art Gallery and Sculpture Garden. 1977.U-2512.

tattered end of his hat speaks of poverty, yet his gesture is one of hope and confidence.

Joseph Stella's composition (Figure 8.19) also places the viewer above his subject, in this case an old man whose head looks up to meet our downward glance. Although the entire figure is included within the composition, this drawing is primarily a portrait of the old man's face. Stella describes a face rich with character that appears to be almost sinking into the heavy, dark overcoat. The face and hands are highly detailed, and the dark form of the coat sets them apart and contributes to the drawing's somber mood and sense of the man's withdrawal.

In contrast, by making the head of the man in *Eyeglasses* (Figure 8.20) fill the entire picture frame, Nancy Lawton brings her subject nose-to-nose with the viewer. By lighting from below and exaggerating the subject's proximity, Lawton suggests an intensity that leaves the viewer feeling a little uneasy. She achieves photorealism through her meticulous rendering of light and shadow. Lawton has eliminated all gestural indication of the drawing process, leaving the impression that value variations are the direct result of light rather than a drawing medium. She tries to remain an unbiased observer of what she sees.

8.20
Nancy Lawton. *Eyeglasses*. 1984.
Pencil on paper, 22¼ × 23".
Arkansas Arts Center, Foundation
Collection, 1984. 84.47.2.

Self-Portraits

Artists have several good reasons for doing self-portraits, long a standard in the artist's repertoire of subject matter. One reason may simply be the availability of an accommodating model, one who is as committed to the drawing's success as the artist. Another is that the artist knows he or she is free to practice and experiment uninhibitedly without the need to flatter or the fear of offending. A third is that it can be a strong affirmation of the self as an artist, a means of satisfying an emotional desire to draw that is prompted by inner need rather than external patronage. As Dine once said, "Drawing is a kind of autobiography."[6] If that is true of drawing in general, it is doubly true of self-portraiture.

Although most self-portraits begin with a reflected mirror image, the artist soon sees another image in the drawing itself, and it is through drawing that the dialogue between artist as drawer and artist as subject takes place. Free to do whatever he or she pleases with a self-portrait, the artist is forced to come face-to-face with the person whose opinion ultimately matters most and who often is the harshest critic. Thus, a self-portrait becomes a form of self-evaluation that goes far beyond recording one's own physical features.

Perhaps no artist was ever as deeply involved in portraiture—or self-portraiture—as Rembrandt. His self-portraits, particularly in oils, range from self-satisfied to humble, from tragic portrayals of historic characters to honest renditions of his own inner life. Rembrandt also used his own likeness to study facial expressions. Figure 8.21, representing surprise, is a small but delightful example.

8.21
Rembrandt.
Rembrandt in a Cap, Open-Mouthed and Staring. Etching, shown actual size, 2⅛ × 1⅞".
Rijksmuseum, Amsterdam.

Jack Beal's self-portrait (Figure 8.22) shows him looking over his spectacles with critical eyes at his mirrored image. In the background, we see enough to inform us that he is in his studio, standing or sitting in front of another drawing, which suggests a gestural beginning for the more detailed image of himself. In Beal's shirt and hat linger the remnants of gestural contour lines, but in the face these lines have been subdued beneath value to create a greater illusion of three-dimensionality. As he once said, "I like to work with chiaroscuro, and that involves precise placement of light and shade, a placement most easily obtained if the artist is also the subject."[7]

Robert Arneson once compared the making of a drawing with boxing: the artist is engaged in a conflict with his or her own work, which, at times, the artist is losing but still

8.22
Jack Beal. *Self-Portrait with Lenses*. 1982. Pastel on paper, 25 1/2 × 20". Courtesy George Adams Gallery, New York. Photo by eeva-inkeri.

8.23
Robert Arneson. *The Fighter*. 1982. Conté crayon on paper, 48 × 48". Courtesy of George Adams Gallery, New York. Photo by eeva-inkeri.

hopes to win. His self-portrait as a boxer (Figure 8.23) reflects this sentiment as he confronts himself with his dukes up. The style of the drawing is physical in itself. He builds his large drawings stroke upon stroke, layer upon layer; and, in a very real sense, the artist is involved in a strenuous workout. Arneson's analogy of drawing as physical struggle is apropos, reflecting what is, at times, the artist's dogged desire to give form and content to sometimes evasive concepts and unobliging media. When the artist triumphs, as Arneson does here, it is often simply because of stubbornness, refusing to quit when things weren't going right. Color Plate 8 reveals the full impact of Arneson's use of mixed media in another of his self-portraits. In it we can see the recorded history of the drawing in its many layers and discover some surprises in the graffiti-like text.

The energetic self-portrait *Her Strength Is in Her Principles,* by Elizabeth Layton (Color Plate 4), portrays an individual sure of herself, not afraid to present the lines and wrinkles of age. The flesh on the arms sags, but it doesn't daunt her gesture of triumph; the flash of energy in the eyes is unmistakable, echoed in the brilliant aura that emanates a sense of personal power as well as humor. Most of Layton's drawings were self-portraits intended to reveal something about her inner life as well as her connection to humanity as a whole. "The worth of the pictures I draw is measured in empathy felt, in understanding of ourselves and of others."[8]

Like Elizabeth Layton, Ann Piper plays a role similar to that of actor-director by casting her own likeness into a thematic series titled "The Baker's Daughter." The title of this drawing, *Cold Heart, Warm Hands* (Figure 8.24), offers a tongue-in-cheek reversal of the familiar adage, "cold hands, warm heart." In a similar vein is the humorous contradiction of a nude wearing an oven mitten. Piper's work fits in with that of a new generation of women artists who use their own bodies as subject matter and sometimes even as media, in the case of performance art. Lynda Nead, in her book *The Female Nude: Art, Obscenity and Sexuality*, argues that theirs is a desire to reposition the image of the female body in Western art, to take back their own image, which has been historically framed and limited to that of sexual metaphor, an object of desire seen from a male perspective.[9]

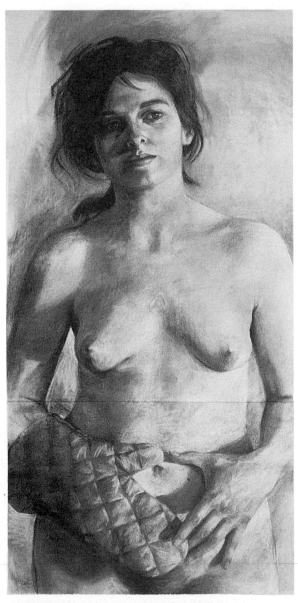

8.24
Ann Piper. *Cold Heart, Warm Hands.* 2001. Charcoal, 45 × 22". Courtesy of the artist.

8.25
Susan Hauptman. *Self-Portrait as Prima Donna Bitch*. 2000. Charcoal, pastel, and gold leaf, 54 × 40".
© Susan Hauptman.
Courtesy of Forum Gallery, New York.

Self-Portrait as Prima Donna Bitch (Figure 8.25), by Susan Hauptman, uses mixed media as well as mixed metaphors to celebrate and commemorate the self. With this drawing, she preserves her likeness and suggests a range of self-perceptions. She presents an introspective recognition of human vanity and the self-focused nature of self-portraiture. But she also takes advantage of an opportunity to create a new or other self. Here, Hauptman plays both saint and self-centered bitch—the self-aware artistic ego having constructed an altar, a communion table, for the alter-ego. With halo, birthday cake, party napkin, and fireworks, Hauptman asserts her position as Prima Donna, the first lady as subject and artist.

William Beckman's large charcoal drawing *Overcoats* (Figure 8.26) is a self-portrait that makes a multitude of references despite its sober, straightforward appearance. First it refers to numerous other drawings and paintings Beckman has made that document himself. Here, he uses two individuals to reference the universal relationship of man and woman. On another level, he harkens to other works of art, such as Albrecht Dürer's *Adam and Eve* (Figure 6.24), but Beckman's figures have

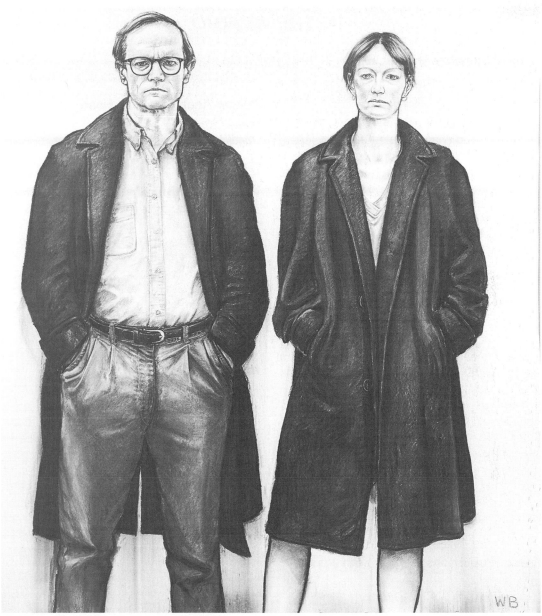

8.26
William Beckman. *Overcoats*. 1997–1998. Charcoal on paper, 76¼ × 90". © William Beckman. Courtesy of Forum Gallery, New York.

been cast out of the garden, covering their nudity with clothing. It also seems to refer to the sober, time-worn figures in Grant Woods's famous painting, *American Gothic*.

The portraits in this chapter tell us not only what people look like but more particularly what the artists see. Each artist has an individual focus and way of working. Some work slowly and meticulously, whereas others draw with quick, spontaneous gestures. Some figures are idealized, others satirized; some present fact, others fiction. The possibilities are endless. Our common anatomical features unite us, our individual features distinguish us, and the interpretation by the artist's mind and hand transcends mere likeness.

IN THE STUDIO

Quick Head Sketches Using Line

Pose – 2 to 5 minutes, 5 or 6 poses
Media – charcoal, conté, or soft graphite pencil on newsprint

Using line only, sketch freely and rapidly. Indicate the overall size and shape of the head with repetitive line and continuous contour line phrases, then begin to suggest the position and form of eyes, nose, mouth, and ears in the same rapid sketching fashion. Your application of line should be almost continuous, building the head's form with crossing and overlapping lines. Be energetic, generous, bold—rephrase your lines, letting them cross and circumscribe the head. See Figure 4.13.

Quick Head Sketches with Value

Pose – 2 to 5 minutes, 5 or 6 poses
Media – charcoal or graphite stick, 1" long

Place your drawing stick flat, with its side, not its end, on the paper. Begin by lightly suggesting the overall shape of head, neck, and shoulders, then suggesting the ovoid form of the head and cylindrical character of the neck. Lightly indicate the location of the eyes, nose, and mouth. Be careful not to get too dark too quickly. The likeness should become visible and sharpened with successive additions of value applied to progressively smaller areas. Think of darker values as indicating recessed surfaces and lighter areas as advancing forms. See Figure 8.12.

Analyzing Proportions from Various Views

Pose – 15 to 30 minutes, each pose from a different angle
Media – charcoal or graphite on newsprint

This exercise emphasizes an objective approach to the study of the head. The intention is not to do a finished portrait but to analyze and plot the proportions of the head of an individual subject, either a model or a classmate. The latter option is preferred because each head can be more precisely studied and compared from both front and profile views, and you can actually take physical measurements as well as sight measurements of a classmate's head or face if desired. Draw life-size, beginning with an oval the size and shape of your subject's head. After drawing the external shape of the head, describe the location and proportions of the facial features. Keep in mind the guidelines established in this chapter (Figure 8.4). Draw the head from a variety of views and angles (Figure 8.10).

Planar Analysis of the Head

Pose – 30 minutes
Media – charcoal or graphite on newsprint

The purpose of this exercise is to analyze the underlying structure and form of the head and face by reducing them to simple geometric volumes and planes. As you draw, analyze the structure of your own head with your fingers to feel the planes of the skeletal understructure. Also observe the way the light falls over your subject. In this way, you employ both tactile and optical means of gathering information. Use line to indicate the edges of planes and geometric facets, adding hatching lines to suggest tonal changes and the slope of surfaces.

Long Portrait Study

Pose – 2 to 3 hours
Media – graphite, charcoal, or conté on regular drawing paper or neutral-toned paper

Create a detailed portrait study, drawn from either a model or yourself in a mirror. Describe the features of the head with line and value. Begin by working lightly, starting with the larger relationships then progressing to smaller, more detailed ones, analyzing the anatomical structure, comparing proportions, and plotting the angles and positions of the various features. You should begin to see the likeness of your subject long before you be-

8.27
Nicole Rawlins. Student drawing.

8.28
Chris Link. Student drawing. Self-portrait narrative.

come concerned with details. Use value both to model form and to render the play of light. To achieve a dramatic chiaroscuro or atmospheric effect, use value to darken areas around the head. See Figures 8.17, 8.22, and 8.24.

Portrait on Colored Paper

Pose – 2 to 3 hours
Media – reddish-brown, black, and white chalk, conté, charcoal, or colored pencils on neutral-colored paper

A middle-value, neutral-toned colored paper is recommended, such as blue-gray, tan, or buff. Begin your drawing by lightly indicating the proportions of the head and the facial features with either the black or white pencils, which you use to further define the shadows and highlights. If you also use a reddish-brown pencil, you can blend the black and white drawing pigments with it to create a full array of values. Refer to Color Plate 1, where Michelangelo uses a sepia ink to tone his drawing surface for a black, red, and white chalk drawing.

Self-Portrait Narrative

Pose – 2 to 3 hours
Media – charcoal, chalk, conté, or colored pencils on neutral-colored paper

Make an expressive drawing of yourself that becomes something more than just a likeness by including images of other objects—animals, birds, or multiple images—or by suggesting aspects of an environment, such as the interior of a room or automobile. Play around with your idea by first doing small, rough compositional sketches to explore compositional variations before you begin your larger drawing. Notice how the inclusion of other objects in the drawing gives your self-portrait an implied narrative and added dimension. See the student examples in Figures 8.27 and 8.28.

Independent Study

The way to become good at drawing heads and faces is to put some extra time and effort into this aspect of drawing from life. To study heads, you don't need a professional model, and, for some exercises, independent study is preferable. **1** The goal here is to review how the bony structure of the skull influences the exterior appearance of the head. Begin with a life-size drawing or photocopy of the skull, then draw what you imagine to be the exterior appearance of the head over your drawing or on an overlapping sheet of tracing paper. **2** To become more acquainted with the detailed shapes of the eyes, nose, mouth, and ears, practice drawing them as individual parts by filling a large page with multiple studies. **3** Take a sketchbook with you on a drawing outing and make sketches of the people you see. A park, a coffee shop, a library, or a train station are just a few locations where you can see a variety of heads to draw and also discover a lot about human nature.

Composition and Expression

> A picture is something which requires as much knavery, trickery and deceit as the perpetration of a crime. . . . The artist does not draw what he sees, but what he must make others see.
>
> *—Edgar Degas*

This last section emphasizes the means by which a figure drawing becomes something more than a figure study. What determines the distinction is not necessarily the amount of time spent on the drawing, but rather how the representation of the figure functions to communicate ideas or aesthetic concepts broader than its mere physical appearance. For the old masters, the study of the figure was a continuous investigation, but not an end in itself. These artists considered drawing from life a vital prelude to works in other media, the figure serving as the vehicle through which to express both their formal and humanistic concerns.

The emergence of drawing in the twentieth century as an independent art form has combined with the recent rediscovery of the expressive potential of the human figure to bring unprecedented attention to the medium of drawing. This text began by presenting the notion that drawings evolve through both conscious and intuitive mental processes, on both objective and subjective levels. These two forces, however, are seldom equal in any one piece or within any creative individual. At times, the objective approach dominates, with the artist opting for a rational and orderly arrangement of formal elements; at others, the subjective side prevails, stressing a more passionate expression of subject matter. In fact, in different periods of art history, one or the other side has gained ascendancy as the predominant focus of art. The battle between ethos and pathos, ideal form and expressive content, can be traced in the dichotomy of classical and Romantic art in the nineteenth century and on into the twenty-first.

The current debate ranges between *Modernism* and *Postmodernism*. Stated simply, the Modernist view stresses that art should be confined to formal, self-contained aesthetic considerations. Postmodernists want their art to be referential, to be interpretive of external events—personal, social, political, or cultural. Modernism advocates "art about art." Post-

modernism values art about life—giving art a meaningful context.

It is along these diverse lines of rational detachment versus emotional involvement that contemporary artists have extended figure drawing beyond the limits of an exercise and placed it in the center of the debate about the proper role of art. Contemporary American artist Philip Pearlstein describes the schism among figurative artists in this way: "The major issues divided the group . . . into those who wanted their perceptual experience hot and full of the meaning of 'life' or with cool detachment."[1]

The following section examines this duality both in contemporary art and in a historical context. The aesthetic manifestation of these approaches to drawing the human figure may be more appropriately referred to as *figurative formalist* and *figurative humanist.* These broad classifications run through the history of art and encompass enormous variety in content and style. Despite the recent emphasis given to the return of representational content in the realm of Postmodernism, the conflict between form and content has raged in the minds of artists and on gallery walls for the past century. Throughout, figurative artists have held to the belief that the human form is art's most potent vehicle through which to convey both formal and expressive concerns.

Making a distinction between figurative formalist and figurative humanist points of view helps to clarify what is meant by *composition* and *expression* in relation to figurative drawing. It can be said that every drawing exists as both a composition and a form of expression, but for these terms to have any real meaning,

it is important to recognize that they do not come to a work of art unattended; they are the direct result of the artist's focus and intent. As you will see, the figurative formalist places emphasis on composition and arriving at an aesthetically pleasing presentation. The figurative humanist's primary aim is the communication, or expression, of subjective content. Many artists have created works of equal quality in either mode. Many drawings blend these approaches—a cool arrangement of formal elements may carry an underlying message within the composition itself, while an overtly expressive drawing may gain much of its power from the strength of its composition. It is clear, however, from both the works and words of a large number of artists, that they have made a conscious effort to emphasize either formalist or humanist concerns in their work. As you shall see, it is this added focus that takes a figure drawing into another realm.

Ideally, the discussion and examples that follow will enhance your awareness that, for the serious figurative artist, composition and expression are not incidental but essential concerns. The dialogue between Modern and Postmodern—between a focus on composition and one on expression, between figurative formalist and figurative humanist—should raise questions for you as an artist: Is your responsibility primarily to your art or to society? Can form have relevance without content? Can content be art outside any formal considerations? In the process, you will inevitably draw some conclusions about your own values and aesthetic focus and what you would like to emphasize in your art and in your use of the figure.

Composition and the Figurative Formalist

But there is another tradition of artistic concern which deals with underlying structures or spatial relationships. . . . In this tradition, to which I relate myself, the primary experience is the artist's.

—*Philip Pearlstein*

A Figurative-Formalist Bias

The formalist approach to the figure is primarily a disciplined and rational one, governed by the intellect. The artist maintains objectivity in analyzing the figure, focusing on physically observable phenomena—the play of light, the structural relationships of form, the body's spatial position and its physical position within its environment, and how shapes are delineated on the two-dimensional picture plane. A figurative formalist is "relationship-minded" rather than "subject-minded." An artist with this bias is concerned with self-contained pictorial relationships rather than with meaning or expressive content.

Contemporary artist Wayne Thiebaud verbalized a formalist philosophy this way: "The figures . . . are not supposed to reveal anything. It's like seeing a stranger in some place like an air terminal for the first time. You look at him. You notice his shoes, his suit, the pin in his lapel, but you don't have any particular feeling about him."[1] With this same emotional detachment, Thiebaud studied the play of light and shadow as he drew *Senior Model* (Figure 9.1). Although intensely observed, the figure is void of sentiment, presented matter-of-factly, in the most formal way possible. A strong light illuminates and isolates the figure so that it can be carefully observed, like a scientific specimen or anthropological artifact on display in a museum. Everything that might distract attention, except the body's cast shadow, has been omitted. By making this solitary figure the sole determinant of the composition, the artist dismisses the possibility of narrative and makes the formal components—the body's form and the pattern of light—the total focus and content of the work.

The formalist often chooses to use a recognizable object, such as a life model, as a point of departure into a study of light and shadow that in turn determines the formal construction of the drawing. The artist views the figure primarily as a compositional device, often posing it formally and consciously as a structural element.

9.1
Wayne Thiebaud. *Senior Model.* 1975. Charcoal, 30 × 22". Courtesy of the artist and Paul Thiebaud
Gallery, San Francisco.

Composition

Composition can be defined simply as the organization of all the visual elements into a unified whole. The composition not only unifies a drawing but also establishes implicit relationships that can make a series of drawings of the same model—even of the same pose, framed in different ways or seen from different angles—compositionally unique. For along with its ability to differentiate visual elements within a work of art, composition formulates the visual idea. The subject matter is not the essential objective; rather, the drawing's construct is the central concept of the drawing. For the figurative formalist, the study of com-

position is an intellectually intriguing and creative endeavor. Drawing is a mental game of image making, played with media and form; composition is the logical arrangement of the pieces during this game. The figure is a desirable subject for the formalist because it serves as a kind of aesthetic catalyst that can provide innumerable compositional variations and renewed intellectual challenges.

These artists may refer to their drawings as expressive; however, this term means something particular for the formalist. As Matisse explains, "Expression, to my way of thinking, does not consist of the passion mirrored upon a human face or betrayed by a violent gesture. The whole arrangement of my picture is

9.2
Henri Matisse. *Grand Odalisque a la Culotte Bayadere.* 1925. Lithograph, 21^1/$_4$ × 17^1/$_4$". Collection of the Grunwald Center for the Graphic Arts, UCLA Hammer Museum. Gift of Mr. Norton Simon. Photography by Robert Wedermayer. © 2003 Succession H. Matisse, Paris/Artists Rights Society (ARS), New York.

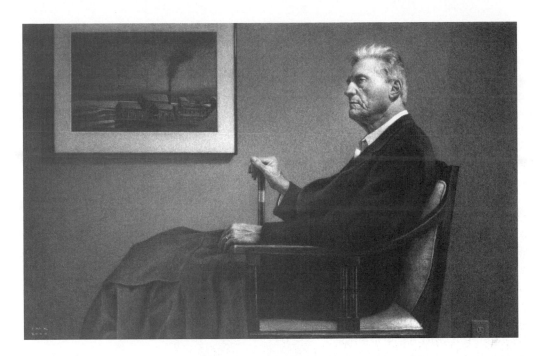

9.3
Ira Korman.
The Chinese Chair. 1999.
Charcoal,
$22^3/_4 \times 29^1/_2$".
Courtesy of
Koplin Del Rio
Gallery, West
Hollywood,
California.

expressive. The place occupied by figure or objects, the empty spaces around them, the proportions—everything plays a part."[2]

For Matisse, the goal is to make the composition expressive as an aesthetically pleasing experience, as demonstrated in Figure 9.2. As he explains, "What I dream of is an art of balance, of purity and serenity devoid of troubling or depressing subject-matter, an art which might be . . . like a good armchair in which to rest from physical fatigue."[3]

Some formalists choose to abstract, dissect, or flatten the body, whereas others insist on photographic realism; however, there exists a common desire to arrive at an aesthetically unified whole. Because structure and composition embody the content of the drawing, any changes in a model's pose result in both a change of composition and a change in content—a new pictorial idea.

The formalist brings into figurative art the notion at the core of modern art: art should be about art. The formalist is involved only with solving aesthetic problems. Drawing the human figure, by extension, should involve no more emotional pangs or political significance than rendering the objects in a still life.

James Whistler, an outspoken American artist, first gave voice to the modern art credo,

"art for art's sake," in a lecture delivered in London in 1885. He wished to rid art of sentimentality and moralizing narratives. In his words, "Art should be independent of all claptrap—should stand alone, and appeal to the artistic sense of eye or ear, without confounding this with emotions entirely foreign to it, as devotion, pity, love, patriotism and the like."[4] Art, according to Whistler, should be treated simply as "an arrangement of line, form, and color."[5] Although flamboyant and confrontational in his personal life, he strove in his art to maintain harmony and an aesthetic aloofness from his subjects, which enabled him to title a painting of his mother *Arrangement in Grey and Black No. 1,* more commonly called *Whistler's Mother.* The public considered Whistler's use of strange titles an affectation, but it was an earnest attempt to affirm his belief in the autonomy of art. Whistler posed his subjects as aesthetic entities, carefully positioning them to harmonize and balance.

Contemporary artist Ira Korman's charcoal drawing *The Chinese Chair* (Figure 9.3) pays homage to Whistler by making an unmistakable reference to his composition *Arrangement in Grey and Black No. 1.* Korman even follows Whistler's example by placing another of his own drawings on the wall as a composition

within a composition and as a counterweight to the seated figure.

Degas also used the figure primarily as an aesthetic device by which to break up the picture plane and on which to hang his color. He created numerous variations on such themes as the dancer and the bather (Figure 9.4). Yet these figures in themselves have no particular significance as individuals; instead they exist as aesthetic devices—"the dancer is only a pretext for a drawing,"[6] as Degas once explained. Facial features, which might have distinguished his model's personality or revealed her emotions, are most often hidden from view or simply dissolved in a play of light or color (see also Figure 5.5 and Color Plate II).

These drawings, like many of his paintings, are based on his research and experimentation with light and color. His methodology of executing numerous studies of the same theme, with subtle compositional changes and alterations in lighting conditions, is typical of the figurative-formalist approach, whereby the artist investigates aesthetic variations in the disciplined and controlled manner of a research scientist. As Degas once said, "It is essential to do the same subject over again, ten times, a hundred times."[7] According to Kirk Varnedoc, author of *A Fine Disregard: What Makes Modern Art Modern*, repetition and variation on a theme are signature characteristics of Modernism.[8]

Breaking Up the Pictorial Space

Edward Hopper's small compositional sketch *Study for Morning in a City* (Figure 9.5) is a preliminary drawing for his painting *Morning in a City* (Figure 9.6). This work, with its single figure situated in an interior space, presents a typical theme for Hopper. The painting and the drawing that preceded it document an external world that Hopper both observed and consciously arranged for the picture plane of his canvas. The content or drama comes not from narrative but, rather, from the interaction of light with the human form and the in-

9.4
Edgar Degas. *Woman Bathing in a Shallow Tub.* 1885. Charcoal with pastel added on toned paper, 32 × 22". Metropolitan Museum of Art, New York, H. O. Havermeyer Collection, Bequest of Mrs. H. O. Havermeyer, 1929 (29.100.41).

terior space. His value sketch (Figure 9.5) defines the structural components of the room that will determine the design of his canvas (Figure 9.6). The nude in the painting is an important compositional component, which helps both to define the three-dimensional space and to divide the two-dimensional picture plane. The figure, like the light, is frozen within a consciously composed arrangement. The nudity of the figure and the rumpled bed are not intended to be alluring symbols; Hopper neutralizes these potentially emotional objects by turning the figure to the window and stripping the interior of any embellishment. His work denotes a sober, almost monastic preference for austerity as he simplifies and eliminates all that is unnecessary, all that might distract us from the basic compositional

elements. As he once said of a similar work, "Any psychological idea will have to be supplied by the viewer."[9]

Hopper integrates the organic form of the body with the formal geometric compositional arrangement, creating the sense of an eternal moment that is typical not only of Hopper's work but also of many other drawings in this chapter. The figure is such an important structural element that you begin to feel that if it were moved, it would destroy the integrity of the composition as a whole.

This psychological and emotional distance from the nude can be seen in a drawing by

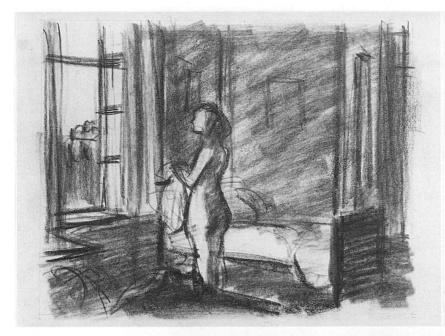

9.5
Edward Hopper. *Study for Morning in a City.* 1944. Conté and pencil, 8½ × 11". Whitney Museum of American Art, New York, Josephine N. Hopper Bequest (70.207). Geoffrey Clements Photography.

9.6
Edward Hopper. *Morning in a City.* 1944. Oil on canvas, 44 × 60". Williams College Museum of Art, Williamstown, Massachusetts. Bequest of Lawrence H. Bloedel. 77.9.7.

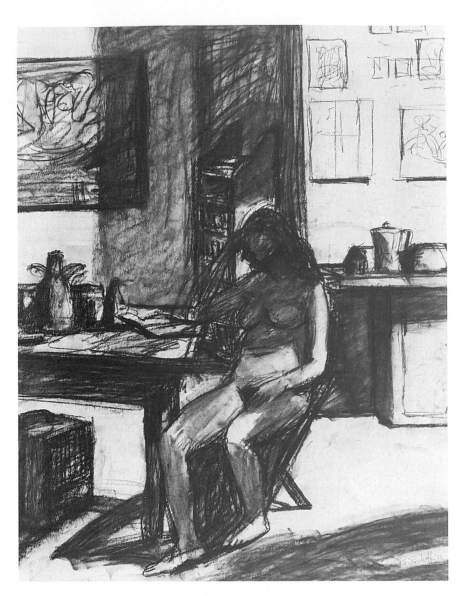

9.7
Elmer Bischoff. *Model Resting.* 1973. Charcoal on paper, 26 × 20".
John Berggruen Gallery, San Francisco. Private collection. Photo by M. Lee Fatheree.

Elmer Bischoff (Figure 9.7). Bischoff, Diebenkorn, and others were dubbed San Francisco Bay Area Figuratists in the late 1950s. Their work was seen as a West Coast antithesis to the New York *Abstract Expressionism* of the same period. In Bischoff's drawing, the model is not just resting but, in fact, posing within a larger composition. She is but one part of the artist's studio. As in Hopper's drawing, the figure forms the focal point of the composition, at the intersection where the vertical panels of dark value in the background cross the horizontal structural elements of the table and counter. Bischoff's drawing extends the value patterns on the body into those of its surroundings, each shape supported by and attached to the next until anchored securely to the outer frame. In this way, he divides the space and defines the structural relationships as the main subject of the work. The model is "resting," like an heirloom that twentieth-century artists inherited from the past. She is treated with the same impartiality as the surrounding interior, the light fracturing her body into a pattern of light and dark along with everything else in the room.

Diebenkorn's figurative drawings, done before he turned to thoroughly abstract compo-

RDGT

9.8
Richard Diebenkorn.
Seated Woman. Charcoal.
Collection of Eve
Benesch Goldschmidt.
Photo courtesy of the
Metropolitan Museum
of Art, New York.
Reproduced by
permission of
Mrs. Diebenkorn.

sitions, employ the figure to the same end: a compositional arrangement of elements. Unlike Bischoff, Diebenkorn prefers to zoom in on his subject, letting the body fill more of the picture frame (Figure 9.8). According to John Elderfield of the New York Museum of Modern Art, "His models usually look down or away. They seem self-absorbed. Part of the reason for this is that Diebenkorn does not want to make psychological contact with the face. He wants us to grasp the meaning of a work from the whole composition and not have it filtered through the personality of the model."[10] The meaning of the work *is* the composition. The physical and purely visual relationships are what is relevant. Diebenkorn uses the model's pose as a profound determinant of the whole composition. He exploits the body's ability to change its configuration and thereby suggest an infinite number of structural arrangements. As Diebenkorn once said, "One of the reasons I got into figurative or representational painting was that I wanted my ideas to be worked on, changed, altered, by what was 'out there.'"[11]

The external reality of the body suggests compositional possibilities to Diebenkorn, and he uses it as a graphic symbol through

which to convey his pictorial concepts. As philosopher Suzanne Langer suggests, "Symbols are not proxy for their objects, but are vehicles for conception of objects. . . . it is the conceptions, not the thing, that the symbols directly 'mean.'"[12] Diebenkorn's presentation of the figure is drained of personality to more freely communicate his aesthetic concern for pictorial design. Notice that the figure receives no more emphasis than the shapes that surround her. In fact, Diebenkorn defines the body as much by drawing its surroundings as by drawing the figure itself. The three-dimensional volume of the model and her environment is compressed and flattened to make them more adaptable to structuring the two-dimensional surface of his drawing. This treatment of the figure, as a component of design, forecasts the even more formal, nonrepresentational work of Diebenkorn's later career.

The Abstract Concerns of the New Realist

The artist who perhaps best exemplifies the formalist application of the figure in contemporary art and who has most articulately verbalized its philosophy is Philip Pearlstein. In the 1970s, he was part of the so-called **New Realism** revolution, which reintroduced representation and figurative imagery into the mainstream. At the time, contemporary art was dominated by *abstraction* and **minimalism,** which disallowed any reference to objects or events outside the work of art. Although New Realism can be seen as the aesthetic antithesis to abstraction, its approach to subject matter remains detached and dispassionate. The nude is primarily form, not content. Compared with Bischoff and Diebenkorn, Pearlstein is more concerned with depicting the body as a three-dimensional volume in a space one

9.9
Philip Pearlstein. *Female Model Seated on a Lozenge-Patterned Drape.* 1976. Sepia wash on paper, 30 × 44". Portland Art Museum, Portland, Oregon. Purchased from Anonymous Purchase Fund and Anonymous Gift of Funds. Acc. #80.15. Courtesy Robert Miller Gallery, New York.

could occupy (Figure 9.9 and Color Plate 5). He is equally concerned with composition: "The volumetric torso, limbs and other parts of the figure have to move choreographically through measurable three-dimensional space; simultaneously they must be the primary architectonic units of the strongest possible two-dimensional structure."[13] Both the Abstract Expressionists and the Bay Area Figuratists emphasized exploration and promoted a free and gestural working of the drawing surface. In comparison, Pearlstein's approach is controlled, and his application of the media is precise, dispatched in carefully considered quantities as his focus narrows from the overall format to the depiction of minute surface details. Pearlstein once said he has rescued "the figure from its tormented, agonized condition given it by the expressionistic artist, and the cubistic dissectors and distorters of the figure, and at the other extremes I have rescued it from the pornographers."[14]

9.10
Steve Bigler. *Figure, Easel*. Charcoal pencil, 27 × 22". Collection, Minnesota Museum of American Art, St. Paul.

In spite of their undeniable physical presence, Pearlstein's nudes are not to be interpreted as metaphorical symbols, as part of a narrative. "I don't want the burden of literature thrust upon me when I only want to use my eyes."[15] He seeks to remain completely objective. Pearlstein, like Diebenkorn, Bischoff, Hopper, and Thiebaud, wants his nudes to be psychologically neutral. They do not interact with the artist or the viewer or one another. Although he offers sensory material—furniture, oriental rugs, naked flesh—we are expected to keep our distance and to appreciate these objects on a higher intellectual level. Pearlstein draws his figures large within the picture frame, often cropping faces at the edge, which adds to their anonymity. He treats the body as a still-life object, observing and rendering it with the same detachment with which Cézanne painted his apples. Without sentiment or preaching, Pearlstein attempts to deal with nothing but the facts, nothing but the visual presentation of light and form. Yet at the same time, he directs our vision. We feel that we are seeing only what he wants us to see from a precise angle, framed exactly as he wishes it framed. As a result, the pictorial arrangement forcefully manipulates us, changes our own perceptions, and slowly increases our aesthetic sensitivity as it dissolves any preconceived notion we may have had about nudity.

Through the representation of the nude, we are taken into a consideration of the work on an abstract level. In a similar way, Steve Bigler uses the nude to seduce and invite the viewer into the drawing to experience its structural arrangement (Figure 9.10). Bigler uses value and line to create a deep space within a composition that balances the geometric shapes of the mirror image with the easel. In many ways, the surface of the drawing paper is similar to that of the mirror image of the far nude in that it offers an illusion of form and space that we cannot physically enter and are expected to appreciate from a distance.

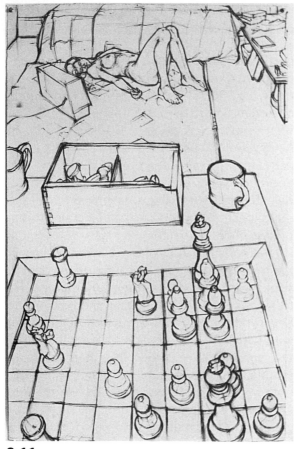

9.11
Regina Granne. *Table and Nude with Chess Set.*
Charcoal, 41 × 26". Courtesy of the artist.

In a purely linear composition (Figure 9.11) Regina Granne uses the model as but one object in her interior still-life. As in the game of chess, where one move prompts another, in the act of drawing, each line takes into account all the preceding ones. Granne's drawing is a record of the moves she made while playing the equally contemplative game of image making. The line works first to divide the surface of the drawing and then to penetrate it, implying a great deal of space with the addition of linear perspective.

Every representational composition works with two levels of reality, one that deals with the two-dimensional surface and another that penetrates the surface to present the illustration of volume and space. The degree to which an artist emphasizes one or the other, or blends the two, is a matter of personal intent. Any representational artist concerned with formal aesthetic issues composes both the two-dimensional reality and the three-dimensional illusion with deliberate purpose.

Harvey Breverman's drawing (Figure 9.12) uses the architectural units of windows, molding, and door frames to create a pictorial scaffolding that divides his composition with geometric shapes like those found in a Mon-

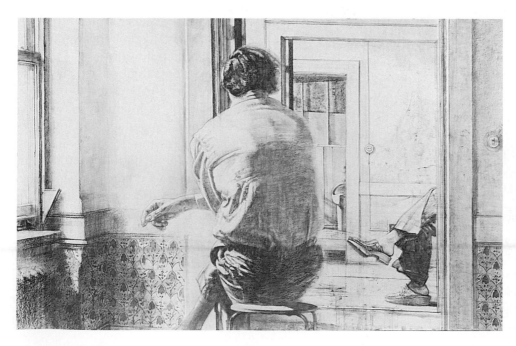

9.12
Harvey Brovorman. *Interior: Four Rooms.* Babcock Galleries, New York. Photo by Don Weigel Studio.

9.13
Catherine Murphy. *Darlene and Wendy*. 1984. Pencil on paper, 16⅛ × 23½". Courtesy of the Lennon, Weinberg Gallery, New York.

drian painting. Again, the anonymity and passivity of the two figures suggest that they, like the interior, serve exclusively as compositional elements. Notice how the architectural lines are parallel with the exterior edges of the format, forming right angles where they meet the frame. Why? Not just because that's the way they appear. This arrangement represents the artist's conscious decision to bring visual elements into alignment with the edge of the drawing and with each other.

Breverman demonstrates an essential characteristic for any artist: the ability to recognize aesthetic potential in the ordinary. In the same way that a poet takes everyday words and composes them in rhythmic relationships that imply a higher meaning than that of common usage, the visual artist transforms the ordinary environment into an object of beauty through design. In Breverman's drawing, the

parallel construction of lines and edges is as structurally unifying as alliteration and rhythm are to poetry.

Catherine Murphy's double portrait drawing, *Darlene and Wendy* (Figure 9.13), is an intriguing work, presenting us with two skillfully rendered portraits in both an interior and an exterior space. Although there is a suggestion of a narrative, the formal aspects of the composition remain the drawing's primary focus. The diagonal couch, window, and floor molding project back into space, while other architectural elements harmonize with and run parallel to the edges of the picture frame, creating the geometric scaffolding that composes the two-dimensional surface of the drawing. Nothing about this drawing is coincidental.

Each of these artists has composed a drawing for the sake of establishing a desired

structural relationship. As Degas once said, "Even in front of nature, one must compose."[16] Whistler also pointed out: "Nature is usually wrong; that is to say, the condition of things that shall bring about the perfection of harmony worthy a picture is rare. . . . The composition is not found but created."[17]

It is this craft of composing a drawing that most quickly separates the professional from the amateur. For figurative formalists, what is most important is not creating a realistic likeness but, rather, creating relationships among the elements within the drawing.

Another defining characteristic of the figurative formalist is the desire for a sense of peaceful resolution. By eliminating the narrative and expressive content, the figurative formalists have made their drawings from life more meditative. *Meditation* is defined by Webster as "deep continued thought" and "solemn reflection on sacred matters as a devotional act." For artists like Hopper, Diebenkorn, and Pearlstein, art is a sacred matter, and the making of art to a great extent becomes a devotional act. In this context, the nude is a highly revered, quasi-sacred symbol, one that

9.14
Robert Brawley. *Afternoon Light, Nude #3*. 1997. Graphite on paper, 36 × 25". Courtesy of the artist.

requires sophistication in order to appreciate it on a purely aesthetic level.

Light as Structure: The Camera's Influence

Since the camera was invented, artists have used it as a resource; its early influence can be seen in the work of Degas, Seurat, Toulouse-Lautrec, and Eakins, and its imprint on contemporary art is enormous.[18] As a tool for artists, the photograph can be a useful way to store information and an efficient means of studying the effects of light. For artists concerned with structure, it is equally useful as an editing device that frames and stores compositional information.

For many artists, it is the light that provides a drawing's structure and its formal content. Light directs the distribution of value and the application of the media in ways that dissolve borders and give dissimilar objects a commonality. For example, in Robert Brawley's graphite drawing (Figure 9.14), the light is what integrates the figure into the space. It is the light that moves our eyes over the draw-

ing's surface, following the path of light as it falls over the wall and the form of the model. As the title—*Afternoon Light, Nude #3*—suggests, light is the real subject of the drawing. Here, the afternoon light provides the figure with a formal attire, as John Berger wrote in *Ways of Seeing:* "To be naked is to be without disguise. . . . Nudity is a form of dress."[19]

As an editing tool, the camera captures and stores images that can later be compositionally synthesized into a drawing. One such example is Ernest Lindner's pencil drawing *In the Reeds* (Figure 9.15). Here, two photographically recorded images, each with its own distinct but not particularly unusual qualities, have been superimposed, one upon the other, to create an unusual structural arrangement. By allowing the images of both the reeds and the figure to remain semitransparent, the artist makes them appear to dissolve into each other, creating an ambiguous, somewhat abstract spatial arrangement. Our focus moves back and forth from one image to the other as we attempt to resolve the ambiguity before succumbing to an appreciation of the drawing on an abstract level as a pattern of lines and value.

9.15
Ernst Lindner. *In the Reeds.* 1975. Pencil, 22$\frac{1}{2}$ × 29$\frac{1}{2}$". Photo courtesy art placement, Saskatoon, Saskatchewan. Photo by Zack Hauser. © CARCC.

9.16
Lorraine Shemesh. *Link.* 1999. Graphite wash on mylar, 21³/₄ × 21³/₄". Allan Stone Gallery, New York.

In a similar fashion, Loraine Shemesh uses the camera to capture an image and freeze the flickering of light on water (Figure 9.16). As the image is transferred with graphite washes onto semi-transparent mylar, its enlargement brings out the abstract patterns within the image. The distinction between realism and abstraction is blurred along with that of the image of figures in the water.

In addition to drawing directly from the model, James Valerio reportedly uses a large-format view camera as a tool for studying light and working out his compositions. *Dancer* (Figure 9.17) exhibits all the qualities of a fine-grain photograph and more. Valerio uses both linear and atmospheric perspective to penetrate the surface of his drawing paper with the illusion of depth. The deep space of

9.17
James Valerio. *Dancer*. 1988. Pencil on paper, 49 × 33". Courtesy of the George Adams
Gallery, New York. Photo by Bobby Hansson.

the interior and the realistic modeling of the three-dimensional form of the nude figure tend to distract us from the fact that the composition has also been designed in terms of its two-dimensional frame. Using the wall and doorway as structural elements, Valerio divides his picture plane geometrically into three vertical units. The organic form of the dancer's body is superimposed in front of the paneled structure of the darkened door. The trim molding on the wall provides a horizontal motif, which is continued through the door panels and echoed in the lines of the threshold, table, and upper door frame. The gridded tile pattern on the floor provides both horizontal lines and lines that project our view into the interior space of the drawing. The effects of linear perspective in the tile, door, and table are enhanced by the use of atmospheric perspective created through the rendering of light. It defines not only the form of the body and the discarded robe on the table but also a spatial progression from the foreground into the deep interior of the next room, whose content is shrouded by darkness. The doorway is a good example of how Valerio gets the two-dimensional and the three-dimensional reality of his drawing to work together. For although the darkness of the doorway implies a deep, indefinable space, it also has a formal integrity as a two-dimensional design element. Valerio may use a camera and consult a photograph while drawing, but unlike a photograph, the drawing portrays no depth of field that is out of focus, as a camera would, and the artist's awareness of human anatomy allows him to give the body a solidity that a photograph could not impart. Notice that the

9.18
Manon Cleary. *Untitled*. Graphite on paper, 23 × 29". J. Rosenthal Fine Arts, Chicago.

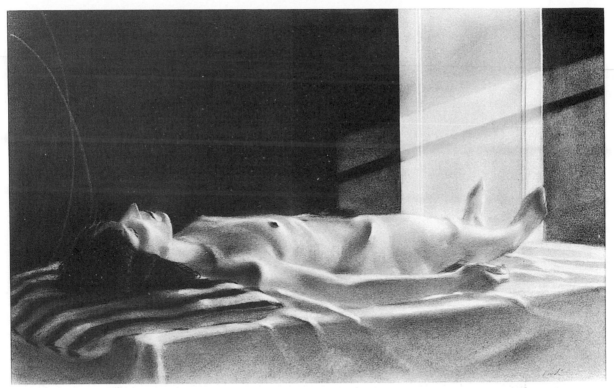

9.19
Norman Lundin. *Supine Model*. 1980. Charcoal, 14 × 28". Courtesy of the artist. Collection of Marie Chun, Los Angeles. Photo by Gary Waller.

form of the body is defined by deep shadow but is never lost in it, whereas the objects of the next room are never defined because, to the artist, the significant content of that space is the shadow. Although he is classified as a photorealist, Valerio's reality is not limited by the photograph; rather, it is extended by his personal vision.

In Figure 9.18, Manon Cleary shows the extent to which a photograph can detach the artist from the subject, even though the subject, in this case, is the artist herself. Cleary bases her drawings on black-and-white photographs to create nude self-portraits. In the style of the artistic nude photographer, Cleary presents her own nudity as an abstract form defined by the play of light. She hones her compositions from paper already toned with a fine layer of graphite, using her eraser to "draw" by removing graphite to represent areas of lighter value. In this way, Cleary can actually render the light patterns rather than imply them indirectly by drawing dark areas only. By employing the intermediate step of the photographer, Cleary remains objective, never easy to do when drawing one's own body, and she is able to experiment freely with *scale*, placement, and cropping.

Although Norman Lundin's drawing of a reclining nude (Figure 9.19) is very realistic, almost photographic, once again the formal elements are what engage both the artist and the viewer. It is the interaction of light with surfaces rather than one person with another that creates the pictorial drama. The passive figure is but a prop, a compositional device, a still-life object. The body, like the wall panels and the table dividing the space, is a dispassionate structural element necessary for Lundin's orchestral manipulation of value.

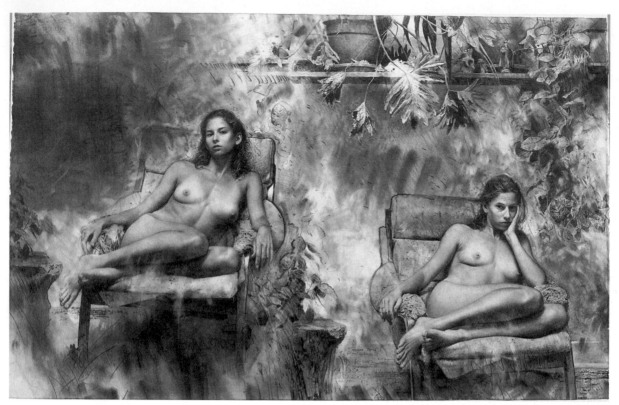

9.20
Kent Bellows. *Megan Twice.* 2002. Graphite, 26 × 41". © Kent Bellows, courtesy of Forum Gallery, New York.

Kent Bellows is another artist who has the skill to transform and transcend the factual information a camera gathers and give it an added poetic dimension. For example, his large drawing *Megan Twice* (Figure 9.20) takes aspects of photorealism to the edge of the surreal. By using a double exposure of his model and the suggestion of forms emerging from and dissolving into their surroundings, Bellows creates a world where form and media are interchangeable, where reality is in a state of flux. Despite the photographic fidelity with which both figures and plants are rendered, his often vigorous manipulation of the medium with hand and erasures reminds us that the ultimate reality of the drawing is that of graphite on paper. Although the model's gaze acknowledges the artist's and the viewer's presence, Bellows uses the two images of the nude as a segue into the drawing; they have no narrative function beyond collaborating in Bellows' aesthetic pursuit.

Toward Expression

The figurative formalists, we have noted, are relationship-minded rather than subject-minded. Although these artists use recognizable objects, such as the nude, in their work, they attempt to see within the subject matter its abstract beauty and compositional potential. They are not particularly interested in suggesting meaning beyond the work itself. Even the identity of the individual posing for the work is often obscured by having the model look away or by cropping out part of the face. However, many artists whose concerns are primarily formalist cannot refrain from suggesting that there is more to their work than meets the eye.

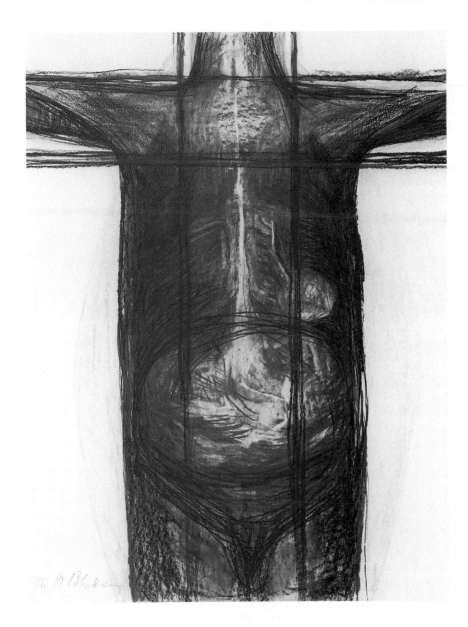

9.21
Magdalena Abakanowicz.
Body 81F. 1982. Charcoal
on paper, 39³/₈ × 29⁵/₈".
© Magdalena Abakanowicz.
Courtesy, Marlborough
Gallery, New York. Photo
by Robert E. Mates.

One drawing that almost erases the boundaries between formalist and expressionist biases is Magdalena Abakanowicz's *Body 81F* (Figure 9.21). The central component of this drawing is composition, the stark contrast of form against background: The vertical of the figure is broken by the horizontal of the extended arms, and both vertical and horizontal forms are accentuated by repeated straight lines. The viewer is distanced from this faceless figure as an individual subject, a recognizable person. But the artist has also imbued the work with subjective content: the action of the mark making, the imagery of the crucifix, the internal organs hinted at beneath the skin. The result is an emotionally charged though somewhat abstract representation of the human form that gains much of its expressive power from the austere, formal compositional arrangement of line and value.

Another content-laden icon is used purposefully within a tightly composed drawing

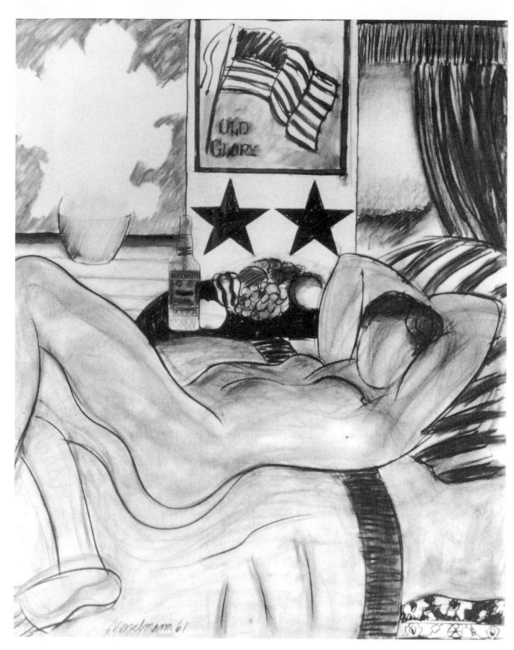

9.22
Tom Wesselman.
*Drawing from
Great American
Nude series.* 1961.
Charcoal on paper,
152.7 × 121.6 cm.
© Tom Wesselman/
Licensed by VAGA,
New York.

by artist Tom Wesselman. During the 1960s, Wesselman created a large body of work, collectively referred to as *The Great American Nude*. On one level, many of these works have both an expressive and an erotic dimension, yet on another level, they function as abstract formal arrangements of form and space reminiscent of Matisse. As we can infer from the pentimenti in Figure 9.22, Wesselman shares Matisse's concern for the

design of the two-dimensional format. By flattening his subjects and eliminating facial features as in this drawing, Wesselman "cools down" his subject matter and converts what is often an erotic pose into an archetypal symbol, a more "acceptable" presentation of the nude. At the same time, he creates a deliberate paradox between the sacred and the profane by juxtaposing the flag and the nude in a symmetrically bal-

anced and flattened composition reminiscent of religious icons. Again, in the words of Matisse, the whole arrangement of the picture becomes expressive.

Representational art of any kind is seldom content-neutral. The artist lacks total control over what a viewer might read into the work. The nude, in particular, carries connotations on many levels. The formalist generally seeks to "flatten" that meaning, to neutralize the figure's expressive content and to amplify its aesthetic role through the formality of its presentation. For the pure figurative formalist, the nude is form rather than content. Some artists blur the distinction between formalist and humanist because of the duality in their intent. However, the following chapter will explore a number of drawings that represent the other end of the figurative continuum—those of the figurative humanists, who focus on or amplify meaningful content and for whom expression is the primary goal.

IN THE STUDIO

Composition is determined by the artist. It need not be arrived at accidentally or dictated entirely by the model's pose. The artist achieves a satisfying composition by considering options and making aesthetic judgments. Granted, there may not be a *right* or *wrong* answer, but for a variety of subtle reasons, there often are *better* or *more satisfying* answers. In figure drawing, understanding composition means becoming aware of how the figure fits into the picture plane. The following studio exercises provide an opportunity to think about the figure in terms of its aesthetic and formal compositional potential.

Quick Compositional Sketches

Pose – 25 to 30 minutes; 5 to 8 sketches (5 minutes each)
Media – graphite, charcoal, or conté on newsprint

This exercise offers a way to explore composition possibilities with quick sketches. The object is to become relationship-minded, to see lines and shapes, value and textures, which are created both by the model and by the surroundings. Before you begin, draw five to eight rectangles, about 5 × 7" each, on several sheets of paper. Some may have a vertical orientation, others horizontal. Leave space between the rectangles. Each one represents a different picture plane in which you will sketch a new composition.

Although the scene in which you pose the model remains unchanged, each sketch should differ in composition. You may achieve this by simply changing your focus or how you crop and frame the subject within the format. You can change value patterns, make light objects dark, shift objects around, add lines where there are none, remove a line in order to balance the composition, or invent your own texture or patterns for greater contrast. The essential ingredient in the study of composition is change, to explore myriad possibilities. See Figure 9.23.

9.23
Susie Tuttle. Student drawing. Compositional sketches.

Composition in Line

Pose – 30 minutes
Media – charcoal, graphite, or conté on drawing paper

Pose the model in the midst of a large setup, such as in a chair by a window or on a model stand covered with different pieces of fabric, or in combination with plants and furniture. The main subject is the model, but as part of a larger environment. The purpose is to use the lines of the body in combination with those of surrounding objects. These lines are tools by which to define structural relationships and arrive at your composition. Take lines out to the edge of the paper. Consider carefully how to frame and crop your subject, and don't hesitate to make changes for the sake of your design, even if they do not conform entirely with what you see.

Composition in Value

Pose – 2 hours
Media – charcoal stick, conté, black and white chalk, black ink, or tempera on drawing paper

The model should again be posed as part of a larger setting or environment. The light should be regulated with spots or by turning down the lights in the studio. Daylight coming through a window can also be effective. The objective is to illuminate the subject matter to create strong contrasting value areas. Although this drawing may begin with a linear breakup of the space, the final composition is to be determined by the description of light patterns and the distribution of value.

Composition in Pattern

Pose – 2 hours
Media – charcoal, conté, graphite, or ink on drawing paper

Pose the model within an environment of variously patterned fabric and objects. Again, the subject is the model, but your drawing should cover the full dimension of your drawing format, and your use of line and value should describe not only the model's pose but also the richness of the surrounding patterns. You need not render every line or fold or detail of the fabric; rather, let these lines suggest ways of breaking up the picture plane.

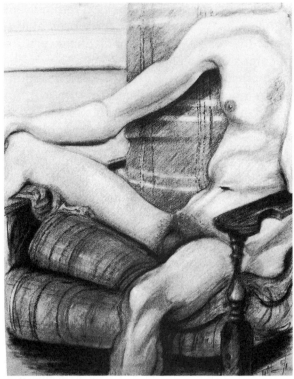

9.24
Susie Tuttle. Student drawing. Composition development.

Composition Development

Pose – 2 to 3 hours
Media – graphite, charcoal, or conté on drawing paper

Ideally, this drawing exercise should follow the development of quick compositional sketches and use the same setup and pose. Building on the exploration done with your sketching, take one of those smaller sketches and develop it into a larger, more detailed drawing. Select a sketch that you feel would be worth spending more time on. The larger drawing should not be considered simply a blowup of the smaller sketch but a more complete development of the visual ideas it presents. You will now have the opportunity to make modifications and clarify the forms. Be sensitive to how elements of the drawing fit together. Is the arrangement interesting or aesthetically pleasing?

Becoming relationship-minded and truly sensitive to the organization of the composition is, for most students, a quantum leap when drawing from life. With this drawing, keep reminding yourself

that you are not drawing the figure; rather, you are using the figure to construct a whole composition. Every part of the drawing, and even areas that are left untouched, should contain a feeling of completion, of having been considered in relationship to the whole. See Figure 9.24.

Synthesized Composition

Pose – 2 hours; standing or sitting
Media – graphite on regular white drawing paper

This is called a synthesized composition because the purpose is to synthesize elements from what you see in front of you with graphic elements you have added for the purpose of design. An additional purpose is to integrate a two-dimensional linear breakup of the surface design with sections of your drawing that are descriptive of volume and space.

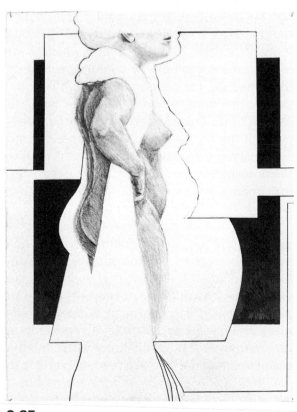

9.25
Carol Powers. Student drawing. Synthesized composition.

Begin by using a straight edge to lightly draw lines that break up your picture frame into several large shapes. The lines may run across the page or create self-contained shapes within the edges of your paper. You will find that those lines that are kept parallel to the edge and to one another will be more readily integrated into a total design than will lines that run diagonally or are out of alignment with any other element. Keep your lines light so that you can change them easily, if you desire, as the drawing progresses.

Next, lightly add figurative elements derived from your model, inscribing them over your lines. During this process, you may wish to draw several images of the model—fracturing the image, shifting its position, changing its scale. At this stage, your editorial decisions are made for the purpose of synthesizing elements of the three-dimensional figure with the two-dimensional linear structure of your drawing. To achieve this, you may wish to erase lines or add new ones or distinguish some areas with texture or value. Line unifies as it moves from the descriptive to the abstract. Your finished drawing will mix two-dimensional and three-dimensional images, combining abstract compositional elements for the sake of design with what you see before you in the model's pose. See Figure 9.25.

Independent Study

1 Discover ready-made compositional material that includes the figure in real-life situations. Take a sketch pad and draw people in their surroundings. Use small formats, about 5 × 7", allowing for some room around the outside of the picture plane, and do ten quick sketches of what you find. The library, restaurants, train depots, airports, parks, and every kind of workplace offer drawing opportunities. **2** Use slides or 35 mm negatives placed in a slide mount and project them, one or several at a time, to suggest a compositional arrangement for your drawing that is a synthesis of several different photographic images.

Chapter Ten

Expression and the Figurative Humanist

An Expressionist, yes. . . . It's been suggested that it's a cross we have to bear in our century. I don't think so. I consider my natural inclination toward Expressionism a great virtue.

—*Jim Dine*

A humanist, by definition, is concerned with human nature and human affairs. Artists who see the figure as a vehicle through which their work can express emotions or some measure of the human condition could be defined as *figurative humanists*. Whether figurative humanists use the figure to convey a particular subject, to represent humanity as a whole, or to reveal their own psyches, they share a desire to express or make known their sensibilities or emotions. In this regard, expression takes precedence over composition because figurative humanists seek to communicate meaning beyond pure aesthetic concerns. They strive to engage us in a poignant experience even at the risk of offending our aesthetic sensibilities.

Where the figurative formalist generally approaches the human form in a dispassionate, objective way, the humanist approaches the figure as an object of content. Figurative humanists use the figure symbolically or metaphorically to convey content beyond its form, beyond the frame. The drawing's message is the state of humanity rather than the human form. This is not to say that the placement of the figure or the arrangement of the composition is irrelevant or accidental. Rather, these elements become tools for enhancing the impact or expression of the drawing, which is the artist's primary intent.

Content becomes the central element of postmodern art work. *Postmodernism* has been characterized as reintroducing representational, content-based art that deals with life issues. Yet it would be a denial of history to pretend that postmodernism creates an entirely new paradigm. Instead, it represents a re-emergence of humanistic concerns into the mainstream of art. The desire among artists to use their art to express their concerns has a rich history as well as a current relevance.

Expressing Empathy

The notion that personal emotions should be the central source and content of art came into vogue in the nineteenth century with the ad-

vent of **Romanticism,** a movement among artists and writers that emphasized personal content and feeling. They asserted the validity of passion and subjective experience as the moving forces in human creativity and expression.

At approximately the same time that Whistler was advocating an art void of sentiment and emotional "clap-trap," the Norwegian artist Edvard Munch, often referred to as the father of **Expressionism,** was writing in his journal: "No more interiors should be painted, no people reading and women knitting. They should be living people who breathe, feel, suffer and love."[1] And, "Just as Leonardo da Vinci studied human anatomy and dissected corpses, so I try to dissect souls."[2] Munch's *The Scream* (Figure 10.1) has become a graphic icon, one with reverberations we still feel today. Munch described the inspiration

for this piece: "I felt a breath of melancholy. Suddenly the sky turned blood-red. I stopped and leant against the railing, deathly tired, looking out across flaming clouds that hung like blood and a sword over the deep blue fjord and town. My friends walked on. I stood there trembling with anxiety and felt a great, infinite scream pass through nature."[3]

Vincent van Gogh also articulated the notion that art should be expressive: "What is a drawing? It is working oneself through an invisible iron wall that seems to stand between what one feels and what one can do."[4] His drawing of a gravedigger (*Stocky Man*, Figure 10.2) gives tangible form to his analogy that drawing represents the artist's struggle to

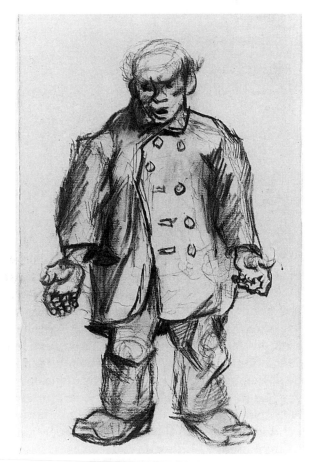

10.1
Edvard Munch. *The Scream*. 1895. Lithograph, $13^7/_8 \times 9^{13}/_{16}$". © 2003 The Munch Museum/ The Munch-Ellingson Group/Artists Rights Society (ARS), New York. © Foto Marburg/Art Resource, New York.

10.2
Vincent van Gogh. *Stocky Man*. 1885. Chalk, $12^1/_2 \times 8^1/_4$". Collection Rijksmuseum Vincent van Gogh; reproduced by courtesy of the Vincent van Gogh Foundation/National Museum Vincent van Gogh, Amsterdam. Inv. No. F1331.

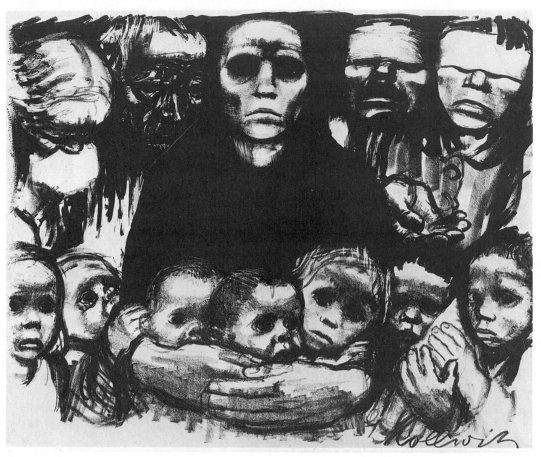

10.3
Käthe Kollwitz. *The Survivors.* 1923. Lithograph on thin wove paper, 23 × 27.4". Courtesy of the Vivian and Gordon Gilkey Graphic Arts Collection, Portland Art Museum, Portland, Oregon (91.84.371). © 2003 Artists Rights Society (ARS), New York/VG Bild-Kunst, Bonn.

make inner emotions visible. From this runt of a man, whose occupation places him near the bottom of the social ladder, van Gogh hacks out a monument, more willfully than skillfully fashioned. Although his subject is coarse and his expression visceral and crude by societal and aesthetic standards of his day, van Gogh had the audacity to confront us with this disheveled figure, standing empty-handed, needing someone to die in order that he might make his living.

One aspect of this drawing that is characteristic of figurative-humanist work is the vigorous use of media as an unrestrained record of the artist's process. Notice that van Gogh restates his lines many times, altering the proportions of the gravedigger, not to make the figure more attractive or more accurately rendered, but to give the figure more presence, more confrontational power.

Another artist who is considered a pioneer of modern Expressionism is Käthe Kollwitz. For her, the figure was always a symbolic metaphor through which to record her views of a struggling humanity and bear witness to what she saw and felt. Kollwitz was a pacifist with profound compassion for the suffering of others. "I am content that my art should have purposes outside itself. I would like to exert influence in these times when human beings are so perplexed and in need of help."[5] Figure 10.3 projects Kollwitz's view, common

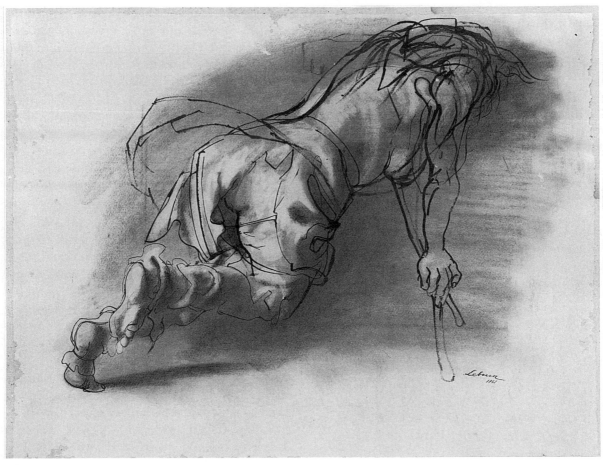

10.4
Rico Lebrun. *Fleeing Cripple*. 1941. Black ink and red chalk on blue paper, 48.2 × 64.6 cm. Fine Arts Museums of San Francisco, Achenbach Foundation for Graphic Arts, Museum purchase from City Funds, 42.20.2. Courtesy Koplin Del Rio Gallery, West Hollywood, California.

among figurative humanists, that art should be about life, that the position of artist goes beyond that of making self-contained, aesthetically pleasing objects. As she wrote, "While I drew, and wept along with the terrified children I was drawing, I really felt the burden I am bearing. I felt that I have no right to withdraw from the responsibility of being an advocate. It is my duty to voice the suffering of men, the neverending sufferings heaped mountain-high."[6]

Rico Lebrun's drawing *Fleeing Cripple* (Figure 10.4) carries with it aspects of both van Gogh and Kollwitz. The figure is drawn loosely, with calligraphic line augmented by subtle washes of value. The subject of the drawing, the figure hobbling on crutches, elicits our interest and empathy. As an inspiring teacher, Lebrun believed that, in addition to developing technical skills, students should let their passions reign in their drawings. Lebrun encapsulates his attitude about drawing in this advice to both student and teacher: "The fundamentals of drawing are the fundamentals of active passion. In teaching we neglect to sponsor passion as a discipline. The only discipline we teach is that of deadly diagrams supposedly to be fertilized later by personal experience. Later is too late."[7]

Expressing Social Concerns

Many artists express their active passion by using their work as a projection of social conscience, revealing for society the truth of its existence—capturing, in poignant visual language, the heart of a political issue or historic event. Picasso, an outspoken advocate of working both from the imagination and from life, expressed his personal outrage in Figure 10.5, one of numerous works he created in reaction to the Nazi bombing of the Spanish village of Guernica (see also Figure 2.3). Here, Picasso distorts the figure to more effectively convey the feeling of anguish. His figures are not necessarily drawn from life, but they are nonetheless an expression of life. "Art," he

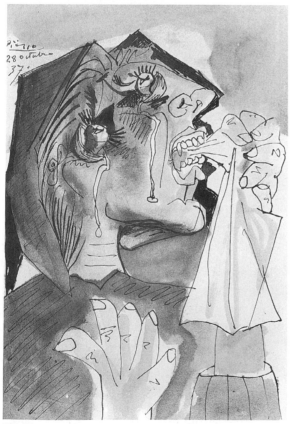

10.5

Pablo Picasso. *Weeping Woman.* 1937. Oil washes and black ink on off-white wove paper, 15$\frac{1}{8}$ × 10". Courtesy of the Fogg Art Museum, Harvard University Art Museums; Francis H. Burr Memorial Fund. © 2003 Estate of Pablo Picasso/Artists Rights Society (ARS), New York.

once said, "is a lie that makes us realize the truth."[8] Picasso did not personally witness the bombing, but this didn't prevent him from expressing his condemnation of the act and his compassion for its victims.

Although the figure may not be realistically rendered, a humanist drawing maintains its authenticity if the viewer feels its subject is a matter of importance and is expressed with force and sincerity. Along with feeling little obligation to present the figure as it visually appears, humanists often share a desire to alter the social or political order as well. For many artists, this concern for valid expression extends to personal convictions about the society in which they live and work. Some are overtly critical or disdainful of human behavior, which they hope to change; others try more subtle approaches. Whereas the formalist would consider this element in art as "propaganda"—or, in Whistler's words, claptrap—and therefore a contaminant, a humanist might consider it an expression of conscience and thus an artist's moral duty.

In the aftermath of World War II, Mauricio Lasansky created a series of large drawings that exists as an indictment of Nazi atrocity. Each drawing, as Figure 10.6 suggests, cries out against the horror and adds momentum to the expressive force of the series as a whole. Jewish Scripture and stenciled numbers in the background lend a poignant context to the soulful development of the figure, drawn in graphite then partially erased and smeared with turpentine and watercolor washes the color of dried blood. Lasansky said, "I tried to keep not only the vision of the Nazi Drawings simple and direct but also the materials I used in making them."[9] The face, distorted in anguish beneath the mask of death, is not meant to represent any one individual but rather the millions of victims of the Holocaust. Symbolic narrative or visual allegory often gives us, as humans, a means to comprehend what would otherwise be beyond our experience. Lasansky does not use a life model but draws from his imagination

10.6
Mauricio Lasansky. *Nazi Drawing No. 27.* Graphite, watercolor, turpentine wash, newspaper, 46 × 46". Lasansky Corporation Gallery, Iowa City. Collection of the Richard Levitt Foundation. Photograph courtesy of the artist.

to create this agonized response to one of life's most horrific moments. His drawings are authentic symbols that both externalize and give tangible presence to his subjectivity. Although the images may not have a specific match in the "real" world, they are no less real. The authenticity of his drawings comes not from truthful rendering but from within, from the core of his humanity.

Some social evils can be more subtle or insidious than a finite event like war, yet spring from the same depths of violence and

inhumanity. In response to racism and escalating incidents of social injustice in the United States, Paul Cadmus created *To the Lynching!* (Figure 10.7), which reels with action and drama. The composition is tightly packed with the men of a lynch mob that you, the viewer, have somehow become part of. The action swirls about you at a feverish pace. The rippling patterns of value suggest a light that flickers from a torch in your hand, and the man on horseback calls out to you to hurry along. The whole composition is like a

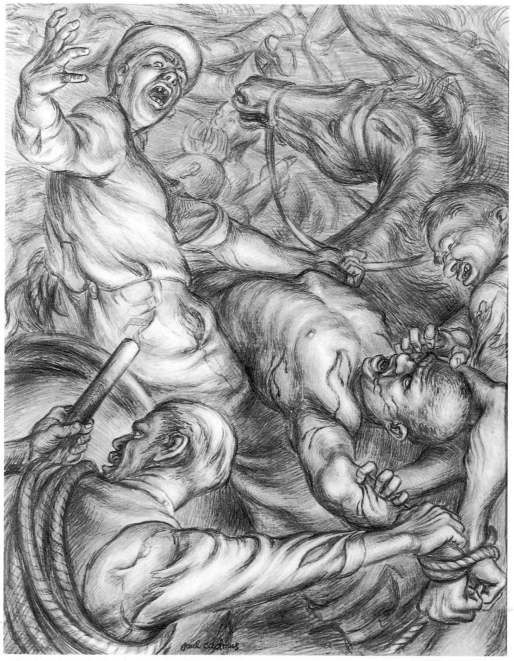

10.7
Paul Cadmus. *To the Lynching!* 1935. Pencil and watercolor, $20^1/_2 \times 15^3/_4$". The Whitney Museum of American Art, New York, Purchase (36.32). Geoffrey Clements Photography.

10.8
Charles White. *J'Accuse! No. 9.* 1966. Charcoal. Courtesy of the Heritage Gallery, Los Angeles.

vortex that pulls you into the center of the action toward the victim. Even the anatomical forms are arranged to suggest the force and strain of the action. In short, every component within the drawing is called upon to heighten the experience and to involve us in this dehumanizing act with the hope that it will elicit a humane reflex. Cadmus's drawing strives to be a cultural force that moves us emotionally and motivates us politically.

Racial injustice culminating in the civil rights movement of the 1950s and 1960s spurred Charles White to complete a series of drawings that both reflected the mood of the day among African Americans and added to the movement's momentum. White's single fig-

ure in Figure 10.8 becomes emblematic for an entire race and a national movement. Planted as solidly as an oak, the figure stirs the air and creates a storm cloud of commotion overhead. The agitation of the upper, abstract portion of the drawing becomes the visual equivalent of rolling thunder, complete with an explosive rallying call to action, justice, and resolution.

Contemporary artist Jerome Witkin is as passionate today about making art that deals with the real issues of life as Käthe Kollwitz and Edvard Munch were a century ago. "The times are too desperate to have an art that avoids life and world problems."[10] His large charcoal drawing depicting an evangelical

preacher (Figure 10.9) is one piece in a complex, thematically related body of work titled *A Jesus for Our Time*. "In these times, a lot of people would like to see a redeemer, a savior, some superman, a charmed advocate who could stop the craziness."[11] Witkin relies heavily on life models, who are often called upon to play parts in the dramatic narratives he distills to a few meaningful images. Reflecting on the figure in his work, Witkin explained: "I want to create people who are seen during crisis. . . . A narrative artist must find a way to present telling moments that we all can relate to in a telling way. The power of the human gesture is profound. . . . More and more I'm aware of the importance of the figure."[12]

10.9
Jerome Witkin. *Wayne Pond as Jesus for Our Time, Study for Panel.* 1986. Charcoal on paper, 84 × 48½". Courtesy of Jack Rutberg Fine Arts, Los Angeles.

A skeleton wearing a gas mask and breathing aparatus was the model for *Biodegradable* (Figure 10.10), created in response to our ever-increasing capacity for destruction of the earth and poisoning of its life forms. The skeleton has been used across cultures and throughout history as a visual embodiment of death. The gas mask symbolizes the futility of thinking that we can separate and insulate ourselves from a polluted world. The title suggests that as we degrade our ecosystems, we are both degrading and endangering ourselves.

The threat of nuclear war spurred Robert Arneson to create the highly expressive *Gotcha* (Figure 10.11). On an abstract level, the marks create an aesthetic tapestry that the mask of death negates. The closer we look, the more horrifying the image becomes. Arneson's use of the written word in the form of graffiti adds momentum to our anxiety. In the partially opened mouth linger the words, "Let's drop the big one." Through his drawing, Arneson not only expresses his fear but also, to some extent, excises it. His drawing is energetic and cathartic. It obviously is not reality but, rather, a new vision he creates to counteract the acceptance of the "technological myth." In this respect, the act of drawing

10.10
Clint Brown. *Biodegrading.* 1997. Charcoal and pastels, 40 × 26".

10.11
Robert Arneson. *Gotcha.* 1983. Acrylic oil stick and felt-tipped pen and pencil on paper. Hirschhorn Museum and Sculpture Garden, Smithsonian Institution, Washington Museum #85.10.

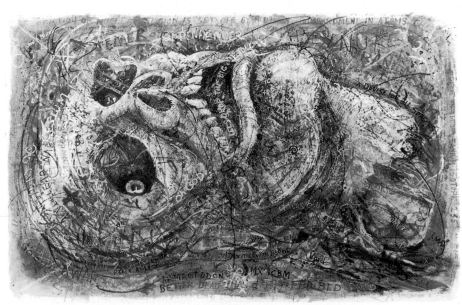

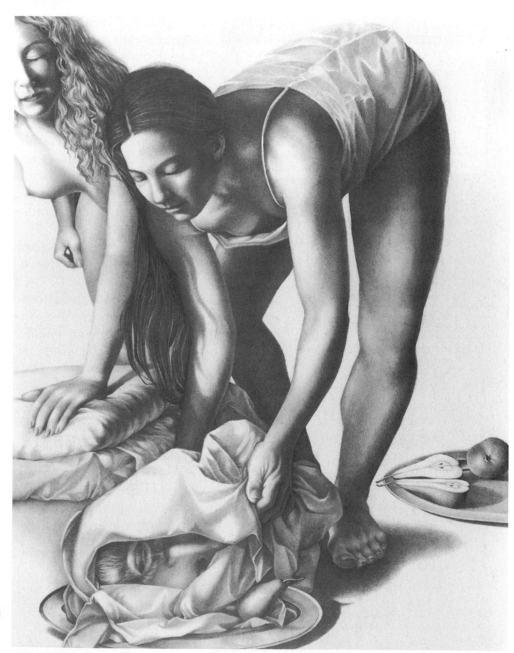

10.12
Julie Schneider.
*Judith, Scene
4 from Heros.*
1989. Graphite
on paper,
29 × 23". From
the collection
of Renee
Stoutjesdyk,
Washington,
D.C. Photograph
courtesy of the
artist.

involves ritual and a kind of magic in its attempt to alter history and to impel social awareness of the need for change. The relationship between art and magic goes as far back in history as the cave drawings, created, archaeologists believe, to give the hunters magic power over the beasts they depicted. In a similar way, Arneson invokes a kind of magic by personifying the threat that hangs over us all in the nuclear age.

Julie Schneider's drawing (Figure 10.12) demonstrates a controlled, realistic rendering that carries a strong expressive, emotional impact. Schneider pays homage to both an Old Testament heroine, Judith, who saved her people by beheading the Assyrian general Holofernes, and to one of the artist's heroines, the seventeenth-century master Artemisia Gentileschi. Gentileschi created a number of paintings depicting Judith, one of

10.13
Artemisia Gentileschi. *Judith and Maid-Servant with Head of Holofernes.* ca. 1625. Oil on canvas, $72\frac{1}{2} \times 55\frac{3}{4}$". Photograph © 1977. The Detroit Institute of Arts. Gift of Mr. Leslie H. Green. Acc. #52.253.

which is shown in Figure 10.13, which influenced Schneider's series of drawings on the same subject. Both artists present us with a dramatic narrative element from the Old Testament story, but for Gentileschi, who had been raped at age nineteen, Judith's deed may have held a fascination for reasons other than its religious or historical significance. Schneider's drawing makes reference both to Judith and to Gentileschi. Within its eloquent formality, Schneider's drawing also makes a feminist statement, paying homage to strong, politically active, and creative women past and present.

For Bailey Doogan, the nude body provides a site for engagement, a forum for dialogue dealing with a host of gender issues. Her work has been described as tough and difficult, raw and honest. Although beautifully crafted, her nudes are far from ideal. "In this

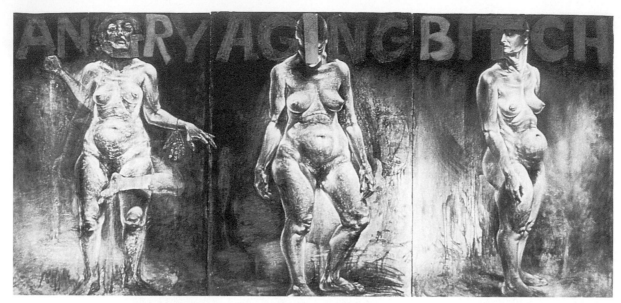

10.14
Bailey Doogan. *RIB (Angry Aging Bitch)*. 2000. Charcoal, dry pigment, and aluminum dust on gessoed paper, 72 × 150". Courtesy of the artist.

culture, we are presented with bodies that are marketed, homogenized, spray-painted. If we see anything other than that, we are shocked. There is a bodily shame."[13] For years, Doogan has been engaged in body politics. In Figure 10.14, Doogan lines up three aging figures in poses reminiscent of a beauty pageant or the judgment of Paris, but in reality more like a police line-up, perpetrators of less-than-ideal forms. The text above the figures spells out *ANGRY AGING BITCH*, with the letters *R, I,* and *B* picked out in red pigment. Doogan's work has sometimes been censored for its lack of modesty, for its truthful descriptions, for getting under the collective societal skin by exposing our folds and wrinkles and imperfections—by emphasizing naked truth. She says she draws "the specific body that evidences the gravity and scars of time and experience."[14]

Self-Expression

For many artists, the stimulus for their expression is more internal than external, more personal than social or political. In addition to expressing empathy or compassion for others, the drawn figure can be a means by which to proclaim and verify one's own individuality. "In a world which is forever trying to make you be somebody else, to be nobody but yourself is to fight the hardest battle a man is called upon to fight," wrote Arturo B. Fallico in *Art and Existentialism*.[15] In the Romantic view of the early nineteenth century, and more recently within the Abstract Expressionism of the 1950s, art was viewed as springing forth from strong emotions, as a kind of catharsis. Spontaneity and self-expression were central tenets manifest in an energetic use of media and dramatic and emotive subject matter.

Willem de Kooning was an artist who bridged the gap between Abstract Expressionism and the use of figurative images as part of an expressive work. Because he continued to use "woman" as a referential symbol after the burgeoning of Abstract Expressionism, de Kooning was viewed by some hard-liners within the movement as a turncoat, an artistic revisionist. But de Kooning

kept the visual vocabulary of the new expressionists and combined it with his Old World appreciation for the human figure (Figure 10.15). Some have criticized his work as being hostile toward women. His images are both created and obliterated by the kinetic manipulation of his drawing media. The force and energy of his drawing process are, through association, transferred to his women and led one critic to write, "You could name a hurricane after any one of them."[16] His haphazard approach to composition, with his passionate bravado and disregard for physical details of appearance and formal aspects of composition, makes his drawing the Romantic antithesis of the formalist work discussed in the previous chapter. His drawings take on aspects of a ritualistic performance, in which the artist vents his emotions and verifies himself through the creative process. They are defiant acts that express his individuality much more than they convey any subject.

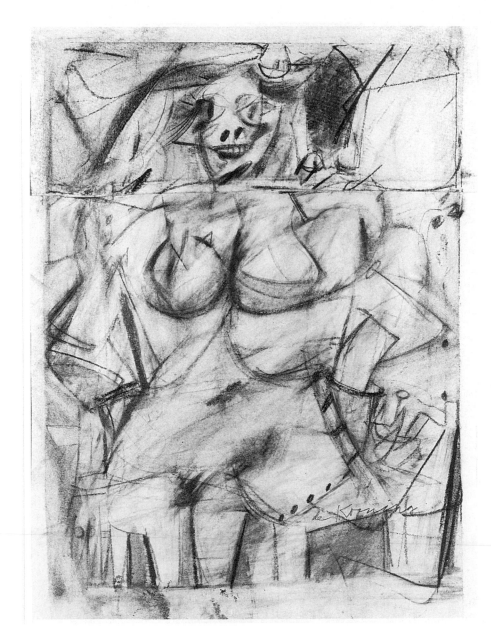

10.15
Willem de Kooning. *Standing Woman.* 1952. Pastel and pencil on cut and pasted paper, 12 × 9¹/₂". Museum of Modern Art, New York, The Lauder Foundation Fund. (33.1975) Photograph © Museum of Modern Art/Licensed by SCALA/Art Resource, New York. © 2003 The Willem de Kooning Foundation/Artists Rights Society (ARS), New York.

Expressionism often is characterized by the vigorous manipulation of the media, as in Jim Dine's *Jessie among the Marks* (Figure 10.16). When describing his drawing process, Dine said: "I begin with charcoal, and then I often rub it out almost completely. . . . I know where to go from there and I start to work on an area and just keep working until finally I have to fix it. Then I take an electric sander or sanding blocks and take out parts of it—arbitrarily sometimes."[17]

Dine, who is an admirer of de Kooning's work, places himself firmly among the Expressionists. "I am almost embarrassed by realism. I think it's quite beautiful, but somehow its depiction of the emotionally impoverished life is a cramped Yankee vision."[18] Dine not only expresses his biases but also points out two characteristics that define the opposite poles of figurative drawing.

On one end of the continuum are the formalist works we admire for their visual aesthetics. Toward the other end are the expressive, humanist drawings we experience through their emotive subject matter.

Although Dine's drawings are vigorously worked, they are based on what he calls the "romance of anatomy."[19] In this respect, his

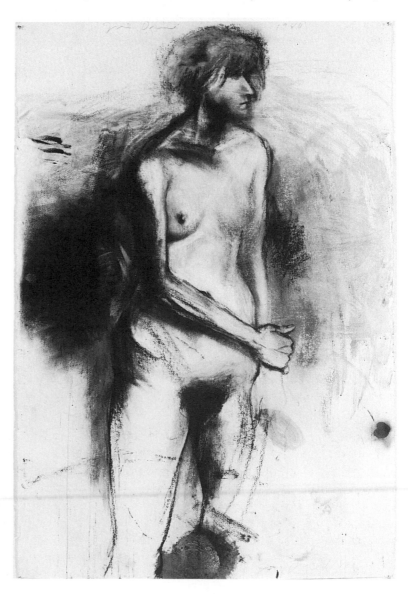

10.16
Jim Dine. *Jessie among the Marks.* 1980. Charcoal, pastel, and enamel on paper, 60 × 40³/₄". Courtesy of PaceWildenstein, New York. © 2003 Jim Dine/ Artists Rights Society (ARS), New York.

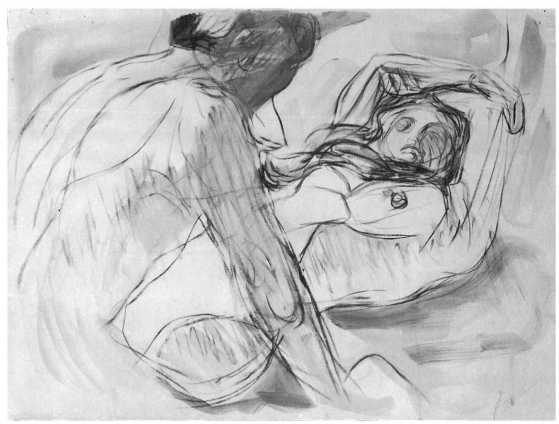

10.17
Edvard Munch. *Man and Woman.* 1912–1915. Watercolor, gouache, and charcoal, 25⅝ × 31³/₈".
Photography courtesy Oslo Kommunes Kunstsamlinger, Munch-Museet. © 2003 The Munch
Museum/The Munch-Ellingson Group/Artists Rights Society (ARS), New York.

drawing style is quite different from that of de Kooning. For Dine, the anatomy of the body is too interesting and appealing to be neglected: "The figure is still the only thing I have faith in in terms of how much emotion it's charged with and how much subject matter is there."[20]

Expressing Sensuality: Nude versus Naked

Every drawing presents imagery perceivable through our senses; therefore, any drawing that is aesthetically pleasing might be considered sensuous. However, whereas the formalist approaches drawing the figure in a disciplined pursuit of purely aesthetic components, the humanist has a more liberal code of propriety and often develops a sensuality within the content of the work. In the context of the for-

malist approach and the desire to appeal to the intellect rather than the emotions, the undraped figure is always distinguished as a *nude* and would rarely be described as *naked*. Figurative humanists, in contrast, are more likely to describe the body as naked. They often share a desire to involve us in all aspects of life's experiences, including sexuality and all the fervent emotions of love, hate, jealousy, joy, or anxiety.

Edvard Munch developed a very personal mythology around the themes of sex and death, which reflected both his rather maudlin personality and his sexual anxiety. Munch believed that woman was the temptress, the "femme fatale" who drew men to her and eventually to destruction. Although he feared women and his involvement with them, human sexuality was a persistent theme in his art.

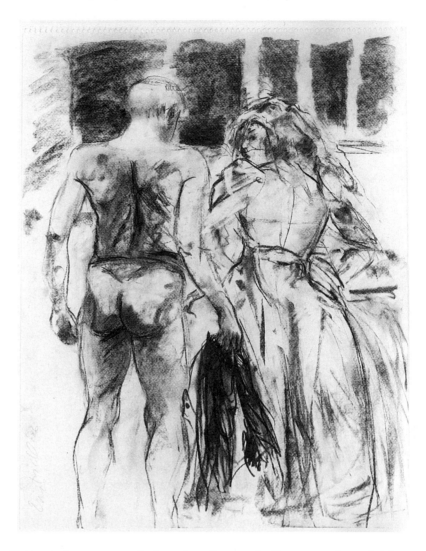

10.18
Eric Fischl. *Untitled.* 1986.
Charcoal on paper, 24 × 18".
Mary Boon Gallery, New York.
Photo by Zindman/Fremont.

Figure 10.17, like many of his other works, expresses this personal conflict but also confirms his strong conviction that "The artist should depict his deepest emotions, his soul, his sorrows, his joys . . . to move people intensely."[21]

The current dialogue between the values of Modernism and Postmodernism, between formalism and humanism, also raises questions about the conflict between nude and naked. Our concept of the nude as a wholesome ideal comes from the Greeks. Our concept of nakedness as shameful was acquired with the Bible's account of Adam and Eve's expulsion from the garden of Eden.[22] It is therefore no wonder that as individuals and as a society we are conflicted when confronted with nudity. This conflict is in part

what makes the nude figure such an intriguing and enduring subject in Western art.

Postmodernist Eric Fischl addressed the metaphoric potential inherent in a naked body: "I'm interested in the way a naked body can be made to reveal a social reality and thus become disruptive for reasons other than its nakedness. I'm interested in the way the body can be coded to reveal what is socially unconscious yet omnipotent."[23] It is significant that Fischl uses the term *naked body* rather than *nude.* According to Kenneth Clark, author of *The Nude*, "To be naked is to be deprived of our clothes, and the word implies some of the embarrassment most of us feel in that condition. The word nude, on the other hand, carries, in educated usage, no uncom-

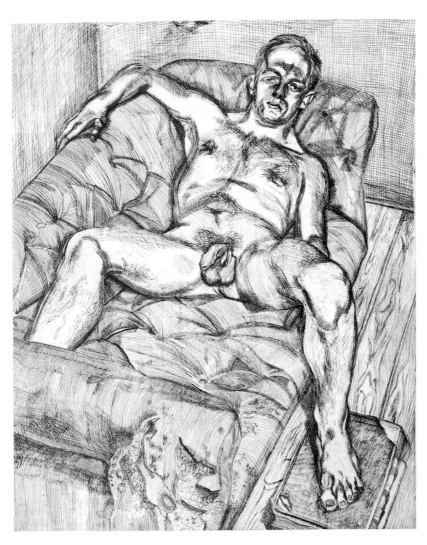

10.19
Lucien Freud. *Man Posing.*
1985. Etching, $21^1/_2 \times 17^1/_5$".
The Metropolitan Museum
of Art. The Elisha Whittelsey
Collection, The Elisha Whittelsey
Fund (1988.1082).

fortable overtone."[24] The distinction is, of course, a question of attitude, but this nuance affects the presentation of the figure in a drawing. Nakedness carries with it a self-consciousness that nudity does not admit to, and in Figure 10.18, the interaction is ambiguous. Here the nakedness is more confrontational, more threatening. Nude is form; naked is content. As Fischl explains: "The thing about modernism was that it separated form from content. . . . Culturally there's been a shift toward a reclaiming of the body itself, because the body is where form and content started and where the shifts are—like the split between the mind and the body. . . . My generation was always aware that the dialogue focused on a search for content."[25]

To further consider the contrast between nude and naked, compare the work of Philip Pearlstein, discussed as a figurative formalist in the previous chapter, and that of his English contemporary, Lucien Freud (Figure 10.19). On one level, their work is very similar—they both use the unclothed figure as the primary source of inspiration, intensely observed within the studio setting. The difference lies in their intent. Pearlstein pursues an aesthetically pleasing presentation in which professional models remain anonymous, admired with a cool, comfortable indifference. In contrast, Freud often presents a sexual undercurrent, leaving the viewer feeling uncomfortable. He uses his acquaintances as models, often rendering them in a way that exposes both

imperfections and vulnerability. As he explains, "The reason I don't work with professional models is that when they are naked, they are clothed in a sense. They are used to being seen that way. And I want something that is not generally on show, something private and of a more intimate kind."[26]

That which is carnal is not necessarily seductive, as Ivan Albright's drawing (Figure 10.20) graphically illustrates. For Albright, the flesh symbolized decay and mortality. "The body is our tomb,"[27] he once proclaimed. This figure is the antithesis of the classical nude, and it is this gap between nude and naked, between the ideal and the real, that gives Albright's drawing its twist of irony. Under a harsh light and the unforgiving scrutiny of Albright's hypervision, human vanity shrivels. Every wrinkle of cellulite-mottled skin is exposed. However, Albright's preoccupation with decay was the result of his desire to reveal what we often wish to deny and keep concealed. Albright saw art as the artist's triumph over death: "The picture is our legacy left by tomorrow's dead for tomorrow's living."[28] For Albright, the wrinkled body was fascinating, if not appealing, and he found greater depth of meaning in the aging process than in the more typically revered beauty of youth. With Albright's figure, we sense the conflict between nude and naked and by extension the conflict between art that pleases and art that reveals.

Expressing Cultural Identity

We live in a multicultural world in which people and ideas are crossing national and ethnic borders to create a rich diversity of expression. The contemporary art scene—the mainstream and beyond—is a pluralistic, multicultural tapestry of diverse influences and stylistic synergies.

Multiculturalism in art is often most visible in work by individual artists who are themselves the product of diverse cultural influences. For example, Rick Bartow (Color Plate VII) draws on the myths and folk tales of his Native American roots to provide him with a rich supply of visual images to conjure, yet he recognizes that both he and his art are equally influenced by contemporary Western art. "Contemporary art set me free. I'm as much taken by the myth of Sisyphus as I am by Coyote. I didn't have to use some pseudo-knowledge of shamanism or ceremonial rites culled from some anthropology book. Contemporary art

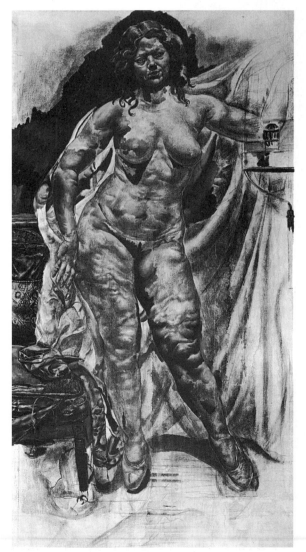

10.20
Ivan Le Lorraine Albright. *Three Love Birds.* 1930. Charcoal and oil on canvas, 7' × 3'8". © 2003 The Art Institute of Chicago. All rights reserved. Gift of Ivan Albright. 1977.38.

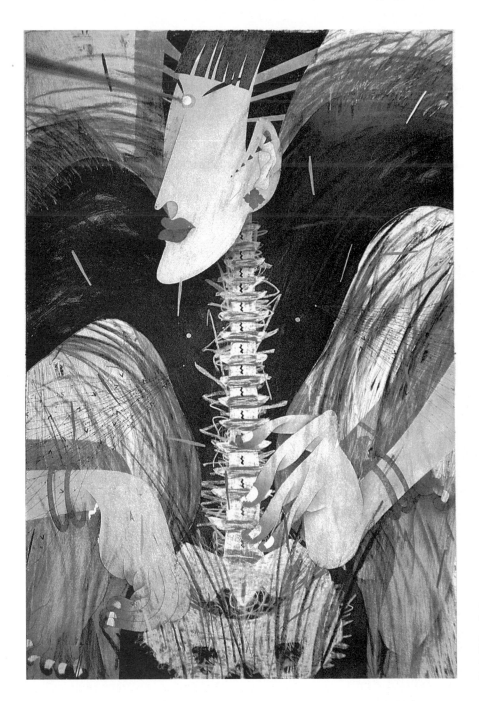

10.21
Yuji Hiratsuka. *Passion Fire.* 2000. Pastel and acrylic on paper, 48 × 31". Courtesy of the artist.

allowed me to vent something of my native interest in an articulate and valid manner. It allowed me to speak of my firsthand experience."[29] His art making is not so much a delving into the past as it is a projection of his native culture into contemporary art.

Yuji Hiratsuka is best known for his prints, which recall the look of traditional Japanese prints but with a contemporary American twist. In similar fashion, his mixed-media drawing (Figure 10.21) is a blending of East and West, incorporating the flat, hard-edged figure reminiscent of Japanese woodblock prints with an array of expressionistic, gestural marks. Hiratsuka lived in Japan until he came to the United States at age thirty-one.

10.22
Jean-Michel
Basquiat.
Untitled. 1982.
Oil paint stick
on paper,
30 × 22".
Photograph by
Myles Aronowitz
© The Solomon
R. Guggenheim
Museum, New
York; gift of
Norman Dubrow.
(86.3442) © 2003
Artists Rights
Society (ARS),
New York/
ADAGP, Paris.

While in Japan, his art work was influenced primarily by Western abstract art. It wasn't until he moved to the United States that he truly discovered ukiyo-e, the traditional print style in Japan. This discovery was prompted in part by American collectors and their enthusiasm for Japanese woodblock prints, but also by a personal need to find his own cultural identity in his newly adopted country.

Stylistically, what emerged is a blending of cultural influences.

Jean-Michel Basquiat was born into a multicultural family in New York City: his father Haitian, his mother Puerto Rican. He learned Spanish before English and began his art career as a savvy, streetwise graffiti artist with a sociopolitical message. By age twenty, he made the transition to the world of art gal-

10.23
Yolanda M. Lopez. *Guadalupe Triptych: Our Lady of Guadalupe, Victoria F. Franco; Portrait of the Artist as the Virgin of Guadalupe; Our Lady of Guadalupe, Margaret F. Stewart.* 1978. Oil pastel on paper, 22 × 30". Courtesy of the artist.

leries, and his work began to be collected by the social elite. Basquiat's black and Latino identity as well as the popular consumer culture of the New York City streets informed his art-making, yet Basquiat was also an avid reader and museum visitor, a culture junkie who cultivated a new primativism in his art work. Figure 10.22 shows the influence of such artists as Jean Dubuffet, Paul Klee, and Pablo Picasso, all of whom advocated a child-like approach to making art. Here, Basquiat's drawing seems the work of an unruly child, with a figure that looks as if he just took a beating yet confronts the viewer with teeth bared. Numbers, letters, and graphic symbols record Basquiat's cryptic message about the cacophony of modern urban life.

For Chicana artist Yolanda Lopez, making art means making statements that alter perceptions. "There were no public images of Mexican Americans or Latinos in mainstream culture that represented us in the broad scope of our humanity," she recalls.[30] Her triptych (Figure 10.23) takes one of the popular icons of her Mexican heritage, the Virgin of Guadalupe, and turns it into both a portrait of maternity and a revolutionary manifesto. In one panel, she shows her mother working as a seamstress. In another, her grandmother holds a skinned snake. In the middle panel, the artist herself runs toward us, clutching a live snake and the banner of Guadalupe. Each woman is ennobled by the sun-ray halo. "To pay honor to the ordinary, that is what interests me," she says.[31] The traditional, passive Virgin is replaced with images of hard-working, assertive women. Like many other postmodern artists, Lopez refers to the methodology and iconography of her historical roots—the Aztecs as well as Catholicism. She then reinvests them with a contemporary vigor and significance that become emblematic of both the Chicano-Latino and feminist movements. The passive and submissive virtues of the Virgin are transformed into those of action and empowerment.

Expressing Subconscious Reality

For many artists, the figure's external appearance becomes a metaphor for expressing an interior world of the human psyche. The mind can be a sanctuary from the technological world, or it can be a cauldron where anxieties and paranoias brew. As Goya once said, "The dream of reason produces monsters,"[32] a sentiment he depicts in *Nightmare* (Figure 10.24). The subconscious offers a source of highly imaginative drawings when the artist blends the rational with the irrational "to make observations for which commissioned

10.25
Nancy Grossman. *Figure 1970*. 1970. Pen and ink on white paper, 117 × 87.5 cm. The Art Museum, Princeton University. Museum purchase, John Maclean Magie and Gertrude Magie Fund.

10.24
Francisco de Goya y Lucientes. *Nightmare (Pesadilla)*. c. 1818–1823. Brush and black ink wash on white paper, $9^{13}/_{16} \times 5^{11}/_{16}$". The Metropolitan Museum of Art, New York, Rogers Fund, 1919 (19.27).

work generally gives no room and in which fantasy and invention have no limit."[33]

One of the expressive tools of artists' drawing from their imaginations is their ability to present convincing details that imbue their drawings with all the elements of truth. Nancy Grossman's skillful application of media works to conjure up images from her imagination, as in Figure 10.25, with a drawing style that leads us to believe this figure exists outside the artist's mind. "At various times in the past," Grossman explains, "I have experienced drawing as magical, the bringing to life of what was not there. The vision of something with all its associations and repercussions, imaging an object or an event, is probably related to the earliest known drawings on cave walls."[34] The image in Figure 10.25 creates a

deliberate frustration and suggests restrained power, a modern Prometheus bound—physically powerful but rendered powerless. The work is deliberately ambiguous, and our inability to discern its ultimate meaning or intent is disorienting. The expression of the surreal often makes us feel uncertain, questioning our own perceptions of reality.

Mexican artist Frida Kahlo completed many self-portraits that went beyond presenting her physical likeness, allowing us a glimpse into her political views, her dreams, her painful disappointments in life, and her often troubled subconscious. *Frida and the Miscarriage* (Figure 10.26) is one such work, created to express her anguish over the loss of a child. Here, her story is told through a symbolic narrative akin to the language of a pictograph. This device allowed Kahlo to incorporate the passage of time in her compositions. Much of Kahlo's work provided her a means by which to exorcise her grief and pain, as well as provide a reason to go on with life in spite of its many hardships. "All of her dramatic life was recorded in her paintings: her miscarriages, the emotional ups and downs of her love life,

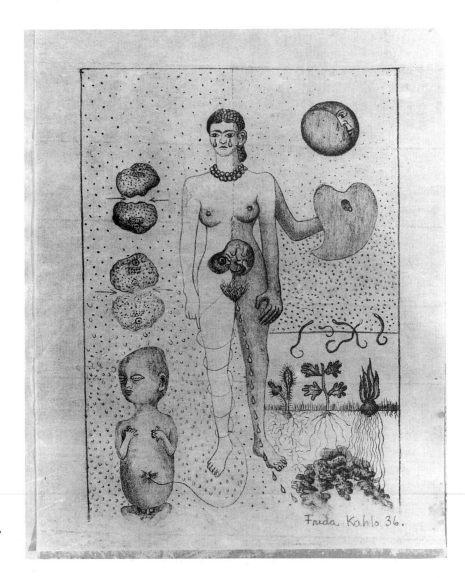

10.26
Frida Kahlo. *Frida and the Miscarriage.* 1932. Lithograph on Japan paper, 8$\frac{1}{4}$ × 5$\frac{3}{4}$". Courtesy of Mary Ann Martin Fine Arts, New York. Photograph by Sarah Wells.

and the recurring physical problems brought on by a traffic accident in her youth,"[35] writes photographer and author Nancy Breslow. Here, Kahlo's likeness is divided into light and dark halves. From the side of darkness springs an extra arm, holding a palette. "I lost three children," she said. "Many things prevented me from fulfilling the desires which everyone considered normal, and to me nothing seemed more normal than to paint what had not been fulfilled."[36]

Distortion and exaggeration of natural features are expressive devices used traditionally by such artists as Hieronymus Bosch, Francisco de Goya, and Honoré Daumier to satirize human folly and more effectively draw attention to what they perceived as society's ills. Rather than faithfully recording only what they saw before them, these artists combined what they had experienced from direct observation with their imaginations to dramatically express their concerns through what might be thought of as pictorial fiction. For the figurative humanist, the imagination often blends with experiential learning. The fictionalization of a subject not only is considered legitimate but is often valued more than an artist's technical skills. Creativity for the humanist is a process of image making and storytelling, and the measure of quality is, to a great extent, the degree to which a work engages the viewer's imagination.

Cadavre Exquis, or Exquisite Corpse, was a parlor game played by surrealist artists. It was based on the random juxtaposition of imagery and encouraged the imagination. In the game, several artists created separate but connected parts of a single drawing without knowing what the others had drawn. Figure 10.27 is such a collaborative work, created by three artists for an exhibition at the Drawing Center, an alternative exhibit space in New York City. Each artist was encouraged to consider the human body as a metaphoric point of departure. The paper was divided according to the number of players into segments roughly corresponding to the human body—

head, torso, legs. The element of chance and random juxtapositioning scrambled logic and placed the creative efforts of each artist in a new context. In addition to reviving the Cadavre Exquis as stimulus for the imagination, the Drawing Center exhibit made both spectator and artist aware of the many ways of seeing. Curator Ingrid Schaffner points out in the exhibition catalog, "The body has been used by contemporary artists to explore is-

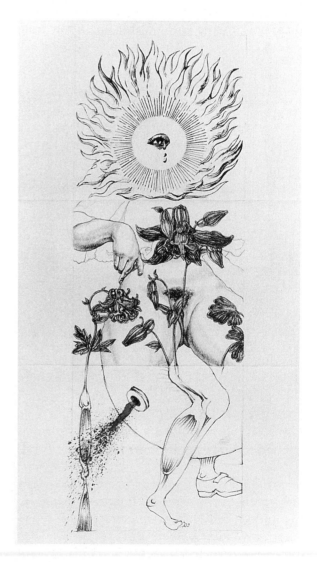

10.27
Josie Robertson, Katharine Kuharic, and Jean-Philippe Antoine. *Cadavre Exquis.* 1991. Courtesy of the Drawing Center, New York. Photo by Gary Graves.

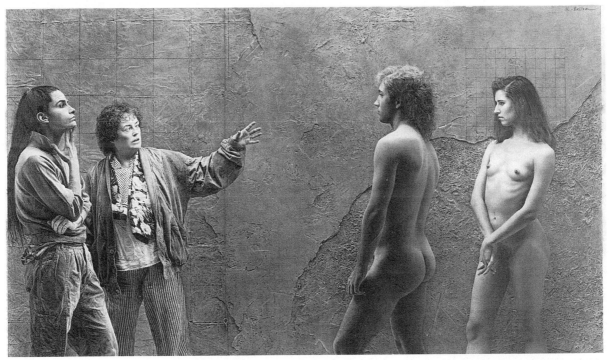

10.28
Kent Bellows. *Four Figure Set Piece.* 1988. Graphite pencil on paper, 17³/₄ × 30¹/₂". The Arkansas Arts Center Foundation Collection: Purchased with a gift from Virginia Bailey, Curtis and Jackye Finch and Director's Collectors, 1989.

sues of identity and gender, public health and private pleasure. It is a complicated realm inscribed with sexual and cultural codes that catalogue human difference as opposed to universal experience."[37]

Expression and Composition

Although the term *artistic expression* is broad enough to apply to the work of any artist, you can see from the examples in this chapter that for some artists it has a more specific meaning. When a drawing communicates something more than the visual appearance of the external world, when the figure becomes a metaphor or symbol through which to vent passions and opinions, the figure loses its neutrality. For the humanist, the drawing becomes a forum where the dialogue is often heated and flamboyant. It is this expression

of subjective views rather than objective facts or purely aesthetic concerns that gives particular emphasis to the term *expressionist.*

Obviously, it is impossible to marshal all drawings neatly into one of the two categories: formalist or humanist. The line of demarcation is not that clear; the groups are not mutually exclusive. For example, *Four Figure Set Piece* (Figure 10.28), by Kent Bellows, represents a very formal composition laden with connotative meaning. A *set piece*, according to Webster's dictionary, is "a composition (as in literature or music) executed in a fixed or ideal form often with studied artistry and brilliant effect." Bellows seems to combine this definition of set piece with another related to theater arts: "a realistic piece of stage scenery standing by itself." The setting has a number of possible interpretations centered on the interaction of the clothed figures and the nudes.

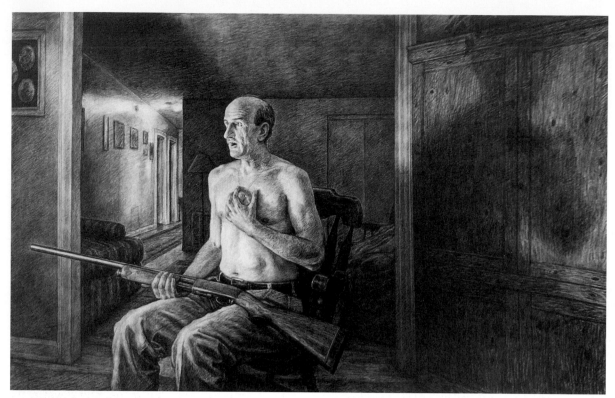

10.29
Edgar Jerins. *Tommy Tells a Story.* 2001. Charcoal, 60 × 94". Courtesy of Tatistcheff Gallery, New York.

The artist establishes a formal composition, a set piece, then imbues it with ambiguous content and implied narrative, leaving the viewer to determine its meaning.

Similarly, *Tommy Tells a Story* (Figure 10.29), by Edgar Jerins, employs both the house interior and the light to create an ordered and balanced composition around the central figure. Yet the drawing also presents a narrative—the gun across the lap of a shirtless figure, the dramatic lighting and cast shadows, the distant gaze and anxious expression all beg for more than an aesthetic appreciation. Jerins tells his story at the same time that he captures a classic moment, ageless and universal—the old man telling stories, be it around a campfire or the kitchen table.

As you develop your own body of work, you may find yourself more appreciative of formal aesthetic concerns or the humanistic temperament—or some middle ground that combines both. In any case, composition and expression hold paramount importance. For representational artists, the figure is not an end in itself but the source through which to delve into broader aesthetic issues or, as Degas suggested, into what they "must make others see."

IN THE STUDIO

A great deal of evidence suggests that creativity is a process that can and must be practiced to be learned, and that it is not an innate quality that one simply inherits. We learn to be more creative and expressive through practice and by defining these as our goals.

Expression does not mean "anything goes." Rather, expressiveness suggests a driving desire to push a drawing as far as possible toward its conclusion, toward making its intent clear and its existence more potent. Just as one learns with practice the skills that relate to rendering a realistic likeness, one also learns how to hone one's message and express oneself forcefully. The exercises that follow are intended to encourage your experimentation into aspects of creativity and expressive problem-solving. They offer only a place from which to begin.

Expressive Accentuation: Media and Process

Pose – 30 minutes; developed further without the model
Media – artist's choice on drawing paper

You may use any pose, with or without props; what is important is to recognize that you must bring yourself to your work in order to develop it beyond what you see. While drawing from the model, look for aspects of the pose or the model's attitude that

you could dramatize. Allow for changes as you progress, and continually and aggressively rework the media, erasing or adding multiple layers. The gestural action of the drawing process is an important part of the drawing. Direct the work toward a more potently charged statement, following intuitive hunches but also stepping back and objectively evaluating what you have drawn, not in terms of its realism but rather in terms of how effectively it gives the figure a heightened presence that is realized through the vigorous drawing process. The final drawing should be as much about you and your expressive actions as it is about the model's pose.

Expressing Empathy

Pose – 60 minutes; developed further without the model
Media – artist's choice on drawing paper

This exercise will most likely require you to develop your ability to fictionalize as well as empathize. Take your clues from the model and develop the drawing further using your imagination, like a good fiction writer, into a metaphoric dramatization. The model should be asked to play a role, assuming a pose suggestive of someone who would ordinarily draw our sympathy—a victim of social or political circumstances, a physical laborer, a murder victim,

10.30
Mark Stockton. Student drawing.
Expressing empathy.

or an imprisoned individual. These roles can be acted out with a few simple props and a little imagination on the part of the model. The success of the drawing, however, will depend on how well you can project yourself into the situation and enhance the drawing with your own empathy and imagination. One's compassion and imagination do not always require firsthand experience. Consider all the artists who have used the crucifixion and the pietà as the subjects of their art yet who obviously never witnessed the actual events. The test of your drawing will be whether it involves the viewer or provokes an empathic response. See Figure 10.30.

Inventive Distortion and Synthesis

Pose – 60 minutes; developed further without the model
Media – artist's choice on drawing paper

By deliberately distorting forms or juxtaposing and synthesizing the model's pose with other visual elements, you can distort reality, creating a surreal image. You want to combine the visual clues presented by a model and alter them through the improvisational forces of your imagination. You may distort existing features of the model's gesture or form or develop a composite image combining fragments of the figure with invented shapes into a synthesis that has no basis in reality. The authenticity of your drawing will depend not on its looking like an existing situation but, rather, on its being drawn with such conviction and authority that the viewers find themselves participating in the reality of the visual clues you create. See Figure 10.31.

Juxtaposing Organic and Inorganic Forms

Pose – 2 hours; developed further without the model
Media – artist's choice on drawing paper

Combine the figure with inorganic elements to create a metaphoric image. The drawing should be a synthesis of the model with forms suggestive of mechanical or electronic elements or some other imagery at odds with the human, organic form of the life model. The nonorganic components can be derived from imagination or supplemented with visual aids from magazines, books, machine parts, and so forth. These elements may be made part of the body or integrated into the composition as a whole. Mechanical drawing tools, such as a compass and straightedge, are useful for developing graphic qualities that contrast with the gestural qualities of freehand drawing.

Independent Study

1 Draw a self-portrait in which your depiction of yourself is atypical, more expressive than realistic. Devices such as aggressive application of the media, distortion, fictional narration, and juxtaposition of unusual objects can add power to your drawing. **2** Create a drawing of an individual on the fringe of society or in some other way a part of a counterculture. This drawing could be based on someone you know or have observed, or on someone you have read about or imagined. **3** Use the human figure as a metaphor to comment on a current or historical event that you find particularly disturbing in terms of its effect on humans.

10.31
Joan Hurley. Student drawing. Inventive distortion and synthesis.

Appendix A

Becoming Your Own Best Critic

Discipline is not a restriction but an aid to freedom. It prepares an artist to choose his own limitations. . . . An artist needs the best studio instructors, the most rigorous demands, and the toughest criticism in order to turn up his sensibilities.

—*Wayne Thiebaud*

In addition to the disciplines, demands, and criticism that you may receive from an instructor or mentor in the drawing studio, your goal should be to become self-motivated, self-disciplined, and self-directed. These qualities, along with the skills you acquire and a knowledge of the history of your craft, will enable you to be truly autonomous, free to follow your own path. But beyond gaining these qualities, you also need to develop your ability to be self-critical, to be your own best critic. You need to be able to step back, out of the persona of artist as maker and into that of artist as critical observer, and honestly evaluate your own work.

During the drawing process, the artist is continuously making evaluative judgment calls: Should the line be here or there, a form larger or smaller, a value darker or lighter? Even the most spontaneous impulses are followed by the artist's assessment of their merit. In this regard, the drawing process consists of an ongoing exchange between action and evaluation. But at some point, the artist evaluates the drawing as a whole, in terms of how well it has fulfilled its potential. At this point the artist must become the honest critic, one whose foremost interest is quality.

Your ability to recognize quality work is determined to a great extent by the breadth of your experience, knowledge, and exposure to superlative works, all of which increase your understanding and ability to make value judgments. In your own drawing, you may have noticed emerging characteristics that are unique to your way of working and are an expression of your aesthetic tastes. Being your own best critic, however, involves more than developing a personal style or a preference for a particular medium or type of work. Making true value judgments is not as easy as classifying a drawing stylistically, nor is it as simple as expressing a prejudicial statement of personal taste. Quality is more demanding and requires greater sophistication and discernment.

Quality, in itself, is difficult to define in an absolute sense. But no matter what the artist's medium, temperament, or method of working,

quality does exist and can be recognized. Quality—that elusive element—is what makes one drawing better than another or, after refinement, better than it was in a previous stage of its development. Quality is something we experience in a comparative sense, and although we may be unable to define it absolutely, it is possible to define some general traits that contribute to the quality of a drawing: *authenticity, presence, enhancement, economy,* and *creative insight.* These five characteristics can serve as guides for assessing the merits of your own work. Although they will not exist to the same degree in every drawing, and it is even possible that one may be developed to the exclusion of others, each contributes to the overall quality of your drawing.

Authenticity is what makes a drawing convincing. It is the feeling that the artist knows the subject and is speaking with authority. Authenticity is present when the drawing is so fully described, so skillfully rendered, that the viewer feels drawn into its reality and accepts its logic. A drawing can achieve authenticity because the content is poignant and expressed with such force and conviction that the drawing's emotional charge presents a genuine expression of the artist's feelings, or an expression that the viewer accepts as authentic.

Presence is that aspect of a drawing that makes us take notice, that demands our attention or invites our consideration. This may be a result of scale, the way a figure fills and activates the space; or it may be the placement that makes the figure the dominant compositional element, or the angle from which it is viewed that makes the subject more interesting and engaging. An artist might achieve presence by describing the subject with such undeniable clarity, revealing one minute detail after another, that we are lured into the drawing. Or it might be that the drawing has such tenacity and force that it seemingly rushes forward to overwhelm us with its intensity.

Enhancement involves the artist's defining the intent of his or her drawing and then re-

fining and sharpening its focus, adding richness and embellishment. To enhance means to make greater, to amplify, to heighten or expand, to intensify or elevate, to advance or exalt, to maximize or bring to fruition. Exactly how a drawing should be developed, or "pushed," beyond the initial and often timid starting point is determined by the artist's intent. Intent establishes the criteria by which to evaluate the drawing's further development, determining whether the artist has brought the drawing closer to his or her goal. It is the refinement of a drawing that gives the impression that it has realized its potential and is fully resolved. For some artists, this may be achieved by giving the subject the greatest degree of realism possible; for others it might depend on a more forceful, energetic execution of the media or on a restructuring of the composition.

Economy relates to the efficiency with which information is conveyed. With a quick sketch, it is the way an artist economically distills and expresses the essence of a subject with limited time and effort. In a more time-consuming drawing, however, economy may be the artist's ability to create a single image capable of conveying a complex message on several levels at once. The economy of a drawing may also be demonstrated in its being satisfying on both a conceptual and an abstract level simultaneously, being both highly informative and aesthetically pleasing. Economy is not simply an abbreviation, for less is not always more; it is the compacting of information into a more potent visual statement.

Creative insight refers to the degree to which a drawing makes known or realizes that which was previously unknown. Every drawing states to some extent what we know, but, ideally, a drawing should also be a revelation. A truly creative and insightful drawing makes new discoveries that are manifest in the act of drawing itself. These discoveries are often as much a surprise to the artist as they are to the viewer. Drawing involves a great deal of craft, but creativity comes through thinking of drawing as

an exploration, an investigative process of image conjuring. At its best, a drawing probes and reveals unknown territory, bringing revelations to the artist. It illuminates that which was obscure. It gives substance and form, making tangible the ideas and feelings that began as unfocused or vague concepts. It makes the ordinary appear new and extraordinary.

How do you do all this within the realm of a life drawing? By playing with all the possibilities, by striving for what lies beyond, by not being satisfied with work that you know you can make better or stronger, and by keeping your eyes and your mind open. Quality is not preexistent. It is arrived at—developed, or coaxed into being. For the artist, quality is a consistent goal, a self-imposed, lifelong challenge.

Appendix B

Drawing Tools and Materials

I thought you had to give up a lot for art, and you did. It required complete concentration. It also required that whatever money you had had to be put into art materials.

—*Alice Neel*

Every artist and every drawing teacher has a preference for specific drawing materials, depending on personal experience, goals, and temperament. Some even develop a preference for a particular brand, which they believe is of a superior quality or is more responsive. The choice of drawing materials is a highly personal matter. However, here are some basic tools and materials that are often selected by artists and art teachers when drawing from life. For the most part, they are not very exotic or expensive.

Mark-Making Tools

Charcoal was used by early humans to make cave drawings, and it remains the preferred drawing medium of many contemporary artists. Charcoal is made by carbonizing wood with heat in an oxygen-reduced environment. **Vine charcoal** is made from twigs and sticks of various sizes and degrees of hardness. **Compressed charcoal** is made from ground charcoal that has been blended with a binding agent and compressed into sticks.

Charcoal pencils are made from ground charcoal and sheathed in either wood or rolled paper sleeves. They range in degrees of hardness from extra soft, which produces the darkest mark, to hard, which makes the lightest.

Conté crayon is a commercially produced chalk that is available in a variety of colors, the most common being terra cotta red, brown, and black. Traditional artists used **natural chalk** that was found in nature. Red (iron oxide), black (carboniferous shale), and white (gypsum) were often used in combination and on colored or toned paper.

Fabricated chalks and **pastels** are made by mixing dry, powdered pigment into a paste with a binding agent and then pressing them into sticks. Like charcoal and conté, pastels are now available in pencil as well as stick form and in varying degrees of hardness. Pastels are also rated in terms of quality or fineness of the ground pigment used in the stick.

Graphite was developed after 1564 when a deposit of pure graphite was discovered in

England. It was at first believed to be a deposit of lead, in part because of its metallic appearance. Thus graphite pencils are still referred to as lead pencils. The scarcity of pure English graphite soon encouraged inventors in Europe and America to experiment with a manufactured pastelike mixture of graphite, fine clay, waxes, shellac, and resins that could be made into wood-sleeved pencils. Graphite pencils range from 8B, the softest, to 10H, the hardest. **Graphite sticks,** pencils, and woodless graphite pencils are also available and can be used in similar ways to create a variety of line qualities and beautiful tonal areas. Compared to charcoal, graphite has a crisper line; it is not quite as messy, and it has more of a waxed or oily texture that can at times create an unintended reflection within large dark areas of a drawing. However, graphite pencils are always available, and even a common 2B pencil can be used to create an amazing range of tones and textures.

Brush, pen, and **ink** have been favorite media for visual artists for centuries. Inks are made by suspending pigment in a solution of water and gum arabic. Traditional inks have been made from carbon, iron salts, or even walnuts. Sticks, reeds, or quills were traditionally used to apply ink in crisp, sharp lines. Ink can also be thinned and applied with a brush to achieve a variety of value tones and washes.

Watercolor is similar to ink with the added advantage of a full spectrum of color, but all aqueous media—whether ink or transparent or opaque watercolor—require more preparation and added paraphernalia in your drawing kit, such as water containers, brushes, paint rags, and paint tubes.

Erasing Tools

Erasers are useful drawing tools as well as tools for making corrections and for cleaning up a drawing. Today there are many different types and brands of erasers from which to choose. Here are three that are very useful.

Kneaded erasers are particularly useful when working with charcoal. The name comes from the fact that the eraser has to be kneaded to make it pliable and absorbent. It is excellent for use with conté and charcoal as well as for general cleanup of smudges and unwanted fingerprints.

Plastic erasers are harder and usually of white vinyl. They have started to replace the pink rubber and art gum erasers as the general, all-purpose eraser in the drawing class. They are excellent on graphite and last longer than the gum or rubber erasers.

Eraser sticks are long rubber pencil-like erasers that come in plastic holders or tubes. The primary advantage of these erasers is that they are smaller and can be used to subtract pigment from smaller areas. They can also be used like a pencil as a drawing tool to make light marks through dark-toned areas.

Drawing stumps and **shams** are used to rub and blend pigment after it has been applied to the drawing surface. A stump is a roll of soft paper or leather about the size of a pencil. A sham is a small square of soft leather.

Paper

Paper has been used as a drawing surface for almost two thousand years. The craft of making paper is believed to have originated about 100 AD in China, where it was made from vegetable fibers. About 1200 AD, the Europeans started making a long-lasting paper from rag fiber. By 1500 just about every major European city was making its own paper. Some of the highest-quality papers available today are still being made from rag fiber in the same way they have been made for hundreds of years. Most of the paper we use today is made by machines from wood pulp. The ratio of wood pulp to rag fiber is the single most important factor in determining the quality and cost of paper. High-quality, long-lasting paper is acid free and made from 100 percent rag fiber. For most drawing purposes, you will want a paper that is durable and slightly textured. The textured quality helps you develop tonal areas and also traps and holds the media.

Newsprint is a wood pulp paper used by virtually every art student because it is inexpensive. Although it will yellow and decay with time, its availability and low price make it an excellent paper for quick poses, experimentation, and drawing exercises.

Student-grade **drawing papers** are made especially for art students by a number of manufacturers. Usually bound in relatively inexpensive pads of varying sizes, they are of a quality, weight, color, and texture (with what is called a medium tooth) to better accept and hold charcoal, graphite, chalk, and water media. They also hold up better than newsprint under vigorous drawing and repeated erasing.

Rag paper that is acid free is the finest drawing paper. It comes in a wide variety of surface textures and weights, each with its own aesthetic appeal. However, rag paper is more expensive and priced out of range for most beginning art students; it is unnecessary for studio assignments.

Accessories

Accessories are all the other items that come in handy but aren't visible in the drawing. A **drawing board** with a smooth surface that is a few inches larger than your paper is important for stability; a $1/8$" thick, 20 × 26" tempered masonite works well for 18 × 24" paper. Two large **metal clips** hold pads or single sheets of paper to the drawing board, and a large **folder** to hold paper, drawing board, and drawing tools keeps everything organized and transportable. A small, hand-held **pencil sharpener** lets you sharpen tools quickly as needed.

Suggested Materials List

Paper
1 newsprint pad, 18 × 24"
1 pad white drawing paper, 18 × 24"
4 sheets of toned paper, gray or tan, 18 × 24"

Mark-Making Tools
3 graphite pencils, 2B, 4B, and 2H
2 woodless graphite pencils and/or graphite sticks, 4B and 6B
3 charcoal pencils, hard, medium, and soft
2 large ($1/2$" diameter) vine charcoal sticks
5 vine charcoal sticks, soft ($1/8$" diameter)
3 conté sticks (red-brown, soft)
1 white charcoal pencil or white conté stick

Erasing Tools
1 large Staedtler Mars plastic eraser
1 large kneaded rubber eraser
1 Pink Pearl eraser stick in plastic tube

Accessories
1 drawing board, 20 × 26"
 ($1/8$" or $1/4$" tempered masonite)
1 large drawing folder, 20 × 26"
2 large metal clips
1 good hand-held pencil sharpener

Endnotes

Section One Introduction

1 Wayne Thiebaud, quoted in "Wayne Thiebaud Figure Drawings," exhibition catalog (San Francisco, CA: Campbell-Thiebaud Gallery, 1993), p. 100.

Chapter One

1 Kenneth Clark, *The Nude: A Study in Ideal Form* (Garden City, NY: Doubleday Anchor Books, 1956), p. 25.

2 Pablo Picasso, interview in *Cahiers d'Art*, 1935, quoted in *A Dictionary of Art Quotations*, by Ian Crofton (New York: Schirmer Books, 1988), p. 1.

3 Pablo Picasso, quoted in *Picasso on Art*, by Dore Ashton (New York: Da Capo Press, 1972), p. 104.

4 Henri Matisse, quoted in *Artists on Art,* by Robert Goldwater, ed. (New York: Pantheon Books, 1972), p. 412.

5 George Bellows, quoted on a mounted placard in a Metropolitan Museum exhibit, New York, 1994.

6 Robert Henri, *The Art Spirit* (New York: Harper & Row, 1984), p. 47.

7 Isabel Bishop, quoted in *Art Talk,* by Cindy Nemser (New York: Da Capo Press, 1972), p. 312.

8 Isabel Bishop, quoted in "Isabel Bishop Discusses 'Genre' Drawing," *American Artist*, June-July 1953, pp. 46–47.

9 Wayne Thiebaud, quoted in "Wayne Thiebaud Figure Drawings," exhibition catalog (San Francisco, CA: Campbell-Thiebaud Gallery, 1993), p. 100.

10 Jim Dine, quoted in *Art News*, Feb. 1996, p. 124.

11 Jim Dine, quoted in *Jim Dine Figure Drawing 1975–1979,* by Constance W. Glenn, exhibition catalog (Long Beach, CA: The Art Museum and Galleries of California State University, Oct. 1979).

12 Edgar Degas, quoted in *Degas et son Oeuvre,* by P. A. Lemoisne (Paris: Paul Brame et C.M. de Hauke, 1946), p. 100.

13 Albertine Gaur, *A History of Writing* (London: Cross River Press, 1992), p. 33.

14 Howard S. Hoffman, *Vision and the Art of Drawing* (Englewood Cliffs, NJ: Prentice Hall, 1989), p. 144.

15 Edgar Degas, quoted in *Degas et son Oeuvre*, p. 100.

16 Pablo Picasso, quoted in *Picasso on Art*, p. 38.

Chapter Two

1 Pablo Picasso, quoted in "Conversation with Picasso," by Christian Zervo in *The Creative Process: A Symposium,* by Brewster Ghiselin, ed. (Berkeley: University of California Press, 1952), p. 57.

2 Eugène Delacroix, quoted in *Artists on Art*, p. 234.

3 Henri Matisse, quoted in *The Drawings of Henri Matisse,* by John Elderfield (London: Thames and Hudson, 1984), p. 10.

4 Auguste Rodin, quoted in *Personal Reminiscence of Auguste Rodin*, by Ludovici, 1926, quoted in *A Dictionary of Art Quotations*, p. 165.

5 Thomas Eakins, quoted in *Artists on Art*, p. 354.

6 Francesco de Goya, from *Goya,* by Chabrun, 1965, quoted in *A Dictionary of Art Quotations*, p. 80.

7 Nathan Oliveira, quoted in *Nathan Oliveira,* by Peter Selz (Los Angeles: University of California Press, 2002), p. 42.

8 Henri Matisse, quoted in *The Seduction of Venus,* by France Borel (Geneva: Skira Press, 1990), p. 46.

9 Ibid.

10 Edgar Degas, quoted in *The Private Degas,* by Richard Thomson (London: The Arts Council of Great Britain, 1987), p. 113.

11 Käthe Kollwitz, diary entry, quoted in *Edvard Munch: The Man and His Art,* by Ragna Stang (New York: Abbeville Press, 1977), p. 292.

Chapter Three

1 Leonardo da Vinci, quoted in *Leonardo da Vinci's Advice to Artists,* by Emery Kelen, ed. (Philadelphia: Running Press, 1990), p. 38.

2 Ernest Hemingway, quoted in *Art Through the Ages* (Rev. ed.), by Horst de la Croix and Richard G. Tansey (New York: Harcourt Brace Jovanovich, 1975), p. 472.

3 Paul Cézanne, quoted in *Artists on Art,* p. 363.

Chapter Four

1 Jean Auguste Dominique Ingres, quoted in *From the Sketchbooks of the Great Artists,* by Claude Marks (New York: Thomas Y. Crowell, 1972), p. 284.

2 Ibid., p. 234.

3 Jean Dubuffet, quoted in *Artist to Artist: Inspiration and Advice from Artists Past and Present* (Corvallis, OR: Jackson Creek Press, 1998), p. 92.

4 Rico Lebrun, *Rico Lebrun Drawings* (Berkeley: University of California Press, 1961), p. 27.

5 Rico Lebrun, quoted in *Conversation with the Artist,* by S. Rodman (New York: Capricorn Books, 1961), p. 37.

6 Philip Rawson, *Drawing* (2nd ed.) (Philadelphia: University of Pennsylvania Press, 1987).

7 Henri Matisse, quoted in *Matisse on Art,* by Jack D. Flam (London: Phaidon Press, 1973), p. 38.

8 Henri Matisse, quoted in *The Drawings of Henri Matisse*, pp. 121–122.

9 Alberto Giacometti, quoted in *Twentieth Century Artists on Art,* by Dore Ashton (New York: Pantheon Books, 1985), p. 57.

Chapter Five

1 Edgar Degas, from his notebook, quoted in *Degas by Degas: Artists by Themselves*, by Rachel Barnet, ed. (London: Bracken Books, 1992), p. 44.

2 Edgar Degas, quoted in *The Private Degas*, p. 46.

3 Leonardo da Vinci, quoted in *A Dictionary of Art and Artists*, by Peter and Linda Murray (Baltimore: Penguin Books, 1959), p. 297.

4 Fred Dalkey, quoted in an interview by Chris Daubert in *Fred Dalkey—Retrospective* (Sacramento, CA: Crocker Art Museum, 2002), p. 110.

5 Ibid.

6 Robert Beverly Hale, *Drawing Lessons from the Great Masters* (New York: Watson Guptill, 1989), p. 90.

7 Ibid., p. 74.

8 Kenneth Clark, *The Nude,* p. 265.

9 Egon Schiele, quoted in *Egon Schiele 1890–1918: Desire and Decay,* by Wolfgang Georg Tischer (Köln, Germany: Taschen, 1999), p. 126.

10 Rick Bartow, quoted in *Rick Bartow My Eye,* by Rebecca J. Dobkins (Seattle: University of Washington Press, 2002), p. 31.

11 Paul Cézanne, quoted in *From the Sketchbooks of the Great Artists*, p. 305.

Section Two Introduction

1 Robert Henri, *Art Spirit*, p. 264.

2 Edgar Degas, quoted in *Degas et son Oeuvre*, p. 100.

Chapter Six

1 Leonardo da Vinci, *Leonardo da Vinci on the Human Body* (New York: Dover, 1983), p. 13.

2 Ibid.

3 Peter Paul Rubens, quoted in *Artists on Art*, p. 148.

4 Martha Mayer Erlebacher, quoted in *Art News,* May 1985, p. 90.

Chapter Seven

1 Leonardo da Vinci, quoted in *Leonardo da Vinci's Advice to Artists,* by Emery Kelen, ed. (Philadelphia: Running Press, 1990), p. 55.

Chapter Eight

1 Leonardo da Vinci, quoted in *Artists on Art*, p. 83.

2 Auguste Renoir, quoted in *Renoir, My Father,* by Jean Renoir (New York: Little Brown, 1962), p. 446.

3 Alice Neel, quoted in *Alice Neel: Black and White*, exhibition catalog (New York: Robert Miller Gallery, 2002).

4 Ibid.

5 Alice Neel, quoted in *Lines of Vision: Drawings by Contemporary Women,* by Judy K. Collischan van Wagner (New York: Hudson Hills Press, 1989), p. 105.

6 Jim Dine, "Conversation with the Artist," *Jim Dine Figure Drawing 1975–1979.*

7 Jack Beal, quoted in *Jack Beal,* by Eric Shanes (New York: Hudson Hills Press, 1993), p. 63.

8 Elizabeth Layton, quoted in *Women and Aging: An Anthology by Women* (Corvallis, OR: CALYX Books, 1986), p. 152.

9 Lynda Nead, *The Female Nude: Art, Obscenity and Sexuality* (New York: Routledge Press, 1992).

Section Three Introduction

1 Philip Pearlstein, "Why I Paint the Way I Do," *New York Times*, Aug. 22, 1971, p. D29.

Chapter Nine

1 Wayne Thiebaud, *Sacramento Bee*, Oct. 3, 1965, p. L9.

2 Henri Matisse, quoted in *Henri Matisse,* by Alfred H. Barr, ed. (New York: Museum of Modern Art, 1931), p. 29.

3 Henri Matisse, quoted in *Artists on Art*, p. 413.

4 James Abbott McNeill Whistler, quoted in *Artists on Art*, p. 347.

5 Ibid.

6 Edgar Degas, *The Private Degas,* p. 46.

7 Edgar Degas, quoted in *From the Sketchbooks of the Great Artists*, p. 283.

8 Kirk Varnedoc, *A Fine Disregard: What Makes Modern Art Modern* (New York: Harry N. Abrams, 1990).

9 Edward Hopper, quoted in *The Artist's Voice: Talks with Seventeen Artists,* by Katherine Kuh (New York: Harper & Row, 1963), p. 135.

10 John Elderfield, *The Drawings of Richard Diebenkorn* (Houston: Fine Arts Press, 1988), p. 22.

11 Richard Diebenkorn, quoted in *The Drawings of Richard Diebenkorn*, p. 25.

12 Suzanne Langer, *Philosophy in a New Key* (Cambridge, MA: Harvard University Press, 1942), p. 61.

13 Philip Pearlstein, "Why I Paint the Way I Do," *New York Times*, Aug. 22, 1971, p. D29.

14 Philip Pearlstein, "A Statement," *Berlin-Dahlia: Satellite Mussed*, exhibition catalog (Preussischer Kulturbesitz Kupferstichkabinett, 1972), p. 14.

15 Philip Pearlstein, *A Realist Artist in an Abstract World*, exhibition catalog (Milwaukee, WI: Milwaukee Art Museum, 1983), p. 15.

16 Edgar Degas, from his notebook, quoted in *Degas by Degas: Artists by Themselves*, p. 64.

17 James Abbott McNeill Whistler, quoted in *Artists on Art*, p. 350.

18 van Deren Coke, *The Painter and the Photographer* (Albuquerque: University of New Mexico Press, 1972).

19 John Berger, *Ways of Seeing* (New York: Viking Press, 1995), pp. 53–54.

Chapter Ten

1 Edvard Munch, from his 1886 diary, quoted in *Edvard Munch*, p. 111.

2 Ibid.

3 Ibid., p. 107.

4 Vincent van Gogh, quoted in *The World of Vincent van Gogh,* by Robert Wallace (New York: Time-Life Books, 1969), p. 148.

5 Käthe Kollwitz, quoted in *Käthe Kollwitz: Woman and Artist,* by Martha Kearns (New York: The City University of New York, 1976), p. 173.

6 Ibid., p. 164.

7 Rico Lebrun, quoted in *Rico Lebrun Drawings*, pp. 24–25.

8 Pablo Picasso, *Quote,* Sept. 21, 1958.

9 Mauricio Lasansky, quoted in *The Nazi Drawings*, exhibition catalog (Philadelphia: Philadelphia Museum of Art, 1966).

10 Jerome Witkin, quoted in *Life Lessons: The Art of Jerome Witkin,* by Sherry Chayat (Syracuse, NY: Syracuse University Press, 1994), p. 54.

11 Ibid., p. 53.

12 Ibid., p. 54.

13 Bailey Doogan, quoted in an interview with Jordan Storms, *Daily Targum,* Rutgers University, Feb. 2000.

14 Ibid.

15 Arturo B. Fallico, *Art and Existentialism* (Englewood Cliffs, NJ: Prentice Hall, 1962), p. 44.

16 Thomas B. Hess, *Willem de Kooning*, exhibition catalog (New York: Museum of Modern Art, 1968), p. 79.

17 Jim Dine, "Conversation with the Artist," *Jim Dine Figure Drawing 1975–1979.*

18 Ibid.

19 Ibid.

20 Ibid.

21 Edvard Munch, quoted in *Edvard Munch*, p. 111.

22 *Genesis* 3–7.

23 Eric Fischl, quoted in *Fischl,* by Donald Kuspit (New York: Vintage Books, 1987), p. 57.

24 Kenneth Clark, *The Nude,* p. 23.

25 Eric Fischl, quoted in *Eric Fischl 1970–2000,* by Arthur Danto, Robert Enright, and Steve Martin (New York: Monacelli Press, 2000), p. 112.

26 Lucien Freud, quoted in *Portraits: Talking with Artists at the Met, the Modern, the Louvre, and Elsewhere,* by Michael Kimmelman (New York: Random House, 1998), p. 106.

27 Ivan Le Lorraine Albright, quoted in "In a Museum of Mirrors," by Michael Bonesteel, *Art in America,* Dec. 1984, p. 143.

28 Ibid.

29 Rick Bartow, quoted in *Rick Bartow My Eye,* p. 22.

30 Yolanda López, quoted in "Yolanda López's Art Hits 'Twitch Meter' to Fight Stereotypes," by Lili Wright, *Salt Lake Tribune,* May 14, 1995.

31 Ibid.

32 Francisco de Goya, quoted in *A Dictionary of Art Quotations,* p. 80.

33 Ibid., p. 139.

34 Nancy Grossman, quoted in *Lines of Vision: Drawings by Contemporary Women,* p. 65.

35 Nancy Breslow in preface to Frida Kahlo's "Portrait of Diego," in *CALYX, A Journal of Art and Literature by Women: Special International Issue,* Oct. 1980, p. 89.

36 Frida Kahlo, quoted in *Frida Kahlo: The Paintings,* by Hayden Herrera (New York: Harper Perennial, 1991), p. 74.

37 Ingrid Schaffner, *The Return of the Cadavre Exquis*, exhibition catalog (New York: The Drawing Center, 1993), p. 19.

Glossary

abstract Nonrepresentational; having little or no relationship to the appearance of actual or imaginary objects. (See also *representational*.)

Abstract Expressionism A term applied to a movement begun in New York in the 1940s that placed emphasis on spontaneous personal expression and the role of the subconscious in the act of creation.

achromatic Possessing no color or hue; involving only black, gray, or white. (Contrast with *chromatic*.)

acid-free paper A high-quality paper with greater durability and longevity; usually made with rag fiber.

action pose An energetic or gestural pose suggesting a frozen moment or action.

additive method A technique of drawing by adding media to the surface or ground. (Contrast with *subtractive method*.)

analytic approach A systematic and rational approach to drawing; often dividing the whole into parts and observing their interrelationships.

anatomical contour line Lines that suggest and follow the skeletal and muscular form of the body as they cross the body's contours.

anatomy The study of the form and structure of the parts of an organism.

angle of perception The angle from which the subject is viewed, which affects *perspective* and *proportions*.

angle of recession The angle at which the subject or parts of the subject recede or tip back in space away from the viewer, thus altering the perception of the subject's proportions.

anterior view Front view.

architectonic Having structural or design characteristics reminiscent of the principles of architecture.

articulation The state of being joined or interrelated; a movable joint between bones or cartilage.

atmospheric perspective A perspective device based on the observation that as objects recede in space, light fades, colors dull, and details become obscured.

background The more recessive portions of a pictorial composition against which objects in the foreground are placed.

blend To apply media uniformly, with imperceptible tonal transitions. (See also *continuous tone*.)

blind contour drawing Describing in a slow, careful manner the outer contour of the body without looking at the drawing surface.

blind gesture drawing Describing in rapid and energetic fashion the gestural movement and thrust of a pose without looking at the drawing surface.

broken outline An outline of form that consists of a series of noncontinuous, separate *line phrases* rather than an uninterrupted, continuous line.

calligraphic line Free-flowing line that varies in weight and application and is presented in graceful, rhythmic phrases that share the aesthetic intent of calligraphic writing: to produce lines of elegance or beauty. (See also *modulated line*.)

cartoon A preliminary, full-scale drawing made to be transferred to another surface.

cast shadow The tonal value created when an object blocks light; a dark area cast upon a surface by a body intercepting the light from its source.

chiaroscuro Depiction of light and shadow, generally associated with a dramatic contrasting arrangement of light and dark. (See also *sfumato*.)

chromatic Relating to or having color. (Contrast with *achromatic*.)

circumscribe Using line to enclose a form and define its outer limits as a discrete configuration.

collage A composition created by adding various materials to the drawing surface.

color The visual perception of the quality of light reflected from the surface of objects. Pigmented colors absorb certain light wavelengths while reflecting those that define their hues.

composition The arrangement of drawing elements in relationship to each other and to the whole.

compositional sketch A quick drawing that delineates the essential elements of a composition; concerned with the division of the picture plane and the relationship of objects within the format.

configuration The form of a figure as determined by its pose and the arrangement of overlapping body parts.

conté crayon Drawing medium originally made in earth tones from pigment and gum binder compressed into small rectangular drawing sticks; commercially made drawing sticks are available in a wide array of colors.

content The subject matter of a drawing, including narrative, symbolic, or thematic connotations that imbue the work of art with perceivable meaning.

continuous line A line that expresses the subject matter in a long, unbroken phrase. (See *line phrasing*.)

continuous tone The application of media in blended gradations of value; having no obvious *vector* or notable directional significance. (Compare with *hatching* and *cross-hatching*.)

contour line Line that represents the contour of an object, both interior contours and outer edge. In figure drawing, line that represents the fullness of the human form, its dimensional contours.

contour modeling line Line that conceptually shapes or molds the body and suggests its surface variations.

cross-contour line Line that describes an object's surface topography, emphasizing the volumetric shape of

an object. (See also *anatomical contour line*, *contour line*, and *schematic contour line*.)

cross-hatching A technique by which value areas are created by building up areas of crossing linear strokes known as hatch marks. (See also *hatching*.)

deckle edge The uneven edge of drawing paper that indicates a mold-made papermaking process.

diagrammatic A drawing having primarily a utilitarian and informative function, devoid of embellishment or extraneous elements.

directional line Line that implies movement or vector.

double-ply Paper with thickness equivalent to two single-ply sheets.

elements of design The principal graphic devices available to the artist for composing a work of art: line, value, space, form, texture, pattern, and color.

Expressionism A term originally used to characterize twentieth-century northern European art that stressed emotional content and the artist's inner vision; an artistic means that gave expression to their feelings.

expressive Dealing with feelings and emotions and the artist's inner vision, as opposed to objective observation of external phenomena.

extended gesture A drawing that begins with a quick gesture sketch but that is expanded upon over an extended period of time.

extensors Muscles that straighten and extend various parts of the body. (See *flexors*.)

eye level Refers to the physical eye level of the artist, which in turn determines the position of the horizon line and the angle of perception.

figurative Art that represents the human figure or other recognizable objects as visual symbols, in contrast with abstract art. (See *representational* and *naturalism*.)

figure-frame relationship See *figure-ground*.

figure-ground The relationship of the positive object or form within its background or surrounding space. (See *foreground*, *background*, and *ground*.)

flexors Muscles that bend various parts of the body. (See *extensors*.)

foreground A position of prominence; the part of a scene or representation nearest to the viewer; correlating to the lower portion of a pictorial representation. (See also *background*.)

foreshortened A form that is viewed in such a way that its normal proportions appear shortened or compressed; also said to be seen in *perspective*.

form One of the elements of design, *form* refers to the three-dimensional volume and structure of the figure, as opposed to *shape*, which refers to two-dimensional planes. In a broader sense, the manner in which a visual *symbol* of the figure is presented as a visual idea or concept.

formalist In art, one who is primarily concerned with the structural composition and pure aesthetic elements in a work. (See also *humanist*.)

format The proportion, configuration, and scale of the drawing area. (See *picture plane*.)

geometric shape Shape relating to or in accordance with the principles of geometry, as in circles, squares, rectangles, and so forth.

gesso A preparatory coating that can be applied to the surface of a drawing support such as paper, wood panel, or canvas. (See also *ground*.)

gestalt The whole; a functional unit that is integrated.

gestural approach A quick graphic representation of form in which the hand (holding a drawing tool) follows the eye's movement over the subject's pose.

gestural contour Expressing volume and surface contours through lines drawn in an intuitive, freehand manner. (See *gesture sketch*.)

gesture The pose or stance of a figure; the movement of the body as a means of expression.

gesture sketch In figure drawing, a quick, energetic drawing that attempts to capture the essential gesture or element of a model's pose.

gouache Water-soluble paint that is more opaque than traditional watercolor.

graphite A crystallized form of carbon used as the main ingredient in lead pencils and graphite sticks.

ground The surface on which the artist works; often a preparatory coating applied prior to drawing, which would be referred to as a "prepared ground." (See also *gesso* and *background*.)

hatch marks Short parallel adjacent lines that, when combined, are perceived as value. (See also *hatching* and *cross-hatching*.)

hatching Building areas of value using adjacent parallel linear strokes known as hatch marks. (See also *cross-hatching*.)

head length A unit of measurement, using the head of an individual to compare proportional relationships. (See *proportion*.)

highlight The lightest areas in a drawing or painting; areas receiving the most illumination; application of light-colored media over a darker *medium* or *ground*.

horizon line An imaginary line in the distance where earth and sky appear to meet and toward which receding forms appear to diminish. (See *eye level*, *vanishing point*, and *linear perspective*.)

hue The attribute of colors that permits them to be distinguished as red, blue, yellow, or intermediary colors.

humanist In art, one who is concerned with expressing subjective feeling and using the figure as a symbolic statement about humanity or the human condition. (Compare with *formalist*.)

icon A pictorial representation; an object of veneration; a religious symbol or image.

illusionistic space The representation of three-dimensional space on a two-dimensional surface.

illusionistic texture Created when the artist accurately represents the appearance and surface quality of an object. (See also *simulated texture, physical texture*, and *invented texture*.)

implied line A suggested or invisible line; a line whose direction or vector continues beyond where the line stops; line that relies on the viewer to conceptually complete the movement the line suggests.

intent An artist's objective or purpose; an aim that guides the artist's action and establishes the criteria for evaluating the work of art.

invented texture An optical phenomenon whereby the artist's manipulation of media creates the visual impression of texture, which is not intended to be descriptive of an object's actual texture. (Contrast with *physical texture* and *illusionistic texture*.)

kinesthesia A sensory experience derived from and stimulated by bodily position, presence, or movement.

kinetic energy Energy associated with motion, which is often recorded by the marks in a drawing.

lateral view Side view.

light In drawing, those tones nearest to white on the value scale from black to white; those areas of a drawing that reflect the most illumination from a light source. (See also *highlight* and *value*.)

line A mark made by a tool as it moves across a surface or ground; distinguished from its background because of the change in value.

line phrase A single, uninterrupted movement of a line from beginning to end.

line phrasing The manner in which the artist applies line; a collection of line phrases. (See also *outline, broken outline, overlapping line, modulated line, multiple phrase line*, and *contour line*.)

linear perspective A drawing technique that relies on the optical impression that parallel lines converge toward distant vanishing points. Also, as our distance from an object increases, the size of its image on the retina decreases. (See also *perspective* and *visual angle*.)

Mannerism A term used to denote the art style of Italy following the High Renaissance; characterized by elongated and overly muscular figures that exaggerate the styles of Raphael and Michelangelo.

mapping The process of graphically defining the position and configuration of a pose. (See also *plotting*.)

mass In drawing, the representation or illusion of an object's weight, volume, and density.

media The physical materials and tools through which the visual artist communicates; the categories or techniques of application of physical media (i.e., drawing, painting, sculpting).

metalpoint A metal-tipped drawing tool; a drawing technique using a metal stylus, usually silver, on a prepared ground. Also called *silverpoint*.

minimalism An art style involving abstract art primarily consisting of geometric forms and characterized by simplicity and spareness.

modeling The use of value to create the illusion of three-dimensional form and space. (See *rendering*.)

Modernism A term generically associated with the mainstream art of the twentieth century that stressed the formal elements in art, emphasizing that art should be self-contained and void of external references.

modulated line Line that varies in weight and thickness to accentuate or de-emphasize form. (See also *calligraphic line*.)

multiple-phrase line A composite line that consists of several adjacent or overlapping lines that together define the form.

multiple-point perspective Employed when compound forms or complex arrangements have parallel lines receding in different directions toward different vanishing points. (See also *perspective*.)

naturalism In art, a conformity to nature; not stylized. (See also *representational* and *figurative*.)

negative space The space surrounding a positive shape or solid; that which is not occupied or filled with an object. (See also *background*.)

New Realism A movement among artists who rejected the aesthetic values of abstract or nonrepresentational art and reintroduced realistic representation of subject matter.

newsprint An inexpensive paper made from wood pulp; used for printing newspapers and by art students for practice drawings.

objective Dealing with factual representation as perceived without distortion by personal feelings or interpretations. (Compare *subjective* and *expressive*.)

oblique angle/oblique view Observing the figure from a view other than front, back, or profile that results in the visual skewing of the body's normal symmetry or proportional relationships.

one-point perspective A system of drawing dependent on the illusion that all parallel lines converge as they recede in space toward a single vanishing point. (See also *perspective, horizon line*, and *linear perspective*.)

organic shape Relating to nature; having free-flowing or biomorphic, rather than geometric, shape.

outline A line used as a tool of demarcation by tracing the outer edge, thus enclosing shapes and separating the figure from its surroundings. (See *circumscribe*.)

overlapping A perspective device whereby spatial relationships are shown by lines and shapes blocking out others, thus implying that one form is behind another.

overlapping line Line that extends over or covers another line to suggest the spatial position of forms.

pattern The sequential arrangement of shapes, values, and textures over a broad area.

pentimenti A still visible remnant or underdrawing that indicates a change made between an earlier stage of drawing and the finished composition. (Italian for "change of mind.")

perspective A means by which the artist suggests three-dimensional space and depth in drawing. (See also *linear perspective, atmospheric perspective, overlapping, vertical positioning*, and *size differentiation*.)

physical texture The actual tactile quality of a surface, including both drawing surface and media application. (See also *invented texture* and *illusionistic texture*.)

pictorial space The created illusion of depth on a two-dimensional surface. (See also *picture plane*.)

picture plane The two-dimensional surface on which the artist works; also, the imaginary plane between the artist and the subject.

pigment The substance responsible for color in media.

planar analysis A drawing process that reveals multifaceted surface planes on the figure. (See also *structural analysis*.)

plane A flat, two-dimensional, continuous surface. (See also *form* and *picture plane*.)

plot plan A lightly drawn sketch indicating the general proportions and intended placement of the figure. (See *mapping* and *plotting*.)

plotting Systematically creating a plot plan with points of reference and lightly drawn lines to suggest the position and proportional relationships of a model's pose. A preliminary schematic sketch usually based on sight measuring and comparative analysis.

point of perception/point of view The eye level and general position from which the artist sees the subject being drawn.

portrait A representational drawing or painting of an individual, focusing primarily on the face and head.

positive image An object that serves as the subject of the drawing, as distinguished from the background or negative space.

posterior view Back view.

Postmodernism A term describing a shift from the cultural and aesthetic values attributed to *Modernism*. Beginning in the 1970s, representation, figuration, and social and political content were reintroduced into works of art to make art more about life.

preperception Stored visual concepts that facilitate recognition of objects but often prevent accurate perception of familiar subjects.

primary colors The set of colors from which all other colors may be derived; in pigment: red, yellow, and blue. Colors that cannot be derived from mixtures of other colors.

profile view The figure seen from the side; particularly the head. (See *lateral view*.)

proportion In figure drawing, the comparative relationship between parts of the body and the whole and between one part and another.

rag paper Paper made from rag fiber; more durable than student-grade drawing paper or newsprint.

reflected light Light that is not from a direct source, such as the sun or a lamp, but an indirect one, reflected from one surface onto another. (See also *light* and *cast shadow*.)

rendering The use of value to depict patterns of light and shadow. (Contrast with *modeling*.)

repeating/rephrasing line See *multiple phrase line*.

representational A realistic graphic depiction of recognizable objects. (See *figurative*.)

Romanticism An art movement flourishing in Europe from the late eighteenth to mid-nineteenth centuries that emphasized spontaneity and expression of one's feelings, embodying an energetic use of media and emotive subject matter.

scale The size of a form in relationship to the viewer or to other dimensions. (See also *proportion*.)

schematic contour line Line that defines the body's three-dimensional character in terms of geometric volumes and planes that contour the body.

schematic line Line used in a diagrammatic way, symmetrically drawn; geometric rather than organic; usually reflective of essential features as in an architectural blueprint or mechanical drawing.

schematic sketch A systematic drawing generally concerned with structure and the delineation of a form's essential structural features, executed in an orderly and rational manner. (See *diagrammatic*.)

sfumato The blending of light and dark by almost imperceptible stages, which eliminates edges and the use of line to enclose form; from the Italian word for smoke. (See also *chiaroscuro*.)

shading Using drawing tools to create variation in tone when rendering light patterns or modeling three-dimensional forms.

shadow Tonal areas created by the blocking of the light falling on a surface. (See also *cast shadow*.)

shape The configuration of an object. As a visual element, shape usually refers to the two-dimensional area of the figure within the picture plane, as opposed to *form*, which implies three-dimensional *volume*. (See also *organic shape* and *geometric shape*.)

sight measuring A technique artists use to visually determine proportional relationships from a distance.

silverpoint A drawing method using a silver stylus on a prepared surface; popular with artists of the fourteenth and fifteenth centuries, when surface preparation consisted of powdered bone, or white lead. *Metalpoint* is another term that refers to silver as well as other metals used in the same way.

simulated texture Created when the artist suggests or represents the tactile appearance and surface quality of an object. (See also *illusionistic texture, physical texture,* and *invented texture.*)

single-ply Paper with a single-sheet thickness. (See also *double-ply.*)

size differentiation A perspective device of regulating the size of an object in drawing to suggest distance from the viewer. (See also *perspective.*)

sketch A quickly executed exploratory drawing often done as a form of notation or as a means of initiating a visual idea for later reference; a drawing made quickly to capture the essential elements of a pose or scene or concept. (See *gesture sketch.*)

solid A form that has density and weight. (See also *positive image* and *mass.*)

space In drawing, the representation of three-dimensional volume or volumetric dimension characterized by height, width, and depth.

spatial plane The position of a shape or form in space.

structural analysis A drawing process that reduces volumetric forms to their basic geometric structure. (See also *planar analysis.*)

student-grade paper Inexpensive drawing paper made from bleached wood pulp; whiter and more durable than newsprint.

stylus See *metalpoint.*

subjective Dealing with the opinions and artistic expression derived primarily from within the individual rather than from objective examination of the external world. (See also *expressive.*)

subtractive method A drawing technique whereby pigment is removed from the surface or ground. (Contrast with *additive method.*)

support The backing, or foundation, on which media are applied; for example, paper, canvas, drawing board. (See also *ground.*)

surface terrain The surface relief; its three-dimensional raises and recesses. (See *contour line.*)

symbol An image that represents something beyond its intrinsic shape or form by reason of relationship, association, or pictorial resemblance.

tactile Relating to the sense of touch.

texture The tactile quality of a surface; the representation of tactile appearance. (See *physical, illusionistic, simulated,* and *invented texture.*)

three-dimensional Having three dimensions: height, width, and depth; in drawing, the illusion of depth.

three-quarter view Observing or presenting a subject in a position between frontal and profile. (See *oblique angle.*)

tone The many value gradations in the value scale between black and white.

toned paper Paper having a value other than white; either hand-toned or produced commercially.

tooth The physical texture of the drawing surface, described as coarse, medium, or fine-grain tooth.

topographical A graphic or pictorial representation of the surface terrain and contours of the figure as determined by its anatomical structure.

topographical contour line Line that expresses the contour of the form, as lines in a contour map indicate shifting topography of the land.

transverse Lines that travel across forms, going back and forth, such as cross-contour lines, topographical lines, or cross-hatching strokes.

two-dimensional Having only two dimensions; lacking depth.

underdrawing A preliminary drawing used to establish the primary structural and proportional relationships over which progressive finishing layers of refinement are added. (See *pentimenti.*)

value The range of tones from light to dark or from white to black; all the shades of gray in between. (See also *light.*)

value scale The graduated steps in tonal range from white through gray to black.

vanishing point In perspective drawing, the imaginary point toward which parallel lines of a form appear to converge or vanish. (See also *perspective* and *linear perspective.*)

vector A directional force. In drawing, an implied force of line created as a record of directional movement. The vector of a line may also be carried by the line's momentum beyond its extremity. (See *implied line.*)

vertical positioning A perspective device that suggests that forms higher on the picture plane are farther back in space. (See also *perspective.*)

visual angle The angle at which light rays enter the eye and thus determine the size of the image on the retina.

visual metaphor The use of graphic or pictorial symbols to convey ideas or concepts beyond their mere physical appearance.

volume The expression of form as occupying three-dimensional space. (See also *mass, form,* and *space.*)

wash A pigmented solution, such as ink or watercolor, applied with a brush to create tonal gradations.

weight An acknowledgment that the body is affected by and responds to the effects of gravity; in the visual arts, a graphic expression of this awareness. Also refers to the relative density of media, as in line weight.

Index

Useful Websites

The following sites provide links to museums throughout the world.

Artcyclopedia: The Fine Art Search Engine
www.artcyclopedia.com

Art Museums Archives Links and Websites
www.museumstuff.com

Art Museum Network
www.amn.org

World Wide Arts Resources
wwar.com

Museum Websites

Many of the museums that provided art for this book are listed below. Find other galleries or museums through a search engine such as Google (www.google.com).

Arkansas Arts Center
www.arkarts.com

Art Institute of Chicago
www.artic.edu/aic

Ashmolean Museum, Oxford, England
www.ashmol.ox.ac.uk

British Museum
www.thebritishmuseum.ac.uk

Cincinnati Art Museum
www.cincinnatiartmuseum.org

Cleveland Museum of Art
www.clevelandart.org

Courtauld Institute of Art, London
www.courtauld.ac.uk

Dallas Museum of Art
www.dm-art.org

Detroit Institute of Arts
www.dia.org

Fine Arts Museums of San Francisco
www.thinker.org

Fitzwilliam Museum, Cambridge, UK
www.fitzmuseum.cam.ac.uk

Harvard University Art Museums
www.artmuseums.harvard.edu

Isabella Stewart Gardner Museum
www.gardnermuseum.org

J. Paul Getty Museum, Los Angeles
www.getty.edu

Los Angeles County Museum of Art
www.lacma.org

Metropolitan Museum of Art, New York
www.metmuseum.org

Minnesota Museum of American Art
www.mmaa.org

Musée du Louvre, Paris
www.louvre.fr

Museo Nacional del Prado
museoprado.mcu.es

Museum of Modern Art, New York
www.moma.org

National Gallery of Art, Washington, D.C.
www.nga.gov

Portland Art Museum, Oregon
www.portlandartmuseum.org

Rhode Island School of Design Museum
www.risd.edu/museum.cfm

Rijksmuseum, Amsterdam
www.rijksmuseum.nl

Solomon R. Guggenheim Museum
www.guggenheim.org

Van Gogh Museum
www.vangoghmuseum.nl

Victoria and Albert Museum
www.vam.ac.uk

Wadsworth Atheneum
www.wadsworthatheneum.org

Whitney Museum of American Art
www.whitney.org

Whitworth Art Gallery
www.whitworth.man.ac.uk

Worcester Art Museum
www.worcesterart.org